W. Brady

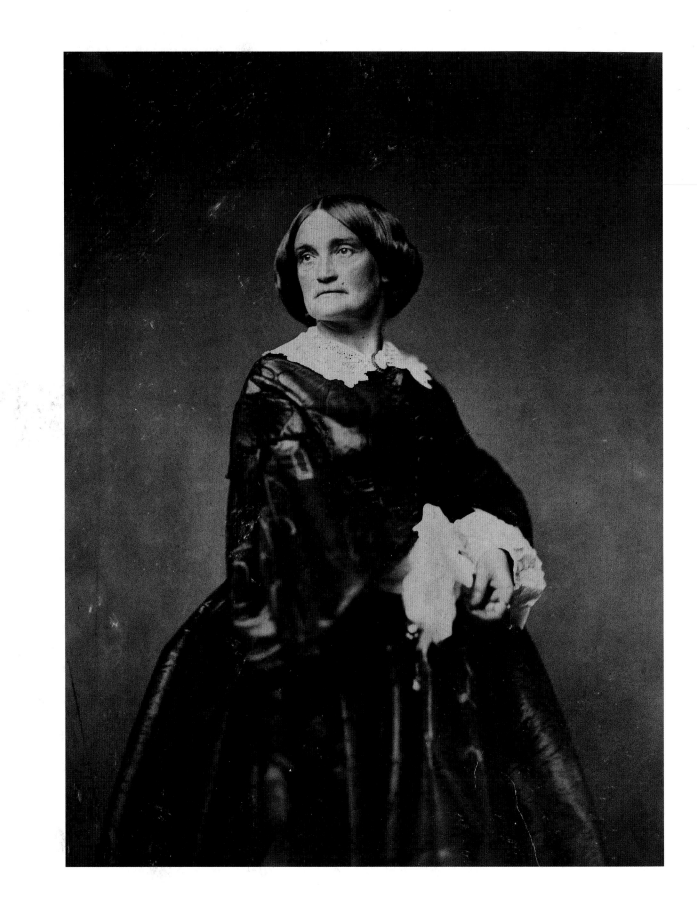

Mathew Brady
and the Image of History

Mary Panzer

SMITHSONIAN INSTITUTION PRESS

FOR THE

NATIONAL PORTRAIT GALLERY

WASHINGTON AND LONDON

All images are by the Mathew Brady Studio
unless otherwise noted.

An exhibition at the

NATIONAL PORTRAIT GALLERY
Smithsonian Institution, Washington, D.C.,
September 26, 1997–January 4, 1998

FOGG ART MUSEUM
Harvard University, Cambridge, Massachusetts,
January 22–April 15, 1998

INTERNATIONAL CENTER OF
PHOTOGRAPHY
Midtown, New York City,
May 1–July 19, 1998

Partial support of the exhibition has been provided by
the Marpat Foundation and the Discovery Channel

EDITED BY: Dru Dowdy
DESIGNED BY: Janice Wheeler
TYPESET BY: Blue Heron Typesetters, Inc.

Library of Congress Cataloging-in-Publication Data
Panzer, Mary.
 Mathew Brady and the image of history / Mary
Panzer : with an essay by Jeana K. Foley.
 p. cm.
 An exhibition at the National Portrait Gallery, Sept.
26, 1997–Jan. 4. 1998; Fogg Art Museum, Harvard Uni-
versity, Jan. 22–April 15, 1998; International Center of
Photography, Midtown, New York City, May 1–July 19,
1998.
 Includes bibliographical references and index.
 ISBN 1-56098-793-6 (alk. paper)
 1. Brady, Mathew B., 1823 (ca.)–1896—Exhibitions.
2. Photographers—United States—Biography—Exhi-
bitions. 3. Portrait Photography—United States—His-
tory—Exhibitions. 4. United States—History—Civil
War, 1861–1865—Photography—Exhibitions. I. Foley,
Jeana K. II. National Portrait Gallery (Smithsonian In-
stitution). III. Fogg Art Museum. IV. International Cen-
ter of Photography. V. Title.
TR140.B7P36 1997
770' .92—dc21
[B] 97-9493

British Library Cataloguing-in-Publication Data is
available

Printed in Singapore, not at government expense
04 03 02 01 00 99 98 97 5 4 3 2 1

FRONTISPIECE: Charlotte Cushman. Imperial salted-
paper print, 1857. Harvard Theatre Collection, The
Houghton Library, Harvard University, Cambridge,
Massachusettes.

Contents

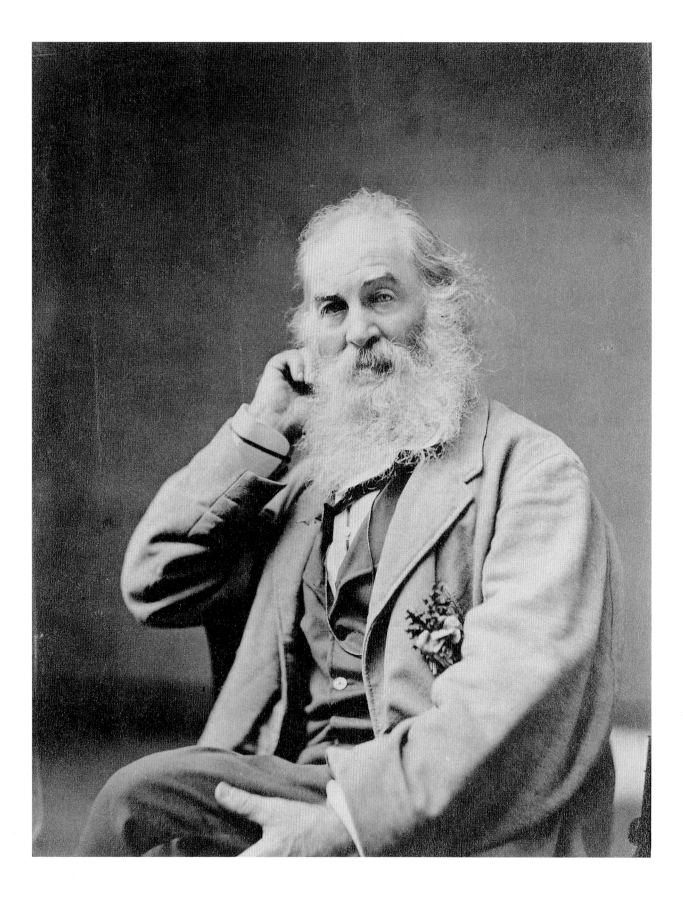

Foreword

Walt Whitman

Albumen silver print, circa 1867.

National Portrait Gallery, Smithsonian Institution, Washington, D.C.; gift of Mr. and Mrs. Charles Feinberg

Few photographers—of any time or any place—are better known to the general public than Mathew Brady. Abraham Lincoln used a Brady studio photograph to support his campaign for the presidency after his 1860 speech at the Cooper Union, and some of the last photographs of Lincoln before his assassination five years later came from Brady's studio. It is difficult to think of the Civil War without calling to mind the remarkable battlefield images and portraits of the officers and men published by Brady. Visiting royalty from England, leaders of American Indian nations, stars of the concert stage and theater—all were immortalized in one of Brady's establishments. Brady's name was known to them, as it is known to us a century or more later.

It is particularly suitable that the Smithsonian's National Portrait Gallery should undertake this study of Brady's portraiture, since his purpose and the Gallery's are so congruent. Brady's principal Washington studio was located just a few streets from the Patent Office Building, which houses the Portrait Gallery today. Brady's tireless quest for images of the notables of his time was part of his plan when he announced the publication of his first major book, *The Gallery of Illustrious Americans*, in 1850. Brady's photographs fully justify the opinion of the *Harper's Weekly* writer of November 14, 1863, who saw them "as materials for history of the very highest value." An 1866 resolution of the Council of the National Academy of Design asserted that Brady's work was "of great value . . . as a nucleus of a national historical museum . . . and illustrative of our history." The resolution proposed that the museum be established at the New-York Historical Society, but this did not come to pass. Substantial collections of Brady's photographs are today in several major institutions in Washington, prominently including the National Portrait Gallery.

The National Portrait Gallery has become a leader in the study of early photographic portraiture, recognizing that Americans had given a special place to the photographic recording of their leaders and celebrities. The exhibition "Facing the Light" was mounted here in 1978, bringing together an unprecedented gathering of daguerreotype portraits from a variety of public and private collections. Several years later, the pioneer daguerreotypist Robert Cornelius was the subject of a one-person exhibition, and today, early photographic portraits take their place next to work in other media in the Gallery's permanent collection. With the acquisition in 1981 of the Meserve Collection, comprising thousands of glass-plate negatives from the Brady studios, augmented by a number of significant accessions from other sources, Brady's work was assured a central place in the Gallery's holdings, setting the stage for this publication and the remarkable exhibition that accompanies it.

Brady was surely the most active exploiter of the peculiar power of the photograph to create or sustain celebrity; his business flourished and his personal reputation grew as Americans increasingly sought

pictures of the notables of their day. Curiously, Mathew Brady is also one of the most elusive figures of his time. The date and place of his birth cannot be documented, and many aspects of his early career are unclear. Much of our knowledge of people he met and jobs he held comes from references in his own, later, reminiscences or from newspaper stories. The autobiographical writings may have been extensively revised and improved, to polish the author's reputation, and some of the newspaper stories even may have come from Brady himself; if Brady did not actually write the many laudatory newspaper stories about his work (as was the habit of the day), he surely prepared the way by cultivating writers and editors wherever he opened a business. While many of the images made in the studios he owned are well known today, what is not known to the general public is that Brady's eyesight was so poor that he rarely operated the camera himself; since he was often sparing in giving credit to his employees, the actual authorship of many of Brady's photographs remains a mystery.

It is ironic that this should be true of a man who was so evidently gifted in public relations, but it is consistent with Brady's personality. He was a genius at management and promotion, and like so many controlling entrepreneurs before and after, he was always vigilant about his image. He was by no means the first, or the only, portrait photographer of his time, but through his diligent advertising, as much as through his considerable talent, his name survives as the epitome of his art, while many of his contemporaries are unfamiliar to the public today.

He came to photography in the decade of the 1840s—a time of seemingly limitless expansion of territory, growth of business, and development of technology. The new art of photography had promise in all of these areas. Truly a creature of his age, Brady felt himself to be uniquely positioned to realize the full potential of this discovery. He opened his first studio in New York City within five years after the introduction of the daguerreotype into the United States. Five years after that, he began to work in Washington, where (starting in 1858) he maintained a studio at one location or another until the year before his death in 1896. At the height of his fortunes, before the Civil War, his studio in New York was located above one of the city's most fashionable restaurants. After a series of financial setbacks, he underwent bankruptcy more than once, tried several schemes to sell collections of his work to public institutions in New York and to the federal government—with only partial success—and ended his life impoverished, ill, and disappointed.

Mary Panzer has done an excellent job of describing the convoluted path of Brady's career, and of placing it in the context of the times and of the cities in which his studios flourished, struggled, and competed. Brady's legacy is a body of work of striking quality, including many images unfamiliar until now. We are particularly glad to be able to see so many of the Imperial prints, the largest standard size produced by the studio after the Civil War; these show the artistry of his operators at its best, perhaps, and certainly attracted the attention of the public when they first appeared. But whether we look at the magical clarity of the daguerreotypes, the stark candor of the Civil War views, the scores of cartes de visite of notables, or the commanding Imperial prints, Mathew Brady admits us back into the nineteenth century in a uniquely powerful way.

ALAN FERN

DIRECTOR

NATIONAL PORTRAIT GALLERY

Acknowledgments

The National Portrait Gallery has long supported research on the work of Mathew Brady. As the first curator of photographs, William F. Stapp acquired the Meserve Collection and many other photographs by Brady. His investigations in nineteenth-century publications, at the National Archives and at Harvard Business School, prepared the ground for my own work. After I arrived, Director Alan Fern and Deputy Director Carolyn Carr provided crucial early endorsements and ongoing encouragement. The reviewers for the Smithsonian Scholarly Studies Program awarded an essential grant, which provided the time and assistance necessary to unravel the tangled story of Brady's negatives, his prints, and his many interlocking collections. At different times, Marc Pachter and Barbara Schneider have given their generous support. In the Department of Photographs, my colleagues have been unfailingly energetic, creative, and tolerant, as the situation required. Without Ann Shumard, Thomas Minner, Adrienne Trieber, Daphne Filides, and Nina Rich, there would be no research, exhibition, or book.

I'm very grateful to Alan Trachtenberg, Elizabeth Johns, Elizabeth Anne McCauley, and R. W. B. Lewis for agreeing to read this while still in manuscript. Their combined wisdom improved the book in countless ways—and they bear no responsibility for the weaknesses that remain. I owe special thanks to David C. Ward for his generous, serious reading of the first complete draft. My editors, Dru Dowdy at the National Portrait Gallery and Amy Pastan at the Smithsonian Institution Press, kept me honest and concise, and convinced me that the book would actually appear (no mean feat). No writer could have a better or more demanding first audience.

Everyone knows that much of the real work anywhere goes on behind the scenes. I am pleased to acknowledge these important people at the National Portrait Gallery: Claire Kelly and Liza Karvellas in the Department of Exhibitions; Molly Grimsley and John McMahon in the Registrar's Office; Deborah Berman, Mary Hewes, and Amy Kirner in the Development Office; Nello Marconi and Al Elkins in Design and Production; Leni Buff in the Department of Education; Rosemary Fallon and Emily Klayman in the Department of Conservation; Frances Stevenson and Dorothy Moss of the Publications Office; Frederick S. Voss of the Historian's Office; and Cecilia Chin, Pat Lynagh, Stephanie Moye, and Jill Lundin in the Library. Curator of Exhibitions Beverly Cox brings all our teams together with energy and conviction. I owe a special debt to Jewell Robinson in the Department of Education for her ability to bring these exhibitions to life, and to Brennan Rash, who insures that everyone finds out about our terrific exhibitions and programs. My close colleagues in the Department of Prints always welcome a question, and always

have an answer; from Wendy Wick Reaves, Ann P. Wagner, Pie Friendly, and LuLen Walker I learn about prints, printmaking, and many other topics. I am also pleased to acknowledge the contribution of researcher Colonel Merl M. Moore, who generously shared his work on the history of American art.

My colleagues outside the museum have been unfailingly generous with their time and knowledge. At the Library of Congress, Carol Johnson was especially helpful in providing access to images and information; Bernard Reilly kindly enabled us to borrow and exhibit images that have long been unavailable to the public. At the National Archives, Jonathan Heller, Nick Natanson, and Elizabeth Hill all provided essential assistance in approaching their vast collection of Brady material. At the Fogg Museum, Debra Martin Kao and Marjorie Cohn guided my research with admirable energy and grace. Dale Neighbors, curator of photography at the New-York Historical Society, was an early advocate for Brady; he provided essential access to unpublished sources, and more important, in discussions about our respective collections, he offered crucial insight into the character and virtue in Brady's work, which often revived my spirits when the outlook seemed bleak. At the Chicago Historical Society, Diane Ryan and her staff unearthed treasures and opened archives, making work both easy and wonderfully rewarding. Barbara Franco shared her work on Henry F. Darby and her insight on Washington history. Maria Morris Hambourg and Jeff Rosenheim at the Metropolitan Museum of Art both provided important assistance. It is always a pleasure to work with Susan Kismaric and Virginia Dodier at the Museum of Modern Art.

I often feel lucky to work in the world of photography, which has brought me so many great friendships. Denise Bethel, Keith de Lellis, George Sullivan, Susan Barger, Robert Schlaer, William Schaeffer, Henry Deeks, William Gladstone, Bill O'Keefe, Julia Van Haaften, Sharon Frost, Elsa Dorfman, Richard Rosenthal, Debi Kao, Sandra Weiner, Arthur Leipzig, Mimi Levin, Sarah Morthland, Ellen Handy, Barbara Michaels, Andy Eskind, Ken Finkel, Bonni Benrubi, Richard Rudisill, and Michael Carlebach have listened with endless patience and kindness (some for many years now). The interest and encouragement from the people who share this curious passion is a constant inspiration.

Several audiences provided a welcome forum for this work in progress. I am grateful to the Daguerreian Society, the Photo-Materials Group of the American Institute for Conservation of Historic and Artistic Works, the National Museum of American Art, the Chrysler Museum, the International Center of Photography, and the American Studies Association for providing opportunities to present and refine my approach to this complex topic. Here at the Smithsonian I have learned from Liza Kirwin, Darcy Tell, Helena Wright, Michelle Delaney, Richard Wattenmaker, Harry Rand, and Paula Fleming, who all combine insight and humor with great knowledge. Thank you.

There are the people who keep me honest. In many ways I work first for Pete Daniel, Charlie McGovern, Grace Palladino, Sally Stein, Sally Webster, Jane Becker, Nina Silber, and Rochelle G. K. Kainer. I continue to profit from the scholars whose own work showed me how to approach this project: Carl Chiarenza, Cecelia Tichi, Sam Bass Warner Jr., Joseph Ablow, Lillian Miller, and David D. Hall. I hope they all like this book.

Jeana K. Foley's resume crossed my desk just as this project was taking shape. She arrived as work began, and I have had countless reasons to be grateful for her assistance from beginning to end. She rapidly demonstrated great skill, intellectual energy, and a true talent for organization that all in the Department of Photographs came to appreciate greatly. Her contribution to this book now enables many scholars to benefit from her strong, original work. They will thank her as I do.

I will never find the words to thank you properly, but Judy Karasik, Elsbeth Bothe, Margo Kabel, and Sara Lacy must know already how much they add to my life. My parents, and my sisters, Elizabeth and Kate, never stop being there. Without you I would not have believed this could all come about. Once again, you were right.

MARY PANZER
CURATOR OF PHOTOGRAPHS
NATIONAL PORTRAIT GALLERY

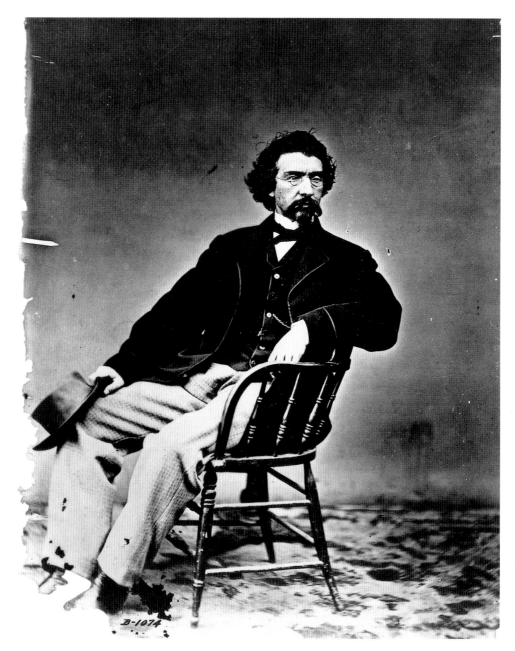

B-1074

Mathew Brady

Albumen silver print, 1861.

Photographic History Collection,
National Museum of American
History, Smithsonian Institution,
Washington, D.C.

Lenders to the Exhibition

Architect of the Capitol, Washington, D.C.

Beinecke Rare Book and Manuscript Library, Yale University, New Haven, Connecticut

James U. Blanchard III

Chicago Historical Society, Illinois

The Chrysler Museum of Art, Norfolk, Virginia

Keith de Lellis

Harvard College Library, through Harvard University Art Museums, Cambridge, Massachusetts

John Hay Library, Brown University, Providence, Rhode Island

Houghton Library, Harvard University, Cambridge, Massachusetts

Clifford and Michele Krainik

Library of Congress, Washington, D.C.

The Metropolitan Museum of Art, New York City

The Museum of Modern Art, New York City

National Archives, Washington, D.C.

National Museum of American History, Smithsonian Institution, Washington, D.C.

National Portrait Gallery, Smithsonian Institution, Washington, D.C.

Don P. Parisi

Private collections

Richard T. Rosenthal

George Sullivan

Tioga County Historical Society, Owego, New York

United States Senate Collection, Washington, D.C.

Bob Zeller

Brady in the field at Gettysburg

Albumen silver print, circa 1864.

Chronology of Mathew Brady's Life

1823?	Born in Warren County, New York.
1835?	Travels to Albany and Saratoga for treatment of a "violent inflammation of the eyes." Probably meets artist William Page.
1839?	Arrives in New York City. Meets Samuel F. B. Morse and Samuel P. Avery and possibly works as a clerk at A. T. Stewart's department store.
1843	Works as independent manufacturer of jewelry cases at 164 Fulton Street.
1844	APRIL: Opens "Daguerrean Miniature Gallery" at 205–207 Broadway, at Fulton Street. OCTOBER: First public exhibition of daguerreotypes at the annual fair of the American Institute. Receives the "premium"—the best rank possible for his art.
1845	Begins collecting images of important Americans. OCTOBER: Wins first prizes in competition at annual American Institute fair for best colored and best plain daguerreotypes.
1846	EARLY: Accompanies Eliza Farnham—editor of the American edition of Marmaduke Sampson's essay on crime and its connection to phrenology, *Rationale of Crime*—to Blackwell's Island and the Long Island Farms to take daguerreotypes of criminals for use in Farnham's publication. OCTOBER: Wins first prize in competition at annual American Institute fair for daguerreotypes. NOVEMBER: *Rationale of Crime* is published with nineteen engravings of criminal inmates after daguerreotypes by Brady.
1849	FEBRUARY 27: *Daily National Intelligencer* (Washington, D.C.) reports, "an artist by the name of Mathew Brady has recently arrived in Washington from New York for the purpose of obtaining daguerreotype portraits of all the distinguished men who may be present at the approaching Inauguration." Studio is located between 6th and 4½ Streets, N.W. The venture eventually failed. OCTOBER: Receives gold medal at the American Institute fair for daguerreotypes.
1849–1850	Takes daguerreotypes of Henry Clay, Daniel Webster, and John C. Calhoun.
1850	JANUARY: *The Photographic Art-Journal* announces the publication of *The Gallery of Illustrious Americans* by Brady, writer Charles Edwards Lester, and lithographer Francis D'Avignon. The volume is offered "in superb gilt bindings for $15 a copy." In the same

issue of the magazine, Lester writes that Brady has made improvements upon the process to produce "miniatures on ivory which combine all the truthfulness and extreme fidelity of the finished daguerreotype."

1850–1851	Marries Juliette Handy (exact date unrecorded).
1851	JANUARY 1: Daguerreotypes by Brady and four others from New York are accepted to represent the United States at the 1851 "Fair of All Nations" in London.

JULY: Leaves for London, placing his New York establishment under the supervision of George S. Cook.

JULY 7: Mr. and Mrs. M. B. Brady named on passenger list for the steamship *Arctic*, bound for Liverpool. Other passengers of note on the same voyage are James Gordon Bennett, Daniel Huntington, Henry Peters Gray, and William Page.

Wins medal at the fair. After visiting London, the Bradys tour Europe for approximately ten months.

1852 FEBRUARY: Continues his stay in Europe while "gradually improving in health." Contemplates "opening a gallery in London," since his photographic reputation has preceded him there.

APRIL 22: Brady and his wife are listed as passengers on the ship *Gallia*, traveling from Le Havre, France, to New York, in the *New York Daily Times*.

MAY: The *Photographic Art-Journal* writes that Brady "has returned from Europe in renewed health and with a rich budget to open for the benefit of his friends."

JUNE: The *Photographic Art-Journal* writes that it is expecting a "rich and racy account of Mr Brady's visit to Europe, from his own pen, in our next number. Mr. Brady had promised its commencement for this number, but he was unable, from a press of business, to prepare it on time . . . [but] is prepared to open a very entertaining budget for the benefit of our readers."

JULY 23: Brady's initial financial report by R. G. Dun & Company states that he has built up a very successful business and that he owns real estate, railroads, bonds, and stock. The report notes that Brady "likes to live a pretty fast life and spends his money freely" but that he "deals honorably . . . is worthy of all confidence, and can buy all he wants freely."

OCTOBER: Hosts New York State Daguerrean Association at his New York gallery.

DECEMBER 15: Marcus Aurelius Root and Brady have "bought a right for taking those splendid crystalotypes [salted paper prints] in this city," according to *Humphrey's Journal*.

1853 MARCH 14: Opens second New York studio at 359 Broadway and invites important citizens to a celebratory dinner at the gallery. The ground floor of this building houses Thompson's Dining Saloon.

JUNE: Invents the "ivory-type"—a photographic image on ivory—according to the *Photographic Art-Journal*.

AUGUST: Displays entries at the New York Industrial Exhibition at the Crystal Palace.

1854 JANUARY: Wins a "bronze medal with special approbation" at the Crystal Palace exhibition in New York.

APRIL: *Humphrey's Journal* prints Brady's notice justifying the prices of his high-quality daguerreotypes on the basis of his ambition "to vindicate true art, and leave the community to decide whether it is best to encourage real excellence or its opposite." Article in April *Photographic and Fine Art Journal* discusses the Crystal Palace daguerreotype exhibition, noting that the quality of Brady's work is good: "Although Mr. B is not a practical operator, yet he displays superior management in his business and consequently deserves high praise for the lofty position he has attained in the daguerrean fraternity."

1855

MAY 2: An advertisement in *The Crayon* for the 359 Broadway gallery notes that "heretofore the French have been regarded as the only successful practitioners of this beautiful novelty in Art; an examination, however, of the results exhibited at his establishment will convince the Public that the acknowledged superiority of American Daguerreotypes extends also to the kindred Art of Photography." This advertisement suggests that Brady was offering the wet-plate photography process *before* he hired Alexander Gardner.

NOVEMBER 17: Brady's gallery is now producing ambrotypes, according to *The Home Journal.*

DECEMBER 15: An engraving of Arctic explorers in *Frank Leslie's Illustrated News* is attributed to Brady, with the note that "Mr. Brady accomplished his work through his new improvement styled Ambrotype."

1856

JANUARY: An observer notes in the *Photographic and Fine Art Journal* that at Brady's studio he saw "transparent colored Photographs [that] show the hand of a first class artist. . . . I also noticed a specimen of Photography on canvas."

SPRING: Alexander Gardner emigrates from Scotland and begins working for Brady in New York.

APRIL: Mr. Cutting, the inventor of the ambrotype process, institutes proceedings against Brady and other photographers for infringement of patent rights, according to *The Photographic and Fine Art Journal.*

JULY 7: R. G. Dun & Company reports that Brady "was formerly in some difficulty and has not yet got entirely out of it, yet he is honest and determined to go right."

DECEMBER 18: R. G. Dun & Company reports that Brady is doing well in his business, but "is still very slow to pay . . . credit has not improved any," and his expenses are quite heavy.

1857

APRIL 11: *Harper's Weekly* features engravings of photographic portraits of the seven cabinet members—the first credited to Brady in this magazine.

OCTOBER 17: Receives credit, according to *Harper's Weekly,* for the process of enlarging an image from an ambrotype.

NOVEMBER: An article on the quality of photography at the fair of the American Institute in the *Photographic and Fine Art Journal* states that Brady is "decidedly ahead of them all in plain full-length life-size photographs. . . . His Imperial pictures are certainly the best. . . . He exhibits a group of three full-length life-size on paper five feet by seven, as remarkable for its excellence in color, tone and detail, as it is in size."

DECEMBER: Wins "Premium" ranking and a gold medal for the "best plain and re-touched photographs" at the fair of the American Institute.

1858 JANUARY: In describing visits to Brady's two New York studios, the *Photographic and Fine Art Journal* notes that Brady's 205 Broadway studio is operated by a Mr. Johnson. Brady himself is at the larger 359 Broadway studio, where he also employs twenty-six artists, operators, and salesmen.

JANUARY 26: Opens Brady's National Photographic Art Gallery at 350–352 Pennsylvania Avenue, N.W., in Washington, D.C. Alexander Gardner manages the studio, with his brother, James Gardner, working as his assistant.

MARCH: Listed as a member of the Washington Art Association in the association's invitation to artists from across the nation to attend a convention in Washington on March 20, 1858.

APRIL: Elected into the membership of the American Society of Arts (organized in Washington, D.C.), according to the *Photographic and Fine Art Journal*, which also notes that Brady was using a camera tube (lens) that employs blue glass.

APRIL 8: Attends a fancy-dress ball in Washington, given by Senator and Mrs. Gwin of California. Brady costumes himself as Van Dyck.

AUGUST: Brady advertises a series of Imperial photographic prints of eminent Americans for sale at his gallery. Subjects mentioned include William H. Seward, Stephen A. Douglas, and Cyrus Field.

SEPTEMBER 1: During celebration commemorating the successful laying of the Atlantic cable, buildings along Broadway are decorated, including Brady's gallery at 359 Broadway: "The upper stories were illuminated by about six hundred candles. The front of the building was decorated with a splendid transparency 50 by 25 feet. It bore on the top the words, 'Science, Labor and Art-Union Cable.'"

NOVEMBER: *Photographic and Fine Art Journal* discusses photography studios in New York, including Brady's two locations, at 359 Broadway and at 643 Broadway at Bleecker Street. The article also comments on Brady's new invention, the "ivorytype."

NOVEMBER 22: *Boston Transcript* discusses the "array of female beauty" on view in the form of retouched Imperial-size portraits at Brady's galleries. The portraits are described as "being in frames of about 12 inches by 18; photographs, carefully and exquisitely colored. . . . The background is generally left to the taste of the artist, who is very felicitous in introducing flowers, curtains, columns, windows and etc to set off his subject." The pictures will be "engraved in the highest style of art . . . and published as an elegant holiday book a year hence. Each of the leading cities will be honored with a fair representative in this unique and beautiful volume. . . . The cost of getting up the book is estimated at thirty thousand dollars."

DECEMBER 8: Prepares illustrations for an edition of Longfellow's *The Courtship of Miles Standish* by photographing original drawings by a Mr. Ehniger, according to *Boston Transcript*.

1859 MARCH 23: R. G. Dun & Company reports that Brady owns property in the Eighth

Ward of Brooklyn, but it is heavily mortgaged. He seems to have a great deal of wealth in pictures and furniture, but their "enforced sale might scarcely pay his indebtedness." Brady "makes money fast but does not lay up. [He] sometimes pays promptly . . . then falls behind. One or two parties sell him what he asks, but his credit is not good generally."

AUGUST 8: Brother, John Brady, dies. *Daguerreian Journal* notes that John Brady "was, we believe, at some time engaged with his brother in the manufacture of cases. This will probably cause [Mathew Brady], who is now in Europe, to return somewhat earlier than he otherwise would."

FALL: Closes studio at 359 Broadway.

OCTOBER 15: Article in *Harper's Weekly* confirms the location change of Brady's studio, to 643 Broadway. It notes that the studio is now located over a barber shop.

1860 Photographs presidential candidates, including Stephen A. Douglas and Abraham Lincoln.

FEBRUARY 1: Prepares to publish a "photographic picture" of all the members of the 1859 United States Senate, according to *New York Tribune*.

FEBRUARY 27: Photographs presidential candidate Abraham Lincoln before his speech at Cooper Union.

MARCH 21: Recovers daguerreotype of Washington Irving, which was thought lost, and produces from it a "life-sized colored portrait."

JUNE: Photographs visiting Japanese diplomatic officers in the reception room of the embassy at the Willard's Hotel in Washington.

JULY 15: Completes a composite portrait of the House of Representatives, featuring 250 members of Congress in a picture "about 20 by 24 inches," according to the *American Journal of Photography*.

OCTOBER 7: Holds opening reception for latest studio at 785 Broadway, to be called the "National Portrait Gallery."

OCTOBER 13: Photographs the Prince of Wales at his studio.

1861 Gardner outfits the Washington studio with four-tube cameras—which make four pictures with one exposure—for making cartes de visite. Brady enters into a contract with E. & H. T. Anthony & Company to produce the cartes de visite on a larger scale.

JANUARY 31: Mortgages the contents of his gallery at 785 Broadway for $3,628, according to financial report from R. G. Dun & Co.

FEBRUARY: Abraham Lincoln poses for his inaugural portrait at Brady's Washington studio.

JULY 21: Unsuccessfully attempts to photograph the Battle of Bull Run in Virginia.

1862 SPRING: Alexander Gardner leaves Brady's employ to serve briefly as General George B. McClellan's official photographer, recording the activities of the Army of the Potomac until the fall.

OCTOBER 4: *Harper's Weekly* credits an engraving of a view of Harpers Ferry and the Maryland Heights to Brady, the first Brady photograph other than a studio portrait published in this magazine.

OCTOBER 18: Engraved images of Antietam battlefield appear in *Harper's Weekly* are credited to photographs by Brady (but were actually taken by Alexander Gardner and James Gibson). These are the first graphic battlefield images, with bodies, published in this magazine.

NOVEMBER 28: R. G. Dun & Company reports that Brady is "under very heavy expenses and has many operators at the seat of War taking views." Brady's "general credit is weak," but he is able to get supplies for his business from E. & H. T. Anthony & Company.

LATE: Alexander Gardner opens his own studio at 511 Seventh Street, N.W., in Washington.

1863 Alexander Gardner publishes a *Catalogue of the Photographic Incidents of the War.*

1864 APRIL: Involved with planning and production of the United States Sanitary Fair, taking portraits of the Executive Committee and the Gentleman's Committee for Fine Art, and selling copies to support the fair. Also publishes a souvenir book of photographs of the fair's fine art exhibition.

AUGUST 6: *Harper's Weekly* reports that Brady has returned from the army in Virginia with a series of views of the campaign, including operations at Cold Harbor (the battle was on June 3). Views are on display at the 785 Broadway studio.

SEPTEMBER 7: Sells half of his Washington gallery to gallery manager James Gibson for $10,000, half cash down and the rest in notes.

1865 MAY: *Harper's Weekly* prints wood engravings of President Lincoln's funeral procession in New York City, after photographs attributed to Brady. James Bachelder commissions Brady to photograph the visitors to Lincoln's deathbed for use in Alonzo Chappel's painting, *The Last Hours of Lincoln.*

1866 JANUARY 6: Petitions the New-York Historical Society to purchase his collection of war views and portrait photographs, so that they may be permanently displayed and stored in a fireproof location.

JANUARY 23: The New-York Historical Society resolves to accept Brady's offer, but the transaction never occurs.

JANUARY 29: Council of the National Academy of Design passes resolution stating that Brady's collection of photographs of scenes, incidents, and portraits connected with the war is "one of great value; as a nucleus of a national historical museum; as a reliable authority for Art, and illustrative of our history." The resolution—signed by such artists as Daniel Huntington and Emanuel Leutze—proposes that the collection should be placed in the New-York Historical Society.

FEBRUARY–MARCH: Exhibits war photographs at the New-York Historical Society, as well as at the 785 Broadway gallery.

1867 OCTOBER: Photographs General Philip Sheridan at New York studio.

1868 Offers his photograph of the House of Representatives impeachment managers (for the proceedings against Andrew Johnson) for sale, according to *New York Evening Post.*

JUNE 26: Files suit against James Gibson over the bankruptcy of the Washington gallery.

JULY 23: Brady's Washington gallery at 625 Pennsylvania Avenue, N.W., is sold at public auction. Brady buys back the studio for $7,600.

OCTOBER: Photographs the All-England Cricket Team during its visit to America.

OCTOBER 31: Credit report from R. G. Dun & Company recounts the events that caused Brady's recent bankruptcy. After selling half his interest in the Washington gallery to James Gibson, Gibson, according to Brady, "collected all the debts, paid off and left for Europe with the proceeds . . . there is no doubt that [Brady] has been badly swindled by the party he sold out to." Brady was able to recover financially and buy back the gallery entirely, clear of debt. The report notes that Brady owns property in New Jersey, which he is trying to sell to pay off creditors. Most of his large debt is to "1 or 2" parties, "who do not trouble him, but his smaller creditors are pressing him and this injures his credit."

1869 Publishes "National Photographic Collection of War Views and Portraits of Representative Men."

NOVEMBER 5: Brady's bookkeeper, William Healy, dies.

1870 Makes photographer Andrew Burgess manager of the Washington studio.

MAY: *Philadelphia Photographer* reports that one of Brady's New York gallery operators, Mr. V. W. Horton, wins a gold medal prize "for the best negative for enlarging in the solar-camera."

1871 JANUARY 14: *Frank Leslie's Illustrated Newspaper* publishes a portrait credited to Brady of Hon. J. H. Rainey, the first African American sworn into the House of Representatives.

MAY 1: R. G. Dun & Company reports that Brady's financial condition remains bleak. Brady "is endeavoring to obtain an appropriation from Congress for the purchase of his views of the War. He has spent a great deal of money now on this object but has not yet been able to accomplish it."

1872 Boss Tweed ousted from office. Brady's connections with Tweed Ring probably protected him from litigation by creditors, but now, many of these cases are finally heard, eventually forcing him to declare bankruptcy.

MAY: The Washington *Evening Star* reports that Brady photographed the Indian Red Cloud and his warriors at the Washington studio for his "great national portrait collection."

1873 JANUARY 30: Declared bankrupt by the District Court of the United States for the Southern District of New York.

FEBRUARY 3–7: Marshal George Sharpe takes possession of Mathew Brady's property (negatives and other photographic materials) by order of the New York District Court.

JULY: Brady takes up official residence in Washington. He repeatedly attempts to get Congress to buy his collection "Records of the War of the Rebellion." He transfers ownership of his Washington studio to his wife, then subsequently mortgages it to her brother and nephew, Samuel and Levin Handy, to prevent the studio's seizure.

1875 MARCH: Congress pays Brady $25,000 to secure title to all of his negatives and prints.

JULY: Pays off creditors and is released from charges of bankruptcy. All of the New York studios are lost, and the Washington studio remains heavily mortgaged.

1881	NOVEMBER: "Brady National Photographic Art Gallery" at 627 Pennsylvania Avenue, N.W., in Washington closes because of mortgage foreclosure.
	Forced to sell Imperial oil portraits of Henry Clay, John C. Calhoun, and Daniel Webster to the government in an effort to raise money to pay off debts.
1882	Works at 450 Pennsylvania Avenue, N.W., in Washington.
1883	Works at 1113 Pennsylvania Avenue, N.W.
1887	MAY 20: Juliette Handy Brady dies.
1888	OCTOBER: Publishes album of recent photographs of the members of the United States Congress, the President, the cabinet, and the Supreme Court justices, with biographies, according to *Photographic Times*.
1889	Works at 1833 14th Street, N.W.
	JUNE: *Anthony's Photographic Bulletin* announces that Brady will be opening a new studio at Pennsylvania Avenue and 13th Street, N.W., in Washington.
	DECEMBER 18: Consults with senator Joseph Norton Dolph of Oregon on founding of a hall in Washington, housing historical art, statues, photographs, and paintings of prominent Americans.
1890	Works at 13th Street and Pennsylvania Avenue, N.W.
	Publishes an album of delegates who attended the International American Conference in Washington.
	MARCH: *Frank Leslie's Illustrated Newspaper* prints a photomechanically reproduced portrait of the Chicago World's Fair Committee taken by Brady.
1891	APRIL: Recounts career in *New York World* interview.
	Photographs the Patent Centennial Convention in Washington and argues with a photographer named Mr. Prince. Brady claims he had a "regular permit" to photograph the convention and that Prince had no right to be taking pictures there. Brady ultimately swears out a warrant against Prince.
1893	Works at 1107 F Street, N.W.
1894	Works at 494 Maryland Avenue, S.W., home of his nephew Levin Handy.
1895	APRIL: Breaks his leg when struck by a horsecar in Washington.
	JUNE 14: Brady writes to Levin Handy that he is living at a boardinghouse at 126 East 10th Street in New York. Brady moved in order to better carry on negotiations for a proposed lecture with lantern slides on the Civil War at Carnegie Hall.
	SEPTEMBER 28: Moves to 232 East 13th Street in New York.
	DECEMBER 16: William Riley, a friend of Brady's, writes to Levin Handy, Brady's nephew, that he has taken Brady to the hospital, apparently with a kidney ailment.
1896	JANUARY 13: William Riley writes to Levin Handy that Brady has developed a swelling in his neck and is "sinking gradually."
	JANUARY 16: Dies at Presbyterian Hospital in New York City. His funeral expenses are paid in part from donations from friends in the art world and by the New York Seventh Regiment Veterans Association.

JANUARY 30: Was scheduled to deliver a lecture on his life and work as a war photographer, with lantern slides, at Carnegie Hall. General Horace Porter was to preside over the event, which was to include Brady's lecture, performances of patriotic music, and poetry readings. He was preparing for this event at the time of his death.

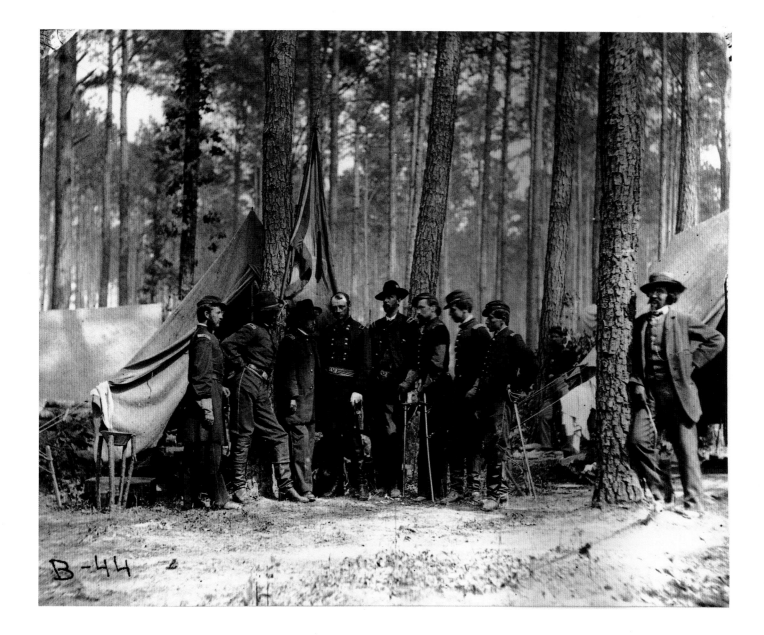

B-44

Introduction

Mathew Brady stands for a generation of photographers who gave us more than just a record of a brief, significant time in the history of the United States. They made it possible for each following generation to remember its common past by representing its heroes, martyrs, and landscapes in a form that continues to be important. Brady accomplished this feat by finding a way to endow the fact-laden medium of photography with myth. *Mathew Brady and the Image of History* tells how this came about.

Paradox abounds. Brady is famous for photographs of the Civil War, but spent most of his career as a portraitist to celebrities whose fame did not endure. Twentieth-century historians admire the documentary value of his work, yet Brady's contemporaries knew him as "a man of artistic aspirations who looks upon the mechanical features of his art as subsidiary to . . . higher aims."[1] In this book I hope to recover some of the "higher aims" that have been lost, concealed both by Brady's own efforts and by our own complex need to see his photographs as windows onto the past, rather than as carefully constructed works of art.

Over the course of my research, it became clear that Mathew Brady saw his photographs as part of a vast machine that would produce spectacles of lasting impact and power. Over and over he told interviewers and biographers that he worked for posterity by creating images that would allow artists to perpetuate a glorious image of an enduring nation. With few exceptions, Brady's war photographs document a proud and strong army. On the field, aboard ship, along the walls of a fortress, or resting in camp, his subjects assume classical poses and convey a sense of power. Most images of body-strewn battlefields can be attributed to his one-time employee Alexander Gardner, who eventually set up his own business and created a very different pictorial record of the war, filled with images of devastation, death, and defeat. Today our image of the Civil War is a synthetic one, composed of Gardner's facts and Brady's glory.

Like his friends Horace Greeley and P. T. Barnum, Brady belonged to a generation of New Yorkers who shaped the public sphere for a growing American middle class and bequeathed us institutions such as the popular press and the circus, which continue to evolve (and sometimes merge). Like them he mastered a new medium, and he found ways to use old rules to guide him.[2]

Brady's strategies and goals have been difficult to identify, because they conflict sharply with twentieth-century assumptions about the development of our culture and history. He saw no inherent conflict between images made by machines (cameras) and those made entirely by hand. He believed that an artist could preside over a large studio where much of the work was done by others. He reveled in his role as entrepreneur, celebrity, and impresario, and viewed his gallery as his most important creation—a collection of portrait photographs, paintings, prints, and negatives that together formed a record of America as it

FIGURE 1–1

General Edward Elmer Potter and his staff with Mathew B. Brady

Albumen silver print, circa 1863.

National Archives, Washington, D.C.

appeared in the middle decades of the nineteenth century. Brady's project is essentially romantic, inspired by such American chroniclers as William H. Prescott and George Bancroft; his artistic guides included Emanuel Leutze, Samuel F. B. Morse, and John Trumbull, who in turn modeled their work on Jacques-Louis David and Benjamin West.[3] Brady was not alone in his determination to apply photography to these adamantly pre- or non-modern ends. With the emergence of modernism in America at the end of the nineteenth century came a new definition of the artist as a craftsman who worked independent of all machines. Photographers gained acceptance into that privileged circle only when they could prove mastery over their methods and materials—first with elaborate handwork added to their photographs, and later through their ability to create images that conformed in every way to the abstract aesthetics of the time. Now, working in a postmodern age, we can see that these definitions are historic constructions, and as a result, it has become possible to reconstruct the context of Brady's endeavors and recognize the method he chose to achieve them.

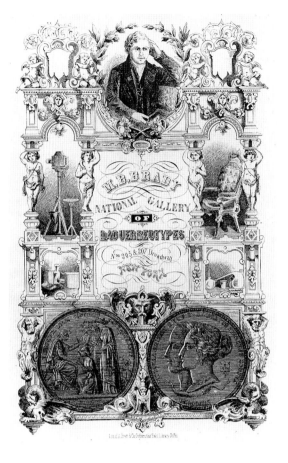

FIGURE 1–2

M. B. Brady National Gallery of Daguerreotypes

Woodcut by A. Brett & Co., 1852.

The New-York Historical Society, New York City

Brady's story begins in antebellum New York. Between 1840 and 1860, New York grew from a colonial center of commerce to the national's cultural capital. The city's population tripled, and its economy boomed, but for all its factories, banks, hotels, crowds, shops, theaters, noise, fashion, and art, many New Yorkers lingered at the threshold of modernity until after the war. The well established and powerful, whose influence rested in the relatively small elite of the 1840s, settled along Broadway, where they continued to enjoy a real sense of intimacy. They knew one another, and knew the faces of their leaders. As Brady began to assemble his gallery of portraits, he strived to re-create a stroll on Broadway on the walls of a single room.[4]

Brady's effort to gather together the country's brightest leaders eventually led him to Washington, where growing political tension around the issues of slavery and abolition attracted attention to spokesmen like Stephen A. Douglas, Abraham Lincoln, and Charles Sumner. As Brady began to pursue the men (and the few women) who led the Union, he collaborated with painters and printmakers to create a new form of heroic portraiture that could combine the accuracy of a photograph with the dignity of an oil painting. He provided portraits for reproduction in the illustrated press, which reached thousands of readers. He sold his negatives of photographs and cartes de visite to publishers, and his portraits entered the private albums found in every middle-class home.

Brady produced his archive at a time when the country itself was acutely aware of the need for a unifying historical narrative. To his generation, the camera became an important tool, with which Brady and his critics might create an infinite documentary collection of faces that would connect the men of the present with the time of the Revolution, and would secure their memory in generations to come. Brady imagined that his work would support a variety of historical paintings, from colorful portraits to elaborate tableaux, such as the huge "cyclorama" paintings that still stand in special structures in Gettysburg and Atlanta. But in the end, Brady's work did not need the transforming hand of the painter or engraver. The photographs themselves picture the tragic years of the war, and in the process they create a transcendent image of the nation itself.[5]

The skillful, hard-working, and productive portraitist who spent his life creating distinctive images of others is hard to see, as if reluctant to come out from behind the camera [Figure 1–2]. When Mathew Brady posed for his own portrait with his new bride and his sister, he decorously placed them in the foreground; in the numerous images that show him on the field and in camp during the war, he stands at the side or turns away from the camera; occasionally he shows off his distinctive profile, but still eludes our gaze. In interviews from the 1850s, Brady is an ambitious, energetic artist. Forty years later, speaking to journalist George Alfred Townsend in his Washington studio [Figure 1–3], Brady spun a shroud of legend and anecdote from which he emerged as a genial relic, a friend to Civil War generals and antebellum celebrities. He left almost no papers, letters, records, or artifacts behind. A biographer must simply accept this evasive quality as part of Brady's nature.[6]

Francis Trevelyan Miller, editor of the 1911 *Photographic History of the Civil War*, perpetuated the accounts that Brady and others left behind. Antiquarian collector Frederick Hill Meserve, who owned thousands of Brady's negatives, published numerous images and textual accounts throughout the early decades of this century, using sources within his own voluminous archives. Brady's nieces Alice Handy Cox and Mary Handy Evans guarded the family collection until 1954, and when their material finally reached the Library of Congress, it remained restricted until 1964.[7]

Within the special field of photographic history, Brady occupies a controversial position. Because he did not make his own pictures, many twentieth-century historians did not consider him an important artist. As a result, his work was rejected by scholars like Beaumont Newhall, who spent the middle decades of this century striving to establish photography as a legitimate art form, with a place in the museum. Newhall's classic text, *The History of Photography from 1839 to the Present Day*, compares the credit line "Photograph by Brady," which appeared on all of Brady's published work, to an industrial trademark.[8]

By contrast, Berenice Abbott, herself a serious photographer, identified Brady, along with French photographers Louis-Jacques-Mandé Daguerre, Nadar, and Eugène Atget, as the originators of a new art form. In 1931, she lent images made from Brady's negatives in the National Archives to a seminal publication, Camille Recht's *Die alte photographie*, which offered a vision of photographic history that differed from Newhall's. Recht emphasized documentary images, in which subject matter was not subordinate to formal elements of art. Through the 1930s, Abbott consistently acknowledged Brady as a contributor to the movement to establish a genuine American aesthetic tradition. The quest for a national school of art had inspired Brady to create documents of American war and heroes in the middle of the nineteenth century. Brady's rediscovery in the twentieth century can be traced to a similar movement led by such critics

American Views.

11078

Washington, D. C.

11078.—Metropolitan Hotel.

FIGURE 1-3

Brady's gallery on Pennsylvania Avenue, to the left of the white building.
Albumen silver prints (stereo view), circa 1865.

National Portrait Gallery, Smithsonian Institution, Washington, D.C.; gift of Robert A. Truax

as Van Wyck Brooks, Constance Rourke, Charles Sheeler, Lewis Mumford, and Abbott herself, who revived interest in American vernacular culture in a movement known as "The Search for a Usable Past."[9]

Revived interest in American vernacular culture also inspired Robert Taft, a professor of chemistry at the University of Kansas, to write *Photography and the American Scene: A Social History, 1839–1889*, which appeared in 1938. Using an approach that drew equally from his training as a Darwinist and his enthusiasm for popular culture, Taft treated American photographic history as an archaeological site formed by ideas and events of the past. He did not judge Brady as a modern artist, but as a citizen and photographer of the nineteenth century, and he easily placed Brady as a leader among his many contemporaries.[10]

In 1946, Scribner's published *Mr. Lincoln's Camera Man* by Roy Meredith, a picture book that used new technology to reproduce Brady's images with unprecedented fidelity. The publication date coincided with Lincoln's birthday, and warm notices appeared in every major magazine and journal, carefully avoiding the clumsy, error-laden text to celebrate the photographs themselves. The *New Yorker* published a typical review, praising Brady's portraits of "Lincoln, Lee, Barnum, politicians, and generals; here are dead boys gaping at the sky; the burned bombed cities of the South, dazed-looking Negro freemen, the wrecked redoubts of the Confederate armies."[11]

In 1955, James Horan and Josephine Cobb both produced new scholarly accounts of Brady and his career. Horan attained access to the Library of Congress collection, including the restricted material left by the Handy sisters; he also corrected many of Meredith's mistakes. Cobb, an archivist with the Still Picture Branch at the National Archives, began with the huge collection of Brady material under her care. Together, Cobb and Horan provided a valuable resource for subsequent work on Brady and Civil War photography in general. Cobb collaborated with Dorothy Meserve Kunhardt and her son Philip B. Kunhardt Jr., who mined the Meserve collection to publish several books on Brady in the 1960s and 1970s, culminating in *Mathew Brady and His World*, published by Time-Life Books in 1977. Philip Kunhardt, himself a longtime editor at *Life*, celebrated Brady as an industrious journalist, and called him the world's first magazine photographer. Insofar as woodcuts of Brady's images regularly appeared in such national journals as *Harper's Weekly* and *Frank Leslie's Illustrated Magazine*, Kunhardt was right on target.[12]

Brady's twentieth-century biographers shared their subject's fondness for celebrity and American heroes. Francis Trevelyan Miller, for example, also wrote biographies of Abraham Lincoln and Charles Lindbergh, polar explorer Admiral Byrd, and, in 1944, Dwight D. Eisenhower. Frederick Hill Meserve reserved his enthusiasm for Lincoln. Roy Meredith produced books on Civil War generals, and James Horan was a prolific popular historian and novelist who wrote more than twenty books from a romantic point of view, celebrating such topics as gangsters of the 1920s, reform-era politicians, the American West, early-twentieth-century politics in New York, and heroic episodes of World War II.

Robert Taft's work has continued to inspire many historians of American photography, including Richard Rudisill, Alan Trachtenberg, Barbara McCandless, and Michael Carlebach, who have contributed new work on Brady and his era. In *Mirror Image* (1971), Rudisill makes an important argument for the essential relationship between the daguerreotype and emergence of a genuine American culture in the years between 1839 and 1860. Trachtenberg's *Reading American Photographs* (1989) uses a broader historical framework to examine the ways in which photographic images made essential contributions to the definition of American society from the daguerrean era through the 1930s. In "The Portrait Studio and the Celebrity: Promoting the Art" (1991), Barbara McCandless reexamines Brady's portraiture in relation to

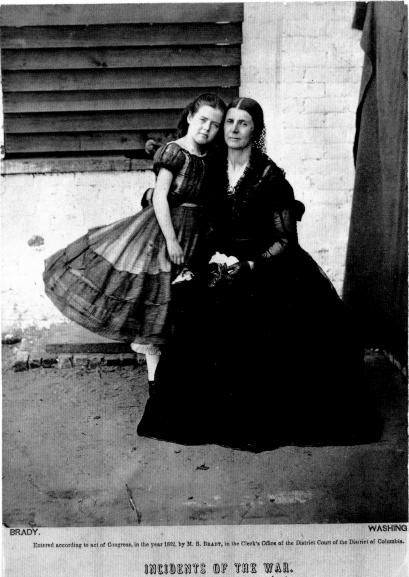

BRADY. WASHING

Entered according to act of Congress, in the year 1862, by M. B. Brady, in the Clerk's Office of the District Court of the District of Columbia.

INCIDENTS OF THE WAR.

No. 212.

MRS. GREENHOW AND DAUGHTER,

Imprisoned in the Old Capitol, Washington.

PLATE 1

Incidents of the War.
No. 212. Mrs. Greenhow
and Daughter,
Imprisoned in the Old
Capitol, Washington

Albumen silver print, 1862.

National Portrait Gallery,
Smithsonian Institution,
Washington, D.C.

the development of celebrity culture that emerged in last third of the nineteenth century. And in *The Origins of Photojournalism in America*, Michael Carlebach recasts this story in terms of the relationship between photographs and printed images, where Brady was an early, innovative master. Their work has made it possible to write this book.[13]

Mathew Brady used art to forge a relationship between photography and history, but when the memory of Brady the artist vanished, we came to accept his images as facts. Acknowledged or not, Brady's careful manipulation of his subjects continues to influence our perception, and still shapes the way in which we see his era, and the story of the nation.

In 1946, when best-selling historian Arthur M. Schlesinger Jr. reviewed Roy Meredith's *Mr. Lincoln's Camera Man* for the Sunday *New York Times*, he praised Brady, and photography overall, as supremely objective, "serene, comprehensive, pitiless." Then, like any good citizen of Brady's New York, he succumbed to the photographer's lure, interpreting the faces before him with frankly partisan pleasure, assessing the character of "Benjamin Butler, heavy-lidded and sardonic, the lines of his face crafty and self-indulgent; Andrew Carnegie, business-like and twinkling; Rose Greenhow, the Confederate spy, with her dark, slumberous beauty [Plate 1]; General Custer, trying hard to look tough . . . exuding cheapness and flamboyance."

Schlesinger's confidence in Brady's portraits shows that time only strengthened the photographer's control over the imagination of his viewers:

> Brady's camera realized war no longer as romance in oils, but as human experience, lucid, gray and awful. His pictures fixed the images of the war so that, as we instinctively think of the Revolution in terms set for us by painters in a conventional romantic tradition—Washington taking command at Cambridge, crossing the Delaware, receiving surrender at Yorktown—so we think of the Civil War in Brady's terms.[14]

Yet Brady consciously modeled his work on the work of the painters who created our images of Washington at Yorktown, and crossing the Delaware. He followed their example in order to construct a lasting image of his own time. As Schlesinger's review shows, Brady achieved his goal.

We have come to know the Civil War through photographs made by Brady, Gardner, and countless others. This pictorial record has contributed greatly to the powerful place this era occupies in the popular imagination. In 1961, Robert Penn Warren called that war "our only 'felt' history." According to Warren, before the Civil War, "we had no history in the deepest and most inward sense"; before the war, the myth of the founding fathers "did not create a nation except on paper; and too often in the following years the vision . . . became a mere daydream of easy and automatic victories." When the war turned a disparate group of states into a unified political body, we simultaneously acquired a history, and the vision of a nation turned from daydream to reality. In short, Warren asserts that the war is more than "the great single event of our history. Without too much wrenching, it may in fact, be said to *be* American history."[15]

While more than thirty years now stand between Warren's observations and the present, our obsession with the Civil War has only grown. Other wars and other conflicts now challenge the Civil War in the national mind—in large part because we know them through photographs, television, and film. Mathew Brady was among the first to understand how photographic images could become historical art. His example has inspired countless others. What, then, is our history made of? Brady's story holds some answers to the questions we are only beginning to know how to ask.

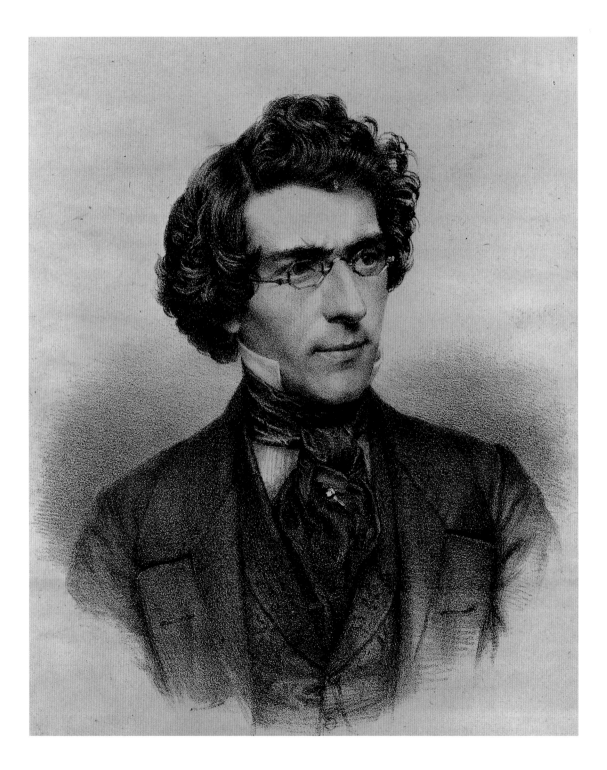

2

A Brief Biography

e know little about Mathew Brady's early life. He was born to Andrew and Julia Brady in Warren County, New York, around 1823. While still in his teens, he traveled through Saratoga and Albany, perhaps in an effort to find doctors who could improve his failing eyesight. During this period, he claimed to have received art lessons and encouragement from the painter William Page. By the early 1840s, Brady arrived in New York City, where Page may also have introduced him to Samuel F. B. Morse, who supported himself in part through lessons in the new medium of daguerreotypy. Brady appears in New York City directories in 1843, as a manufacturer of the rigid leather and metal cases that held daguerreotypes, jewelry, and painted miniatures. In 1844, while still in his early twenties, he won a gold medal at the national annual competition sponsored by the American Institute in New York, the first of many medals he would receive over the next decade [Figure 2–2].[1]

In 1846, Brady's daguerreotypes appeared as woodcut illustrations for *Rationale of Crime* [Figure 2–3], a treatise by the British phrenologist Marmaduke Sampson, enlarged and edited by Sampson's American disciple, Eliza Farnham, matron of the women's prison at Sing Sing.[2] This early project reveals the skills that allowed Brady to flourish in New York's rough, unpredictable commercial world of the 1840s and 1850s, and sustained him for the rest of his career. Brady's work for Farnham brought him in contact with publisher Daniel Appleton and with phrenologists Fowler and Wells, who also published books, magazines, and a phrenological journal. Brady's friendships with these men continued well into the 1850s, bringing with them business, new contacts, and a secure place in New York's publishing world. Brady must have also recognized that portraitists were known by their subjects, and that having criminals as a specialty would not enhance his reputation, for he never advertised his work with Farnham.

Throughout his career, Brady paid close attention to the location of his studio. The first stood at 205 Broadway, near St. Paul's Church and City Hall Park, across from a grand, pillared building that housed the business of publisher and art collector Daniel Appleton; steps away from P. T. Barnum's American Museum [Figure 2–4]; and near the city's best hotels, including the Astor House. He shared this building with Edward Anthony, who supplied Brady (and the rest of the city's daguerreans) with chemicals, plates, and cameras. But if proximity alone could explain Brady's ability to exploit these relationships, then many other photographers would have enjoyed his success, for the blocks of Broadway around his studio were crowded with artists and daguerreotypists, as well as publishers of books, magazines, and newspapers, along with hotels, restaurants, theaters, and clubs. But Brady had something more. In 1860, his friend Nathaniel Parker Willis called him "felicitously prehensile. He knows how to seize upon opportunity and how to handle it afterward."[3]

FIGURE 2–1

M. B. Brady

From a lithograph by Francis D'Avignon (circa 1814–circa 1861) for the *Photographic Art Journal*, 1851.

Library of Congress, Washington, D.C.

9

Delivery of Silver Medals awarded at the 19th Fair 1848

Names	Residence	Signature

D. M.

In 1845 Brady established his gallery as a modern Hall of Fame, where the public could view his portraits of the contemporary celebrities who were his clients. Anecdotes describe his pursuit of such important men as Daniel Webster, Henry Clay, and James Fenimore Cooper, in which he combined equal parts flattery and determination to lure them from their hotel rooms to his studio.[4] After the elections of 1848, Brady traveled to Washington to photograph the large contingent of political figures who had assembled for Zachary Taylor's inauguration. Brady returned to New York in 1849, having made daguerreotype portraits of Taylor, Fillmore, nearly every member of the Senate, many congressmen, and the justices of the Supreme Court. He made portraits of the era's best-loved politicians, like Webster [Plate 2] and Clay, and used their reputations to enhance his own.

In 1850, he collaborated with journalist Charles Edwards Lester and lithographer Francis D'Avignon to translate a group of these new daguerreotypes into large lithographs [Figure 2–5]. Brady and Lester originally solicited subscribers for a series of twenty-four images and biographical essays titled *The Gallery of Illustrious Americans;* only twelve images actually appeared. This publication also joined his interest in politics with his desire to reproduce and distribute his images to a wide public.[5]

The following year, Brady entered his daguerreotypes in the International Exhibition sponsored in London by Queen Victoria and Prince Albert, where his work won a medal; American daguerreotypists

FIGURE 2-2
(opposite, left)

American Institute's Register of Premiums

Page listing the silver medals
awarded at the institute's
nineteenth fair, 1846.

The New-York Historical
Society, New York City

FIGURE 2-3
(opposite, right)

"D. M."

Engraving by an unidentified
artist, after a daguerreotype
by Mathew Brady Studio,
from *Rationale of Crime*, 1846.

Library of Congress,
Washington, D.C.

FIGURE 2-4 (right)

View from the American Museum,

showing Brady's gallery at
205 Broadway.
Woodcut by an unidentified
artist, 1847–1851.

The New-York Historical Society,
New York City

Martin M. Lawrence and John A. Whipple won medals as well. Horace Greeley (who sat for Brady) reported on the American triumph, "In daguerreotypes we beat the world." Brady himself sailed to England in July 1851 and remained in Europe for nearly a year.[6] He brought back portraits of European celebrities, including the British scientist Michael Faraday, Cardinal Wiseman, the Archbishop of Westminster, Lord Elgin, and Giuseppe Garibaldi.

In March 1853, Brady moved to a fancy new studio at 359 Broadway, over Thompson's Saloon, a popular restaurant, where he held a lavish opening reception for colleagues and friends [Figure 2–6]. In laudatory reviews, Brady's drapery, carpets, mirrors, furniture, and chandeliers received nearly as much attention as the portraits displayed in his gallery. By this time, Brady employed more than twenty-five workers, including the men who actually operated the cameras, technicians who prepared and processed plates, and finishers who mounted each daguerreotype in a frame or leather case. Like many businessmen of his time, Brady proudly left the handwork to others. He presided over the studio, attracted new business, and posed the most important clients.[7]

In the early 1850s, after British doctor Frederic William Archer discovered a means to attach light-sensitive silver salts to transparent plates of glass, Brady, and all camera-workers, began to make new kinds of pictures. Among the most popular was the ambrotype, which resembled a daguerreotype; a unique image on glass, it was sold in an elaborate, velvet-lined case. Without the daguerreotype's luminous silver surface, the ambrotype was less attractive, but also much less expensive. And though a complicated lawsuit led Brady and other high-quality New York photographers to cease making ambrotypes after 1856, the form remained popular through the Civil War.[8]

A more important innovation came in the form of photographs, positive prints on paper made from negatives on glass. Most often, negatives were placed directly in contact with the paper, but they could also be placed in an enlarging device, which allowed photographers to project images onto any distant surface

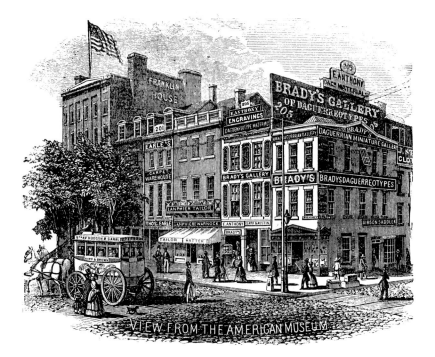

VIEW FROM THE AMERICAN MUSEUM

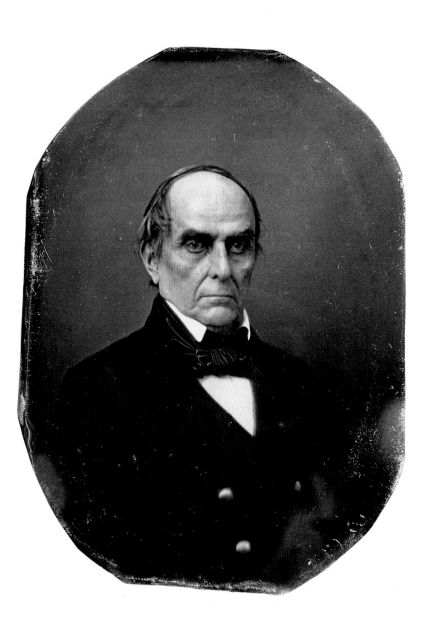

treated with light-sensitive materials. Paper photographs offered many advantages over daguerreotypes. They were easy to exhibit, easy to reproduce, and could be enhanced with watercolor, oil paint, ink, chalk, or pencil. By 1855, Brady advertised his new work in the art magazine *The Crayon*, calling attention to a "beautiful novelty in Art." Alluding to his previous success at the 1851 Crystal Palace exhibition in London, Brady observed that "the acknowledged superiority of American Daguerreotypes extends also to the kindred Art of Photography." He claimed to make the images in any size, "susceptible of coloring [which could] thus supply the place of Oil Portraits or miniatures," and described the work his studio produced, including "large copies from small originals, Daguerreotypes from Life, Old Pictures, Paintings, and Statuary as Usual."[9]

In 1856 Brady introduced a special large format, using a negative approximately twenty-four inches high and twenty inches wide to produce large pictures that he named "Brady Imperials." The soft, dark brown surface of the Imperial prints combined the best of the precision of a daguerreotype and the tactile surface of a fine mezzotint or lithograph. These large portraits also made it possible for Brady to imitate the portrait styles that he and his operators learned from prints by the Old Masters. Classical columns, rich draperies, and delicate handling of light and shadow gave Brady's Imperials a rich, monumental quality, well suited to the ambitions of clients like actor Edwin Forrest, General Winfield Scott, or Harriet Hosmer, a sculptor with an international following [Plate 3].

Changes in the medium also increased expenses and intensified competition. The terse phrases of Brady's R. G. Dun & Co. credit report reveal that while his work grew more ambitious and his reputation

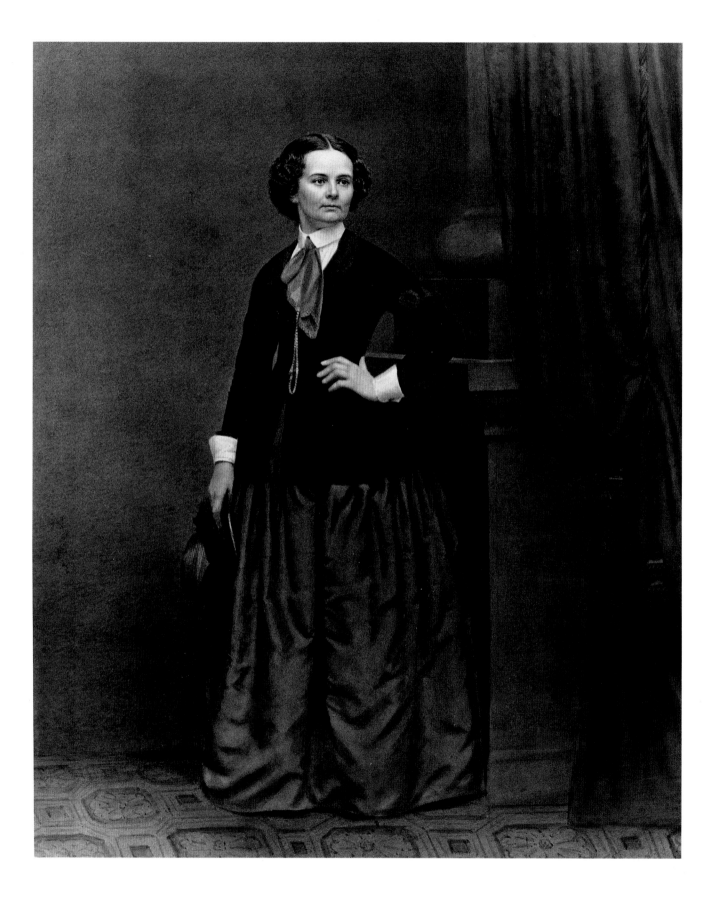

glowed, his finances suffered. In March 1859, creditors observed, "He is w[ell] consid[ered] . . . but it is all in pictures, furniture, wh[ich] might realize handsomely if sold to some man of means in his line, but if bro[ugh]t to enforced sale might scarcely pay his indebtedness. He makes money fast, but does not lay up."[10]

Brady worked with painters and printmakers throughout his career, and the Imperial form brought him many chances to see his photographs transformed into large oil paintings. Artists of varying talent and reputation, from Henry F. Darby and Alonzo Chappel to Charles Loring Elliott and G. P. A. Healy, all created portrait paintings that exhibit close ties to Brady's photographic images. Brady also forged profitable relationships with publishers of popular magazines like *Harper's Weekly* and *Frank Leslie's Illustrated Newspaper*, where his portraits appeared in the form of woodcuts to accompany articles on contemporary politics and culture. The credit "From a Photograph by Brady" further advertised its maker, and became a mark of authenticity.

By instinct and design, Brady built an archive of national dimensions. In 1858 he returned to Washington, and this time his business flourished under the management of Scottish photographer Alexander Gardner. Working from Washington as well as New York, Brady easily acquired portraits of all the men and women whose names came before the public. As he added new portraits to his existing archive, Brady created a stunning cumulative historical display, in which Presidents, politicians, actors, businessmen, artists, military men, clergy, scientists, and entrepreneurs joined in a pictorial celebration of the American

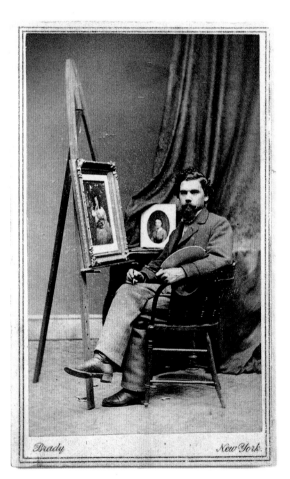

Union as stable, lasting, and full of purpose [Plate 4]. In retrospect, the process appears especially ironic, for figures like Stephen A. Douglas, Jefferson Davis [Plate 5], John Breckinridge, and Charles Sumner achieved much of their national recognition thanks to the crises that caused the nation to split apart [Figure 2-7].[11]

In 1859, Brady faced another technical innovation in the form of the carte de visite. In Paris, studio photographer A. A. Disderi found he could increase his efficiency when he fit four lenses onto one camera and recorded four images on a single glass negative. The small pictures (the size of a visiting card) rapidly became a popular novelty; within a year, the form had traveled to America. Literally millions of these images were sold in photographers' studios, print shops, newsstands, and bookshops, as well as by other dealers in popular ephemera.[12]

While the standardized, multiple carte de visite made it easy to produce large numbers of portraits for an expanded number of clients, and contributed to the growth of the celebrity industry that brought Brady so much profit, the new form also changed the nature of portrait photography. These portraits no longer required the close connection to individual sitters. They were easy to copy, and because painters could work from these simple portraits directly, they no longer had to collaborate with photographers to create the large, dramatic, artistic images that Brady made his specialty. According to tradition, Brady himself did not like the new form, and many credit his Scottish assistant, Alexander Gardner, with successfully introducing it to Brady's business.[13]

One of Brady's best-known cartes de visite was also one of the earliest. Made

HARPER'S WEEKLY.
A JOURNAL OF CIVILIZATION

VOL. V.—No. 214.] NEW YORK, SATURDAY, FEBRUARY 2, 1861. [PRICE FIVE CENTS.

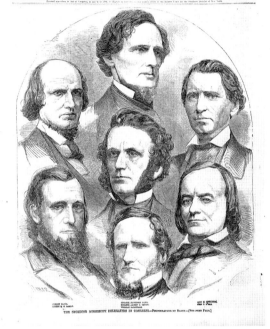

FIGURE 2–7

The Seceding Mississippi Delegation in Congress— Photographed by Brady

Woodcut by an unidentified artist, from *Harper's Weekly*, 1861.

Library of the National Portrait Gallery and the National Museum of American Art, Smithsonian Institution, Washington, D.C.

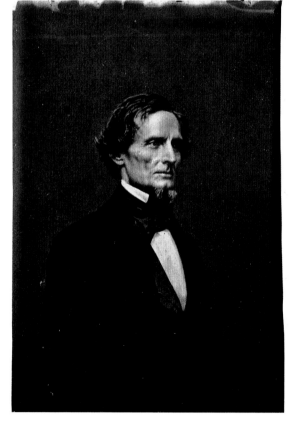

PLATE 5

Jefferson Davis

Modern albumen silver print from a collodion glass-plate negative, 1858–1860.

National Portrait Gallery, Smithsonian Institution, Washington, D.C.

in 1860 and published as a woodcut on the cover of *Harper's Weekly*, it illustrates Abraham Lincoln's nomination-grabbing speech at the Cooper Union in New York [Plate 6]. A few months later, Brady also produced a carte de visite of Edward, Prince of Wales, who paid a visit to his studio during his stay in New York City. Brady teamed up with P. T. Barnum to produce portraits of his best-known performers, and served as wedding photographer when Tom Thumb married Lavinia Warren in 1863. Brady copied many of his old Imperial portraits into the new small size, and also collaborated with his old friends, the publishers Edward and Henry T. Anthony, to issue carte-de-visite portraits in a series called "Brady's Album Gallery." While Brady made handsome profits from cartes de visite, these sales further undermined the attraction of his studio exhibition, for the public could now assemble private portrait collections of its own [Figure 2-8].[14]

In the fall of 1860, Brady moved his New York studio to a still more prestigious location, at the corner of Broadway at Tenth Street, near the fashionable Grace Church and across from the Tenth Street Studio Building, where many established artists worked. The new building was just a block from Union Square, the city's center [Figure 2–9]. Brady called his new studio the "National Portrait Gallery." With its lavish decoration, and extensive exhibition of portraits, this studio showed Brady at the peak of his power.[15]

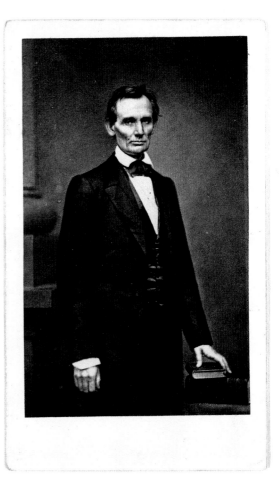

FIGURE 2–8 (left)

Carte-de-visite label

noting image's publication "by E. Anthony . . . from Photographic Negatives in Brady's National Portrait Gallery," 1860.

National Portrait Gallery, Smithsonian Institution, Washington, D.C.

PLATE 6 (right)

Abraham Lincoln

Salted-paper print (carte de visite), 1860.

National Portrait Gallery, Smithsonian Institution, Washington, D.C.

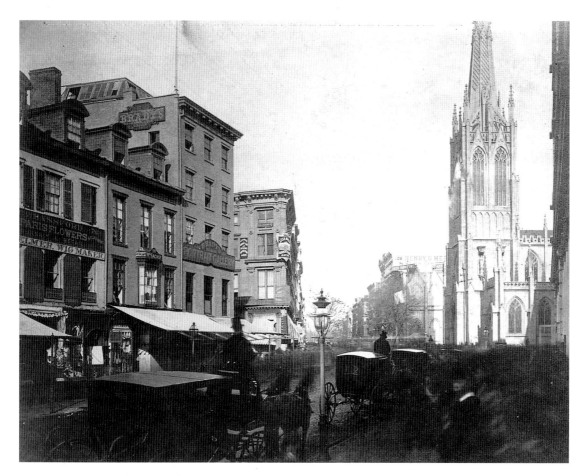

FIGURE 2–9 (left)

Brady's studio at 785 Broadway

Albumen silver print by an unidentified artist, 1864.

Private collection

PLATE 7 (opposite)

General Philip Henry Sheridan

Albumen silver print, 1864.

National Portrait Gallery, Smithsonian Institution, Washington, D.C.

Brady approached the outbreak of war with the same energetic eye for opportunity that characterized every other step in his career. Later, as he told interviewer G. A. Townsend, "My wife and my most conservative friends had looked unfavorably upon this departure from commercial business to pictorial war correspondence and I can only describe the destiny that overruled me by saying like Euphorion, I felt that I had to go. A spirit in my feet said 'Go,' and I went." He obtained permission for his staff of photographers to join the Union army in the field, and they brought back portraits to add to the Gallery collection [Plate 7].[16]

Under Alexander Gardner, Brady's photographers made images after the battle at Antietam that shocked viewers profoundly. By 1863, Gardner had set up business on his own, and Brady issued few disturbing images of war. Instead, Brady's operators concentrated on portraiture of individuals and groups in camp, in the field, on board ships like the *Monitor*, and in battlefields from which all evidence of war had vanished.

Brady's fortunes, always precarious, declined after 1865. He sold real estate holdings to settle debts incurred at the time he set up his Tenth Street studio, but expenses accrued during the war remained. His businesses no longer generated high profits. He could not, or did not, attract high-caliber staff, had little sympathy with current, standardized styles of portraiture, and, in truth, preferred the glamorous company of artists and politicians to the workaday world of the portrait studio. A large blow came in the late 1860s, when Brady offered his entire archive to the New-York Historical Society, then the city's most important institution for art. Though he enlisted the support of leading artists and war heroes, and roused a unanimous chorus of support from the press, his old friends and old methods failed him—the sale did not take place.[17]

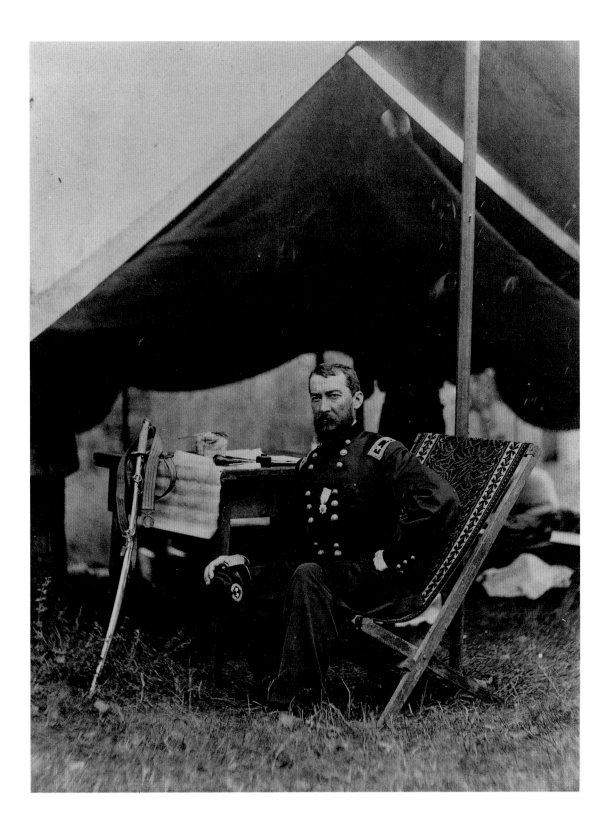

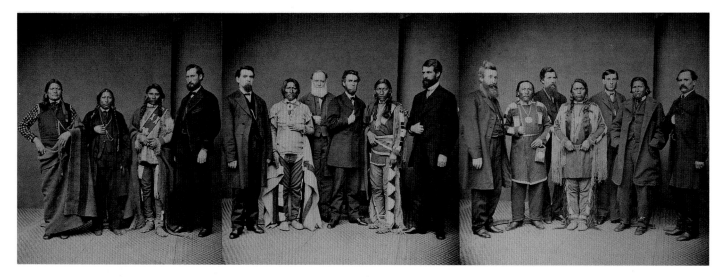

PLATE 8

Ute Delegation

Albumen silver prints, 1868.

National Portrait Gallery,
Smithsonian Institution,
Washington, D.C.

By 1870, Brady had moved to Washington and began a new campaign to sell his entire archive to the United States government. In 1872 he closed his New York gallery and filed for bankruptcy. Three years later, Congress agreed to purchase his collection for $25,000, in exchange for the title to his collection of negatives and prints, and Brady thus paid off his debts. He also kept aside a group of photographs and negatives, including daguerreotypes and paintings that formed the centerpiece of his New York gallery.[18]

For the next twenty years, Brady worked in Washington with his nephew Levin Handy, also a photographer. He made portraits of large official groups, including the Sioux and the Ute delegations [Plate 8] who came to make treaties with the United States government; the Patent Centennial Convention; the Committee for the World's Columbian Exposition; and the members of the International Congress that formed the Organization of American States. Brady once enjoyed these grand ceremonial occasions, but without the friendship of his powerful clients and the status they conferred, the pleasure was gone. Most of the images he produced in later years reflect his diminished enthusiasm, though rare events commanded his skill and interest. After Brady's wife Juliette Handy Brady died in 1887, age, discouragement, and alcohol further eroded his health and reputation [Figure 2–10].[19]

In 1890, Brady opened a new studio (his fifth since 1881) as "a museum of historical photography" and drew in a fresh group of journalists who had never heard his stories or seen his famous collection of portraits. But the real attraction was Brady himself [Figure 2–11]. As a lone survivor of the corps of photographers who worked during the Civil War, Brady claimed credit for innovations that he should have shared with Gardner and others. On the strength of his familiar inventory of political dignitaries, he offered himself as a kind of living panorama: "They all came to me, and I can see them in my mind's eye, like a procession of ghosts, passing in review." With a memory that extended back fifty years to a time made more

FIGURE 2–10 (left)

Juliette Handy Brady

Albumen silver print, circa
1868.

National Portrait Gallery,
Smithsonian Institution,
Washington, D.C.; gift of Claire
Kaland

FIGURE 2–11 (right)

Mathew Brady

Albumen silver print by
Levin C. Handy (circa
1854–1932), circa 1890.

Photographic History Collection,
National Museum of American
History, Smithsonian Institution,
Washington, D.C.

distant by the intervening war, Brady almost seemed to provide a bridge back to the Revolution. Townsend compared Brady to Charles Willson Peale, Thomas Sully, and Van Dyck.[20]

Brady must have felt vindicated by renewed interest in the war. He began to work on an illustrated public lecture, using slides of his old photographs. In 1895 he broke his leg in a traffic accident and never fully recovered; a year later, he died in New York and was buried in Washington, in Congressional Cemetery. In the end Brady was best loved by the soldiers he immortalized, and by the New York artists who knew him when he was young. Brady's funeral was financed by New York's Seventh Regiment, of which he was an honorary member. On January 18, 1896, the art dealer Samuel P. Avery wrote to the *New York Daily Tribune*, in honor of his old colleague, "Mr. Brady is still warmly remembered by many of our old residents as a most talented and enthusiastic artist, and as a modest, gentle, generous man."[21]

The ambitious master of the celebrity machine, friend to politicians, actors, generals, writers, editors, and artists, achieved early success through hard work and a considerable talent for seizing opportunities that others had failed to recognize. At the end of his life, Brady took on a new identity, turning himself into a living relic. Like the politicians he first portrayed, Brady personally served as a bridge from the present to a historic past. But unlike Webster, Clay, and Calhoun, Brady created a memorial that did not fade, because it was made from material that continued to have meaning for generations who never knew him. He was born into a world without photographs. By the time he died, photography had entered every crevice of modern life.

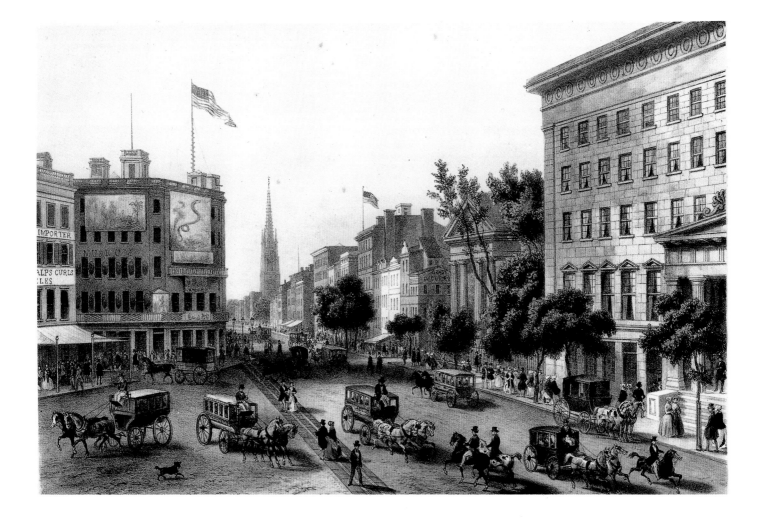

3

"A Perfect Kaleidoscope"
New York City

Mathew Brady came to New York in the early 1840s, part of the wave of immigrants from the hinterlands and abroad who filled America's major cities in the decades before the Civil War. In just a generation, New York had changed from an eighteenth-century colonial capital to an international, modern metropolis. The speed and intensity of this evolution shaped the city's destiny in the manner of a great natural event, creating social and political structures, setting standards of taste and decorum, and making and destroying countless individual fortunes. In the eyes of its citizens, and the country at large, New York had come to serve as an emblem for the nation.[1]

Standing in the middle of New York, at the center of Broadway, Brady's studio exhibited the portraits of the individuals who profited most from this chaotic process, though they did not always benefit most from its results [Figure 3–2]. In this world full of new pleasures and new problems, success came to those who found opportunity where others failed to see it; most had to invent their own methods to attain it, and often had to invent the very tools that would make it possible to carry out the work they first imagined. Their own discoveries and accomplishments changed the world, and in the process they made themselves obsolete. This story repeated itself countless times, and in every conceivable form. Architects who dared to build six-story buildings finally stood in the shadow of ten-story office blocks; workshops replaced human and animal labor with compact steam engines, and were eventually overtaken by factories propelled by dynamos. Actor Edwin Forrest, who personified the Young America movement in his roles as the Indian Chief Metamora or the gladiator Spartacus, was rejected by the next generation as a symbol of overblown, old-fashioned melodrama [Plates 9 and 10]. By the 1860s, Brady himself felt the harsh consequences of developments he had helped set in motion. Painters who once relied on photographers like Brady soon learned to copy the camera's record of detail and spontaneous gesture. And when the wide reproduction of his celebrity portraits in woodcut illustrations and inexpensive cartes de visite allowed everyone to assemble a private portrait collection, it dulled the luster of his Broadway gallery.

Between 1840 and 1860, New York's population swelled from 312,000 to 814,000, and settlement pushed north until the once-suburban Union Square, which extended from Tenth to Fourteenth streets—bound on the east by Broadway and on the west by Seventh Avenue—marked the middle of the city. As in other urban centers, rapid growth was accompanied by great upheaval, both social and physical. Streets were perpetually under construction, and a single structure could turn from a luxurious private mansion to a boardinghouse or storefront before making way for a towering six-story office block. Commonplace urban services such as water, light, and sanitation existed in a rudimentary state. Fire posed a constant threat, in part because fire control was left to volunteers, gangs of young men notorious for their territorial brawls. Tension between immigrants and native citizens, between classes, and between the political

FIGURE 3–1

View of Broadway Looking South from Park Row

Lithograph by Isidore Laurent Deroy (1797–1886), 1850.

The New-York Historical Society, New York City

23

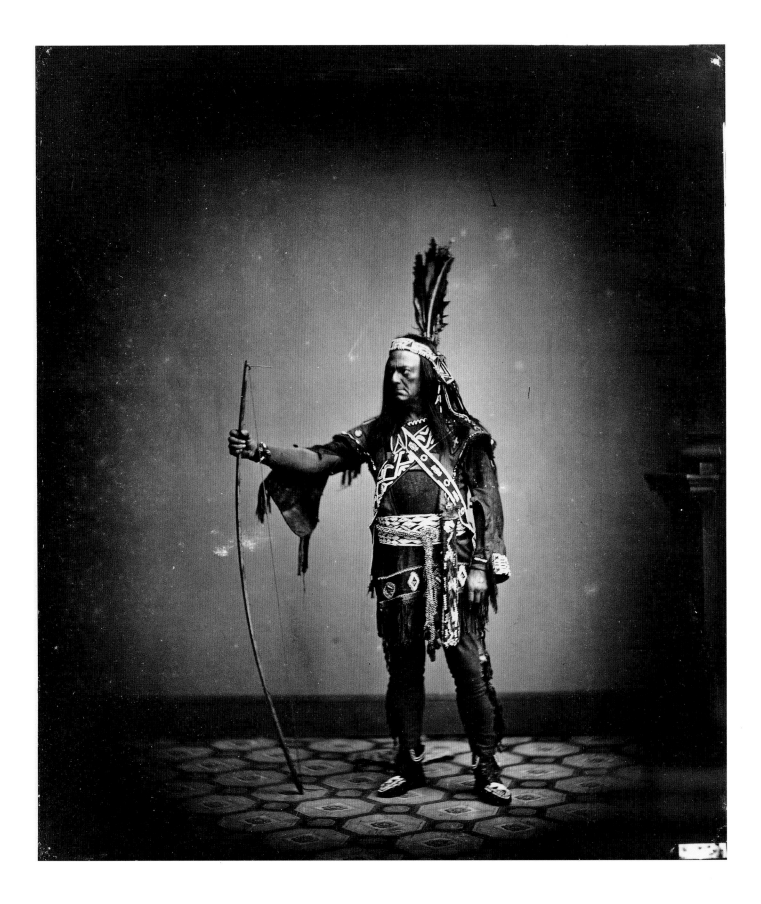

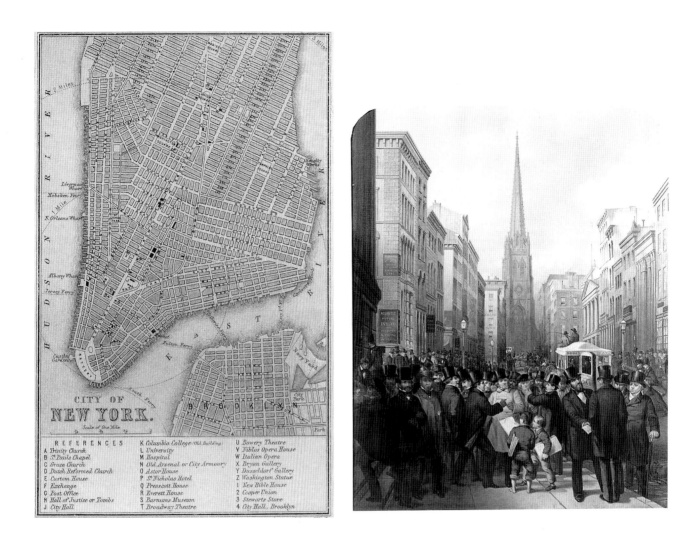

factions who profited from their antagonism, erupted into bloody riots, as in 1849, when a theatrical feud between Edwin Forrest and his British rival William Macready ignited a war in Astor Place that raged for three days and cost more than twenty lives. In the chaotic year of 1857, the stock market crashed, and three riots took place, one culminating in the arrest of the mayor by the governor's police force [Figure 3–3].[2]

At the same time, these decades brought enormous innovation, and contemporary critics never seemed to tire of listing the marvels of their age: the telegraph, steam power, ocean liners, photography, the railroad. Factories and manufacturing plants seemed as impressive as the goods they produced. Large, efficient printing presses produced cheap newspapers, which disseminated information faster and further than before. The Colt Company revolutionized manufacturing by assembling its revolvers from standardized, interchangeable parts. American manufacturers of textiles, ships, and agricultural machines began to compete in an international marketplace. Altogether this age produced more goods, in more quantity, with greater efficiency than ever before imagined. The effect was to shrink distances, conquer time, and in every way change the dimensions of the civilized world.

By the middle decades of the nineteenth century, newspaper editors, writers, politicians, and financiers had created a national center of culture, thanks to the wide dissemination of New York journals and

newspapers. Nearly everyone who ever tried to write for a living had something to say about New York and its central street, Broadway. Like Brady, they also earned a national reputation by representing New York City and its inhabitants. Through guidebooks, travel memoirs, popular novels, and newspaper columns, New York City was turned into the nation's urban emblem.

In his introduction to the *Pen and Ink Panorama of New-York City*, Cornelius Mathews [Plate 11] explained that he found his topic "genuinely 'American.'" To Junius Browne, New York itself was "a symbol, an intensification of the country." And if New York was the heart of America, Broadway was the heart of New York. "Broadway represents the national life, the energy, the anxiety, the bustle, and the life of the republic at large."[3]

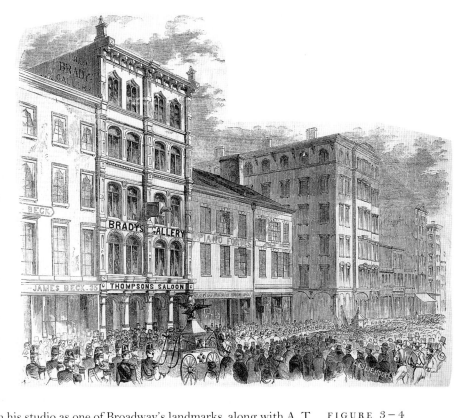

FIGURE 3–4

Firemen's Celebration— The Procession in Broadway, featuring Mathew Brady's studio at 359 Broadway

Wood engraving by Leslie Hooper (active 1850s), from *The Illustrated News*, 1853.

Library of Congress, Washington, D.C.

Brady came to identify himself with this place and time, and he worked hard to establish his studio as one of Broadway's landmarks, along with A. T. Stewart's Department Store and Barnum's Museum. From 1844 to 1860, Brady moved steadily north, beginning at 205 Broadway, near City Hall. In 1853 he moved to 359 Broadway [Figure 3–4], above Thompson's Saloon; for a few months in 1859 he moved to 643 Broadway, at Bleecker; and finally, in the fall of 1860 he opened his fourth, and most glamorous, studio at 785 Broadway, at Tenth Street, a block from Union Square. In 1859, Nathaniel Parker Willis called Brady a "very reliable indicator of the popular temperature—the quicksilver [in] the Broadway-mometer. . . . Find the photographic emporium of our friend Brady, and you find the spot where the city of New York is liveliest."[4]

A particularly charming account of Brady's New York comes from Henry James, who posed for his daguerreotype at Brady's studio when he was twelve years old. From roughly 1847 to 1855, the years when Brady rose to prominence, the James family lived at Fourteenth Street and Sixth Avenue, in one of the gracious mansions that lined Union Square. As a young boy, Henry James wandered the city in the company of his brothers—William, Robertson, and Wilkie—his father, his aunts, and his friends. His father taught James the art of the flâneur—the urban citizen who found modern culture in life on the streets and sidewalks, greeting local celebrities and shopkeepers, buying fruit from street vendors, enjoying New York's shops, restaurants, and public spectacles. William and Henry regularly ate ice cream at Thompson's Saloon, when for most Americans it was still an exotic novelty—or a once-a-year treat. They attended concerts and plays at Broadway theaters, visited Barnum's American Museum with its "spurious relics and catchpenny monsters in effigy," and began their education in art at the Düsseldorf Gallery, where "if one wanted pictures there *were* pictures, as large, I seem to remember as the side of a house, and of a bravery of color and lustre of surface that I was never afterwards to see surpassed."[5] Most of all, James remem-

bered Broadway itself, "the feature and the artery, the joy and the adventure of one's childhood, and it stretched, and prodigiously, from Union Square to Barnum's great American Museum by the City Hall."[6]

At the end of his life, Henry James located the "aesthetic seeds" of his art in this time and place. In New York he learned to be a careful and creative observer of an enormous range of people and events. But with typical frankness, James acknowledged that the world which as a boy he had found so enchanting appeared very different to his adult eyes. James coolly opened his own memory to scrutiny when he stopped to recall "the small warm dusky homogeneous New York world of the mid-century," and asked, "*was* it all brave and charming, or was it only very hard and stiff, quite ugly and helpless?" James himself accepted both sets of perceptions, and traced the root of his modernity to Broadway itself, where as a child he found "a different order of fascination and bristling, as I seem to recall, with more vivid aspects, greater curiosities and wonderments."[7]

If Henry James was New York's most generous critic, James Fenimore Cooper was its angriest [Figure 3–5]. In his 1838 novel *Home as Found*, he described a contemporary New York pervaded with extravagance, where "all principles are swallowed up in the absorbing desire for gain—national honor, permanent security, the ordinary rules of society, law, the constitution, and everything that is usually so dear to men, are forgotten, or are perverted in order to sustain this unnatural condition of things."[8] Cooper incisively identified this society's dual nature. Apparently in a "constant state of mutation," New York never really changed. "In short, everything is condensed into the present moment; and services, character . . . and all other things cease to have weight, except as they influence the interests of the day."[9]

In fact, the problems that James Fenimore Cooper, Cornelius Mathews, and others saw on Broadway occupied contemporary culture on both sides of the Atlantic. The conflict between aristocracy and democracy, between wealth and poverty, between the lure of the present and the weight of the past, absorbed European realist writers Charles Dickens and Henry Mayhew in London, and Charles Baudelaire and Victor Hugo in Paris, as they struggled to find a way to represent their world.

The problem can be understood as one of perception. These writers, artists, and citizens confronted a visual field that seemed too large and fast and varied to understand. Cornelius Mathews described the disorienting dilemma of the viewer who constantly faced new things and strange people: "So peculiar, variable and shifting . . . that it is no easy matter for a Native to keep his foothold and point of observation."[10] For Charles Baudelaire, writing in Paris in the 1850s, the solution came in the form of an artist who could create his own order through the act of representation, comparing him to "a mirror as vast as the crowd itself; or to [a] kaleidoscope gifted with consciousness . . . at every instant rendering and explaining [life] in pictures more living than life itself, which is always unstable and fugitive."[11]

FIGURE 3–5

James Fenimore Cooper

Engraving by H. B. Hall & Sons (active 1865–1899), after a daguerreotype by Mathew Brady Studio, after 1860.

National Portrait Gallery, Smithsonian Institution, Washington, D.C.

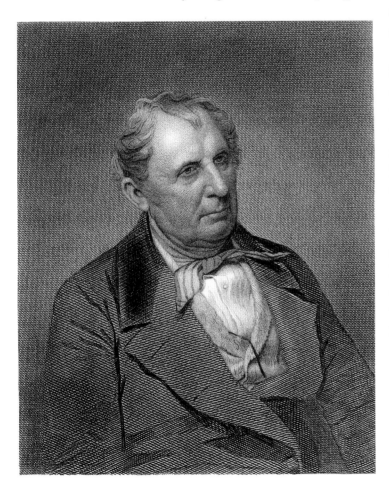

An unnamed critic, writing about his stroll down Broadway, used the same metaphor to distinguish a new, nineteenth-century vision from earlier habits of perception:

> There are always pictures enough in Broadway for those who have eyes to see them; pictures which few painters take the trouble to put upon their canvas and fewer *connoisseurs* to enjoy as they pass in panoramic succession before their eyes; pictures of the varied human life of the Nineteenth Century; comedies of New York life, pregnant as the wonderful color dramas of Hogarth; bits of sentiment, as touching as Edward Frère ever imagined—quaint, stirring, saddening—a kaleidoscope succession of appeals through the eye to all that feels, judges and enjoys within us.[12]

FIGURE 3–6

Polyangular kaleidoscope

From *The Kaleidoscope: Its History, Theory, and Construction*, by David Brewster (London: John Murray, 1858).

The Library Company of Philadelphia, Pennsylvania

The kaleidoscope [Figure 3–6], invented in 1816 by British optician Sir David Brewster, was an artifact of the youth of those writers who invoked its image; it arrived just in time to aid perception of the modern scene.[13] The simple device of mirror, lens, and prism offered an appealing means to contain the flood of visual information that nearly drowned the casual visitor to New York and Broadway. Its fractured, repetitive images gave a decorative, symmetrical, abstract order to the chaotic view. If it conferred no more meaning than an unaided glance at Broadway, it promised more pleasure. In lieu of the anxiety inspired by the constant lure of advertisements and commodities, by the desire for objects, and for the status conferred by public recognition, the kaleidoscopic vision provided orderly, colorful nonsense; it invited the viewer to delight in purely personal, temporary powers of observation and imagination.

This metaphor also reminded readers how the visual realm came to preside over the other senses. F. Saunders, describing "New York in a Nutshell" in 1853, remarked, "The great characteristic of New York society is perhaps excitement, everything in *furore*." He encouraged visitors confused by Broadway's "incessant noise and din" to enjoy the sheer volume of sights. Broadway offered "more varied aspects of character than any other spot on the globe. It is a perfect Kaleidoscope—each day presenting some new feature or change."[14]

The consequences of this form of visual pleasure could be found in a new focus on the present and the personal, as noted by journalist-boulevardier Nathaniel Parker Willis, one of Brady's most loyal advocates [Plate 12]. Willis was fond of making up words to suit his needs. He titled one collection of essays *Hurrygraphs*, and elucidated his meaning in an introduction that described his work as "copies from the kaleidoscope of the hour . . . one man's imprint from parts of the world's doing at one place and time." Though Willis's topics are frequently trivial, and many despised him (including his sister, the popular writer Fanny Fern, and the outspoken lawyer and diarist George Templeton Strong), his work successfully imparts the spirit of modernism that inspired his French and British contemporaries.[15] Today Willis's work reminds us that in the 1850s, New Yorkers had sophisticated pretensions; they classified writers such as Edgar Allan Poe and James Fenimore Cooper as first-class members of an international community that included Charles Dickens, William Makepeace Thackeray, and Victor Hugo. Willis explained his relentless fascination with the fleeting topics of the day as a sign of his commitment to a modern aesthetic:

> The author, long ago, made up his mind that the unreal world was overworked—that the Past and Future were overlauded—and that the Immediate and Present, and what one saw occurring, and could truthfully describe, were as well worth the care and pains of authorship as what one could only imagine or take from hearsay. He

PLATE 12 (opposite)

Nathaniel Parker Willis

Imperial salted-paper print, late 1850s.

National Portrait Gallery, Smithsonian Institution, Washington, D.C.

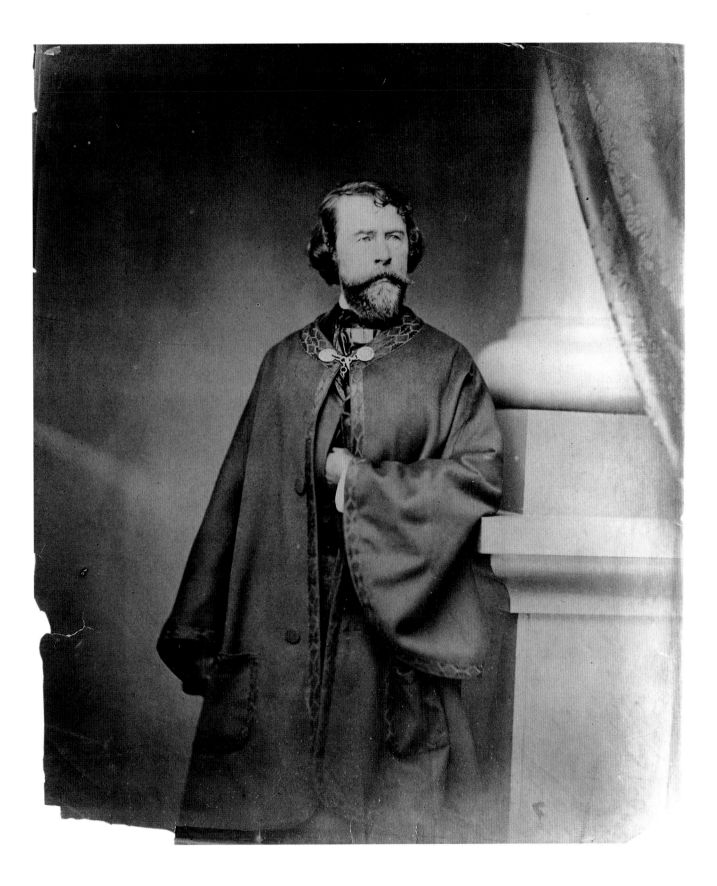

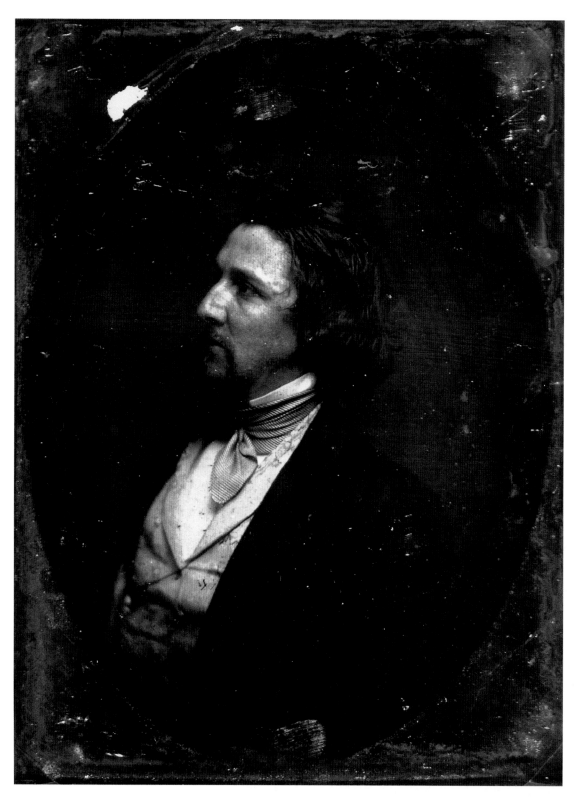

PLATE 13

Charles Edwards Lester

Daguerreotype, circa 1850.

Library of Congress,
Washington, D.C.

has written, therefore, upon topics as the Hour presented them. . . . New York, and what interested it in the middle of the nineteenth century, will be a chapter for History to which this volume will contribute.[16]

Most descriptions of Broadway began with the street's commercial character, where "everything is for sale, all signs, all faces, all advertisements, all voices, all outward aspects of things urge you to buy."[17] Charles Edwards Lester [Plate 13], a writer and critic who later collaborated with Mathew Brady to create the *Gallery of Illustrious Americans*, disguised a promotional volume as a descriptive guidebook, calling *Glances at the Metropolis* "a *record of the progress of American genius and achievement*" (emphasis his), as seen in the "blaze of glittering temptations" found in and around Broadway.[18] His title was deceptive, for this collection of light glances took shape as a huge bound volume destined for the central table of a public parlor in a hotel, train station, or steamship, where its persuasive essays could reach a large, idle audience. The variety of New York businesses who subscribed to *Glances* remains instructive (as does the relatively unsophisticated state of the marketplace, where manufacturers continued to sell their own wares). Lester's essays promoted pianos, carpets, wallpaper, mirrors, picture frames, silverware, prints, dry-goods stores, sellers of books and music, makers of daguerreotypes, and manufacturers of goods and services such as cast iron, safes, and steam engines. A typical, if unintentionally revealing, advertisement praised a manufacturer of pianos and billiard tables as "an artist, a man of genius . . . a generous, princely liberal home-loving, working Republican citizen [whose] friends are true men; society thanks him; art compliments him, scholars love him and the poor bless him."[19]

The topic of commerce also provided endless opportunities to moralize about the deceptive lure of material gain and condemn those earnest, acquisitive, industrious consumers. Mary Jane Windle, a Washington journalist with southern sympathies, began her 1857 visit to New York with a visit to Ball & Black's famous jewelry establishment. Then she passed down Broadway, with its bustling exhibition rooms, lounging dandies, and noisy streets filled with traffic [Figure 3–7]. Like everyone else, she could

FIGURE 3–7

The entrance to the sales room of Hiram Anderson's carpet store in New York City

Wood engraving by an unidentified artist, from *Frank Leslie's Illustrated News*, 1853. In John Grafton, *New York in the Nineteenth Century* (New York: Dover Publications, 1977).

Library of the National Portrait Gallery and the National Museum of American Art, Smithsonian Institution, Washington, D.C.

not restrain her amazement at the "wealth of luxury in shop windows . . . gorgeous jewels, glittering time-pieces, brilliant glass, noble engravings, costly furniture." But she was shocked and saddened by "the number and deplorable aspect of the little beggar children who seemed to present themselves at every step of our way . . . their features wasted by want and privation, their limbs pinched with hunger, and blue with cold." This vision aroused her anger at *"Abolitionists* of New York! You whose sympathies with the wide colored humanities are so fresh and clear. . . . There is no *slavery* on the wide surface of our country can be found comparable to that which we have seen within the area of a mile around your dwellings!"[20]

Herman Melville conducted an even more scathing attack on the social structures that sustained this culture in a series of sketches for *Putnam's* magazine throughout the 1850s. Melville lamented the transformation of dignified old residences to commercial storefronts, and acidly condemned the suddenly wealthy who had no use for the past. And in stories such as "The Two Temples" and "Jimmy Rose," Melville also employed another theme favored by Broadway writers, the way individuals become invisible to the public gaze, which can only accommodate the prosperous, the lucky, and the rich. His series of stories culminated in "Bartleby the Scrivener, a Story of Wall Street," a modern ghost story narrated by a nameless lawyer whose business embodies the empty materialism that Melville deplores, from its dim loft location, to its cast of broken employees, to the cold opacity of the lawyer's language. In "Bartleby," Melville created a character who finally defeated this insidious system when he simply decided not to participate in any exchange at all, and ceased to work, eat, and sleep, until he withered away.

George Foster, who also sat for Brady, used his satire of New York and Broadway to support a long, successful career. In 1849, he created a series of articles for the *Tribune* on a model made popular by sociologists and realist writers in London and Paris. *New York in Slices by an Experienced Carver* was an immediate success, spawning imitations (which he ridiculed as "Hudson in Patches, Wisconsin in Chunks, and Mississippi in Gobs") and inspiring sequels (*New York Naked* and *New York by Gaslight*).[21] Foster began his

first book with a fulsome account of its "Glorious City! happy people! nothing but palaces and carriages . . . splendor, refinement, luxury, and ease!" Then he announced his true goal, to "go among the naked and apparent miseries of the metropolis [and] stand by the very rotting skeleton of City Civilization."[22]

Foster devoted his very first slice to Broadway, which he denounced as a chaotic monument to "false and frivolous ambition." Though Foster acknowledged that "Broadway well deserves its reputation as the centre of fashion and republican aristocracy," he ridiculed the individuals, especially the women, who sustained its reputation, the "sauntering Queens, Duchesses, and Countesses of Republican New York" who patronized the "smothered and groaning counters" at Stewart's [Figure 3–8] and Ball & Black's. According to Foster, this commercial abundance only produced a dreary monotony,

> a certain well-bred and immovable level. . . . Mark the passengers: not as the people, in other more Democratic precincts, scrambling freely about, dashing to right and left, taking across the way at an angle—but all moving in a right line, to the right up, to the right down. All dressed in about the same decent habiliments, all carrying heads up, and observing the decorum of the street with due gravity and steadiness.[23]

Cornelius Mathews deftly identified the street's capacity to display both objects and citizens, and used Broadway's distinctive shop windows as a means to make a larger point. Mathews celebrated the fact that no one quality set Broadway apart from "the commonest street." He boasted that, as the "mighty medium for the exhibition of all that is singular and eccentric, Broadway cannot claim a single peculiarity for itself." In its inherent formlessness Mathews recognized a new kind of form, calling Broadway "a great sheet of glass, through which the whole world is visible as in a transparency."[24]

Others admired the energy and variety of Broadway's human stream. Mathews delighted in its wide range of visitors—"turk, chinaman, choctaw . . . and whatever else strange and wonderful in character the world could furnish." Guidebook author F. Saunders celebrated its "incongruous elements," listing

> the rude and the refined, the sordid and the self-sacrificing, the religious and the profane, the learned and the illiterate, the affluent and the destitute, the thinker and the doer, the virtuous and the ignoble—the young and the aged—all nations, dialects and sympathies—all habits, manners and customs of the civilized globe.[25]

Readers of W. H. Graham's *Guide around New York* learned that a visit to Broadway might reveal the baker, butcher, soldier, Irish immigrant, poet, artist, and merchant's clerk, as well as the country's most famous citizens. "W. C. Bryant will touch you with his elbow, Bancroft may be, perhaps, crowded into the gutter and the author of 'Knickerbocker's History of New York' may pass you."[26]

The most articulate spokesman of this democratic time and place remains Walt Whitman, who as a journalist and poet found inspiration on Broadway and in the Bowery, and incorporated "the blab of the paves . . . the tires of carts and slap of bootsoles and talk of the promenaders" into *Leaves of Grass* in 1855.[27] Twenty-five years later, when the poet assembled his autobiographical *Specimen Days*, he called Broadway "that noted avenue of New York's crowded and mixed humanity" and listed the celebrities he saw there: "Andrew Jackson, Webster, Clay, Seward, Martin Van Buren . . . Bryant . . . the first Japanese ambassadors," all of whose portraits appeared in Brady's gallery.[28]

Whitman's sheer genius overshadows the work of nearly every writer of his generation. What his contemporaries strain to describe, Whitman captures in robust, supple poetry. But Whitman and his

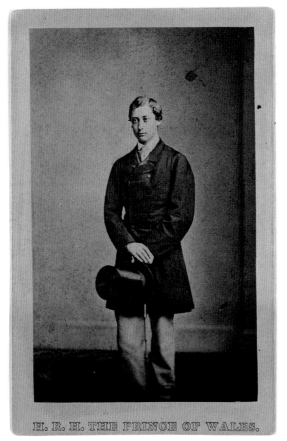

H. R. H. THE PRINCE OF WALES.

PLATE 14

**Edward Albert,
Prince of Wales**

Albumen silver print (carte
de visite), 1860.

Clifford and Michele Krainik

contemporaries clearly agree that Broadway effected a dramatic change in consciousness. In a fragment of verse, he used reflections in a shop window as a poetic device to combine the noisy "hum and harshness" of the street with "the reflection, moving, glistening, silent. . . . The faces and figures, old and young all so various, all so phantasmic."[29]

Junius Henri Browne described a similar vision with less grace, if more precision, when he said, "A walk through Broadway revives recollection; makes life flow backward for the hour; lifts the curtain from scenes of the past; recreates feelings often pleasant, oftener painful—all ghosts of the dead years that shimmer through our darkened memory."[30]

On Broadway, as George Foster observed, death and life could be judged according to a single standard—fame:

Hundreds and thousands in New York . . . cannot live out of Broadway: who must breathe its air at least once a day, or they gasp and perish . . . whose sole luxury, whose chief enjoyment in the world is to have certain hats touched to them every day of their life in Broadway. This is their morning's anticipation, their evening's reminiscence; and when at length they find this world and its affairs closing upon them, they call a confidential friend to their bedside, and whisper in his ear, as they are going, "Let the funeral go through Broadway!"[31]

Browne also showed how Broadway had become the main thoroughfare through time, when he asked "But who is not in Broadway? All who are not dead are, or have been, or will be. And dead may be, too, in another form. Stay there, and the World will come round to you in its own season."[32]

Or one could simply meet the world in Brady's gallery. Brady's daguerreotypes and photographs gave a public face to their sitters. As his portraits looked out at their admirers with unseeing eyes, they mimicked the cold Broadway stare that Melville deplored, and the regular rows resembled the straight up-and-down march that Foster ridiculed. Brady's images of pretty women attracted many observers, including the customers who waited patiently to add their faces to his collection. He also created a great, timeless, canonical collection of heroes, which one Caleb Lyon described in verse (the first stanza suggests the rest):

Soul-lit shadows now around me;
They who armies nobly led;
They who make a nation's glory
While they're living—when they're dead,
Land-marks for our country's future,
Have their genius left behind;
Victors from the field of battle;
Victors from the field of mind.[33]

In 1860, when the Prince of Wales came to New York, he spent one long free day sightseeing, and followed common wisdom; he stayed at the new Fifth Avenue Hotel at Broadway and Fifth Avenue, purchased gifts for his mother and family at Ball & Black's, lingered at Barnum's American Museum, and paid a call on Winfield Scott. The Prince and his entourage began the day at Brady's gallery [Plate 14].[34]

4

The Making of a Daguerreotypist

hen Mathew Brady first set up his business in 1844, he chose the photographic district at the lower, older, less fashionable (and less expensive) end of the city's fast-growing commercial strip where a group of photographers had already clustered.[1] By 1850 an observer could insist there was "probably no city in the United States where the Daguerreian Art is more highly appreciated and successfully practiced than in New York." He counted 71 rooms (independent of manufacturers of materials), which contained 127 operators (proprietors and employees), 11 women, and 46 boys. A year later, in 1851, another journalist expanded that claim, insisting that no comparable streetfront in "this Western Hemisphere" supported as many daguerreotype studios as the stretch of Broadway from City Hall to Union Square. By 1853, the *New York Tribune* counted 100 daguerrean establishments in New York and Brooklyn, employing 250 men, women, and boys. The same source estimated that the photographic industry employed 13,000 to 17,000 individuals across the country who produced 3,000,000 daguerreotypes a year. Brady's space extended across 205 and 207 Broadway and was "the largest and most fashionable establishment in the city." The ground floor was occupied by the photographic supply business operated by his friends and colleagues, the brothers Edward and Henry T. Anthony.[2]

Who took up this new profession? The most famous description comes from Nathaniel Hawthorne, who cast a daguerreotypist as the hero in his romance, *The House of the Seven Gables*. With the freedom afforded by fiction, Hawthorne sketched a comic picture of an energetic young man on the make, who had already tried every kind of work, short of manual labor. Despite "exceedingly humble" origins, and the "scantiest possible" education, Holgrave had attained knowledge and sophistication while working in the hinterlands. Though just short of twenty-two, he had already been a country schoolmaster, a salesman in a country store, the political editor of a country newspaper, a peddler, a dentist, and a "supernumerary official, of some kind or other, aboard a packet ship."[3]

A British journalist painted a similar picture, taking a similarly ironic tone:

> Are you a lawyer and have no cases? console yourself! Are you a doctor and nobody comes to be cured? despair not! . . . Are you a journalist and nobody reads you; or a financier menaced with ruin; finally, whatsoever road you may have chosen, if while seeking fortune you meet with only misery! Pause! Calm yourself and behold! There she now stands reaching out her arm to you! Go at once and become a photographer![4]

From what little we know about those early workers, Hawthorne and his anonymous British colleague offered an accurate view, despite their satire. In fact, in examining how the earliest daguerreans entered their profession, one can see how truly fluid American society was, and how easily one could enter

FIGURE 4—2

M. M. Lawrence's
Daguerreotypes

Wood engraving by
Nathaniel Orr (active
1844–1860), 1854.

The New-York Historical Society,
New York City

FIGURE 4—3

Root & Co. Daguerrian
Gallery,

next to Brady's gallery at 359
Broadway.
Calotype by Victor Prevost
(1820–1881), circa 1853.

The New-York Historical Society,
New York City

the middle class, given a grasp of the proper attributes. Sheer skill and ambition propelled many careers, along with certain practical skills and a great deal of stamina. Failure did not stop them, and interestingly, success seemed to bring only partial satisfaction. The best workers seemed to be inspired by change and challenge for its own sake.

Mathew Brady manufactured jewelry and daguerreotype cases in New York before he opened his stu-

dio; Edward Anthony trained as an engineer; Jeremiah Gurney and Martin M. Lawrence began as jewelers in New York [Figure 4–2]. Philadelphian Robert Cornelius was a brass manufacturer; his colleagues Dr. J. E. Parker and Dr. Wildman began as dentists; and Mr. Mason had learned to handle plates as an engraver. In Boston, John A. Whipple began by selling photographic chemicals. Others began as artists and portrait painters, including T. C. Faris in Cincinnati and Marcus Aurelius Root in Philadelphia and New York [Figure 4–3]. Gabriel Harrison was an actor and a playwright. Perhaps the most exotic story belongs to C. D. Fredricks, who got his earliest education in Havana, worked on Wall Street, took a camera along to South America as insurance if business became slow, and found photography a much steadier source of income. Fredricks became an important innovator—he brought artists from France to color his photographs and later introduced the carte de visite to New York from Paris [Figure 4–4].[5]

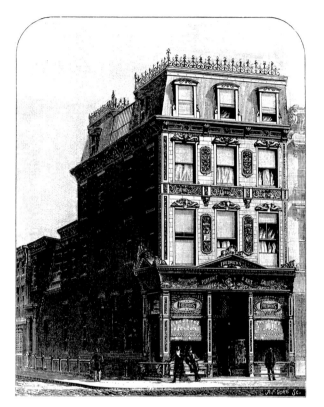

Skilled, self-sufficient, and tolerant of a profession without a history or precedent, these men were also quick to recognize opportunities that others did not see. The daguerreotype was announced to the world in Paris in 1839, and within five years it was possible to open a studio and earn a living for an investment of about $300, almost a year's salary for a skilled worker. In 1855, Marcus Aurelius Root boasted that after only sixteen years "nearly every village of note in the United States" had at least one photographic studio, and the biggest cities, like New York and Philadelphia, had dozens.[6]

As the years went on, the leaders of New York's photographic community remained remarkably stable, despite the volatile nature of the marketplace and the great changes in the city itself. A small group dominated the field for about twenty years; the prizewinners of the 1840s were, on the whole, still at the head of the industry in the 1860s, including Edward Anthony, Jeremiah Gurney, Mathew Brady, the Meade brothers [Figure 4–5], C. D. Fredricks, Gabriel Harrison, Martin M. Lawrence, Marcus and Samuel Root, John A. Whipple, James Wallace Black, and William and Frederick Langenheim. This generation of photographers maintained their position over a period of enormous technological change: they followed photography from its origins in the daguerreotype—a unique image on silver-plated copper—through the elaborately manipulated paper photographs of the 1850s, to the multiple, mass-produced card portraits of the 1860s. They presided over the expansion of the industry, from a few practitioners to a field of thousands.[7]

The leading practitioners left behind a voluminous record, in the form of specialized journals that catered to professional photographers, scientists, engineers, and naturalists who applied photographic technology to their work, as well as to devoted amateurs who enjoyed photography as recreation.[8] The earliest, *The Daguerreian Journal*, was short-lived, appearing in 1850 and lasting barely a year. It was followed by the *Photographic Art-Journal* (1851–1853)—which expanded to become *Photographic and Fine Art Journal* (1854–1860)—and *Humphrey's Journal* (1852–1868). Like photography itself, these magazines were an important by-product of New York's growing communication industry.[9] From a technical standpoint,

they pioneered methods for publishing pictures at a time when reproductive processes such as wood-engraving and chromolithography were still very new. These publications also enabled photographers to establish a national professional network based on the exchange of technical tips, chemical formulas, professional advice, and, perhaps most important, gossip. Through these journals, the photographic industry found a way to communicate a whole range of information about the way to conduct business, produce images of high technical and aesthetic quality, attract new customers—in short, how to be a photographer.[10]

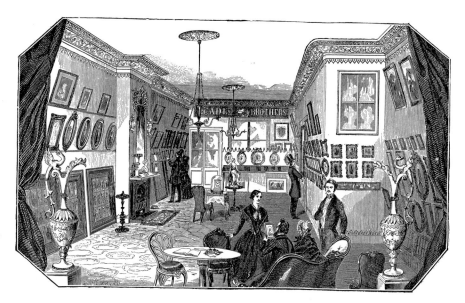

FIGURE 4−5

Interior View of Meade Brothers' Daguerreotype Gallery, Broadway, New York

Wood engraving by an unidentified artist, from *Gleason's Pictorial Drawing-Room Companion*, 1853.

National Portrait Gallery, Smithsonian Institution, Washington, D.C.

Nearly all professionals based their business upon portraiture. Insistent editorials and articles in the high-toned *Photographic Art-Journal*, by writers such as Marcus Aurelius Root and H. H. Snelling, encouraged Broadway portrait studios to set high standards and maintain the prestige of the industry—as well as high prices—by producing images that clearly declared the artistic nature of their work. The shrill tone of these accounts suggests that standards were difficult to define and uphold. Higher standards alone could not lure business away from lower-priced competitors. Prices varied widely, from twenty-five cents on the Bowery to five dollars at the highest-priced studios, at a time when many workers earned less than five dollars in a week. Early images show that a clear range of quality did exist, but no one studio could guarantee uniform results. (There was also the difficulty of defending the art value in an image that was essentially made by a machine, though, as we shall see, Root and his colleagues developed many ingenious ways to make their case.)

Photographers conformed to the standards of the day. Their industry became divided by price, quality, and class, with cheaper studios clustered on the Bowery, along with theaters, restaurants, and stores that catered to the working class. Photographers with fancier aspirations located their studios on Broadway.[11] And the most ambitious (such as Brady, Gurney, and Fredricks) continually moved their studios north to keep pace with the business district, as fashionable merchants followed their customers past Bleecker to Fourteenth Street and Union Square. Their images record, in a rudimentary way, the visual attributes that won customers and earned prizes around the city. In addition, descriptions of successful galleries and their owners clearly show that a photographer's reputation derived in large measure from attributes that had little to do with one's ability to record a portrait on a plate. Root and his contemporaries consistently applaud the photographers who were able to create environments in which "taste and beauty" could flourish. Individual careers undoubtedly rested on a photographer's ability to project specific desirable attributes, which in turn could inspire the confidence of his customers. The photographer himself can be seen as the most elaborate product within this hothouse of taste.

It is important to see these photographers as both producers and consumers, participants in the same social economy that sustained their customers. One can easily situate the photographic business within a new category of merchants that populated Broadway—the jewelers, haberdashers, chemists, sellers of fur-

niture, carpets, fabric, mirrors and picture frames, books, prints, cast-iron ornaments, and the new general department stores, the "blaze of glittering temptations" that journalist Charles Edwards Lester compared to "a string of sparkling gems of all hues, from the burning ruby to the dreamy opal."[12] This was also the district of the city's most luxurious hotels, including the Astor House, the Metropolitan Hotel, and the St. Nicholas Hotel, which all housed visitors and permanent residents and also provided local headquarters for visiting dignitaries and politicians.

These businesses all shared a common organizing principle, in which the production of goods—whether hats, carpets, pianos, or daguerreotypes—was separated from their display and sale. (Even hotels conformed to this model, by separating their residents from all domestic responsibilities.) The consequent division of labor not only produced surplus value for the proprietor, but as Stuart Blumin has shown, it effectively created a whole new class of white-collar workers, the bookkeepers, clerks, receptionists, and salesmen who occupied the intermediate levels between the men who controlled the capital and the laborers who made the goods. As a result, Broadway's bazaars housed a new market, and at the same time actually produced a significant component of the middle-class public that sustained it.[13]

Broadway's photographic studios contained this entire economic system. The products were several: the portraits; the subjects themselves, whose identity took on a new form and significance through the act of representation; and the greater middle-class public, exemplified by the many skilled practitioners who contributed to the making and selling of these images—the operators and technicians who prepared the plates, exposed them, developed them, added color, assembled them with mounts, frames, and cases; the receptionists who greeted customers; and the clerks who managed the supplies and collected the bills. The photographer whose name appeared on the studio thus presided over a virtual factory whose most important product was a new kind of worker and a new class of American.

When Brady proudly employed more than twenty-five workers in his studio, he proved his stature to both his customers and his peers. As an interview of 1851 shows, Brady's audience accepted him as an artist and photographer even though he did not operate the camera. "Brady is not an operator himself, a failing eyesight precluding the possibility of his using the camera with any certainty, but he is an excellent artist nevertheless—understands his business so perfectly, and gathers around him the first talent to be found." One reporter even referred to Brady's business as a "Daguerrean College," where he trained and employed "the most skillful and learned professors in the art." In fact, Brady's frailty may have worked to his advantage, removing him from all technical work to concentrate on the artistic side of his trade—the winning of clients, the poses, the lighting, the composition, and the training of new professionals.[14]

INSIDE THE STUDIO

American daguerreotype studios became showcases for the latest styles in carpet, furniture, and interior decoration. When Brady opened his new studio at 359 Broadway in 1853, *Humphrey's Journal* described the decoration in detail:

> At the door hangs a fine display of specimens which are well arranged in rich rosewood and gilt show cases. The Reception Rooms are up two flights of stairs, and entered through folding doors, glazed with the choicest figured cut glass, and artistically arranged. . . . The floors are carpeted with superior velvet tapestry, highly colored and of a large and appropriate pattern. The walls are covered with satin and gold paper. The ceiling frescoed, and in the center is suspended a six-light gilt and enameled chandelier, with prismatic drops that throw their

enlivening colors in the most costly needle worked lace curtains, while the golden cornices, and festooned damask indicate that Art dictated their arrangement. The harmony is not in the least disturbed by the superb rosewood furniture—tetes a tetes, reception and easy chairs, and marble-top tables, all of which are multiplied by mirrors from ceiling to floor. Suspended on the walls we find the Daguerreotypes of Presidents, Generals, Kings, Queens, Noblemen—and more nobler men—men and women of all nations and professions [Figure 4–6].[15]

The high-minded Marcus Root provided his readers with detailed advice in the construction of the proper atmosphere, designed to produce "a genial, elevated tone of sentiment." Rich fabrics, soft light, an ample supply of books and pictures to stave off ennui, and an assortment of "curiosities having classic, romantic and historic associations," such as coins, medals, vases, and urns. These could be "original or transcript," real or fake. Root identified "the authentic line of beauty" as the curve, and he advised its presence everywhere—on window shades, wallpaper, woodwork, sculpture, furniture, carpet pattern. Through a relentless "unity of idea," he sought to envelop his sitters in an atmosphere that would calm, inspire, and soothe.

To a reporter for a French photographic journal, the motive behind such lavish style seemed utterly transparent:

FIGURE 4–6

Brady's New Daguerreotype Saloon, New York, at 359 Broadway

Wood engraving by an unidentified artist, 1853.

National Portrait Gallery, Smithsonian Institution, Washington, D.C.

> Everything is here united to distract the mind of the visitor from his cares and give to his countenance an expression of calm contentment. The merchant, the physician, the lawyer, the manufacturer, even the restless politician, here forget their labors. Surrounded thus, how is it possible to hesitate at the cost of a portrait?[16]

Whatever the motive, extravagance paid off, and photographers obviously thrived in the competition to construct ever larger and more luxurious palaces.[17]

These draped, upholstered public spaces bear little relation to the needs of the daguerreotypist (and later the photographer and his technicians) for abundant light and open workrooms in order to create a photographic image. Urban daguerreotypists (like the photographers who followed) located their businesses above street level. In 1839 and 1840, Samuel F. B. Morse and John Draper built a glass house on the roof of New York University in order to pursue their photographic experiments. (Morse took on students and charged sitters to recover his expenses.) Later, studio operators built special windows and skylights to insure a large, steady source of illumination in the "operating rooms" where the cameras were located. Some studios even advertised the merits of their skylit rooms, large enough to accommodate big group portraits and bright enough to insure good results even on cloudy days. Some credited Brady with developing special skylights, and for a while he also claimed that blue glass in his skylight improved his images. Some photographers achieved the same effect by placing a blue glass filter over the camera lens [Figure 4–7].[18]

Aside from the operating room itself, studios needed room to prepare the plate, develop and finish the

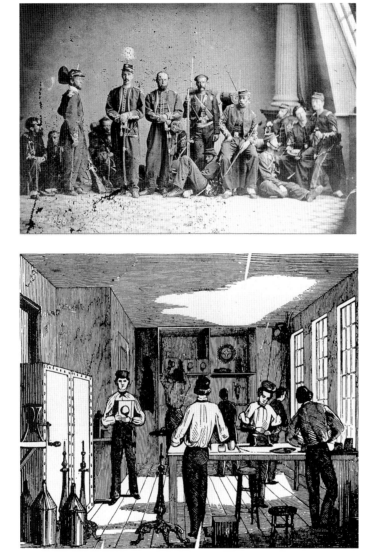

image after exposure, and secure it in a case or frame, as well as a reception area for customers who waited for their turn before the camera, and, after posing, to receive the finished product. Virtually from the start, American daguerreotypists were careful to separate these functions. The essential, preliminary work of cleaning, buffing, and sensitizing plates was tedious and time-consuming, and was performed by the boys who formed a significant segment of the photographic workforce [Figure 4−8]. After the operator made an exposure, another group of workers developed and finished the plate. For an extra fee, colorists tinted cheeks, or added gilt paint to earrings and watch chains, before finishers sealed the image under glass and a brass mat and inserted the image in a frame or case. The whole process took less than an hour. As photographer Abraham Bogardus recalled, "the picture was gilded, finished and cased while the lady was putting on her bonnet; delivered, put in her pocket and you had the money in your pocket."[19]

The public encountered only the most mysterious component of the photographic process, when they entered the ominously termed "operating room" to sit before the camera. In this isolated space, the operator's work consisted of making a series of subtle decisions. He arranged the light, posed the sitter, elicited the proper expression, and removed the lens cap from the camera to make the exposure [Figure 4−9]. Most operators placed a metal stand behind their sitters, to hold the head and body still.[20] Because the lens could keep a sharp focus only on a very shallow plane, when eyes and face were sharp, hands often appeared large and distorted, leading many practitioners to concentrate on the head and shoulders only and hide the hands altogether, or position them carefully, clamped around a book or resting on a table in shadow. More sophisticated workers also manipulated the light that fell on the sitter, using screens and reflectors to bounce illumination onto the face and create soft shadows that surrounded the sitter, placing him or her in a deep, three-dimensional space.

WHAT MAKES THE BEST DAGUERREOTYPE?

Despite plentiful competitions, with all the diplomas and medals, no one ever managed to find a single, objective way to describe a successful daguerreotype. Today, even when daguerreotypes are distinguished by maker, it is virtually impossible to assign signature qualities to a studio or to characterize the work of a single operator in a studio where many were employed. (An exception can be found in the stylized use of "Rembrandt" lighting, favored by the Boston daguerreans Albert Sands Southworth and Josiah Hawes.) After a brief, early period of experimentation, the medium attained several strong stylistic features that remained constant. Rectilinear format, shallow depth of field, and monochrome images with a wide range of tones and crisp details all conform to an aesthetic that privileged line over light and shadow. These images could not success-

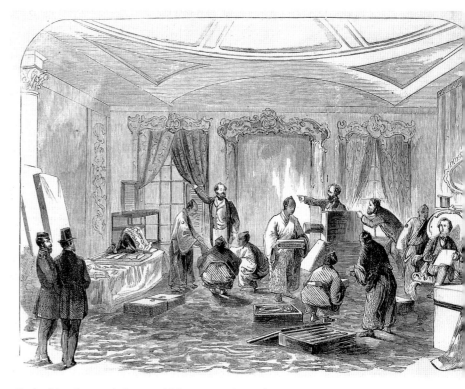

fully render spontaneous motion or gesture; they were limited in size; and they could be seen only under controlled light.

These relatively specific technical limitations coincided closely with established artistic conventions of portraiture, which traditionally had been understood to demonstrate the absence of any "improvements" or distortions from the artist's hand. A plain, frontal pose, a limited palette, a clear, diffuse source of light, and an unforgiving approach to idiosyncratic features had been used by such American portrait painters as Charles Willson Peale and John Singleton Copley to show verisimilitude and also to demonstrate the republican virtue of their sitters.[21] Daguerreotypes were often described as being made by the sun or by nature, forces that could not lie.

Still, within these strict formal boundaries, subtle stylistic distinctions emerged; but because critical vocabulary is often impressionistic, images rare, and authorship uncertain even within a specific studio, it is not always easy to match laudatory comments with actual images. For example, some critics observed that Jeremiah Gurney's work exhibited a brilliant shine, which one critic attributed to the heavy use of mercury. (Pursuit of these effects might have led to Gurney's dangerous case of mercury poisoning in 1852.)[22] Others noted that his images possessed a distinctive "bold and powerful finish," where Brady's, by contrast, were "delicate."[23] In 1853, Edward Anthony enlisted the help of his professors—Samuel F. B. Morse, James Renwick, and John F. Draper—as jurors for a national competition to recognize the finest daguerreotypist in the country. Gurney won first prize. (Ten years later, Marcus Root remembered that it was difficult to distinguish one good result from another, and speculated that the award was made largely on the basis of the beauty of Gurney's female sitter rather than the photographer's skill. Root doubtless remembered that his own brother Samuel took second prize. The competition was not repeated.)[24]

Marcus Root never tired of explaining that the successful photographer had to maintain a precarious

balance between technical considerations and aesthetics. He had to arrange the camera so that the figure appeared "accurate, rightly shaded, well rounded, and distinctly pronounced," adjust the light to "throw into shade all defects of the face and bring prominently into view its best lines and finest features," and elicit that most elusive feature, "the desired expression." Of course, no amount of instruction could actually instill the knowledge necessary to get the finest results, which he deemed "an achievement reserved for genius alone."[25]

What did an expression consist of? Root called it "that indefinable *somewhat* which reveals to the beholder the soul within; which shapes a man with that *individuality* which distinguishes him from all men else."[26] As one visitor to the Meade brothers' studio observed, the best expressions were so natural that they were nearly invisible. But as everyone knew, a natural appearance was difficult to render. Though most sitters faced the camera for less than an minute, the act of remaining still, even for a short time, produced portraits that were rigid, wooden, awkward, and usually kinder to the clothing than to the features of the sitter. The combined discomforts of the metal posing stands, impersonal operators, and the unnatural stillness often distorted faces past recognition. One articulate observer accused these unlucky faces of "looking like debating politicians attempting to start first speeches, or unpracticed lovers struggling to pop the question, or youths sitting for the first time in barbers' chairs to undergo the momentous and man-developing process of shaving." And Francis Wey, the astute French critic whose work was regularly translated for the American press, compared some daguerreotypes to "fried fish stuck to a silver plate."[27]

How to mitigate the discomforts of the operating room to produce a pleasing image and a satisfied customer? Most critics understood that the personality of the photographer himself had much to do with his success.

Root described the process as telepathy, in which the photographer must "act on the *mind* of his subject" and "*his own mind and manner . . . may be among* the most potent agencies to this end." Using his own ornate diction, Root imagined a kind of sympathetic transference, in which the photographer used "a large measure of genius and talent, [and thereby] combined . . . culture and accomplishments with genial dispositions and finely toned character [to] exert on his subject a pleasant influence" and so attain a pleasing result.[28]

As early as 1850, one commentator observed,

> no one can be a successful Daguerreotypist unless he is an artist, as well as a manipulator. As a mere rhymer is not a poet, a mere talker not an orator, so a mere manipulator is not capable of producing agreeable pictures, however good his subjects may be. A real artist, with the most unpromising subjects, will surpass him.[29]

Advice columns and handbooks give elaborate recommendations on the manipulation of the subject, whether through technical use of light and shadow, or more specific adjustments of pose and props, for which the advisers often refer to prints of old master paintings. But it soon became clear that the most important manipulation took place between the operator and his subject. And the most successful daguerreotypists were the ones who knew how to please their customers.

From a scattered set of clues, one can also recognize the ways in which Brady and his peers understood the theatrical nature of their enterprise. When Brady performed the role of the ideal middle-class man, he elicited a similar performance from his subjects, and so together they created a new, public identity for the sitter.

An interesting account of Henry Clay's sitting for his daguerreotype in New York in 1850 suggests how the experienced orator transferred his skills of performance to the act of sitting for the camera [Plate

15]. Though reluctant, and busy, Clay agreed to be photographed at City Hall before a planned reception. After the photographer (probably Brady) set up his camera, the room filled with Clay's admirers, and

> it appeared as if the real object of the moment would be defeated. Mr. Clay, however, suddenly waved his hand, which had the effect to command the utmost silence; then dropped both hands before him, one grasped within the other. While the process of taking the picture continued, which was for some seconds, many of the spectators, unaccustomed to mental discipline, grew pale in their efforts to subdue their interest in what was going on, or from fear of being rude by some unfortunate interruption. Mr. Clay all the while seemed to be perfectly at his ease; the blood flowed calmly through his cheeks, his eyes beamed with peculiar intelligence, and his large, expressive mouth was firm but kindly disposed. . . . When the click of the instrument announced that the affair was ended, an enthusiastic but subdued demonstration was made by the spectators.[30]

Other portraitists, including daguerreotypist Gabriel Harrison, and later the Swedish art photographer Oscar Rejlander, conceived of portraiture as performance as a result of an earlier career on the stage.[31] In 1857 a British journalist made the point explicitly when he described a portrait session with Rejlander, who had worked as an itinerant actor before beginning his photographic career:

PLATE 15

Henry Clay

Daguerreotype, circa 1849.

The Museum of Modern Art, New York City; gift of A. Conger Goodyear

PLATE 16

Henry James Sr. and
Henry James Jr.

Daguerreotype, 1854.

James Family Photographs,
Houghton Library, Harvard
University, Cambridge,
Massachusetts, bMSAm 1092.9
(4597.6)

The good-natured operator, in the best English he could master, explained to me the nature of the process (even taking me into his dark den of magic), and remarked with great truth—"When beebles do come for vaat you call bortraits, they most not dink dey are in the leetle rum by demself, bot dey most dink that all de world look at dem! dat they hare having deir bortraits bainted before a crowd, oh! so vast! dat dey are on the stage of de theatre, wid den dousand beebles all a looking at dem, and not shot up here in de leetle rum, but demself. Now, sare! gompose your feature for de bortrait: and when I saw 'Now!' de operation will gommence."[32]

When Henry James and his father posed for their portrait at Mathew Brady's studio in the summer of 1854, they intended their portrait as a surprise gift for Mrs. James [Plate 16]. In his memoir James used memories of the image and the occasion to unite a series of apparently unrelated motifs: his father's spontaneity and joy in society; their mutual love for city life; a meeting with celebrity novelist William Makepeace Thackeray, who laughed at the bright buttons on young James's jacket; and the wave of self-consciousness that his laughter inspired in James as a boy. In the course of the "interminably long" pose for this daguerreotype, thoughts of his father, Thackeray, the buttons, and his own intelligence combined to form the origins of the vision that sustained him as a writer, artist, and citizen of the modern world. "It had been revealed to me thus in a flash that we were somehow *queer*, and though never exactly crushed by it I became aware that I at least felt so as I stood with my head in Mr. Brady's vise."[33]

James's ironic self-awareness marks him as an essentially modern individual. The daguerreotype, and

the memory of its making, helped him locate the emergence of his own identity. But most others could only come to see themselves with the help of an audience outside the one provided by their own imagination. Even today, Richard Avedon insists that a portrait is a performance in which the role is one's self and the photographer is the audience.

In 1858 an enthusiastic review in the *Photographic and Fine Art Journal* alluded again to the act of performance when it acknowledged Brady's high reputation. When Brady's audience looked at his portraits, they saw a familiar representation of themselves, "a reflexion of one's lineaments, as can never be seen but in the looking glass and his camera," and also gained another, more valuable perspective:

> It is no wonder that his gallery should be thronged constantly, and that it should become the very Rialto of fashion and elegance. The eminent men who visit New York, are taken at once to Brady's rooms that they may not only see all our great men grouped together there, but that they may see themselves as others see them.[34]

Where did the charm of Brady's work reside? In 1851, a British writer's account of the spectacular Crystal Palace exhibition praised Brady's technical proficiency and the unusual, three-dimensional quality of his work, which seemed at once sculptural and free from manipulation, saying, "The portraits stand forward in bold relief upon a plain background. The artist having placed implicit reliance upon his knowledge of photographic science has neglected to avail himself of the resources of art." (The meaning of this statement is not clear, but may refer to the absence of added color, elaborate backgrounds, or exaggerated expressions.) A few years later, one writer simply confessed, "Brady's pictures always have a peculiar charm to me; but I cannot describe it. It reminds me of a lady of whom an artist said, 'She laid her hand at once upon a good picture; she could not tell *why*, and *laughed* if you asked her.'"[35]

The large collection of Brady daguerreotypes now at the Library of Congress, along with the many daguerreotypes that can be securely attributed to Brady's studio, allow us to identify some general characteristics that Brady daguerreotypes seem to share. Much of the artistry can be traced directly to Brady's successful manipulation of light. Brady's sitters always occupy a deep space; this simple illusion gives his figures a pleasing physical integrity. Brady also paid careful attention to the placement of the body in relation to the camera. He favored simple poses and worked with a fairly small vocabulary of gestures. His sitters rarely face the camera straight on, but sit at an angle; they often look away from the camera, which invites the unchecked gaze of the viewer, who can freely examine the portrait subject without seeming to intrude, or attract attention. When Brady's sitters turn to address the camera directly, a different kind of interest results: the subtle twist in the body produces formal tension, which is further underscored by the sitter's direct gaze. Brady carefully illuminated the faces of his sitters, and often allowed the remainder of their bodies to rest in shadow, which emphasized eyes and expression; this formal element has strong psychological consequences, as the faces of Brady's sitters always attract and hold our interest and yet seem utterly unself-conscious.

Brady's image of Horace Greeley, sitting alone on a chair with a newspaper folded in his lap, demonstrates many of Brady's portrait techniques [Plate 17]. Greeley's body is alert and relaxed, he turns slightly from the camera, and his face is in full light. The subject seems to welcome our gaze without appearing aware of any large audience, as if he is alone with Brady, in conversation. A less spontaneous mood informs the group portrait of Brady, his wife, and his sister, who pose for the camera in a tight, pyramidal

PLATE 17
Horace Greeley
Daguerreotype, circa 1851.

Library of Congress, Washington,
D.C.

composition, but the careful off-center arrangement, created by Brady's enclosing hand on his wife's shoulder, and the physical closeness of the two women, whose hands are joined at the bottom of the frame, establishes a pleasant intimacy that includes the viewer [see Plate 47].

One can also compare Brady's carefully lit compositions with the work of Jeremiah Gurney, whose fine craftsmanship and hard-edged style won equal esteem from his contemporaries. Gurney's dual portrait of Moses Yale Beach and his wife, with its clarity and stark, shining surface, certainly conveys the wealth and influence that Beach and his wife enjoyed, while it preserves a likeness that one can confidently

accept today [Figure 4–10]. But when Gurney's subjects face the camera, and sit in a pool of wide, even light, all elements of the composition assume equal importance, from clothing, to face, to physical form. Moreover, the subjects exhibit an expression that is both self-conscious and opaque, so that the viewer is never tempted to feel any relationship to these individuals. The portrait invites little speculation and suggests no mystery.

In the end, it is this elusive, expressive quality that distinguishes Brady's portraits made during the era when he specialized in the daguerreotype and the Imperial print. Despite the static poses dictated by technical limitations, Brady's sitters always appear relaxed and confident. A sense of contentment prevails, and as a result his sitters appear unusually accessible. This appraisal admittedly falls short of a strict formal analysis, but it can be tied to studio technique—especially to the manipulation of light, which placed the figure in a deep, clear empty space; because Brady softened the light with blue glass and guided it with screens and shades, the sitter did not need to withstand the glare of bright sunshine. This doubtless improved the expression on the faces of Brady's sitters. Credit must also go to the operators, who deliberately arranged each sitting as a pleasant encounter.

Between 1850 and 1860, several articles (including a phrenological analysis) describe Brady as a man who knew how to win over even the most difficult customer. Many emphasize his ingratiating manner. In 1852, he impressed an examiner from R. G. Dun & Company as a man who "deals honorably and honestly and is worthy of all confidence."[36] According to the editor of the *Photographic and Fine Art Journal*, "he has a Paradise within that keeps his heart open and free, and always ready to relieve the troubled mind!"[37] A long article in *Frank Leslie's Illustrated Monthly* praised his solicitous concern for his customers, "[his] urbanity of manners, and . . . [his] untiring attention to the feelings and happiness of those with whom he comes in contact. . . . Mr. Brady has the happy faculty of being attentive without being officious, of possessing suavity without obtrusiveness, and is altogether eminently the right man for the right place."[38]

In 1863, *Harper's Weekly* remembered the "indefatigable" energy with which he "inveigled" his famous sitters into posing for his camera. Such characteristics endured. When G. A. Townsend interviewed Brady as an old man, he attributed his success to his "deferential, sincere" manner. As Townsend observed, Brady consistently won over his prestigious sitters with his "conscientious appreciation of their usefulness. Men who disdain authority and cultivate rebellion know not the victories achieved by the conquering sign of *Ich Dien*—I serve." And then he quoted Brady, who claimed, "I never had an excess of confidence, and perhaps my diffidence helped me out with genuine men." In retrospect, it seems that Brady's own drive and ambition must have contributed to his charm for this driving, ambitious group of citizens.[39]

Interesting data comes from Fowler and Wells's *American Phrenological Journal*, which in 1858 used a special scientific vocabulary to describe Brady's character in an essay written as if to Brady himself [Fig-

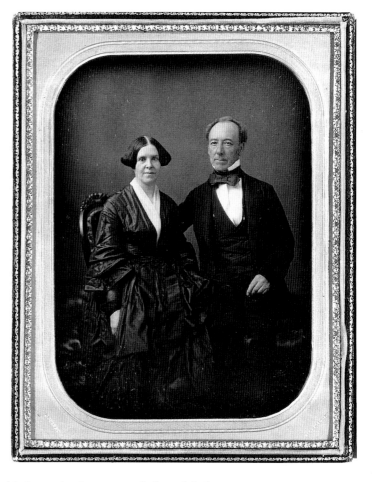

FIGURE 4–10

Mr. and Mrs. Moses Yale Beach

Daguerreotype by Jeremiah Gurney (active 1840–circa 1890), circa 1855.

National Portrait Gallery, Smithsonian Institution, Washington, D.C.

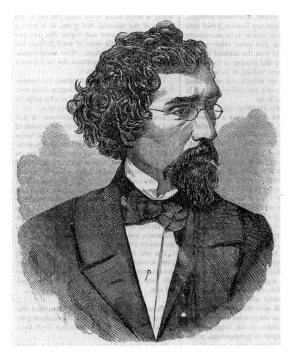

ure 4–11]. The phrenologists identified his most prominent traits, including great force of character and "Self Esteem," which "appear to have been greatly increased by use, for they stand out sharply beyond the other organs." His great "Ideality," or sense of style, and "Observation" and "Imitation," which supported his skill as an artist, caused his neglect of finances, and accounted for the intensity of his moods. "Few men are as highly pleased as you with that which is gratifying to your faculties and few, indeed are so deeply exasperated when things go wrong." The journal summed up with a warning, "You are working too hard, and wearing out your constitution. You should husband your powers, take life more easily."[40]

This composite portrait suggests that Brady's success came from his ability to match the standards that his contemporaries set for a professional, public man. They admired his solicitous manner and his enormous drive, his sense of style, and his raw ambition. Brady's studio style, which placed its sitters in a distinctive three-dimensional space, gave them a sculptural integrity, which reinforced and enlivened the mechanically driven conventions of the daguerreotype. Through his portraits, Brady managed to represent the dignified image that citizens of this grasping society wished to present to the world. His portraits revealed his sitters to themselves, and to the world, as they most wanted to appear.

The accumulated reports of technical, aesthetic, and stylistic strategies combine to show that the best portrait photographers understood that their portraits were not just transcriptions, but actual creations. They used their cameras to give their sitters a face that could withstand public scrutiny. Brady and his fellow daguerreotypists made an important contribution to the social fabric of mid-nineteenth-century America, by giving a face and form to the new middle class. They realized their goals both through the images they made and through their own individual embodiment of the material success their sitters longed for.[41]

In his capacity to represent a new class of people on their own terms, Brady, like all daguerreotypists, belonged to the modern era. Social historian Arnold Hauser has identified this period with the emergence of a new kind of artist who addresses a new kind of audience. In his classic *Sociology of Art*, Hauser describes the pre-modern era as a time when artists appealed to society at large, the public was more or less homogeneous, and success was measured according to a single standard accepted and understood by all. But in the modern world, art ceases to be "a social activity guided by objective and conventional criteria"; instead, it "becomes an activity of self-expression, creating its own standards; it becomes, in a word, the medium through which the single individual speaks to single individuals."[42]

Such large statements rapidly lose their usefulness when applied to particular cases, and Hauser himself observes that actual events and individuals seldom conform completely to neat, periodic categories. Brady is no exception. It is difficult to know whether his wall-sized exhibition of contemporary faces provided the first representation of a new, modern American society or the very last embodiment of a pre-modern American public, still homogeneous, still secure in its authority over New York society and the nation. But it seems clear that Brady himself was inspired by the sheer vitality of his time, the opportunity of his profession, and the warm response he received from clients and colleagues on Broadway. In the course of turning every encounter to profit, Brady created a gallery of faces that achieved a moving paradox—he found a way to turn the ephemeral present into a lasting image.

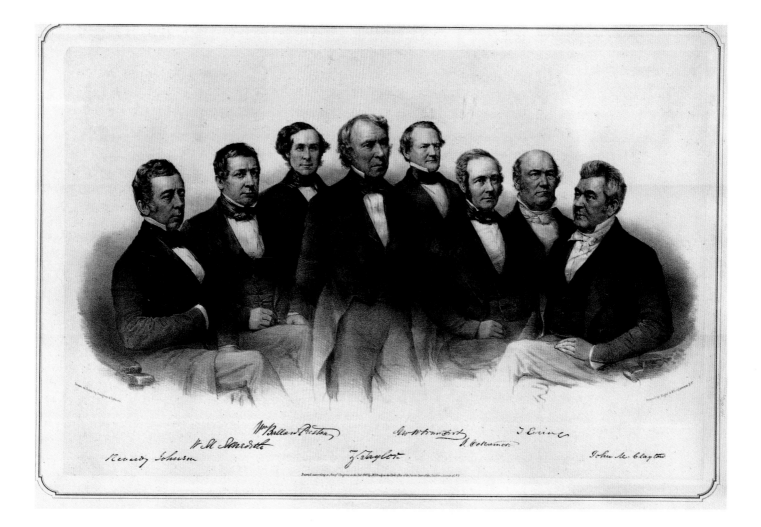

Reverdy Johnson W. M. Meredith Wm. Ballard Preston Z. Taylor Geo. W. Crawford J. Collamer T. Ewing John M. Clayton

5

Building a National Gallery

From the very first, Brady defined his quest for famous faces in explicitly political terms. In the spring of 1848, he publicized his arrival in Washington, D.C., through a newspaper story about his effort to obtain portraits "of all the distinguished men who may be present at the approaching inauguration. [Brady's] object is to form a gallery which shall eventually contain life-like portraits of every distinguished American now living." According to this account, he already had portraits of President James K. Polk, President Zachary Taylor and his cabinet, and John C. Calhoun. In 1849, Brady returned to New York, where he displayed the images made in Washington. A review in the *New York Knickerbocker* declared, "There is scarcely a prominent man in the country, from the past and present Presidents, their cabinets, and families, and high political magnates, out of office . . . down, or up, to the distinguished literary, scientific, and artistic men of our time, but are here represented and precisely 'to the life.'"[1]

In 1850, when Brady advertised his gallery in *Doggett's New York City Directory*, he listed the names of more than a hundred sitters, forming a canonical list of American celebrity [Figure 5–2]. In 1850, writer Charles Edwards Lester lauded Brady's collection of portraits of

almost every man of distinction among our countrymen . . . and every member of the U.S. Senate for a considerable number of years past; all the Judges of the Supreme Court, most of the members of the lower House of Congress, nearly all the foreign ambassadors, the generals of the army, the commodore of the navy, the governors of the state and nearly all those men who have acquired influence in the departments of literature, science and public life . . . the venerable Mrs. Alexander Hamilton, Mrs. Madison, Mrs. Polk . . . J. C. Calhoun and General Taylor.

Throughout the 1850s and 1860s, reviews of Brady's gallery mention these same sitters, and because death or circumstance would have prevented him from making these portraits after 1850, it seems clear Brady's reputation as the "court photographer" to the nation rested on this early work.[2] Like every portrait photographer then and now, Brady clearly enjoyed the fame he garnered from his celebrated clients.

A combination of accident and opportunity aided Brady's efforts to obtain portraits of the most important political figures of the day. Daniel Webster, Henry Clay, John C. Calhoun, and Winfield Scott all enjoyed long public careers. These men were themselves adept manipulators of public opinion and careful managers of their public image. Like Brady, they used the growing network of New York institutions that sustained national reputations. Their portraits appeared in the form of popular prints, their speeches were published in newspapers and magazines, and the many surviving photographic portraits of Scott, Clay, and

Webster demonstrate that these men recognized that the new medium served their needs.

Brady's contemporaries also viewed portraits as didactic images, similar in nature to biography. In a much-quoted essay inspired by a proposed exhibition of Scottish portraits, Thomas Carlyle expressed his frank preference for pictures over texts. "Often I have found a Portrait Superior in real instruction to half-a-dozen written 'biographies.'" Carlyle insisted that "Historical Portrait Galleries far transcend in worth all other kinds of National Collections of pictures whatever," and laid out simple rules for the creation of such a gallery: When possible, get portraits made from life; wait a generation to discriminate "between popular monstrosities and Historical realities," and always maintain a dignified tone, avoiding "Yankee-Barnum methods." He sympathized with the enthusiasm for history that propelled prices and drew large crowds, but believed that the real object of popular desire did not yet exist. "If one would buy a [hero's] indisputable authentic *old shoe* . . . for hundreds of pounds. . . . What would one give for an authentic visible shadow of his face, could such, by art natural or art magic, now be had!"[3]

Though Brady left no evidence of any intellectual pretensions, he clearly aligned himself with a well-established American tradition when he sought to assemble a collection of portraits that expressed national and patriotic ideals. The country's first and most important patriotic portrait gallery was formed by Charles Willson Peale, who as early as 1780 began to assemble portraits of notable Revolutionary heroes [Figure 5–3]. Exhibited as part of a much larger museum devoted to scientific knowledge, Peale's museum included fossils, skeletons, and stuffed specimens of animals and birds. Organized according to Enlightenment principles to show the wonders of the world and its overarching order, Peale's collection came to include portraits of important intellectuals from Europe as well as America, in an effort to honor knowledge and civic virtue. His portraits were made in a spare style, without artistic embellishment of any kind—no props, fancy backgrounds, or environmental detail—which derived from the classicism of the late eighteenth century. Endorsed by such artists as Benjamin West and Jacques-Louis David, this style was intended to align both artist and sitter with a republican idealism, simplicity, and greatness, as opposed to the hedonistic, sensual values of a past governed by royalty and decayed traditions [Figure 5–4]. Peale's collection of portraits was eventually placed on view in Independence Hall in Philadelphia, where it remained through the first half of the nineteenth century as a shrine to the leaders of the Revolution.[4]

After Peale, painters John Trumbull and Samuel F. B. Morse both attempted to create large patriotic paintings of the Founding Fathers based on portraits made from life. Beginning in 1819 and continuing through 1824, Trumbull installed three large tableaux in the Rotunda of the Capitol. He chose to depict scenes of both historic and political significance, such as *Jefferson Presenting the Declaration of Independence to the Continental Congress* in 1776, *The Surrender of Cornwallis at Yorktown* in 1781, and *The Resignation of*

General Washington, December 23, 1783 [Figure 5–5]. Trumbull's scenes are full of carefully researched portraits of the men who helped create the new nation, but despite the diligent authenticity of the portraits and the careful research supporting details of costume and architecture, these compositions never rise above their origins as simple visual catalogues. Their essential failure may have been a factor when Congress declined Samuel F. B. Morse's offer to contribute to the decoration of the Capitol. In 1823, Morse sketched portraits of members of Congress to populate a carefully constructed portrayal of government in action (now in the collection of the Corcoran Gallery of Art). Filled with anecdotal incident (including a visiting Native American in the balcony), Morse's work lends little drama to the business of government, though as a document it provides an effective record of customs, dress, and decoration [Figure 5–6].[5]

These images contrast poorly with another canvas on the walls of the Capitol Rotunda, Robert W. Weir's 1843 tableau, *The Embarkation of the Pilgrims at Delft Haven, Holland.* Weir emphasized composition, organizing light, gesture, sparkling costumes, and theatrical expression to give his painting genuine emotional power. Nineteenth-century audiences freely acknowledged their preference for Weir over Trumbull. Weir did not have access to contemporary portraits of his seventeenth-century subjects, and he knew that no one would really question the accuracy of his rendering, as long as viewers were able to suspend disbelief long enough to enjoy the scene.

Early in the nineteenth century, the sculptor John Brouwere assembled a remarkably lifelike collection of portraits of American heroes made from life casts of his subjects, which he then transformed into portrait busts. Brouwere developed his own technique, which managed to capture spontaneous expressions despite the fact that subjects were encased in plaster to obtain the cast. Brouwere's first major commission took place in 1825, when he made a portrait of Lafayette on the general's return tour through the United States. Following this success, Brouwere made portraits of such prominent figures as James Madison, Dolley Madison, Gilbert Stuart, Henry Clay, John Adams, John Quincy Adams [Figure 5–7], Martin Van Buren, and Thomas Jefferson.

Brouwere hoped to establish a "National Portrait Gallery," filled with bronze casts of his work. He pursued Revolutionary War heroes, actors, newspapermen, and cabinet secretaries, but much to his disappointment he failed to find a patron for his nationalistic project. Brouwere clearly had little patience for those who did not share his passion for authenticity. Moreover, his outspoken personality did little to endear him to more powerful figures in the world of art. In a letter to John Trumbull, Brouwere contrasted Trumbull's Capitol tableaux unfavorably with his own portrait busts, explaining that he preferred his own life casts to his rival's re-creations of historic events. "In my opinion, ideal likenesses ought not to be palmed off on a generous public for real ones," he wrote. Later Trumbull dismissed the sculptor: "Poor man! too much vanity hath made him mad." Their rivalry was cut short in 1834, when Brouwere died in a cholera epidemic.[6] Today Brouwere's busts survive in plaster and bronze, astonishingly realistic simulacra of their subjects.

After Brouwere, the collecting of American national portraits was largely conducted by publishers of prints. The making and collecting of portrait prints was not new. In the seventeenth century, Dutch, English, and German collectors assembled portraits of royalty and political and religious leaders; by the end of the eighteenth century, collectors of portrait prints included theatrical stars, writers, composers, and other well-known public figures in their portfolios.

Prints were well suited to the encyclopedic representation of American heroes.[7] Charles Willson Peale's 1778 portrait of George Washington was one of the first mezzotints made in America. Early in the nineteenth century, another technical innovation, the lithograph, attracted skilled practitioners. Lithography—which replaced complex and time-consuming engraving with the ease of drawing with a crayon on a prepared plate—greatly increased this market. Altogether, the pleasing form and faithful reproduction of an individual painting for a broad market employed such talented American artists as John Sartain and Thomas Sully. Many, including Peter F. Rothermel and Alonzo Chappel, began to create paintings specifically to be made into engravings, so that their original painting was simply an intermediate step to the finished print.

The economics of print publishing also divided the risk between artist and publisher. Unlike Morse, Trumbull, or Brouwere—who had to find their own subjects, create their images, and market their work—publishers concentrated on the production and sale of work made by others. Their patrons came from the marketplace, and were not confined to the government or to a very limited number of wealthy subscribers.

The American publication of collections of portrait prints began in 1815, when Joseph

Delaplaine published *Delaplaine's Repository of the Living Portraits of Distinguished American Characters*, including engraved copies of portraits by Charles Willson Peale, Gilbert Stuart, Thomas Sully, John Trumbull, Bass Otis, and John Singleton Copley.[8] A decade later, James B. Longacre and James Herring entered the market for portrait pictures issued along with short biographical essays, in a series titled the *National Portrait Gallery* [Figure 5–8]. It was a financial failure. Yet despite the costly risks of creating the prints, paying for the prose, publishing the images, and finding an audience who could meet the price, these efforts continued, including collections such as William H. Brown's *Portrait Gallery of Distinguished American Citizens*, published in 1845 by Edmund B. and Elijah C. Kellogg, Benson J. Lossing's *Biographic Sketches of the Signers* (1848), and Abner Dumont Jones's *Illustrated American Biography* (1853). The last of this genre appeared in 1862, illustrated by Alonzo Chappel and published by Evert Duyckinck; *National Portrait Gallery of Eminent Americans* . . . remained in print for a decade.[9]

In 1840, when the first photographic portraits were made, it was easy for innovators to recognize their utility for assemblers of group portraits. The most famous application of photographic portraits to such a project began in 1843, when Scottish painter David Octavius Hill attempted to commemorate a momentous split within the Church of Scotland by making a group portrait of

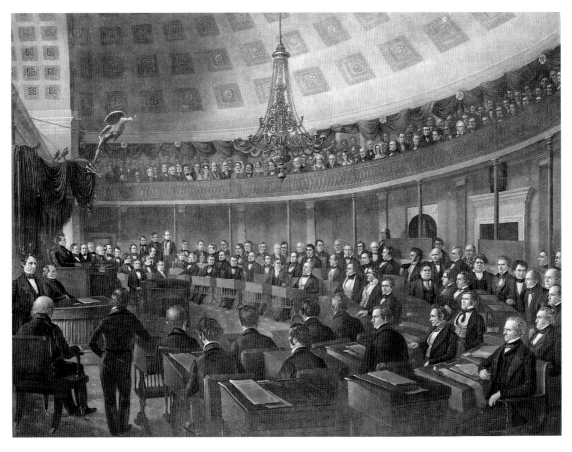

the dissenters. Sir David Brewster, head of the University of St. Andrew's and himself a distinguished inventor, suggested that Hill use the new medium of photography to capture portraits of the 155 dissenters before they dispersed; Hill collaborated with Robert Adamson, who had learned to use a camera, and over the next four years they made more than 1,400 images, including more than 400 likenesses of the members of what had become the Free Church of Scotland. Hill completed his painting more than twenty years later; *The Signing of the Deed of Demission* covers a canvas more than 11 feet high and 5 feet long.[10]

Edward Anthony was the first American photographer to recognize the ways in which photographic images could be used to enhance this well-established tradition. As an engineering student at Columbia University in New York, Anthony had taken up daguerreotypy to assist in a survey of the boundary between New York State and Canada. He learned daguerreotypy from Samuel F. B. Morse, and it must have seemed quite logical to extend the new medium to his teacher's cherished effort to depict the nation's leaders. Between 1842 and 1844, Anthony and his partner, Victor Piard, worked in Washington, where they set up a studio in the Capitol. Over two years they made daguerreotype portraits of every member of Congress, as well as of several dozen national figures such as John J. Audubon and Samuel F. B. Morse. Anthony paid artist James A. Whitehorne to transform these individual portraits into a reportorial tableau, *The United States Senate Chamber*, showing the politicians at their desks in the congressional chambers, filling the balcony with notable spectators. He hired Thomas Doney to engrave it, and sold the print himself [Figure 5–9].[11]

When Edward Anthony set up business at 247 Broadway in 1843, he displayed the portraits made in Washington, and called his studio the National Miniature Gallery. He and a series of partners continued to seek out opportunities to make portraits of "the most distinguished citizens of America." Around 1847, Anthony gave up his studio to concentrate on selling cameras, chemicals, and prints and publishing a journal; a series of owners continued to operate the gallery until it was destroyed by fire in 1852. (Though newspaper accounts of the fire insisted that nothing survived, a number of known daguerreotypes strongly resemble likenesses in the Anthony engraving, including portraits of Dolley Madison and Albert Gallatin, which came to the Library of Congress as part of Brady's collection [Figure 5–10].)[12]

The earliest collector of photographic portraits of celebrities was creative entrepreneur John Plumbe. Plumbe conceived of a national network of transportation and communication well before the country could support it; he established a chain of portrait studios along the eastern seaboard; invented a new lithographic process (called the "Plumbeotype") to translate his daguerreotypes into prints; and invested heavily in a railroad that could unite the country. Plumbe's business began in Washington in 1840 and flourished, in part thanks to his successful images of national monuments (such as the Patent Office Building,

the White House, and the Capitol) and famous faces. In 1846 he published the *Plumbeotype National Gallery*, with portraits of former Presidents John Quincy Adams and Martin Van Buren, Justice Levi Woodbury [Figure 5–11], Senators John Calhoun, Lewis Cass, and Sam Houston, and assorted other celebrities, including Plumbe himself. Plumbe's far-reaching business collapsed in 1847, when his investments failed.[13]

Plumbe's collection of daguerreotypes became the property of subsequent Washington portraitists who moved into his studio. In the early 1850s, a daguerreotypist named Plante practiced at Plumbe's address and advertised the collection of portraits on display as his own. (Brady himself moved into Plumbe's old studio in 1858.) Many other photographers assembled and exhibited collections of portraits of their notable sitters, including the Meade brothers and Martin M. Lawrence in New York, Gabriel Harrison in Brooklyn, and Marcus Aurelius Root in Philadelphia.[14] But Brady alone emphasized his collection as a free-standing accomplishment. And although Brady lacked Plumbe's ambitious imagination, his timing was better. By the time Brady looked for them, railroads and shipping lines were in place, carrying magazines, newspapers, prints, and photographs throughout the country. In many ways, these networks created the national audience that in turn established a demand for exactly the kinds of portraits that Brady could produce.[15]

In 1850, Charles Edwards Lester announced the publication of a subscription series of twenty-four lithographs by Francis D'Avignon, based on daguerreotype portraits by Mathew Brady, for which Lester himself supplied the biographical texts. The series, titled *Gallery of Illustrious Americans*, included portraits of Zachary Taylor, John C. Calhoun [Figure 5–12; Plate 18], Daniel Webster, Henry Clay, John C. Frémont, John James Audubon, William H. Prescott, Winfield Scott, Millard Fillmore, William Ellery Channing, Lewis Cass, and Silas Wright. At the time of publication, all but Wright and Channing were still alive. Many were subjects Brady had already advertised and exhibited. And, as Brady later recalled, the subjects were "Presidential": Taylor was President at the time of publication, Fillmore succeeded him, and Scott, Frémont, Clay, Webster, Cass, Calhoun, and Wright were known as actual or perpetual presidential candidates. Channing and Audubon were revered for their explicit contributions to national cultural identity.

Lester advertised the *Gallery* by promoting it as a new monument to national identity and modern history, all the time celebrating its advanced technology.[16] He aligned the project to earlier "National Galleries," predicting that this one would succeed where all others had failed. Earlier collections had suffered from poor art, beginning with paintings "in which few traces could be discovered of resemblance to the originals," which then reached engravers who had never seen their subjects. Now, using daguerreotypes, the *Gallery of Illustrious Americans* would bring new, high standards to an old task, and endow its portraits with "vital energy and living truth" that earlier efforts had lacked. He compared this work to the images of "Stuart, Trumbull, and other celebrated portrait painters [who] did their best to transmit to us the

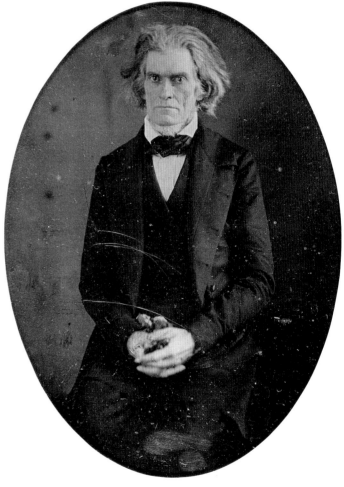

FIGURE 5–13

The United States Senate
A.D. 1850

Engraving by Robert
Whitechurch (1814–circa
1880), after Peter Frederick
Rothermel, after daguer-
reotypes, 1855.

National Portrait Gallery,
Smithsonian Institution,
Washington, D.C.; gift of Mrs.
Richard K. Doud

forms of those venerable founders of our empire." Lester adeptly employed the visual properties of the da-guerreotype as an ideological tool, separating the formal, official stance of eighteenth-century portraiture from contemporary art, which demanded a different perspective, appropriate to its current leaders. When looking at the portraits of the past, Lester observed, one cannot know if they represent "the habitual char-acteristic expression worn in the cabinet, in the field, and around the fire-side, by the patriarch of the Rev-olution." Lester did not question the value or need for such an intimate view of the nation's leaders. He simply rejoiced in the modern form of picture-making, "which will make posterity as familiar with the faces and forms of distinguished men as are their own contemporaries."[17]

Lester noted that the *Gallery* faced one overwhelming problem, which stemmed directly from the con-temporaneity of its subjects, and its method. Virtually all the subjects of the *Gallery* were still alive, and "in America, more than in any other country, death is needed to sanctify the memory of the great." Lester's essays in part sought to compensate for this liability by claiming to "anticipate the awards of posterity." Lester adopted the distant, reverent tone of an obituary, and encouraged his audience to evaluate its pre-sent leaders according to the vision of the future:

The first half of the century has now drifted by, and the dim form of its successor is hastening on, bringing we know not what mysterious changes. We contemplate the past with gratitude and exultation, because it is secure. And we wish before those great men who have made it illustrious are gone, to catch their departing forms, that through this monument of their genius and patriotism, they may become familiar to those whom they will never see. . . . As there is nothing sectional in the scope of this work, it will be comprehensive in its spirit; and it is hoped that it may mark an era in the progress of American Art, and bind the Union still more firmly together.[18]

By anticipating the way the present would appear to coming generations, the authors transformed what was "mysterious" and unknowable into something settled, fixed, "secure." The long tenure of this particular generation of politicians, and the universal esteem they enjoyed, made this seem to be a fairly simple process. It was also an extremely creative way to control the present; as critics and historians anticipated their eventual place in history, they shaped a vision of themselves that neatly contained sectional struggle and dissent in favor of a strong, unified procession of heroes.[19]

Only twelve portraits appeared in the *Gallery of Illustrious Americans*. Its success is difficult to measure. Brady and Lester were both able publicists, and they provided the text for the many repetitive, enthusiastic announcements that appeared in the photographic press and in general publications. Although their collaboration did not pay, D'Avignon continued to make lithographic portraits from photographs, Brady pursued his national heroes, and Lester kept on searching for easy ways to get rich as an advertiser and promoter in the marketplace. It is tempting to ascribe the failure of the *Gallery* to the same overall problems that earlier "Galleries" faced—high costs and low demand. But in Lester's account of the uncertain present, we can also see that price alone did not prevent the sales of this nationalistic collection. In fact, though there was "nothing sectional" in its heroic canon, the *Gallery* alone could not create a "comprehensive spirit" or "bind the Union still more firmly together." It is tempting to suggest that by 1850 there was no audience strong enough to support the *Gallery* and its Union-building ideals.

Subsequent efforts to use daguerreotype portraits to support popular prints and lithographs returned to the environmental composite format that Anthony (and Morse) chose. In 1852, as a memorial to Henry Clay, Peter F. Rothermel executed *United States Senate A.D. 1850*, which was subsequently engraved by Robert Whitechurch [Figure 5–13]. This narrative composition was very successful; Clay had been an immensely popular politician, and the image incorporated cameo portraits of all of his well-known colleagues. No fancy ideological explanation was needed to promote this historical tableau, which effectively memorialized a whole generation of men who strived to preserve the new nation in the new century. As Lester remarked in 1850, these men needed only death to secure their reputations. By 1852, Clay, Webster, and Calhoun had died, but because Rothermel worked from daguerreotypes, his commemorative image acquired a documentary quality. Though the assembled senators look rather stiff and awkward, the detail-laden faces have the kind of rigidity that marks their daguerrean origins, and this obvious source was perceived at the time to endow the portrait with a kind of immediacy and realism that a simple artist's sketch could not convey. And unlike 1842, when Edward Anthony had to create his collection of portraits before commissioning Whitehorne's engraving, this time Rothermel could go straight to Mathew Brady, where he found images of all the national figures he required.[20]

Painter and illustrator Alonzo Chappel owed the most to Brady's collection of portraits. Much like Brady, Chappel devoted the greatest part of his career to nationalistic portraiture. He is now best known

as the maker of engraved images of notable Americans that illustrated the encyclopedic *National Portrait Gallery* published by Evert Duyckinck in 1864. Chappel specialized in producing monochromatic canvases that could be easily translated into engravings or woodcuts. For Duyckinck, Chappel used a simple, synthetic method, attaching heads copied from Brady's portraits onto generically constructed bodies. Chappel's technique evolved in part to overcome the fact that photographic images often lacked the kind of atmospheric detail that readers and publishers wanted. And even when satisfactory photographs did exist, they could not be reproduced in the large numbers that Duyckinck required [Figure 5–14].[21]

Chappel also made colorful historical tableaux or portraits in oil. His oil portrait of General John Ellis Wool [Plate 19], hero of the Mexican American War, painted expressly for Duyckinck, appears to digress

slightly from his usual method; in this case, Chappel seems to have appropriated almost all of his portrait from a photograph by Brady. Wool's sharply detailed face, balanced on a brilliant, decorated body set against rich drapery, resembles the synthetic figures that Chappel constructed for his engravings. Chappel has "improved" Wool's body, however—his feet are smaller, his waist narrower, and his hair fuller than the photographic original. Chappel also added fancy wallpaper, furniture, and upholstery to the setting. Yet the overall pose and placement of the figure within the frame conforms closely to the full-length portraits Brady produced in his studio after 1855.

In the late 1850s, Brady tried to market his portrait photographs as the equivalent of paintings or fine prints, bypassing any intermediate engraver or lithographer. Throughout the summer and fall of 1858, he issued his own series designed for a popular audience. His subjects included the inventor of the Atlantic cable, Cyrus Field [Plate 20], and Senators William H. Seward (of New York) [Plate 21], Stephen A. Douglas (of Illinois), and Governor Henry A. Wise (of Virginia), all well-known advocates in the mounting debate over slavery. Reviews praised the portraits as images of "rare excellence," representing "persons of national reputation." Brady touted his own accomplishments alongside those of his famous sitters, advertising himself as the author of their fame, insisting that his work "has made the public familiar with the faces of the celebrities of the day. His gallery . . . contains the largest collection of valuable portraits in the United States."[22]

Just where did the value of these portraits lie? Like Peale, Brouwere, Trumbull, and Morse, Brady offered the public a comprehensive exhibition in which heroes of the present and the recent past embodied

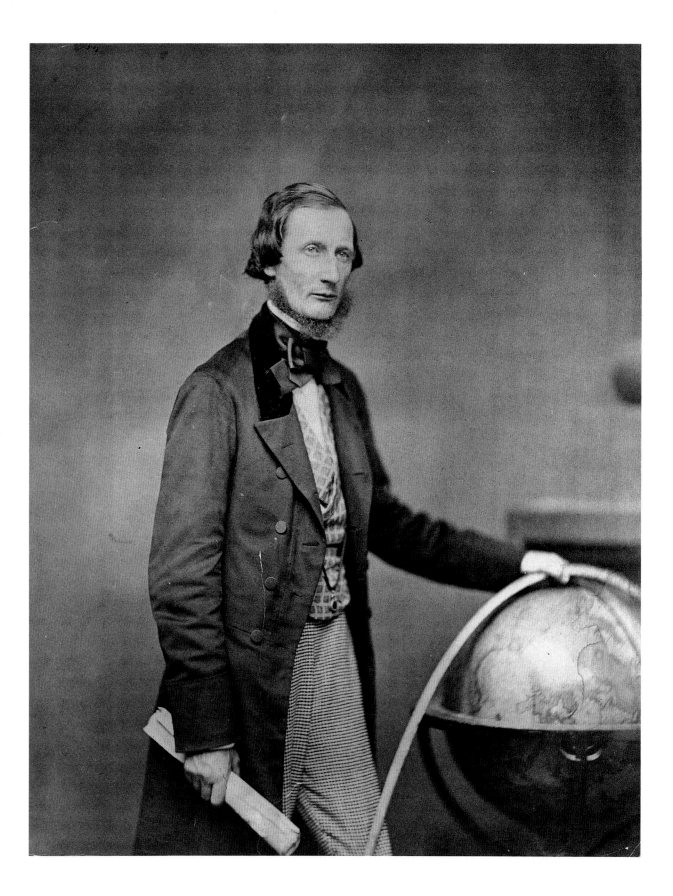

national virtue. He brought up-to-date methods to a familiar project, and in the process endowed his images with authenticity that few other portraitists could match. Brady's collection also offered a solution to the serious conceptual problem that faced artists and historians alike—namely, how to establish a relationship between the present and the past. Brady's photographs of men like Webster, Clay, Calhoun, and Taylor preserved likeness and inspired strong feelings; his viewers understood that these men forged a living link to the generation of the Founding Fathers, and their photographic portraits, in turn, established ties between the heroes and the viewers.

In formal composition, material, and choice of subject, Brady's images applied the same synthetic principles as Chappel, as can be seen in comparing Chappel's portrait of Wool with a simple Imperial photograph by Brady. When Chappel added color, lush detail, and softening effects, he showed where photography fell short. But in building his traditional portrait around a photographic base, he also revealed just what painted images lacked. Today this work fits no accepted artistic category. Neither painting nor photograph, the hybrid character of Chappel's work removes it from any but the most comprehensive history of American art. However, this painting, and others like it, provide an invaluable document of the wide-ranging character of American artistic enterprise as it stood at midcentury. Above all, Chappel's work leads us to see how the promotion of a strong national identity sustained a large market in portraiture, which strived to invest photographs of contemporary heroes with the romantic aura associated with figures from the past.

6

Photography and American Art at Midcentury

In February 1855, Brady wrote Samuel F. B. Morse, asking the famous artist to comment on "the aid which the process of Daguerreotyping has offered the kindred arts of painting, drawing and engraving." Brady offered his own view that the "universalizing" influence of the daguerreotype had brought "the rarest and most subtle of artistic effects" within reach of all. Brady also reminded Morse how he strived to make his photographs "as far as possible an auxiliary to the artist," an effort he considered "of paramount importance." But as he explained to Morse, the art world had not acknowledged Brady's work, and so he came to Morse for help:

> How far I have succeeded and whether the recognition of the effort among artists has been commensurate with the aid they have received from it—I know of none so eminently qualified to judge as yourself. I shall esteem it a favor if you will take early occasion to respond to this communication. And also to signify your assent to its publication.[1]

If Morse replied, no record survives.

Why did Brady write to Morse? By 1855, the painter had abandoned his art career and was deeply involved in the effort to lay a telegraph cable across the Atlantic. Still, no one had taken over his leadership of the New York art world. A large body of evidence, both formal and anecdotal, places Brady at the perimeter of the art circle that developed around Morse in the late 1820s and continued through the 1840s, when he taught on the faculty of New York University and anchored the National Academy of Design as a founder and its first president.

Brady made many handsome daguerreotype portraits of New York artists. His portrait of Henry Inman, made before 1846 (the year of Inman's death), helps date a large group of images to the middle and late 1840s. Brady also made daguerreotypes of painters Asher B. Durand, Charles Loring Elliott, Thomas Cole [see Plate 40], G. P. A. Healy [see Plate 43], Henry Peters Gray, and Francis Bicknell Carpenter. After he began making Imperial prints, Brady photographed sculptors Erastus Dow Palmer, Launt Thompson, and Harriet Hosmer [see Plate 3]; painters Rembrandt Peale, Frederic Church, and Daniel Huntington; and printmakers John Sartain and F. O. C. Darley. In the 1860s, he made carte-de-visite portraits of sculptors Clark Mills and Henry Kirke Brown, and new photographic portraits of Elliott and Gray [Plate 22].[2]

These artists all enjoyed the esteem of their contemporaries, though today's historians draw great distinctions between them. The reputations of Church, Cole, and Durand remain high; Peale, Sartain, and Darley, though less well known, enjoy a secure place in the story of American art. But most of the others belong to a class of workers whose reputations have not survived them. With few exceptions, when they

71

studied in Europe, they went to Düsseldorf and Rome, not Paris, and specialized
in figure painting, history painting, and portraiture. They remained acade-
mic and traditional at a time when the best artists sought new ground.

However, by staying alert to the needs of their audience, these
men made a real contribution to their generation, and to all who
followed. Unlike John Trumbull and Samuel F. B. Morse, who
found little encouragement in the first decades of the nine-
teenth century, this enterprising, social group raised the sta-
tus of art and artists among their peers. In the decades before
the Civil War, they encouraged private collectors like Daniel
Appleton, Marshall O. Roberts, and A. T. Stewart; estab-
lished and supported institutions such as the National
Academy of Design and the New-York Historical Society;
and patronized smaller dealers and exhibitors of art lining
Broadway and Fifth Avenue. After the war, New York
artists built lasting careers upon the foundations these men
had put in place.[3]

Brady clearly belonged to this circle. He often boasted
that the renowned painter William Page had given him draw-
ing lessons and encouraged his career in Albany before Brady
came to New York. In 1851, when Brady sailed to London to see
the Crystal Palace exhibition, his ship's roster included Page, Daniel
Huntington, and Henry Peters Gray, as well as James Gordon Bennett,
editor of the *New York Herald.* In 1858, Brady served on the Washington
Art Association, a committee formed to promote American art, hold exhibitions,
and establish a national school; members included many of Brady's New York colleagues,
such as Henry F. Darby, Henry Kirke Brown, Huntington, Darley, and Charles Loring Elliott [Plate 23].
Elliott painted Brady's portrait in 1857, and in 1896 Samuel P. Avery donated the canvas to the Metro-
politan Museum of Art as a memorial to the photographer and their friendship [Figure 6–1].[4] In 1864,
Brady photographed the artists and their patrons who formed the Gentlemen's Committee of the United
States Sanitary Fair, placing himself at the center of the group, behind John Frederick Kensett. Though
nearly insubstantial on their own, these small clues combine to form a picture of Brady's constant pres-
ence in this community, and suggest that these artists viewed him as a colleague. Without having explicit
documents, however, it is impossible to know whether they also viewed him as an artist, or accepted his
work as equal to their own.

An analysis of Brady's photographs and their relationship to contemporary paintings and prints must
begin with a discussion of the way in which American artists perceived their relationship to art's history and
to contemporary aesthetics, as well as to their own role in contemporary society. American artists at mid-
century aspired to membership in the international art world, and they struggled with the problems that all
artists faced, namely the effort to find a way to create art that met the uncertain needs of the present day.
They also understood their role as part of a larger national effort to establish a genuinely American aesthetic.

PLATE 23

Charles Loring Elliott

Daguerreotype, circa 1850.

National Portrait Gallery,
Smithsonian Institution,
Washington, D.C.

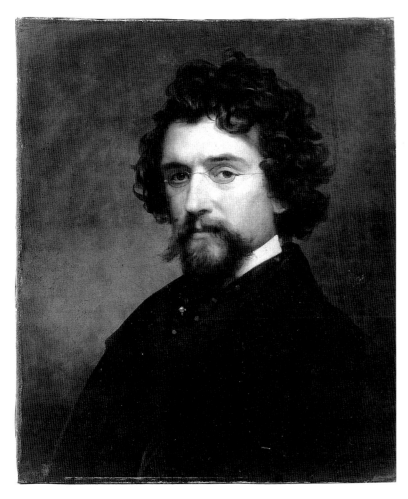

Ironically, this quest united them firmly with an international movement that sought to reinforce national identity and culture throughout Europe and the West.

At the risk of appearing too simple, the problem can be approached in two ways. Some artists worked from a technical perspective, adopting new methods and new ways of working. Men such as Morse, Page, and Peale experimented widely, choosing new tools, like photography, to help them create more convincing pictures. Others strove to find new subjects, and many American artists felt that their search could be confined to the representation of American themes—American men and women, American houses, American rivers and mountains. This impulse led writers like Nathaniel Hawthorne and James Fenimore Cooper or historians George Bancroft, Francis Parkman, and William Hickling Prescott to develop strong, new voices that could compete alongside their Old World contemporaries. The sheer spectacle of North America's landscape seemed to offer landscape painters an especially strong resource for developing a truly American form of art. Such subjects also allowed artists to celebrate the moral virtue of the New World, to blend what Lillian Miller has described as "nationalism, naturalism and morality" into a distinctive American style of art.[5]

But the best critics understood that only the search for a distinctive form of expression would lead artists to identify a truly national subject. As Francis Parkman observed in his essay on the work of James Fenimore Cooper, the two efforts could not be severed. And only a figure who owed nothing to Europe and Old World ideas would be able to lead the way:

> The vigorous life of the nation springs from the deep rich soil at the bottom of society. Its men of greatest influence are those who have studied men before they studied books, and, who, by hard battling with the world and boldly following out the bent of their native genius, have hewed their own way to wealth, station, or knowledge from the plowshare or the forecastle.[6]

The insistence on specifically American material proved especially crippling to artists. Writers could share the English language without damage to their national character, but artists discovered that their dependence on a European visual tradition aroused suspicion. "We should think it strange if one should go to France or Germany to learn to speak English, and yet we go there to learn to think American, how to look at American nature, and study the characteristics of American people! Was there ever such madness?"[7] American artists in search of a new visual form felt pressure to abandon foreign influences and start anew, on their own terms.

This led painters like Morse, Elliott, and Peale to find promising solutions in new technology, which had no ties to any tradition in any nation. In a flurry of metaphors, journalist E. Anna Lewis compared her world to sixteenth-century Florence, "on the eve of a great intellectual revolution [where] a great mental volcano is about to burst forth that shall send a thrill down the veins of future times." For such optimists, the camera was as important as steam power, electricity, and the swift printing press. This group placed photography "among the modern magicians" that would advance American culture and provide "an equal chance in the new race of art."[8]

Journeyman artists in New York in the 1830s and 1840s worked far from the European galleries and studios where they could receive adequate technical training. Buoyed by the optimism of the nationalistic movement that united writers, politicians, and entrepreneurs under the banner of "Young America," they viewed their relative isolation from European influence as an advantage, using it to proclaim national autonomy. (Such freedom from foreign influence did not last long; nearly every man in this group traveled to Europe as soon and as often as he could, and stayed as long as possible.) Memoirs reveal an innocent mood of experimentation and adventure. When Charles Elliott shared a studio with T. B. Thorpe, sculptor John Brouwere often visited them to describe his new method for casting heads from life (a process that nearly killed Thomas Jefferson), and he stripped to the waist to demonstrate anatomical structure. Daniel Huntington, who studied with Morse in the 1830s and later succeeded him as the head of the National Academy of Design, recalled his teacher's spirit of experimentation and his ability to combine various interests, having "wires strung around his studio and his chemical apparatus side by side with his easel."[9] In a late memoir, Huntington confessed that he had feared Morse was wasting time on the telegraph.

At first glance, the insistent American critics of the 1850s seem to belong to the larger history of art when they ask that the artist be "not only a student of art, of color, of pictorial effect, but likewise of the living world." Many thought American art suffered because it "worshipped the past and unconsciously reproduced its images, and therefore failed to enlist the sympathy of a living generation." Another anonymous American critic chose an oddly antique metaphor to call for a new kind of contemporary art:

> Art has nobler work to do than to invoke the ghosts of dead ideas. She must ally herself to the realities of daily life. She must link herself with the great thoughts that are stirring the hearts of living men and women. She must not live a pale nun amidst dry skulls and moldering relics, but rather put on armor, like Joan of Arc, and lead the hosts in the great battle of Truth.[10]

On the surface, this rhetoric seems to echo the call raised by Gustave Courbet, whose work inspired a virtual revolution in the practice of modern painting in France. Courbet named his movement realism and declared that he would only paint what he could see: "Show me an angel and I'll paint one!" Courbet recognized that it was necessary to unite the search for new subject matter with a quest for a method adequate to its needs. He showed how the intense observation of nature led artists away from academic habits developed by painting from plaster casts in north-lit studios. His canvases replaced kings and mythic figures with common laborers and village citizens, though often his elaborate tableaux were organized with the same academic symmetry that informed more traditional paintings. And in his masterpiece, *The Artist in His Studio*, Courbet surrounded his own portrait with depictions of actual individuals whom he used to represent abstract themes, as he explained by adding the ironic subtitle, "An Allegory of Real Life."[11]

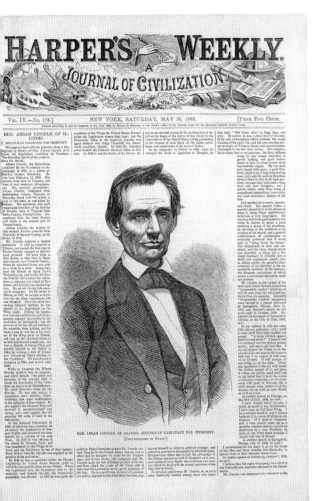

FIGURE 6−2

Abraham Lincoln

Woodcut by an unidentified
artist, after a photograph by
Mathew Brady, from *Harper's
Weekly*, 1860.

Library of the National Portrait
Gallery and the National
Museum of American Art,
Smithsonian Institution,
Washington, D.C.

Courbet treated the human figure with a frank sensuality that often alarmed the Americans, but one suspects that cautious American critics saw no difference between Courbet's gleaming models, with their tactile skin and strong, three-dimensional bodies, and the boneless, pastel fantasy figures that less accomplished academic painters produced. Because most Americans continued to judge painting by its subject matter, all French painting carried the taint of immorality, and most of Courbet's lessons regarding the relationship between philosophy and technique were lost on this generation of American figure painters, though landscape painters learned a great deal from his paintings of trees, fields, and hunting scenes that entered American collections.[12]

In England and in America, artists inspired by John Ruskin also turned to nature and away from the academic traditions that they traced to the Italian Renaissance, as best seen in the work of Raphael. The Pre-Raphaelites devised their own method of close observation to produce detailed depictions of natural phenomena as a method to unseat conventional academic approaches to art. Though the British members of this school produced large, incident-filled paintings, Americans usually chose topics inspired by the close observation of flowers, birds, and bits of landscape, producing small, fragile drawings and watercolors.[13]

But most American critics associated technical innovation with effete European training, and so turned back to subject matter when they tried to describe what they felt American artists lacked. Because they had no words to describe problems of representation, they evaluated art in terms of its ability to inspire the viewer. They talked about art as a kind of bridge uniting the mood and emotions of the artist with his audience, and about subject matter as the material from which it was built. Or, in the words of a critic who called himself "Hawkeye," "A True picture is the embodiment of an idea—a living idea. . . . To render a picture capable of awaking emotion . . . it must have the emotion or thought put into it in its creation."[14] This school suggested that American artists would succeed when they learned to choose appropriate topics—George Washington, not Roman kings; the Hudson River, not the Arno or the Rhine. As an anonymous critic wrote in the *Photographic Art-Journal*, "The fact is, the people care nothing for what they do not understand. They do not value pictures as mere 'pictures.'. . . It is the *subject* of the work which fixes their attention; the character and feeling and passions expressed."[15]

American critics further evaluated art on a standard that they used to measure all endeavor—namely its utility. Thus in 1856, a reviewer of the thirty-first annual exhibition at the National Academy of Design used a grotesque image to describe the disappointing state of American art: no longer a child learning to walk, but a mature, stunted form, "a dwarf in leading strings." American art seemed horribly stagnant before the "greatness, wealth and splendor" of contemporary structures, such as the new Opera House, Fifth Avenue's hotels and palaces, the Gothic architecture of Trinity Church, or even the profuse decoration found in steamships and hotels.[16]

According to this standard, Mathew Brady provided a shining example to his peers. From the beginning of his career, he supplied portraits to publishers [Figure 6–2] who needed illustrations for countless

books, essays, and periodicals. In 1846, Brady's por-
traits of prison inmates illustrated the American
edition of *Rationale of Crime*, and his daguerreotype
portrait of Henry Inman appeared (without credit)
in Charles Edwards Lester's *The Artists of America: A
Series of Biographical Sketches*. An account of Brady's
portraits, published in the form of woodcut illustra-
tions, also charts the emergence of the American il-
lustrated press; his work first appeared in woodcut
versions in *Graham's Magazine* in 1854, in *Frank
Leslie's Illustrated Newspaper* in 1855, and in *Harper's
Weekly* in 1857. In January 1857, *Leslie's* praised
Brady's artistic expertise, his zeal and determina-
tion to show the "utility" of his medium, and his
ability to promote its "social and esthetic use."
Leslie's acknowledged Brady's contribution to en-
gravers, beginning with its own journal and ex-
tending to "the millions of engraved portraits issued
during the past fifteen years by the publishers of the
Union, most [of which] have been executed from
originals derived from his collection."[17]

One distinctive school of criticism refined its
demand for utility, insisting that the best art was
dedicated to a single goal, namely "the conservation
of patriotism," or, in today's language, the construc-
tion of a national identity. This goal could be served
in countless ways, the most popular being the por-
trayal of historical events. "As language keeps alive
the fire of nationality, so should painting embalm

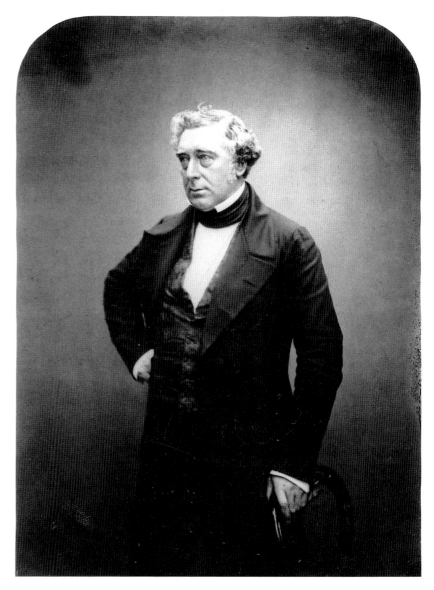

FIGURE 6-3

Robert Stephenson

Albumen silver print by
Maull & Polyblank (active
1850s–1860s), circa 1856.

Gernsheim Collection, Harry
Ransom Humanities Research
Center, The University of Texas
at Austin

the genius of a country by preserving memory of familiar scenes, or by transmitting to posterity reminis-
cences of actions, deeds, or manners."[18] According to this scheme, the best art inspired patriotic feeling
through the representation of American heroic ideals. But even more important, as the art helped to shape
a collective memory, it also united its many viewers. The very act of viewing such an inspiring scene trans-
formed a miscellaneous crowd of observers into a cohesive body, with common interests and a common
identity. In this way, patriotic art turned its viewers into a nation. "Thus into the hands of art is commit-
ted dominion over the passions not only of the individual, but of the masses composing the body politic."[19]

This widely held conviction created a large demand for images with patriotic themes, as the overall
market for art began to grow. In commercial galleries on Broadway, in the prints and paintings produced for
the Art Union, in illustrated books, and in popular lithographs and engravings, images devoted to Ameri-
can history drew crowds and sales. From scenes of colonial struggle to battles of the Mexican American
war, American artists and audiences remained fascinated with pictorial representations of historical events.

Obsession with national identity was also understood as a reflection of the uncertain political mood. By the end of the 1850s, as political conflict threatened to rip the nation apart, the call for artistic support of a national body politic became frantic and shrill:

> the hour has arrived when the necessities of our country not only justify but inexorably demand the production of a series of national paintings . . . the establishment of our Versailles, or of our Luxembourg . . . throw aside the monotonous placidity and deleterious inertness which hangs, as a nightmare, upon the general mass of our American painters. . . . Our people mourn a purely national painter, to transmit to our children the grandeur of our fathers.[20]

In many ways, Mathew Brady built his gallery, and his archive, in direct response to this need for a healing nationalistic vision.

In the middle 1850s, changes in photographic technology allowed Brady to make heroic portraits in a bold new form. In the mid-1850s, when it became possible to make many photographs from a single glass-plate negative, the small, unique daguerreotype began to lose ground to the photograph, which could be large, easy to exhibit, and easy to duplicate. Around 1855, Brady and his operators began to make Imperial portraits, measuring 20 by 24 inches, on rag paper that was prepared with a solution of table salt, known as "salted paper." These images had soft, rich brown tones. Brady's studio never surpassed the work of this period. At their best, his Imperials displayed a stunning union of formal elegance, technical brilliance, and psychological depth.

The composition remained simple; to the austere setting of the daguerreotype, Brady made very few additions. Many backgrounds are empty; to others he added a column and a drape. Eventually he also included a chair, table, and a few ornaments, such as a thick, bound volume and a decorative clock. Brady displayed the subjects of his best Imperial portraits as human sculpture, grand and alive. The scale of the large negative enabled Brady to represent his sitters more fully, to accommodate torsos and full figures with dramatic depth. The inherent stability of the photographic image on paper meant that Imperials could be viewed by a large audience, from a distance, exerting a visual power that daguerreotypes could never achieve. As a result, these images also gained emotional impact.

This style of photographic portraiture can be seen in the work of many other studios, including C. D. Fredricks in New York, the Haenfstangl Studio in Munich, Auguste Belloc in Paris, and Maull and Polyblank in London [Figure 6–3].[21] What accounts for the international character of this style? Wide opportunities for exchange existed within the photographic community; operators traveled across the ocean; and periodicals reached easily through every European capital, as well as to Boston, Philadelphia, and New York. American photographers were both capable practitioners and leaders in the field; and despite political rhetoric, the American art world, in general, welcomed the opportunities to learn from (and improve on) European examples.[22]

The portrait of military leader Winfield Scott offers an excellent demonstration of Brady's trademark use of traditional, stylized elements to support a vigorous, modern likeness [Plate 24]. Along the right-hand edge of the frame, a classical column and a rich brocade drape refer to a portrait heritage that extends back to the Renaissance. A fragment of a tabletop, which shows Scott's feathered hat, intrudes on the

lower left corner of the frame. At the center stands Scott in full-dress uniform. With his heavy epaulets, gold embroidered cuffs and collar, gleaming buttons, and gilded sword belt supporting his scabbard, he might appear today as a typical antique figure, at home in this formal setting. To his contemporaries, Scott's figure presented a flashing contrast between tradition and contemporary life. This image was made around 1860, when Scott was already seventy-five years old. His own personal achievements bridged nearly half a century of the nation's history: Having first made his mark as a hero in the War of 1812, he distinguished himself in the 1846 war with Mexico, and rose to the rank of lieutenant general, in charge of the entire United States Army. This portrait shows a commander of monumental power. The obvious marks of age attest to his endurance. His severe expression, deep, sharp eyes, and large hand show his strength, even at rest. Brady has manipulated the light and shadow to emphasize Scott's face and give extra shine to his signs of rank. The camera also renders detail in a way that undermines pomposity—we see stray hairs and heavy jowls, and it is hard to ignore the massive belly beneath Scott's tunic—but in the end this image that reveals Scott's vulnerable nature endears him to us.

As the master of a new form, Brady made a direct contribution to the nation by making it possible for artists to improve upon inherited traditions. Brady compared his own work to "the best English engravings," calling attention to "depth of tone and softness of light and shade [which] display all the artistic arrangements of the highest effort of the painter."[23] Photographic editor H. H. Snelling described paper photographs as "a medium between pencil and water color drawings and the engraving, partaking in their nature a little of each."[24] In fact, Brady and others employed artists and colorists to add ink, pencil, and crayon to the surface of their paper photographs, further blurring the distinction between their work and the more familiar forms of lithography, drawing, watercolor, or crayon images.[25] Snelling moved easily from the material aspects of photographs to more complex issues of form, advising his readers to study painting and prints, repeatedly citing the work of Rembrandt, Van Dyck, and Sir Joshua Reynolds.

Snelling refers to artists known for their portraiture. And with the introduction of portrait daguerreotypes in 1840, it became apparent to everyone that photography posed an undeniable challenge to painters who specialized in portraiture. In 1857, painter Rembrandt Peale, writing for the *Crayon*, noted that photography had altered standards and expectations that audiences brought to portraiture, but he confidently returned to painting as the more successful and satisfying medium. Peale remarked, "Now it has become necessary for the portrait painter to make his portraits not only *as* true but expressively *more true* than the daguerreotypes, with which but few, at present, are 'content.'"[26] That same year, an unsigned article on photography for *Harper's Weekly* observed that the art of portraiture was "not gone but modified." According to *Harper's*, photographs had become as necessary to the portraitist as "a pallet and an easel," making old methods "as completely defunct as navigation by the stars."[27]

Charles Loring Elliott, a student of Morse, was among the first to embrace the aesthetic contribution of the daguerreotype. According to his colleague T. B. Thorpe, Elliott "never saw a picture made by the process that did not have something about it to admire. He liked Rembrandt better, if such a thing were possible, after he had studied daguerreotypes, for they justified his extreme effects of light and shade," and he freely compared portrait daguerreotypes to "Rembrandt's etchings of the human face."[28] Elliott was considered the most talented portraitist of his generation. His work was characterized by its aggressive depiction of detail, its harsh, daguerreotype-like contrasts of light and shadow, and its unflinching rendering of tiny details and flaws, which one critic called "savage realism."[29] Thorpe recalled

PLATE 24 (opposite)

Winfield Scott

Imperial salted-paper print, circa 1861.

National Portrait Gallery, Smithsonian Institution, Washington, D.C.

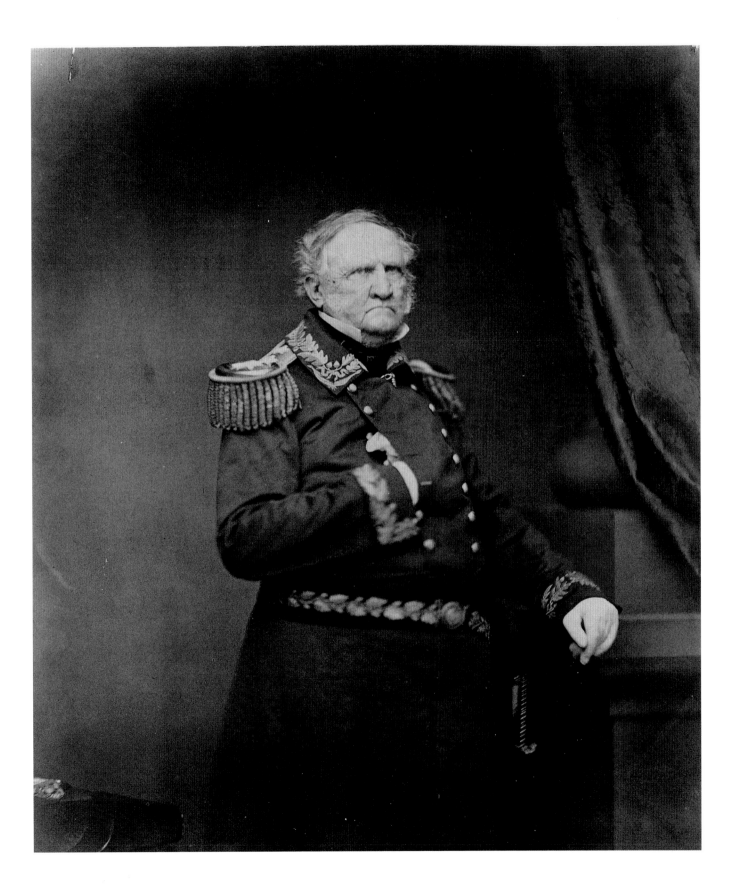

that Elliott painted James Fenimore Cooper's portrait from a daguerreotype made by Mathew Brady. His posthumous portrait of Henry Inman closely follows Brady's daguerreotype. Elliott's 1860 self-portrait, in which he poses in Rembrandtesque beret and cloak, uses exaggerated shadows and brown tones, and closely follows Brady's second portrait of Elliott, of whom he made both a daguerreotype and a photograph. Critic S. G. W. Benjamin located Elliott's work at the dividing line between the camera and the brush. For Benjamin, Elliott's art marked "the essential and irreconcilable difference between photography and the highest order of painting."[30]

Most painters were neither as successful, talented, or frank as Elliott, and while their dependence on photographic images was never hidden from their first audiences, today this relationship must be reconstructed from formal evidence and a wealth of circumstantial clues.[31]

FIGURE 6-4 (above)

M. B. Brady's New Photographic Gallery, Corner of Broadway and Tenth Street, New York

Wood engraving by Albert Berghaus (active 1850s–1880s), from *Frank Leslie's Illustrated Newspaper*, 1861.

National Portrait Gallery, Smithsonian Institution, Washington, D.C.

FIGURE 6-5 (opposite)

Henry Clay

Oil on canvas by Henry F. Darby (1829–1897), circa 1858.

United States Senate Collection, Washington, D.C.

For example, in woodcut illustrations of the interior of Brady's gallery of 1860, portraits of Calhoun, Clay, and Webster hang prominently at the center of his elaborate display [Figure 6–4]. A reviewer from the *New York Times* described Calhoun's "striking picture" at length: "a half length portrait, photographed, life-size, from a daguerreotype miniature, and finished in oil. It is a beautiful piece of work and wonderfully life-like. The ragged, wiry character of the face marking nervous energy, the overhanging brow and broad intellectual development [capture] Calhoun at a glance."[32] Journalist Gail Hamilton swooned before the image, praising "those marvelous eyes that thrill you and fix you, gazing into a mystery, abstracted, solemn, and almost supernal."[33]

The portraits of Calhoun and Clay [Figure 6–5] were made by a self-taught artist, Henry F. Darby, who listed Brady's New York studio as his own place of business in 1855.[34] Both images assert kinship with daguerreotypes through plentiful, precise detail, bright illumination, monochromatic palette, and absence of any context that might enhance or distort perception of the sitter. These same qualities also suggest authenticity and verisimilitude. Most important, these portraits mark the aesthetic territory that portrait painting and photography shared.

Together, Brady and Darby navigated freely between images made by the camera and those finished on canvas. They understood that when a painter turned to the daguerreotype, he could select useful aspects of the flickering images and use them to enhance the stature of his own work. It is just as interesting to note that Brady, not Darby, received all the credit.

In 1859, when Brady and Darby collaborated on a new, posthumous portrait of Washington Irving, press accounts fully described the elaborate process by which it came about. Brady proudly announced his discovery of John Plumbe's previously unknown daguerreotype, which he copied and enlarged into an Imperial photograph, and Darby's final "enhancement" of the image with oil paint. The *New York Tribune*

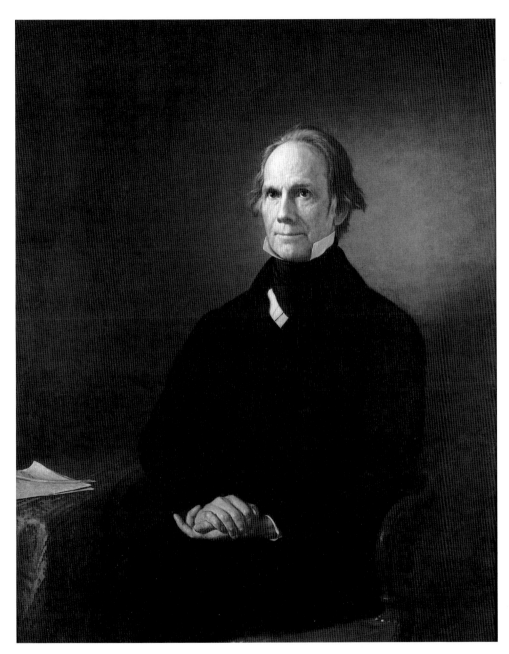

called the final product a "nearly perfect resemblance of Geoffrey Crayon." The *Home Journal* admired Brady's technique—the "legerdemain for which he is to have a conjurer's credit and renown" and the "patient and skilful elaboration of a well-practiced and preserving hand," which was applied to the old daguerreotype and which produced, in the end, a likeness of Irving "as he appeared in the mellowing of his best days."[35]

Darby made a fine collaborator for the ambitious Brady. He was an able craftsman, but seemed content to receive little credit for his work. Today we acknowledge Darby, not Brady, as the artist of these portraits. Our criteria for authorship have changed since Brady's day. His audience honored the photographer who both made the first image and paid for its transformation from photograph to canvas; today we respect the craftsman who brought that transformation about. If one carries the analogy into another field, Brady could be seen as a conductor while Darby was the first violin.

The collaboration between Brady and well-known portrait painter G. P. A. Healy produced a large, complex body of work. Healy was a fine technician and one of the most successful American painters of his time. He developed a rich, realist style in the 1830s, before he had access to photographic images, but from the 1840s onward, many clues point to his ongoing use of photographs. In 1846 he asked President James K. Polk to sit for a daguerreotype in preparation for his painted portrait; the maker was John Plumbe.[36] As late as 1870, photographs were made to assist his portrait, *Arch of Titus*, which depicts Henry Wadsworth Longfellow and his daughter at the famous ruin in Rome; a photograph of the poet and his daughter survives, scored for easy transfer to canvas [Figures 6–6 and 6–7]. Healy's prolific output alone suggests a technique distinguished by astonishing speed and efficiency. Over the course of his sixty-year career he painted nearly three thousand portraits; from 1855 to 1865 alone he painted more than five hundred canvases, an average of one a week for a decade. In addition,

FIGURE 6–6 (left)

Arch of Titus

Oil on canvas by George
Peter Alexander Healy
(1813–1894), Frederic E.
Church (1826–1900), and
Jervis McEntee (1828–1891),
1871.

The Newark Museum, New
Jersey; bequest of Dr. J. Ackerman
Coles, 1926

FIGURE 6–7 (below)

Henry Wadsworth Longfellow and his daughter Edith

Albumen silver print with
pencil by an unidentified
artist, 1868.

Marie De Mare research material
on George Peter Alexander
Healy, Archives of American Art,
Smithsonian Institution,
Washington, D.C.

Healy spent many years in France, where academic painters such as Léon Bonnat, Dominique Ingres, and P. A. J. D'Agnan-Bouveret were well known for their use of photographs to aid their work. Moreover, Healy's own distinctive style incorporated the sorts of small, transient details (wrinkles in the face, accidental twists in clothing, precise shadows that result from fleeting effects of light and shadow) that photographs record so faithfully.[37]

Like Brady, Healy developed a reputation as the painter of national heroic portraits. He received his first presidential commission in 1842, when he painted John Tyler. Many official commissions for presidential portraits followed, including Presidents John Quincy Adams, Martin Van Buren, James K. Polk,

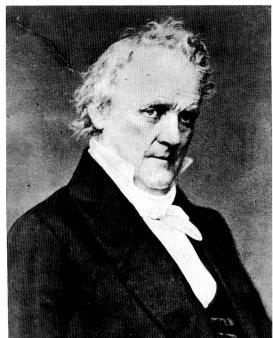

FIGURE 6-8 (left)

James Buchanan

Oil on canvas by George
Peter Alexander Healy
(1813–1894), 1859.

National Portrait Gallery,
Smithsonian Institution,
Washington, D.C.; transfer from
the National Gallery of Art, gift
of Andrew W. Mellon, 1942

FIGURE 6-9 (below)

James Buchanan

Albumen silver print, from a
negative made circa 1859 by
the Brady/Handy Studio.

National Portrait Gallery,
Smithsonian Institution,
Washington, D.C.

Franklin Pierce, Millard Fillmore, and James Buchanan. Many of these images still hang in the White House. Most interestingly, he enjoyed the patronage of King Louis-Philippe, whom he met in 1842, and who arranged for Healy to make portraits of American heroes for his own historical gallery at Versailles; but after Louis-Philippe was deposed in 1848, the commission came to an abrupt end.

A great deal of formal evidence suggests that Healy and Brady collaborated closely and often on official portraits, such as Healy's highly idealized portrait of President James Buchanan. Buchanan was a notoriously difficult portrait subject, with a wall eye, a squint, and a crooked back, though these defects do not come through in Healy's portrait, commissioned by Congress in 1858 and painted in June 1859 [Figure 6–8]. Healy seems to have borrowed the pose directly from Brady's photograph of Buchanan, where he posed the President with one hand on a table, and turned his head toward the camera in a way that masks his physical flaws [Figure 6–9]. But even the combined talents of Brady and Healy could not redeem

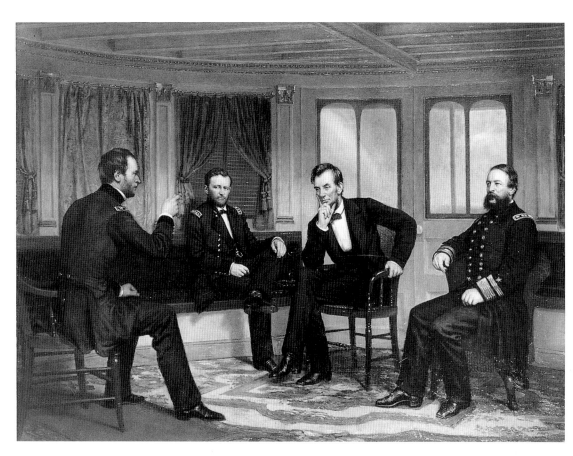

Buchanan's weak reputation by the end of his term. Early in 1861, Healy had still not received his full fee from the United States Treasury. Buchanan, by then a lame duck awaiting Lincoln's inauguration, refused to buy the painting himself, so the portrait remained with the artist. When a Chicago reporter visited Healy's studio, he looked past Healy's flattering image to the actual man, and evoked the "sad placid visage of poor Mr. Buchanan . . . with the lack-lustre eye, and the infirm weak old mouth."[38]

When journalist Gail Hamilton visited Brady's studio in Washington, she immediately compared Healy's portraits to Brady's and she preferred the latter. Healy's elegant technique raised her suspicions. Instead, she favored the immediate, transparent appearance of the photograph, as if the sheer absence of art testified to the truthfulness of the portrait:

> In oil paintings we see Washington through Healy's eyes, nor can we be certain how much is the man Washington and how much is the painter Healy, but here, is no allowance to be made for the imagination of the artist. They are facts. The sun is a faithful biographer, and no respecter of persons. He gives us men as he saw them, shining down on their faces at noonday.[39]

Many viewers understood that Brady's gallery offered historical evidence of unchallenged veracity. In later years, Walt Whitman, who sat for Brady in Washington, claimed to have initiated Brady's historical mission:

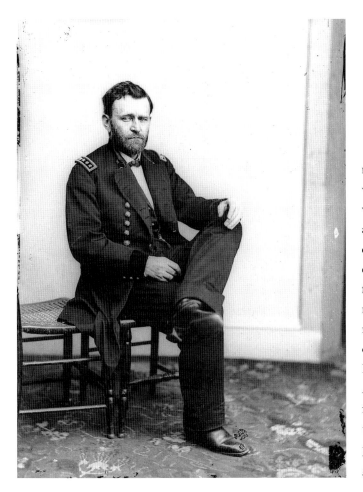

We had many a talk together: the point was, how much better it would often be, rather than having a lot of contradictory records by witnesses or historians—say of Caesar, Socrates, Epictetus, others—if we could have three or four or half a dozen portraits—very accurate—of the men: that would be history—the best history—a history from which there could be no appeal.[40]

Brady, however, was not content to simply amass an accurate record. He envisioned his work as part of a larger endeavor, in which he collaborated with artists to transform simple facts into vivid tableaux that could bring the past alive. He saw photographs as part of the material from which the historians and painters could construct their record. In 1867, when he sought and received the endorsement of Ulysses S. Grant in the effort to sell his collection for permanent display at the New-York Historical Society, Grant's recommendation echoed Brady's own view. Grant could have been referring to Healy's new painting, *The Peacemakers*, in which many of Brady's portraits were used to depict a meeting between Grant, Lincoln, Sherman, and David Dixon Porter just two weeks before Appomattox [Figures 6–10 and 6–11]: "If Art could have preserved for us, with equal fidelity, the scenes of the Revolution, and the features of the eminent men of that time, how much it would have simplified the labors of the historian and the historical painter; how greatly it would have enriched their work!"[41]

Of the many American artists who aspired to become historical painters, the most important remained Emanuel Leutze, and of his large oeuvre, the single most influential canvas was his monumental depiction of George Washington, commonly known as *Washington Crossing the Delaware*. Leutze himself was greatly indebted to the work of Benjamin West, who, a generation earlier, had successfully combined historical evidence, current events, and the commemoration of a martyr in his 1781 canvas, *The Death of General Wolfe*. If it is difficult today to see how photographic images could contribute to the construction of these melodramatic tableaux, it is important to remember that Leutze, Brady, and their contemporaries perceived history in terms that owed a great deal to these romantic images, and in many ways they used these canvases to establish a continuous line between themselves and the past. When Brady assembled his archive of portraits of contemporary heroes, he deliberately offered artists like Leutze the raw material from which to construct even more convincing historical narrative pictures.[42]

Throughout the middle of the century, Brady's colleagues—including Healy, Alonzo Chappel, Francis Bicknell Carpenter, Peter F. Rothermel, and Robert W. Weir—tirelessly applied formulas learned from Leutze and West to create an American art based on the momentous historical events of the day. Carpenter actually lived in the White House for six months during 1864 while he was preparing to paint Lincoln's portrait. Carpenter turned his unusual access to political events into a group portrait of Lincoln and his cabinet—Secretary of the Treasury Salmon P. Chase, Secretary of the Navy Gideon Welles, Secretary of War Edwin M. Stanton, and Attorney General Edward Bates—gathered for the first reading of the

Emancipation Proclamation. Despite the gravity of the situation and its historical significance for the country, Carpenter's depiction of a meeting of men around a table lacks momentum and drama, as contemporary reviewers freely noted. Carpenter wrote a pleasant memoir about his White House sojourn and the painting that resulted after Lincoln's death [Figure 6–12]. Though his narrative implies that all his work was done under Lincoln's supervision, it is apparent that Carpenter cribbed every face and every pose from photographs made by Mathew Brady [Figure 6–13; see also Plate 21].[43] (Brady photographed Carpenter in the early 1850s.) When one sees how closely Darby, Carpenter, and others

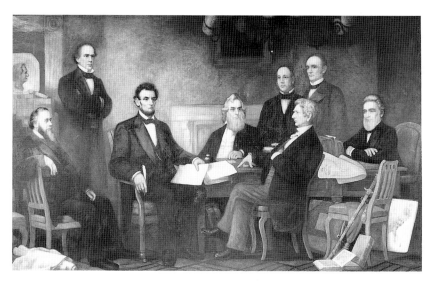

relied on Brady's photographs, it is easy to understand how Brady could write to Morse for recognition.

Given Brady's diligent pursuit of Presidents and political celebrities, and his successful collaboration with Darby, Healy, and others in the creation of large oil portraits, how can one account for the absence of a monumental portrait of Lincoln? Though Brady photographed Lincoln and his family on several occasions, beginning with his important 1860 portrait of Lincoln as he was securing the nomination of the Republican Party, he never produced a portrait on the scale of his portraits of Clay, Webster, and Calhoun. A short letter suggests that Brady simply ran out of time. On March 2, 1865, he wrote to Lincoln, asking for a new sitting:

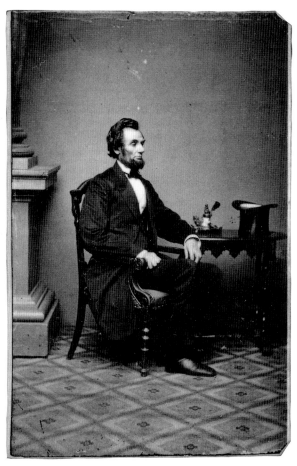

> Dear Sir,
>
> I have repeated calls every hour in the day for your photograph and would regard it as a great favour if you could give me a sitting today so that I may be able to exhibit a large picture. . . . If you cannot call today Please call at your earliest convenience.[44]

In the end, Brady's images supported numerous large pictures of Lincoln, most notably the posthumous portraits painted by Healy. But the most interesting example of Brady's collaboration with an artist was inspired by the dramatic hours before Lincoln's death, in which his partner was the history painter Alonzo Chappel.

A fascinating group of artifacts suggests that Brady and Chappel developed a working method that enabled them to exploit their individual talents to their mutual benefit. From the middle 1850s onward, Chappel

produced illustrations of American historical events for the publisher Henry Johnson, who issued popular illustrated multivolume works such as *Life and Times of Washington*, *Battles of the United States*, and *History of the United States*. Chappel ably borrowed from existing images and synthesized new scenes based on accounts in the texts, using formulas already perfected by West and Leutze. As noted above, beginning in 1862, he acted as sole illustrator for Evert Duyckinck's *National Portrait Gallery of Eminent Americans . . . from Original Paintings by Alonzo Chappel*, also published by Johnson, in which Chappel borrowed liberally from Brady's photographs to supply accurate faces for his highly fictionalized images of Presidents, generals, and other canonical figures.

Though Brady and Chappel created the image, publisher John Bachelder later took full credit for the construction of *The Last Hours of Lincoln*, painted by Chappel specifically to be engraved for popular sale [Figure 6–14]. As Bachelder explained in a publicity pamphlet, he arrived in Washington just when Lincoln was shot, and though overcome with grief, he immediately began arrangements to make an image that could commemorate the tragedy. His effort was not original. Death scenes of heroes had long been popular subjects for prints; on a more ordinary scale, Victorians also created private mourning pictures that substituted stylized motifs for descriptive deathbed tableaux. These images combined reverence and remembrance in a way that Victorians found dignified and soothing. Even Lincoln's first biographer, Isaac Arnold, deferred to this tradition when he refrained from attempting any account of what he called "that terrible night" when Lincoln died, adding, "I leave that for the pencil of the artist!"[45]

History also aided established conventions for deathbed scenes, in which a panorama of important Americans appear. As everyone well knew, Lincoln survived, unconscious, for nearly nine hours in a small bedroom in a house across from Ford's Theatre, and the procession to his bedside included senators, congressmen, cabinet members, physicians, Civil War heroes, and family friends. The method used to depict this assembly with accuracy became part of Bachelder's promotional literature. According to Bachelder, after he designed the tableaux, "arrangements [were] made with Brady & Co., Photographers[;] as soon as the remains of the President left the city[,] each of the persons represented were visited and at their convenience were *posed* and photographed in the position which they now occupy in the painting."[46] Bachelder then handed the design and photographs to Chappel, who assembled a new composite painting, just as he had done when making portraits for Johnson and Duyckinck.

To promote sales, Bachelder exhibited the painting in several cities and bound a group of letters and photographs into order books, two of which still survive. Both show many of the photographs Brady made, as if to reinforce Bachelder's claims for authenticity. Charles Sumner, Edwin M. Stanton, Gideon Welles, Miss Harris (who shared the box at Ford's Theatre with the Lincolns), and Robert Lincoln all appear in the exact poses they hold in the painting [Plates 25, 26, and 27]. Another supporting document, a letter from Andrew Johnson's secretary dated May 2, 1865 (only two weeks after Lincoln's death), states that "When [the President] visits Brady's gallery he will stand for the photograph you wish."[47] Though Bachelder enlisted many subscribers (Robert Lincoln himself ordered a $100 deluxe edition), the image survives only in the form of two slightly different painted canvases, and no engraving was made.[48]

Another version of the same subject was painted by Alexander Hay Ritchie, who successfully published *The Death of President Lincoln* in 1867. Ritchie's prices were considerably lower, the top price being

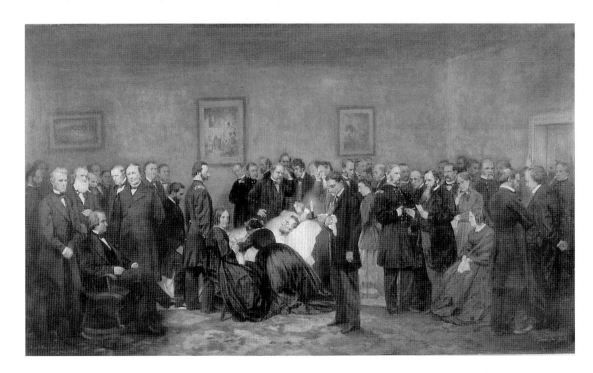

FIGURE 6–14

(above)

Last Hours of Lincoln

Oil on canvas by Alonzo
Chappel (1828–1887), 1868.

McLelland-Lincoln Collection,
John Hay Library, Brown
University, Providence, Rhode
Island

PLATE 25 (right)

Robert Todd Lincoln

Albumen silver print from
John Bachelder's subscription
book, 1865.

Private collection, the eastern
collector

PLATE 26 (opposite)

Clara Harris and
Joseph Barnes

Albumen silver prints from a
page in John Bachelder's
subscription book, 1865.

Private collection, the eastern
collector

only $30 (still expensive, but barely one-third of Bachelder's deluxe issue), and his method was substantially the same, though his cast was confined to seven figures—probably contributing to the overall success of the picture. Ritchie was also a more accomplished painter.

Both Ritchie and Bachelder held widely publicized exhibitions of their original oil paintings, and obtained endorsements from well-known military men and politicians, who praised the fidelity of the portraits within these tableaux. Bachelder quoted a long review from the *Washington Sunday Herald* of March 31, 1867, ascribing the "greatness" of his picture to "its correct transcription of an actual scene and perfect portraiture of American men. It is just such a work as, above all others, should be American property, for if ever there was a *National* picture, this is one."[49]

Today, Chappel's picture of a dying man in a crowded room arouses no emotion. The faces of these once-famous men no longer inspire wonder or recollection. More important, we have lost the ability to detect allegorical meaning embedded in pictures, and along with this, we have lost the pleasure that comes from careful interpretation. Yet we can find much to admire in the elaborate documents that Brady helped Bachelder assemble. The photographic portraits that were planned and posed now carry a poignant charge. They are records of men and women in the act of mourning before a camera. They are also portraits of the nation's leaders performing their public roles, representatives of the people at the deathbed of a martyred President. Many of these portraits remained in Brady's collection, where they became part of the large inventory of portraits now held at the National Archives—part of the composite "*National* picture" that Brady's work has become in the twentieth century.

B-4964

7

Washington and the War Years

I n the winter of 1858, Mathew Brady returned to the capital, drawn, like many ambitious young men, by "a native impulse to breathe the intensest atmosphere of the nation's life."[1] He established his gallery in rooms on Pennsylvania Avenue that had once been occupied by daguerreotypist John Plumbe, at the center of the city's commercial district, near newspaper offices, shops, restaurants, theaters, and hotels. Alexander Gardner was in charge of the new studio, while Brady divided his time between Washington and New York.

Brady took up residence at Willard's Hotel, which was, in Nathaniel Hawthorne's eyes, "more [the] centre of Washington and the Union than either the Capitol, the White House or the State Department" [Figure 7–2]. Willard's lobby was to Washington what Broadway was to New York:

> You exchange nods with governors of sovereign States; you elbow illustrious men, and tread on the toes of generals; you hear statesmen and orators speaking in their familiar tones. You are mixed up with office-seekers, wire-pullers, inventors, artists, poets, prosers . . . clerks, diplomatists, mail-contractors, railway-directors [and] longwinded talkers of all sorts.[2]

(Though what New York needed a whole street to contain, Washington fit in one large room.)

Throughout the nineteenth century, writers consistently describe Washington as a city small in population, large in territory, and southern in outlook. Washingtonians embraced southern values such as "blood, gentle bearing, and careful mental cultivation," as opposed to northerners' "undue honoring of riches and empty show." If New York was "a city where a great cause produces a small effect," the Washington public was keenly alert to the hidden significance behind every public gesture. Status derived from invisible power of family, connections, and political influence rather than simple wealth. Washington, in short, was a village that thrived on illusion, offered little to strangers, and cherished memories of the past and of its first illustrious citizens, the Founding Fathers.[3]

Charles Dickens called it "the City of Magnificent Intentions," and like nearly every other nineteenth-century visitor, he found easy metaphors in the city's paradoxical appearance, with its classical monuments that remained unfinished, broad avenues that remained unpaved, streets impassable with mud in the spring and choked with dust in the hot summers. Surrounded by a brackish river and malarial swamps, the city was actually unhealthy, and postwar accounts frequently equate the threat of disease with moral decadence. A. D. White, who came to Washington as a young man during the 1850s, left after only a few years, having grown discouraged by the fact that this "forlorn, decaying, reeking city was the goal of political

FIGURE 7–1

View of the Capitol

Albumen silver print, circa 1863.

National Archives, Washington, D.C.

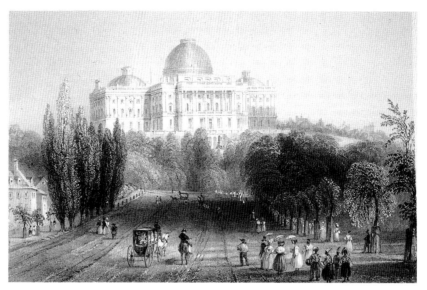

FIGURE 7–2

The Capitol

Engraving by William H.
Bartlett (1809–1854), from
Picturesque Views, circa 1840.

Machen Print Collection,
Historical Society of
Washington, D.C.

FIGURE 7–3

White House Reception

Wood engraving by an
unidentified artist, from
Harper's Weekly, 1858.

Machen Print Collection,
Historical Society of
Washington, D.C.

ambition." To White, a northerner and a Whig, the "whole life there bore the impress of the slipshod habits engendered by slavery, and it seemed a civilization rotting before ripeness."[4] When Henry Adams arrived in 1860 to work for his father, Charles Francis Adams, soon to become Lincoln's ambassador to London, he found that little had changed from his previous visit a decade before. But where others prized the city's timeless quality, Adams viewed its adherence to tradition as another sign of decay. He found "the same rude colony was camped in the same forest, with the same unfinished Greek temples for workrooms, and sloughs for roads." To Adams, Washington seemed full of arrogance and ignorance, a society where "one could learn nothing but bad temper, bad manners, poker, and treason."[5]

Though Virginia Clay interprets this view with considerably more tolerance and goodwill, she echoes many of Adams's observations. One of the most charming defenders of the South, Virginia Clay came to

Washington in 1853 as the wife of Clement C. Clay, junior senator from Alabama, and she departed in 1861 when Alabama seceded from the Union. Mrs. Clay remembered that throughout the administrations of Zachary Taylor, Millard Fillmore, and Franklin Pierce, social life in Washington remained "smiling and peaceful," largely because the dispute over slavery divided the political community into distinct, if undeclared, factions, which observed a "mutual instinct of repulsion," and seldom came together except at the largest public events [Figure 7–3].[6]

But by the time of James Buchanan's election, the placid surface had shattered. Late in 1856 she wrote to her father-in-law in Alabama, describing the mood and conditions of the city as factions formed to support—or defeat—the status of slavery in the territory of Kansas:

> Everything is excitement and confusion. I tell you Fusion reigns in truth and Southern blood is at boiling temperature all over the city, and with good cause, too. . . . I wish you could be here to witness the scenes daily enacted in the halls of Congress, to hear the hot taunts of defiance hurled into the very teeth of the Northerners by our goaded but spirited patriots. I expect any day to hear of bloodshed and death, and would not be surprised at any time to witness . . . the Civil War of Kansas![7]

Virginia Clay frankly enjoyed the intensity of Washington society under Pierce and Buchanan. To her mind, the heated political struggle drove American culture to a new level of brilliance. She understood that the city's competitive round of parties and receptions, its "reckless gaiety everywhere apparent," reflected the "life-and-death struggle [that] raged between political parties, and oratorical battles of ominous import were fought daily in Senate Chamber and House" [Figure 7–4].[8]

Mrs. Clay's memoirs are filled with episodes from the struggle that took place on the social battlefield. She anxiously imagines that the British ambassador's reception will force her to dine beside a northerner, or a Republican. She zealously protects the social boundaries that stand between the southern social leaders and their northern counterparts. Throughout her account she manages to preserve the sense that she, her friends, and their families were the ones who truly supported the Union, while northern policy alone forced them to create a new nation that could best preserve tradition.

As George Forgie has shown, most of Henry Adams's contemporaries used sentiment as a useful and important ideological mechanism to connect events of the present with history, and the past. In the process, mythic images became more important than facts, and common habits of perception encouraged confusion between ideals and actualities. There often seemed to be no difference between abstract principles and the individuals who put those principles to work. Charles Dickens

was chagrined to discover that frequent references to the dignified nature of Washington's heads of state meant "not their chiefs and leaders, but literally their individual and personal heads, whereon their hair grew, and whereby the phrenological character of each legislator was expressed."[9]

This same line of reasoning led national history to become closely associated with the specific men who held office, and power. In 1853, Senator John J. Crittenden from Kentucky boasted that he had dined with every President since Monroe, and he was certainly not alone.[10] As James Parton said regarding Daniel Webster, "there seemed one solid thing in America, so long as he sat in an arm-chair of the Senate-chamber." (Webster rarely appeared in this context without the names of his contemporaries, Henry Clay and John C. Calhoun.)[11] When young historian John Lothrop Motley learned of Webster's death, he wrote to his parents that "thinking of America without Webster . . . seems like thinking of her without Niagara, or the Mississippi, or any other of the magnificent natural features which . . . seemed likely to endure for-ever."[12] As long as these men lived, they preserved, in the minds of their contemporaries, a secure link to the glorious past. But by the early 1850s, the deaths of Webster, Clay, and Calhoun severed this connection to tradition and the patriotic ideals they embodied, and it became dangerously clear that some replacement must be found.

For citizens in search of a connection to these men, and through them to the past, Brady's gallery sup-plied an important need. A writer for *Frank Leslie's Illustrated Newspaper* praised Brady's "Gallery of Na-tional Portraits" as a collection that "concentrates and embalms the greatness of an era."[13] To Gail Hamil-ton, writing from Washington in 1858, "The most valuable part of the gallery is that devoted to the great and good who have gone from among us. . . . These are living portraits of those, who, in their days, were living men." Hamilton, born in 1833, and since 1858 an influential journalist, had certainly met many of these leaders, and she assumed that a collection like Brady's would shore up memory, and introduce a new generation to men who might otherwise be forgotten. "In proportion as a character recedes into the twi-light of romance and history, do we cling to everything which shall help us to realize and personate them."[14] She seemed to suggest that the mere exposure to a portrait could preserve and convey the full personality of a man like John C. Calhoun to one who had never known him.

Many commentators approached Brady's portraits as they would a personal encounter. In 1859, a writer for the *New York Times* found it "pleasant, after reading what Senator Hale said, to look at the fea-tures of the man who said it." He approved of "Mr. Giddings [who] looks as if he could eat up every South-ern man in Congress without so much as winking." The reporter's (and the *Times's*) Republican sympa-thies grew explicit around the subject of Buchanan: "When we learn that the President has been doing something tricky and evasive, it is not bad to have one's surprise immediately removed by a glance at the corresponding expression of features in the portrait of that venerable man." The reporter's disdain ex-tended to the President's niece, Miss Lane, "a fine, handsome girl, with an imperious rather than a win-ning, a handsome rather than a loveable style of countenance." Like everyone else, the reporter enjoyed much "retrospective pleasure" from the "historical associations" that Brady's portraits inspired. But most of all, he appreciated the way in which the gallery displayed men and women of the present. Their por-traits contradicted "the croaking cant of the day which seeks to decry the present generation as unworthy to share the fame of previous ages." The reporter saw in Brady's images the portraits of "living statesmen and jurists now upon the scene of active life who will not be justly appreciated until they shall have re-moved from among us and whose virtues and ability will then be as highly lauded as are those of the

Benjamin, J.P.

Judah P. Benjamin — Attorney General — Confederate States. 1864.

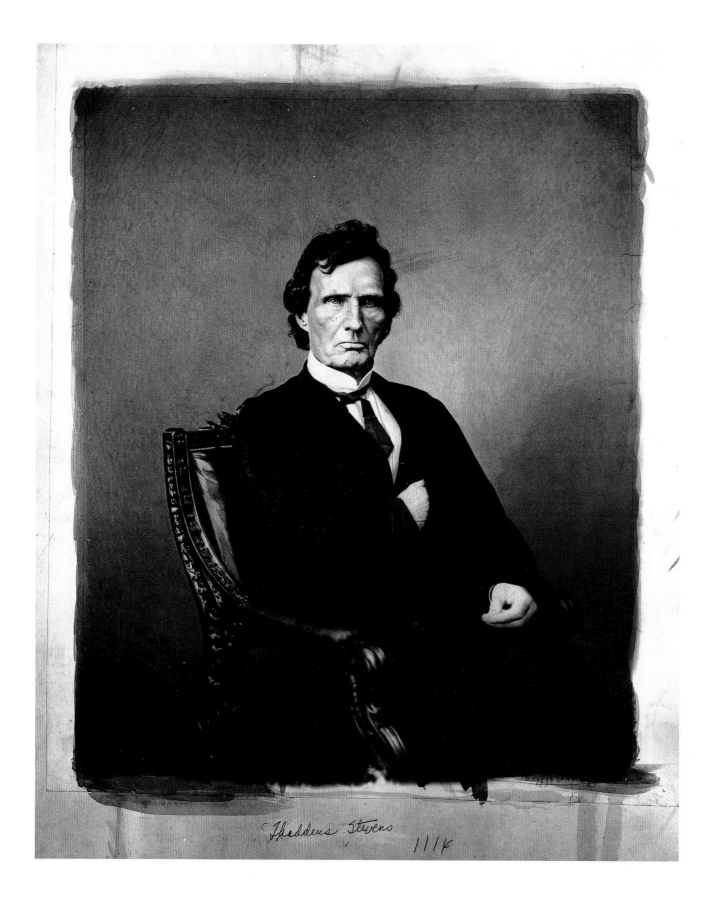

Thaddeus Stevens

1114

PLATE 29 (opposite)

Thaddeus Stevens

Imperial salted-paper print
with ink and pencil, circa
1858.

Chicago Historical Society,
Illinois

preceding century." In Brady's gallery he saw images of living men who deserved all the attributes ordinarily reserved for the dead.

Brady's gallery offered an entrancing vision of the present for a public that was increasingly in need of comfort. Gail Hamilton read Brady's gallery walls as if they were an allegory of the present. Writing in 1859, she knew that her Washington readers would understand the unusual gathering that this collection made possible, in which Charles Sumner, James Buchanan, John C. Breckinridge, William H. Seward, Judah P. Benjamin [Plate 28], and Thaddeus Stevens [Plate 29] appeared side by side; her light tone did not disguise the somber political observation that "the millennium has come, seeing the lions and lambs of the Senate lying down together in one place."[15] Her longing for a return to peace and Union infused her prose with palpable emotion, which seems, in retrospect, all the more affecting for her reluctance to acknowledge that such reconciliation had become impossible.

In October 1860, the *New York Times* used the same allegorical strategy to describe the gallery as one great picture. This point of view also enabled the *Times* reporter to account for the fact that despite the veracity of each individual portrait, Brady's gallery displayed a gathering of individuals that could never actually take place. On an international level, no one could imagine that any other single room might contain Italian nationalist Garibaldi, Maximilian—the Austrian-born emperor of Mexico—and the editor of the *London Times*. "If the men themselves whose physiognomies are here displayed would but meet together for half an hour in as calm a frame of mind as their pictures wear, how vastly all the world's disputes would be simplified; how many tears and troubles might mankind still be spared!"[16]

The allusion to European upheaval could not mask the real message depicted on Brady's walls. The significance became clear when regarding portraits of

> the dead of history. Story and Calhoun . . . Adams, Jackson and Benton . . . here they are all in their lives so divided . . . as one now in the interest they all inspire and in the respect which enshrines their memories. Let the living, famous or unknown, pictured or unpictured, pause here and take a . . . lesson.[17]

But Brady's gallery could offer only a retrospective view. The real challenge came as artists sought to represent the present struggle. No known formula could encompass Washington's political strife. In June 1860, Brady fell back on an old strategy when he created a composite image that represented the Thirty-sixth Congress, combining individual portraits of all 250 members of the House and Senate into two enormous panels three by five feet, which he copied and sold as large photographs [Plate 30]. Every American recognized the historic character of this assembly, perhaps the last that the Union would ever convene. The *New York Times* reviewed Brady's images as an extraordinary political event. For the *Times*, this comprehensive picture showed "the House of Representatives as it really is, individually and collectively" and displayed all "the actors in the political drama now enacting on the federal stage." Brady's image was "both happy and grand. . . . The likenesses are excellent, the grouping is spirited and effective and the *tout ensemble* perfect."[18]

As political parties convened to select the candidates for the presidential election of 1860, sectional loyalties overwhelmed all other affiliations, especially among the Democrats. The first Democratic convention ended prematurely in April, when southern delegates withdrew from the proceedings. On a second meeting in June, Stephen A. Douglas won the nomination, and southern Democrats seceded from the

Composite of the
1860 Senate

Albumen silver print, 1860.

Library of Congress,
Washington, D.C.

Elmer Ellsworth

Albumen silver print (carte
de visite), 1861.

National Portrait Gallery,
Smithsonian Institution,
Washington, D.C.

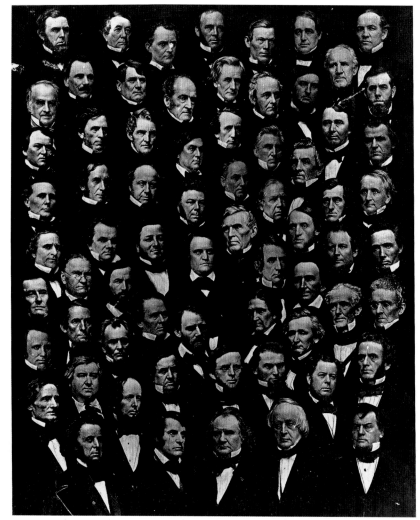

party altogether to support their own ticket, with John Breckinridge for President. Old Whig and American Party members met to form the Constitutional Union Party, as a conservative alternative to both Republicans and Democrats, with John Bell of Tennessee as the candidate. The Republicans met in Chicago and nominated Lincoln. Lincoln's victory came from his support in seventeen free states; his closest opponent, Breckinridge, won eleven slave states and no free states; Bell carried three slave states and no free states; and Douglas, who tried to appeal to both slave and free, won only two states, both free.[19]

The election took place on November 6, 1860. On December 20, South Carolina seceded from the Union. Six days later, Colonel Robert Anderson moved his troops to Fort Sumter in Charleston harbor, while South Carolina troops seized the federal arsenal on shore. During the first six weeks of 1861, the states of the lower South seceded one by one—Mississippi on January 9, Florida on January 10, Alabama on January 11, Georgia on January 19, Louisiana on January 26, and Texas on February 1.

Mrs. Clay described the last days of the Senate as a Greek tragedy: "Men wept and embraced each other mournfully. . . . There was everywhere a feeling of suspense, as if, visibly the pillars of the temple were being withdrawn and the great Government structure was tottering." By contrast, Henry Adams felt little emotion in contemplating the dissolution of the nation. In his eyes, secession had become inevitable, because "there was so little to secede from. The Union was a sentiment, but not much more."[20]

Throughout the fall of 1860 and the spring of 1861, as *Harper's Weekly* and *Frank Leslie's Illustrated Monthly* reported on the conventions, the election, and the process of secession, Brady's portraits continued to provide an invaluable resource. Engravings made from photographs by Brady accompanied terse biographies and short, suspenseful accounts of the unfolding events in Washington. The truly national character of Brady's gallery here comes clear, for he provided images of every figure, from every party and every state. Brady's collection and gallery became the last place in which it was possible to see the nation whole. With secession, and the establishment of the Confederacy, Brady's collection retained its value while its meaning changed. Once a reflection of national unity, it had become a source for portraits of heroes from both sides of the conflict. Brady's friend and former employee, George S. Cook, in Charleston, provided the E. & H. T. Anthony Company (and the press) with portraits from the South, including the first portrait of Colonel Robert Anderson. And because Elmer Ellsworth had stopped at Brady's Washington studio before beginning his tour of duty in Alexandria, Brady also sold many carte-de-visite portraits of the first Union casualty [Plate 31].

After the war, Mathew Brady and Alexander Gardner, who ran Brady's Washington studio, both claimed credit for inaugurating the effort that led them, and countless others, to send photographic wagons out into the field. In truth, the connection between this war and the camera was universal and immediate. According to one London reporter, cameras had already become a distinctive aspect of warfare when Roger Fenton accompanied the British army to the Crimea in 1855 and French photographers followed their army into the Italian peninsula. In addition to documenting the official progress of the troops, posing for camera portraits became part of a soldier's private ritual:

> The young Volunteer rushes off at once to the studio when he puts on his uniform, and the soldier of a year's campaign sends home his likeness that the absent ones may see what changes have been produced in him by war's alarms. In every glade and by the roadsides of the camp, may be seen all kinds of covered carts and

portable sheds. . . . Washington has burst out in signboards of ambrotypes and collodionists [who] follow the camps as well as they can.[21]

When the subjects were youthful soldiers as well as august political leaders, a metaphor that had once explained the relationship between photographic portraiture and history took on grim new implications. The war seemed to benefit "members of the mighty tribe of cameraists . . . in the same way that it has given an impetus to the manufacturers of Metallic air-tight coffins and embalmers of the dead" [Figure 7–5].[22]

As early as June 1861, the *Boston Transcript* observed that photographs would bring great profits to their makers. "Any photographer who would follow the Army . . . and be fortunate enough to obtain views of battles, or even skirmishes, would make a fortune by the sale of copies."[23] And by September, *Humphrey's Journal* asked, "Why should [Brady] monopolize this department. . . . What a field would there be for Anthony's instantaneous views and for stereoscopic pictures. Let other artists exhibit a little of Mr. Brady's enterprise, and furnish the public with more views."[24] A reporter for *Humphrey's Journal* expressed bias when he found Brady's images the sole reliable source of information:

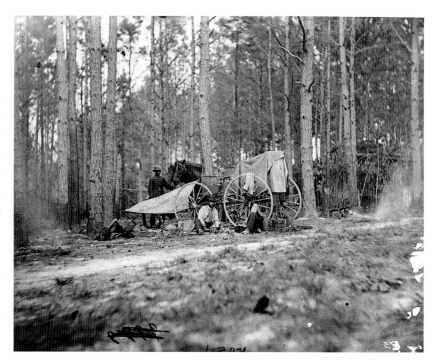

FIGURE 7–5

One of Mathew Brady's picture wagons

Albumen silver print, circa 1861.

National Archives, Washington, D.C.

> The correspondents of the rebel newspapers are sheer falsifiers, the correspondents of the Northern journals are not to be depended upon, and the correspondents of the English press are altogether worse than either; but Brady never misrepresents. He is to the campaigns of the republic what Vandermeulen was to the wars of Louis XIV.[25]

However, when this same reporter suggests that Brady made "the only reliable records of the fight at Bull's Run," we quickly begin to doubt him. Today, after more than a century and half, historians agree that no photographs survived the battle.[26] What could the reporter have seen? He continued, "The groupings of entire regiments and divisions, within a space of a couple of feet square, present some of the most curious effects as yet produced in photography." To these images the reporter added his own impressions of war, which gave an air of glamour to portraits of regiments present at the battle: "Considering the circumstances under which they were taken, amidst the excitement, the rapid movements and the smoke of the battlefield, there is nothing to compare with them in their powerful contrasts of light and shade."[27] Today it seems difficult to understand how a reporter could equate photographs of troops with graphic scenes of destruction. Sheer excitement could account for some of his enthusiasm on seeing the first photographic reports of an American battle. Soon, it would be impossible for anyone to mistake these portraits for grim documents.

At the same time, we have lost sight of the important role that portrait photography played during the war. Common expectations regarding Civil War photography have been dominated by the relatively small number of images that were published in the form of books, such as George N. Barnard's *Photographic Views of Sherman's Campaign*, with its ravaged landscapes, and in the even more familiar collection assembled by Alexander Gardner, the *Photographic Sketchbook of the War*. Out of the one hundred plates that Gardner published, about seventy-five show battlefields and landscapes, fewer than ten can be classified as portraits, and an additional fifteen show camp life, though few identify sitters by name. In the archive that Brady assembled in the course of his documentation of the war, these proportions are reversed. While one-quarter of Brady's images represent battlefields and ships, fully three-quarters are devoted to the representation of individuals, groups, and regiments.

Where did Brady go? Portraits made in camp, and with officers, document his presence at several important campaigns: the first battle of Bull Run (July 18, 1861), Antietam (September 1861), Gettysburg (July 3–5, 1863), Wilderness (May 1864), Petersburg (June 1864), and at City Point, with Generals Ulysses S. Grant and Ambrose E. Burnside and the Army of the Potomac. It is impossible to establish his movements with certainty. Moreover, because Brady continued to acquire prints and negatives long after the war was over, the actual itinerary of his teams of photographers cannot be determined from the archive alone.[28]

Brady's work can be understood as an extension of his earlier efforts to accumulate portraits of men who could claim some significance for the present, and for posterity. In addition, it provided an opportunity for the kind of grand flourish that Brady obviously enjoyed. It freed him from the studio, which after nearly twenty years must have come to seem predictable at best. Though the technology of the carte de visite raised efficiency and profits, its regular format and tiny size also robbed portraiture of much of its drama and art. Out in the field, Brady could continue to work with men of great fame, whose company gave him pleasure and whose reputations would, incidentally, enhance his own.

An undated description of Brady's gallery during the war years shows how thrilling it was for the public to see any visual representation of the battlefields, or of the leaders. In addition, Brady was clearly aware of the way in which his own prestige rose when he could obtain, and exhibit, portraits of the men whose names had become so well known. To one reporter, men like McClellan, Grant, and Sherman "are as brilliant but as distant from us as planets; it is a pleasure to have these planets photographed and be upon whispering terms with the Generals who are now to the nation as gods."[29]

In the field, Brady's operators and their sitters brought along a set of conventions that had become synonymous with the art of portraiture itself. They welcomed conditions that would mimic the empty, placeless setting of the studio, with its dreamy, constant light. Sitters assumed the heroic postures they had learned to hold with the help of iron posing stands and tables, though now they supported themselves against trees, camp furniture, and tent poles [Plate 32]. Though they are no longer confined by the studio walls or the reach of a skylight, groups are posed and organized in the same rhythmic, symmetrical clusters that studios required [Plate 33]. The outdoor setting introduced freshness to what had become clichés, as can be seen when officers pose with their horses in postures that recalled military portraits of the eighteenth century [Plate 34].

One British writer, familiar with Roger Fenton's photographs of Crimea, suggested that photographic pictures of warfare differed from earlier battle art. Not every change brought improvements. Because

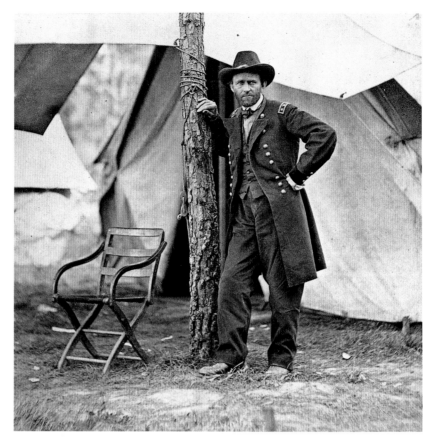

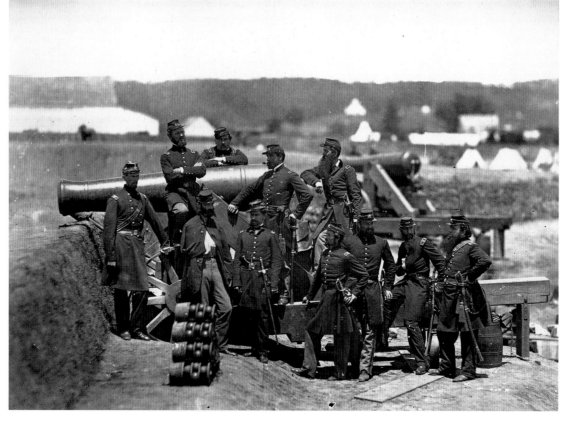

PLATE 32 (above)

Ulysses S. Grant

Albumen silver print, 1864.

National Portrait Gallery,
Smithsonian Institution,
Washington, D.C.

PLATE 33 (left)

Officers of the Sixty-ninth New York State Militia, Fort Corcoran, Virginia

Albumen silver print, 1861.

Library of Congress,
Washington, D.C.

PLATE 34 (opposite)

Joseph Hooker

Albumen silver print, 1863.

National Portrait Gallery,
Smithsonian Institution,
Washington, D.C.

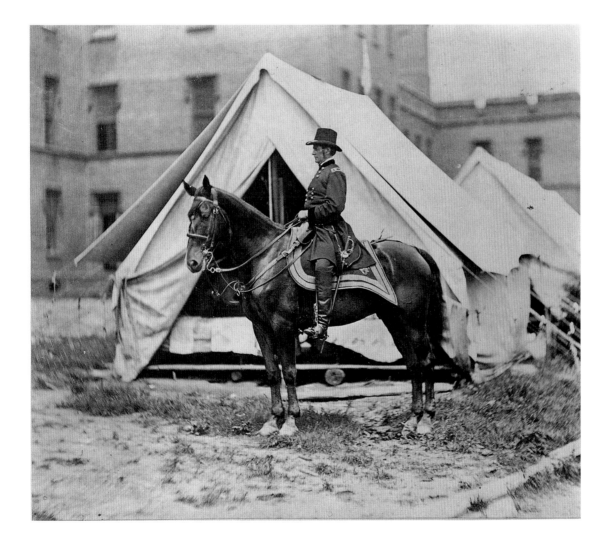

PLATE 35

Scenes of Camp Life–Army of the Potomac

Albumen silver prints
mounted on card, 1862.

Library of Congress, Washington,
D.C.

photographers made and exposed wet-plate negatives on the spot, they could not capture action. Photographers who followed modern armies had to be content with "conditions of repose, and with the still life which remains when the fighting is over." To some, this meant that photographs of modern warfare gave less information than the wall-sized battle scenes painted for the palaces of France and Germany a hundred years before. "It must be admitted . . . that the object of giving an idea of what a 'battle is like' . . . was then more successfully accomplished than it is likely to be by [photographs] as we know of them at present."[30]

In subtle ways, cameras captured information that effectively challenged the practice of portraiture at its very foundations. Traditionally, portraitists sacrificed transitory, incidental information in order to capture something more essential and lasting. In fact, the ideal quality of a portrait depended upon the portraitist's ability to separate the essential from the circumstantial, to depict a heroic character against a pure ground. While photographers remained in the studio, they were able to conform to these conventions. Once in the field, however, the photographers took advantage of the new environment; as a result, they gradually came to produce pictures that represented their subjects on entirely different terms [Plate 35]. As one writer explained, "Whatever he represents from the field must be real, and the private soldier has just as good a likeness as the General." These figures occupy a distinct place and time; the location of the camp, the hour of the day, the very objects that surround the sitter all fix the subject within a particular historical moment.

In 1862, when Brady exhibited photographs from Antietam at his studio on Broadway, he introduced his contemporaries to a peculiar modern phenomenon, in which the form of representation takes all precedence over content [Figures 7–6 and 7–7]. As the *Times* admitted, New Yorkers encountered war largely

FIGURE 7–6 (right)

Soldiers on the battlefield at Antietam

Albumen silver print by Alexander Gardner (1821–1882) at the Mathew Brady Studio, 1862.

National Archives, Washington, D.C.

FIGURE 7–7 (below)

A Contrast. Federal Buried; Confederate Unburied, Where They Fell on Battle Field of Antietam. No. 551

Albumen silver prints (stereo view) by Alexander Gardner (1821–1882) at the Mathew Brady Studio, 1862.

Bob Zeller

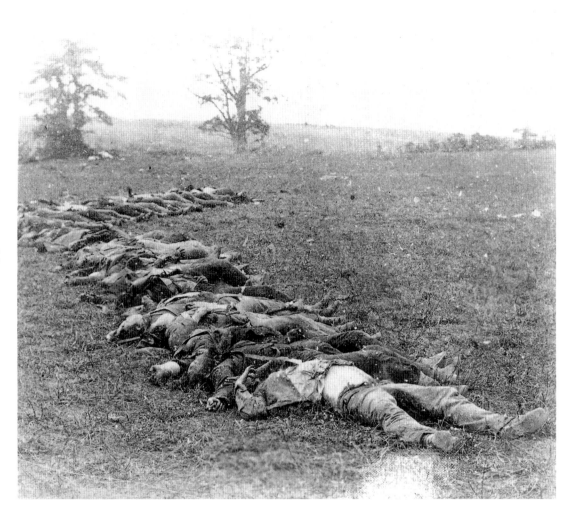

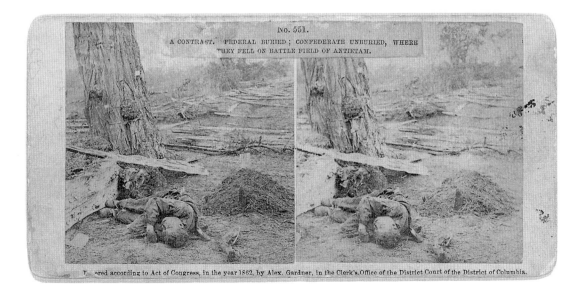

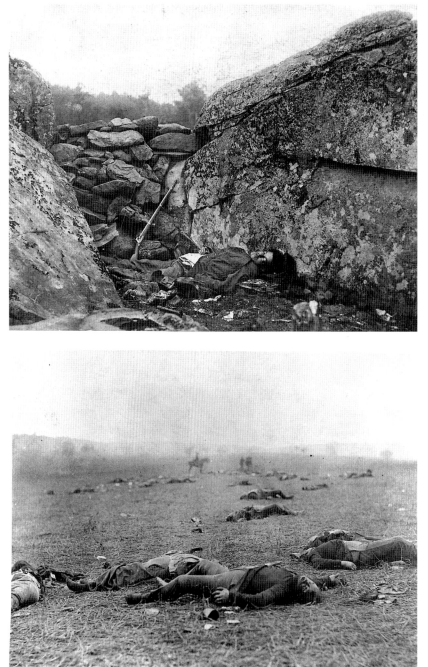

FIGURE 7−8 (left)

Home of a Rebel Sharpshooter, Gettysburg, July, 1863

Albumen silver print by Alexander Gardner (1821–1882), 1863.

National Archives, Washington, D.C.

FIGURE 7−9 (below)

A Harvest of Death, Gettysburg, July 1863

Albumen silver print by Timothy O'Sullivan (1840–1882), 1863.

National Archives, Washington, D.C.

as endless, printed lists of names, and the war was "like a funeral next door. . . . We recognize the battle-field as a reality, but it stands as a remote one." The reporter observed that "our sensations might be different if the newspaper carrier left the names on the battle-field and the bodies at our doors instead." According to the *Times*, Brady's photographs had "done something to bring home to us the terrible reality and earnestness of war. If he has not brought bodies and laid them in our door-yards and along the streets,

he has done something very like it." Crowds came to stare at the photographs, which were, in essence, a grim, inverted form of portraiture. The reporter noted

a terrible fascination . . . that draws one near these pictures, and makes him loth to leave them. You will see hushed, reverend groups standing around these weird copies of carnage, bending down to look in the pale faces of the dead, chained by the strange spell that dwells in dead men's eyes.

For Brady's audience, accustomed to gazing at portraits of the famous, the drama of these images revolves around their anonymity, a condition that seems unnatural or false. When the reporter imagines the mother who finds her son in such a scene, he turns an anonymous body into the lifeless corpse of a cherished son or brother, the transformation that Brady's rapt audience anticipates and dreads.[31]

These images were made by Alexander Gardner, and after Gardner left Brady's employment, Brady's operators seem to have shunned such difficult subjects. (Though, as Keith Davis notes, Brady's photographers recorded the dead at Fredericksburg on May 20, 1864.)[32] A good comparison between the styles of Gardner and Brady can be found in the work each firm produced on the battlefields of Gettysburg in July 1863. Gardner and his colleague, Timothy O'Sullivan, arrived just in time to photograph the battlefields where corpses lay, unburied [Figures 7–8 and 7–9]. Brady, who arrived only a week later, produced a very different record, comprising structures, vistas, and wide landscape views [Figures 7–10 and 7–11]. Though Brady's images lack the grim information that Gardner preserved, they satisfied readers of *Harper's Weekly*, for whom these nearly empty landscapes provided a screen on which they could project a private vision of the battle.[33]

An undated review of Brady's "Incidents of War" shows how these audiences turned landscapes into elaborate maps of memory, emotion, and the unconscious. These viewers could

recognize every mound and every hillock; each has its own story, its own mournful significance. . . . We have sent out our thousands to battle and there is scarcely a hearth in the whole broad land that has not had its

representative on each well-fought field. It was here that a son flashed his maiden sword, here a father fell, here one brother won an epaulet, another an epitaph. Go into the Gallery when you may and you will see crowds gather around these pictures, some with tearful eyes, some with eyes that brim with pride and all with swelling hearts. To one who has moved in the scenes represented, these pictures are pregnant with strange, sad reminiscences. . . . You recognize the very sycamore to whose base a young Lieutenant had crawled to die. You knew him, when a few seasons ago as school-boys you went nutting and bird-nesting together in the country.[34]

Critics also reveal the ways in which landscape views, however remote from battle, could still bring viewers close to the experience of war. When, in 1864, Brady exhibited portraits of generals along with images of Cold Harbor, Wilderness, Petersburg, and other camps and battlefields, *Harper's Weekly* remarked on the usual detail and veracity, but it was a more intimate association that gave the photographs power: "All who follow the army with their private hearts as well as their public hopes will see with curious satisfaction the roads, the fields, the woods, the fences, the bridges, the camps and the streams which are the familiar daily objects to the eyes of their loved soldier boys."[35] Brady's photographs allowed viewers to see the war through the eyes of their loved ones. Gardner's, by contrast, revealed the world that those soldiers would never see.

Even as early as 1860, it was clear that Brady's gallery contributed to the changed understanding of American heroes and history. In a review of that year, the *Times* anticipated that such images would "make common mortals of many a . . . living idol." But for Brady and his generation, the nation's past was still almost within reach of personal memory, and the future stretched ahead, a long, continuous procession of great men.

Brady and his first audiences believed that photography would preserve their heroes and their world forever. In fact, the reverse occurred. Over the next twenty years, Brady's gallery grew to include new politicians, new performers, new Presidents, and new heroes, but Brady could not fix the meaning that these faces had for their first viewers. His gallery comprised a record of the men (and the few women) who led the country in the middle of the century; at the same time, his collection provided a perfect representation of a certain ideal of heroism and citizenship that did not survive the war. What began as a lasting testament to an optimistic and ambitious era was transformed, almost overnight, into an assembly of the dead and forgotten.

The men who preserved the Union through compromise now appeared to be the ones who laid the foundations for war. The monumental heroes of the past did not preserve the nation, and after the war ended, their ideals of moderation and compromise inspired no one. Wartime values entered politics and, indeed, all postwar culture. The military itself was not immune, as the glamour and pomp of Scott and McClellan gave way to the ruthlessness and efficiency of Sherman and Grant. The condition of disillusionment affected North and South alike. In 1863, when the Confederate spy Rose Greenhow wrote from exile in London, the years before the war seemed "to belong almost to another state of being," and she compared that time to "the years before the Flood." Even worse, terrible memories cut her off from that pleasant time. "I look back to the scenes of that period through a haze of blood and horror."[36]

In essence, those who survived the war had themselves *become* the next generation. Brady and his audience no longer needed to imagine what posterity would see in all those faces. They knew that their chil-

dren would confront a collection of portraits of the men who had misled the country, and women in out-of-date gowns. In place of grand, monumental representations of deposed heroes displayed in an official gallery, the postwar audience sought portraits for their family albums, showing men and women who inspired more private memories. They preferred an old carte de visite sent home by a soldier, or the frank charm of a picture of an actress, to the stately portrait of a politician one no longer admired. James Parton could have been talking about Brady's gallery when in 1867 he used a brilliant metaphor to describe the status of citizens who led the nation before the war. "It is not merely that [their] work is done . . . but the thing upon which [they wrought] . . . has perished. . . . If the workmen have not all passed away, the work is at once finished and destroyed, like the Russian ice-palace, laboriously built, then melted in the sun."[37]

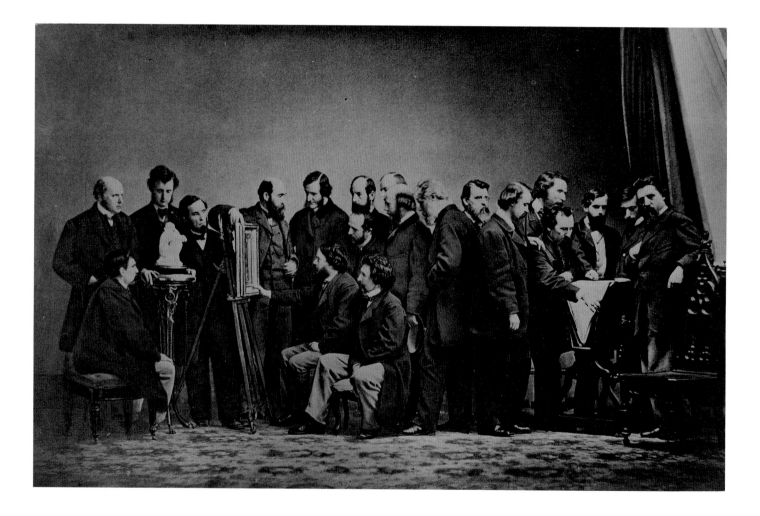

8

History as Image, Photography as Art

T hroughout his career, Mathew Brady stayed loyal to a vision produced by his colleagues Emanuel Leutze, G. P. A. Healy, Francis Bicknell Carpenter, and Alonzo Chappel, who depicted the history of the nation through portraits that linked past and present and prepared the way for future generations. This vision led Brady to collect and exhibit daguerreotype portraits of his contemporaries. It inspired him to go out into the battlefields of the Civil War to create an archive that would aid the historians of the future. It also caused him to produce images that would erode all confidence in the romantic history he cherished. Brady's failure to understand the true influence of his work lends great poignancy to the final chapter of his story, in which he fought to preserve the very portraits that made his own convictions obsolete.

Brady's daguerreotypes met the needs of antebellum New Yorkers, full of ambition, proud of American endeavor, and fascinated by celebrity. His portraits also fit the theatrical world of Washington of the 1840s and 1850s, where shifting presidential figures and a rigid supporting cast played to the public, and to posterity. In many ways these images resemble a speech or a performance, for Brady's daguerreotypes had to be seen in person. Then as now, the true, silvery nature of the daguerreotype eludes exact reproduction.

Extending the speech metaphor, one could say that daguerreotypes represent the political process that had preserved the Union. On the shining silver plates, the portraits appear remarkably sober and still; the fragile, unstable image suggests the precarious nature of the balance between rhetoric and actuality that enabled men like Webster, Clay, and Calhoun to devise the compromises that seemed to maintain the United States as a unified political body.

Contemporary intellectuals and historians such as Thomas Carlyle, Lord Macaulay, John Lothrop Motley, Francis Parkman, and George Bancroft regularly commented on the similarities between the writing of history, the art of history painting, and the performance of historical drama on stage. They found the three kinds of history joined with thrilling conviction in the novels of Sir Walter Scott. American critics observed a similar equation between history, art, and theater in the tableaux produced by John Trumbull, Samuel F. B. Morse, and Emanuel Leutze. Washington's politicians prided themselves on their ability to perform before the audiences that crowded the galleries of Congress. James Parton alluded to this view when he compared Washington's most successful citizens to "pictures expressly designed to be looked at from a distance [like] the scenery of a theater, for example." To Parton, these masters of imagery were a special breed, "formed by Nature to stand forth before multitudes, captivating every eye, and gathering in great harvests of love with little effort." He was not troubled if, upon close investigation, these pictures and these men lost some of their charm. As he reminded his audience, "'scenery' has as much right to exist as a Dutch painting which bears the test of the microscope."[1]

PLATE 36

Gentlemen's Committee on the Fine Arts for the Metropolitan Fair in Aid of the U.S. Sanitary Commission

Albumen silver print, 1864.

National Portrait Gallery, Smithsonian Institution, Washington, D.C.

Still, Brady's subjects eagerly sat for their daguerreotype portraits, even though these images invited close scrutiny. Like Parton's "Dutch painting," a daguerreotype portrait revealed the kind of information that brought its heroic actors down to the stature of ordinary men, and inevitably contributed to the collapse of their theatrical system. Nathaniel Parker Willis observed that old-fashioned, idealized portraits were as like their original sitters "as an elegiac poem is like the undertaker's bill for the same event. But would I prefer in that case a veracious daguerreotype . . . to rest my eyes upon? Certainly not." He frankly preferred his heroes with illusions intact. "And there is many a balloon of portrait-fame gracefully afloat for immortality which would be left behind if collapsed by a daguerreotype into a bundle of rags."[2]

A British critic reached similar conclusions when he saw Brady's photographs in the official United States section of the Great International Exhibition held in London in 1862. Not surprisingly, the national display was small, though some ambitious individuals entered the competitive international sections devoted to cotton gins, printing presses, and power looms, and one American critic felt that Brady's work belonged in the Photographic Section, alongside work by Nadar of Paris and Silvy of London. The reviewer for the *London Times* found Brady's photographs to be by far the most compelling part of the American section. Interestingly, he moved quickly past images of the *Monitor*, and battlefields near Yorktown and Richmond, to dwell on Brady's portraits, examining the faces of President Lincoln [Plate 37], members of his cabinet, southern politicians Jefferson Davis and Alexander Stevens, and generals from both Union and Confederate armies [Plate 38], among them P. G. T. Beauregard, Stonewall Jackson, Robert E. Lee, George B. McClellan, and Ambrose Burnside; there were also literary figures, like Henry Wadsworth Longfellow, and well-known women, including Mary Todd Lincoln and President Buchanan's niece, Harriet Lane. Revealing his political sympathies, the writer claimed that the men from the South appeared far more dignified than those from the North. But a more important response came to the form of the images, not their content. Despite finding the photographs to be of "lasting attractiveness," he noted, "We are too apt when looking at them now to forget that we are scanning the features of men who will be famous hereafter as actors in the greatest drama which the world has seen in the later ages."[3]

When a foreign reporter viewed these portraits far from the site of the struggle, he could not invest them with the meaning that they certainly had for Brady, for Brady's sitters, and for the American public that viewed them in Brady's gallery, in their own album collections, and in reproductions in illustrated magazines and journals. In London, the portraits of Lee, Lincoln, McClellan, and Beauregard aroused no associations, and formed no heroic pantheon; nor did they convey the majesty that might be expected from "men who

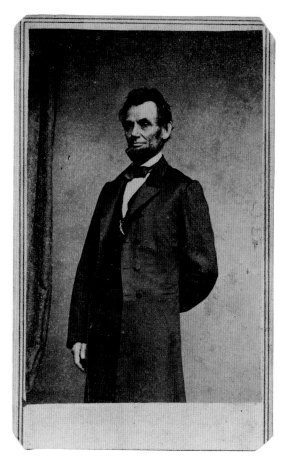

PLATE 37
Abraham Lincoln
Albumen silver print (carte de visite), 1864.

National Portrait Gallery, Smithsonian Institution, Washington, D.C.

**Winfield Scott Hancock,
David Bell Birney, and
their staffs**

Albumen silver print,
1863–1864.

National Portrait Gallery,
Smithsonian Institution,
Washington, D.C.

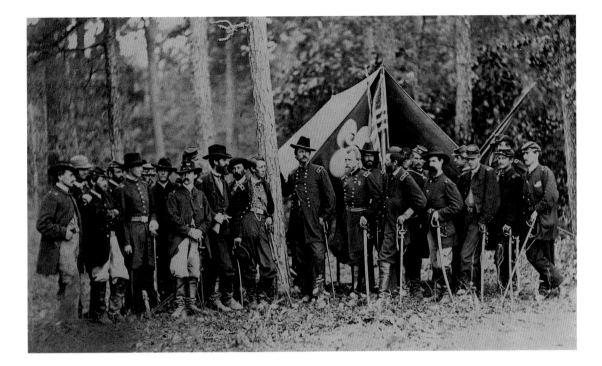

will be famous hereafter." Instead, these photographs simply represented men and women of the present day. Ironically, this British reporter's response anticipates that of the twentieth-century viewer. Time, historical circumstance, and profound changes in our approach to history, heroism, portraiture, and art separate us from Brady and his audience just as surely as nationalism, the Atlantic Ocean, and political preference divided Brady from his London critic.

Many journals reprinted this British review, including the *American Journal of Photography*, which strongly objected to its "secesh" politics. The *Journal*'s editors took even greater exception to the British writer's assigning Brady "the highest place" among American photographers. The editor acknowledged that Brady had attained "a pretty wide distinction" as "the photographer of the camp, and court. But no one here would think of according him the 'highest place' for skill in our art." In fact, "no intelligent photographer would offer Mr. Brady's photographs as a representative of the highest condition of the art in America."[4]

In retrospect, one could trace much of Brady's later unhappiness to this single, apparently casual, remark. By 1862, Brady had given up his place at the pinnacle of the American photographic community, because he had set his sights on another, grander goal. Brady began to see himself as an artist, entrepreneur, and historian, the creator of a national pictorial archive. In 1863, *Harper's Weekly* called him the "Father of American photography" and defined his collection as "material for history of the very highest value."[5] Endless articles referred to the historical value of his collected portraits. However, contemporary notions of history as a form of art had altered, due in part to Brady's own enterprise.

Early in 1866, Brady had initiated a campaign to sell his entire archive to the New-York Historical Society, then the city's leading institution for art. He called his work "Brady's National Historical Collection" and set the high price of $30,000 on his prints and negatives. Brady revived all the old arguments to

justify the value of his archive, calling his work "an essential auxiliary to future historical inquiry." His "really faithful representation of important scenes and actions" and extensive portraits of distinguished men and women were both significant relics and modern innovations. "Photography was never before applied to so important an object and it rarely, if ever, produced such brilliant and satisfactory results."

Again, Brady linked his photographs to earlier attempts to represent the Founding Fathers, imagining the aid his images would have provided to past historians and history painters. He also assumed that history and historical art would continue to be based on biography and on portraits like the ones he had worked so hard to assemble. To promote his views, Brady solicited the help of all of his old friends. In New York, at the National Academy of Design, Daniel Huntington, Henry Peters Gray, Thomas Hicks, and Emanuel Leutze endorsed Brady's offer, calling it the "nucleus of a national historical museum, reliable authority for Art and illustrative of our history." General Ulysses S. Grant wrote Brady from army headquarters in Washington to congratulate him on plans for a permanent exhibition of his work.

The press warmly commended Brady's effort. Now, "the memorable scenes and personages of that eventful struggle are not . . . left wholly without a witness. . . . The faithful camera . . . has written a true history of the war." Best of all, Brady's images enabled the viewer to see with the perspective of history,

and in imagination project himself into an historical point of view. It is not merely what these representations are to us, but what they will be to those that come after us, and to whom the scenes that have passed before us will be visible only through the purple haze of history. . . . It is because man is essentially a historical creature; because he is bound by mysterious ties of interest and affection to the past; because he "looks before and after," that we desire to see the large and valuable collection of Mr. Brady . . . fitly placed for permanent preservation and exhibition.[6]

But the sale did not take place.[7]

Why did the effort fail? The price was high—but not so far from the $25,000 that Brady obtained when he finally sold a large group of negatives to the United States government in 1872. It could be that Brady's work was simply too easy to obtain. His most popular images had reached the marketplace in many forms: both Brady and Anthony published thousands of cartes de visite and stereo views; numerous images had already appeared before the public as woodcuts in *Harper's* and *Leslie's* illustrated magazines. By the end of the war, plenty of other photographers had accumulated archives of their own and had found ways to present their work before the public. In 1866, Alexander Gardner published his *Sketchbook*, and George N. Barnard issued one hundred copies of his photographs entitled *Sherman's March through Georgia*. In November of that year, the *Evening Post* gave the latter a favorable review and ended with a note, "We suggest to Mr. Brady, who, perhaps more than any other of his profession, has photographed the actual incidents of the war, the expediency of preparing from his varied and interesting material a popular album similar to the work of Mr. Barnard."[8]

Another answer lies in the fact that Brady intended his images for a special audience. Brady believed that his archive would allow future historians and artists to represent their time-honored subjects with greater veracity. He imagined that with the help of his photographs, artists would be able to create more compelling illusions, and make truly American pictures.

Oliver Wendell Holmes, famously, reached a different conclusion when he confronted photographs made by Brady's photographers at Antietam. Holmes himself had gone to the battlefield to search for his son, who had fought there. Months later, he found Brady's images almost unbearable to look at,

so nearly like visiting the battlefield . . . that all the emotions exerted by the actual sight of the stained and sordid scene strewed with rags and wrecks came back to us and we buried them in the recesses of our cabinet as we would have buried the mutilated remains of the dead they too vividly represented.[9]

Holmes courageously acknowledged that these new pictures inspired a strong emotional reaction, far different from the one Brady anticipated. Holmes insisted that

war and battles should have truth for their delineator. . . . It is well enough for some Baron Gros or Horace Vernet to please an imperial master with fanciful portraits of what they are supposed to be. The honest sunshine . . . gives us . . . some conception of what a repulsive, brutal, sickening, hideous thing it is, this dashing together of two frantic mobs to which we give the name of armies.[10]

This response signaled the end of glorious historical paintings like the ones that Brady and his artist colleagues had produced, though the genre faded very slowly. New standards of evidence and verisimilitude led some, like Carpenter in the *Emancipation Proclamation* and Healy in *The Peacemakers*, to paint modern records of historical events in which men gathered sedately around conference tables. Even Brady tried his hand at such pictures, as shown in his portrait *Managers of the . . . Impeachment of Andrew Johnson*, with a genteel interior painted into the background [Figure 8–1]. Others, including Chappel, Peter F. Rothermel, and Robert W. Weir, turned to colonial subjects, where a paucity of documentary evidence provided more room for fanciful reconstruction. Leutze himself turned away from the celebration of specific histor-

ical events in favor of "emphatically original and American . . . characteristics that neither art nor litera-
ture have yet dealt with . . . producing new forms of artistic beauty from the natural features of the Rocky-
Mountain region" populated by nameless hunters and wanderers—the painting now known as *Westward
the Course of Empire Takes Its Way*. When Nathaniel Hawthorne came to Washington in 1862, it was "an ab-
solute comfort . . . to find Leutze so quietly busy at this great national work . . . beautifying and idealizing
our rude, material life, and thus [demonstrating] a more enduring national existence."[11]

Henry James, in his complex discussion of Emanuel Leutze's masterpiece, *Washington Crossing the
Delaware*, was able to describe this shift in terms of both form and content [Figure 8–2]. Though he men-
tions no date, James's first encounter with this painting most certainly took place in October 1851, when
it was exhibited at the Stuyvesant Institute in New York City, and James was seven or eight years old. On
a rare evening excursion, the whole James family saw the painting illuminated by gaslight. Henry James
remembered the event as his first encounter with a three-dimensional illusion, and his excitement on dis-
covering "the capacity of accessories to 'stand out.'" Everything about the image thrilled him, "the marvel
of wintry light . . . the sharpness of the ice-blocks . . . the sickness of the sick soldier . . . the protrusion of
the minor objects . . . the profiled national hero's purpose," and he long cherished the memory of the spec-
tacle. When, as an adult, he saw the painting again, none of the glamour remained. He cited this story as
a fable of "the cold cruelty with which time may turn and devour its children." James was shocked to find
that Leutze's painting now seemed "lividly dead—and that was bad enough. But half the substance of one's
youth seemed buried with it."[12] With his innate gift for irony, James could mourn his youthful illusions with-
out wanting to reinstate them, but more commonly, the painful loss of cherished ideals inspired cynicism.

Immediately after the war, audiences found it impossible to welcome a glorious rendering of patriotic
portraits. In the 1860s and 1870s, many visitors to Brady's gallery simply encountered unpleasant re-
minders of the past. In 1867, the *New York Times* returned to Brady's montage portraits of the House and
Senate of 1860 and saw just a clumsy assembly of has-beens, "large pictures, of no artistic merit whatever
. . . merely collections of faces, massed together without any attempt at arrangement." The disorderly, but
complete, composite that once inspired patriotic emotion and vivid recollection of the Congress that had
endured secession, had become simply an item of curiosity, "most interesting . . . to the historian and to the
student of history."[13] Changes in the perception of other public figures, especially government officials,
also altered the value of Brady's collection. In 1877, when Brady invited members of Congress to his
Washington gallery, one reporter dutifully observed that "one can get very sentimental and do a deal of
philosophizing in Brady's as we look upon face after face of prominent men," but he again reached conclu-
sions that differed from the swooning reverence of an earlier generation. This time, the reporter found
"pictures of all the intellectual idiots of the present day, which will be valuable some years from now as a
souvenir of the days of ungrammatical wisdom."[14]

In 1860, the *New York Times* had predicted that future generations would turn to Brady's photographs
to learn "what manner of men and women we Americans of 1860 were."[15] His audiences saw (or thought
they saw) the present as it would appear to future generations, and the illusion was entrancing. Brady and
his supporters believed that these images would provide a resource for future historians, and that new
forms of representation promised access to subjects that had been virtually impossible to contemplate.
Conventions of heroic portraiture shifted, as few modern politicians could sustain idealized trappings once
ubiquitous carte-de-visite portraits had placed their faces alongside relatives and friends in family albums.

The family album allowed everyone to construct a private gallery and create a different kind of national narrative, in which mothers and fathers appeared alongside generals, Presidents, and celebrities.

The practice of writing history changed as well, and when historians looked for objective facts, they turned to the camera to supply information that seemed to come without bias. Where history was once a fictive narrative seen through "purple haze," or "a formal thing, sometimes bedaubed with patriotic rouge and oftentimes a dry and lifeless skeleton," photography would enforce new standards and provide the kind of information that older historians had never asked for. A modern chronicler, who might ask about the experience of war from a common soldier's point of view, would have someplace to turn:

> It is safe to say, that if hereafter one of the succeeding generation shall attempt . . . to figure to himself what manner of man a private soldier, Federal or Confederate was. . . . Then with what satisfaction will he turn to these faithful photographs in which the very shapes of men and scenes are bodied forth![16]

But sometime after 1870, a lone journalist, in a column titled "History in Art," reconsidered the interpretation of photographs. His views help show how Brady could continue to believe in the goals that united history, photography, and art. For this writer, Brady's gallery was "a museum for reflection," which demonstrated the capacity of photographs to arouse the imagination [Plate 39]. "As you gaze upon them memory recalls a thousand incidents public, personal and peculiar." He admitted that photographs had not always inspired emotion, and "gave little play at first to the imagination. The copies were so exact as to be lifelike, and the artist, who loved to revel in gay colors and impossible beauty, whose figures and faces were rather those of gods and goddesses than of men and women, disdained the aid of . . . a machine." But this account suggests that perception had changed. For this writer, photography was "no longer a mere register of human lines and curves. It aspires to eminence in the spiritual, and it is succeeding."[17]

Brady's gallery was, in this view, especially well suited to the telling of a complex American story. The comprehensive nature of the collection seemed to provide a way to think about the war as part of the history of the nation. The composite views of 1860 formed "the most interesting part of his collection," preserving "the likenesses of the senators and representatives . . . who took part in the great historical legislation that preceded secession and rebellion." At the same time, the portraits' monumental style set the figures of wartime within a larger artistic context.

> Grace of attitude and dignity or beauty of expression are not now the exclusive gift of the painter. It would be well to let the whole story be first told by the photographic process. It can offend no patriotic heart, and would be a lesson to an endless and grateful posterity.[18]

When twentieth-century audiences returned to Brady's archives, they sincerely valued the detailed records of heroes and battlefields, but the "spiritual" quality of the pictures elicited their lasting admiration. Neither enthusiastic amateurs like Roy Meredith nor trained historians like Arthur Schlesinger Jr. or Francis Trevelyan Miller stopped to see that these information-filled images were also carefully considered works of art. In one sense, the confusion between fiction and history had been present from the start, though attitudes toward history and the Civil War kept changing. Brady's contemporaries wanted to forget the war, while Miller and Meredith and Schlesinger wanted to remember it. All gratefully turned to Brady for evidence that they could trust.

Today we can celebrate Brady's many achievements—his early leadership in photographic technology, his pioneering work with painters and publishers, his attempt to document the war—and we can admire his great energy, which finally brought his collection to the nation, where it functions as he hoped it would, to preserve the memory of a heroic chapter of our history. But it is important to remember that Brady built his work on the foundation established by Leutze and his followers. By infusing old-fashioned romantic vistas with the precision, detail, and documentary authority of photographic images, Brady's images gave their constructed artistic history new life.

If we prefer to keep our confidence in Brady and his operators, there is a good reason we seek refuge here. Brady saw no need to separate truth from art. He knew that history and memory could not be split apart. He strived to create an ideal historical territory for the American people, and he was successful. Today we occupy the past that he made from photographs.

PLATE 39

McPherson's Woods— Wheat Field in Which General Reynolds Was Shot

Albumen silver print, 1863; printed later.

National Archives, Washington, D.C.

NOTES

CHAPTER 1. INTRODUCTION

1. Quoted from an undated clipping in the Mathew Brady Scrapbook, Brady/Handy Collection, Library of Congress (hereafter MBS/LC).

2. One of the best sources on this period remains Constance Rourke, *Trumpets of Jubilee: Henry Ward Beecher, Harriet Beecher Stowe, Lyman Beecher, Horace Greeley, P. T. Barnum* (New York: Harcourt, Brace, 1927); on Barnum himself, the best single source remains Neil Harris, *Humbug* (Chicago: University of Chicago Press, 1973). On the formation of middle-class American culture, I was aided immensely by Lawrence Levine, *Highbrow/Lowbrow: The Emergence of Cultural Hierarchy in America* (Cambridge: Harvard University Press, 1988), and Karen Halttunen, *Confidence Men and Painted Women: A Study of Middle-class Culture in America, 1830–1870* (New Haven, Conn.: Yale University Press, 1982). On the emergence of the public sphere, the most important texts have been Benedict Anderson, *Imagined Communities* (London: Verso Books, 1983) and the authors of *Habermas and the Public Sphere*, ed. Craig Calhoun (Cambridge: The MIT Press, 1992), especially Mary P. Ryan and Michael Warner.

3. For the best discussion of this topic from a literary point of view, see David Levin, *History as Romantic Art* (Stanford, Calif.: Stanford University Press, 1959).

4. On class and society in antebellum New York, see Sean Wilentz, *Chants Democratic: New York City and the Rise of the American Working Class, 1788–1850* (New York: Oxford University Press, 1984); Christine Stansell, *City of Women: Sex and Class in New York, 1789–1860* (New York: Alfred A. Knopf, 1986); Elizabeth Blackmar, *Manhattan for Rent, 1785–1850* (Ithaca, N.Y.: Cornell University Press, 1989); Mary P. Ryan, *Women in Public: Between Banners and Ballots* (Baltimore, Md.: Johns Hopkins University Press, 1990); and Peter F. Buckley, *To the Opera House: Culture and Society in Antebellum New York* (forthcoming).

5. George Forgie, *Patricide in the House Divided: A Psychological Interpretation of Lincoln and His Age* (New York: W. W. Norton, 1979); also R. W. B. Lewis, *The American Adam: Innocence, Tragedy, and Tradition in the Nineteenth Century* (Chicago:

University of Chicago Press, 1955). On history painting, see Barbara Groseclose, *Emanuel Leutze, 1816–1868: Freedom Is the Only King* (Washington, D.C.: National Collection of Fine Arts, 1975), and William Truettner, "Art of History: American Exploration and Discovery Scenes, 1840–1860," *American Art Journal* 14, no. 1 (Winter 1982): 4–31.

6. C. E. Lester, "M. B. Brady and the Photographic Art," *Photographic Art-Journal* (1851): 36–40; George Alfred Townsend, "Still Taking Pictures," *New York World*, April 12, 1891.

7. Henry Wysham Lanier, "Photographing the Civil War," in *The Photographic History of the Civil War*, ed. Francis Trevelyan Miller, 10 vols. (1911; reprint, with a new introduction by Henry Steele Commager, New York: Thomas Yoseloff, 1957), vol. 1, pp. 21–54. Examples of Meserve's publications include Frederick Hill Meserve, *The Photographs of Abraham Lincoln* (New York: privately printed, 1911) and *Portraits of the Civil War Period* (New York: Corlies, Macy, & Co., 1903); also see Dorothy Meserve Kunhardt, *Twenty Days: A Narrative in Text and Pictures of the Assassination of Abraham Lincoln . . .* (New York: Harper & Row, 1965).

8. Beaumont Newhall, *The History of Photography from 1839 to the Present Day*, 5th ed. (New York: Museum of Modern Art, 1982), p. 34.

9. Camille Recht, *Die alte photographie* (Paris and Leipzig: H. Jonquieres, 1931). For a general history of the movement to rediscover American literature, see Richard Ruland, *The Rediscovery of American Literature* (Cambridge: Harvard University Press, 1967), also Joan Shelley Rubin, *Constance Rourke and American Culture* (Chapel Hill: University of North Carolina Press, 1980). Important primary texts in this movement include Van Wyck Brooks, *America's Coming of Age* (1915; reprint, New York: Octagon Books, 1975); Constance Rourke, *Trumpets of Jubilee* and *American Humor: A Study of the National Character* (New York: Harcourt, Brace, 1931); and a series of books written by Lewis Mumford in the 1920s and 1930s, including *The Golden Day: A Study in American Literature and Culture* (New York: W. W. Norton, 1926), *Sticks and Stones: A Study of American Architecture and Civilization* (New York: Boni & Liveright, 1925), *Melville* (New York: Harcourt, Brace, 1929); and *The Brown Decades: A Study of the*

Arts in America (New York: Harcourt, Brace, 1931). My own interest in this subject has been greatly influenced by David D. Hall and Cecelia Tichi. I am also grateful to Peter Barr, who shared a chapter of his dissertation, "Becoming Documentary: Berenice Abbott's Photographs, 1925–1939" (Ph.D. diss., Boston University, 1997).

10. Robert Taft, *Photography and the American Scene: A Social History, 1839–1889* (1938; reprint, New York: Dover Publications, 1964).

11. Roy Meredith, *Mr. Lincoln's Camera Man* (New York: Charles Scribner's Sons, 1946); "Mr. Lincoln's Camera Man," *Book Review Digest* (1946): 565–66; "Mr. Lincoln's Camera Man," *The New Yorker* (February 23, 1946): 88.

12. James Horan, *Mathew Brady, Historian with a Camera* (New York: Crown Publishers, 1955); Josephine Cobb, "Mathew B. Brady's Photographic Gallery in Washington," *Records of the Columbia Historical Society* 53–56 (1953–1956): 28–69; Dorothy Meserve Kunhardt and Philip B. Kunhardt Jr., and the editors of Time-Life Books, *Mathew Brady and His World: Produced by Time-Life Books from Pictures in the Meserve Collection* (Alexandria, Va.: Time-Life Books, 1977).

13. Richard Rudisill, *Mirror Image: The Influence of the Daguerreotype on American Society* (Albuquerque: University of New Mexico Press, 1971); Alan Trachtenberg, *Reading American Photographs: Images as History, Mathew Brady to Walker Evans* (New York: Hill and Wang, 1989); Barbara McCandless, "The Portrait Studio and the Celebrity: Promoting the Art," *Photography in Nineteenth-Century America*, ed. Martha A. Sandweiss (New York and Fort Worth: Harry N. Abrams and the Amon Carter Museum, 1991), pp. 48–75; Michael L. Carlebach, *The Origins of Photojournalism in America* (Washington, D.C.: Smithsonian Institution Press, 1992).

14. Arthur M. Schlesinger Jr., "Mathew B. Brady, Photographer," *New York Times Book Review*, February 16, 1946, pp. 1, 23. Schlesinger also took the opportunity to deride those photographers after Brady who discounted the documentary nature of the medium in order to attain the status of artists. He concluded with a nod to Walker Evans as the inheritor of Brady's legacy.

15. Robert Penn Warren, *The Legacy of the Civil War* (Cambridge: Harvard University Press, 1961), pp. 3–4. I am grateful to R. W. B. Lewis for bringing this text to my attention.

CHAPTER 2. A BRIEF BIOGRAPHY

1. Death certificate, reprinted in Horan, *Mathew Brady*, p. 88; *Doggett's City Directory* (1843–1844), p. 46; "Report of the Judges on Daguerreotypes," *American Institute 1844 Fair* and "Report of the Judges on Daguerreotypes," *American Institute 1845 Fair*, both in the New-York Historical Society, New York City. The American Institute was an association of scientists, businessmen, and entrepreneurs who promoted American enterprise through annual industrial fairs throughout the middle decades of the nineteenth century.

2. Marmaduke Sampson, *Rationale of Crime, and Its Appropriate Treatment*, with notes and illustrations by Eliza W. Farnham (1846; reprint, with a new introductory essay by W. David Lewis, Montclair, N.J.: Patterson Smith, 1973); Madeleine B. Stern, "Mathew B. Brady and the Rationale of Crime: A Discovery in Daguerreotypes," *Quarterly Journal of the Library of Congress* 31 (July 1974): 127–35.

3. "Art Items," *New-York Tribune*, March 19, 1860, p. 6, March 21, 1860, p. 7; "Portraits of Irving," *Home Journal*, May 5, 1860, pp. 1–2; "Letter from New York," *Boston Transcript*, March 29, 1860, pp. 1–2. "Topics Astir," *Home Journal*, March 31, 1860, p. 5.

4. Colonel T. B. Thorpe, "Webster, Clay, Calhoun and Jackson: How They Sat For Their Daguerreotypes," *Harper's Monthly Magazine* 38 (May 1869): 787–89. Though Thorpe does not name Brady, Brady does repeat some of these stories in later interviews, such as Henry George Jr., "From Brady's Gallery: Portraits Taken by the Famous Washington Photographer," *The Times* (Philadelphia), February 12, 1893; see also Townsend, "Still Taking Pictures," *New York World*, April 12, 1891.

5. On the *Gallery* and its publication, see Lester, "M. B. Brady and the Photographic Art" and "New Books," *Home Journal*, February 9, 1850. Additional reviews and information about unpublished images appear in a unique advertisement, "To the Trade and the Public/A National Tribute to Our Great Men/ The Gallery of Illustrious Americans," *Literary World* 7, no. 4 (July 27, 1850): 80–81; unpublished portraits

include DeWitt Clinton and Washington Irving; many thanks to Richard Rosenthal for making this publication available. Also see William F. Stapp, "Daguerreotypes onto Stone," in *American Portrait Prints*, ed. Wendy Wick Reaves (Charlottesville, Va.: University Press of Virginia, 1984), pp. 194–231; and Trachtenberg, *Reading American Photographs*, pp. 33–52.

6. Horace Greeley, "Report on the Crystal Palace Exposition," *Daguerreian Journal* 2 (1851): 19; for this quote and other accounts of the American photographic triumph at the Crystal Palace Exposition see Taft, *American Scene*, p. 69 ff. The Brady/Handy Collection at the Library of Congress includes portraits of Faraday and Elgin.

7. Brady's new gallery received many reviews, including "Brady's Daguerreotype Establishment," *Humphrey's Journal* (June 15, 1853): 73–74; see also Rudisill, *Mirror Image*, p. 202. On the signs of the middle-class businessman, see Stuart Blumin, "Black Coats to White Collars," in *Small Business in American Life*, ed. Stuart W. Bruchey (New York: Columbia University Press, 1980), pp. 100–121; and Blumin, *The Emergence of the Middle Class* (Cambridge, England: Cambridge University Press, 1989).

8. A lengthy and tedious dispute over ownership of the ambrotype patent brought an end to Brady's use of this medium. A discussion of the debate can be found in William Welling, *Photography in America: The Formative Years, 1839–1900* (New York: T. Y. Crowell, 1978), pp. 110–12; see also Taft, *American Scene*, pp. 123–29.

9. "Photographs," *The Crayon* 1, no. 18 (May 2, 1855): 287.

10. Register, R. G. Dun & Co., New York Volume 368, p. 442, Baker Library, Graduate School of Business, Harvard University.

11. On Brady's Washington gallery, see Gail Hamilton, "Brady's Gallery," *National Era*, March 24, 1859, p. 46; also "History in Art," undated clipping, MBS/LC; and Josephine Cobb, "Brady's Photographic Gallery in Washington," *Records of the Columbia Historical Society* (1953–1956).

12. Brady entered into an agreement with E. & H. T. Anthony to print and distribute cartes de visite made from his negatives. Eventually Anthony acquired sole ownership of these negatives, which were probably used to settle Brady's debts to the company. Anthony continued to print these images through the end of the century. Early in this century, Frederick Hill Meserve acquired these negatives from the successors to the Anthony firm. For additional information on the relationship between Brady and Anthony, see William and Estell Marder, *Anthony: The Man, the Company, the Cameras* (Amesbury, Mass.: Pine Ridge Publishing Co., 1982), pp. 176–80; also see Jeana K. Foley's essay in this volume.

A comic story told by a fictional victim of this celebrity system reveals a great deal about its structure. In this case, the hero traces illicit copies of his portrait to an original carte de visite bought from his own son, in exchange for a carte de visite portrait of an exotic dancer. See "My First Carte de Visite," *American Journal of Photography* 5, no. 17 (March 1, 1863): 385–92.

13. For more information on Alexander Gardner, see Brooks Johnson, *An Enduring Interest: The Photographs of Alexander Gardner*, with contributions by Susan Danly, Paula Fleming, Donald McCoo, Lloyd Ostendorf, and William F. Stapp (Norfolk, Va.: The Chrysler Museum, 1991).

14. On Brady's "Cooper Union" portrait of Lincoln, see George, "From Brady's Gallery," and Charles R. Macloon, "War Time Pictures: Brady, the Washington Photographer, and His Valuable Work," *Chicago Evening Post*, February 11, 1893, p. 5. The visit from the Prince of Wales was widely reported in the daily press, including the *New York Times*, October 14, 15, and 16, 1860. For a typical contemporary discussion of this medium see "Cartes de Visite," *American Journal of Photography* 4, no. 12 (November 15, 1861): 265–68; reprinted from the *Art-Journal*. A whole generation of photographers stepped down as a result of this innovation, including such fine photographers as J. W. Black in Boston and John Moran and Marcus Root in Philadelphia. The best and most complete account of this photographic form is Elizabeth Anne McCauley, *A. A. Disderi and the Carte de Visite Portrait Photograph* (New Haven, Conn.: Yale University Press, 1985).

15. Brady's move to Tenth Street also inspired numerous reviews, including "Brady's New Photographic

Gallery, Broadway and Tenth Street," *Frank Leslie's Illustrated Newspaper* 11 (January 5, 1861): 186; "A Broadway Valhalla," *New York Times*, October 6, 1860; "Art," clipping from unidentified source, MBS/LC.

16. Townsend, "Still Taking Pictures," *New York World*, April 12, 1891.

17. On the story of Brady's negotiations with the New-York Historical Society, see Helena Zinkham, "Pungent Salt: Mathew Brady's 1866 Negotiations with the New York Historical Society," *History of Photography* 10 (January–March 1986): 1–8. No single source documents Brady's later years. Additional information about bankruptcy proceedings against Mathew Brady is in the National Archives.

18. The United States Census found Brady in Washington in 1870, where he lived in a boarding-house and declared his profession to be "artist." For a detailed discussion of his negotiations with the United States government for the sale of his collection, see Jeana K. Foley's essay in this volume. Information on Brady's 1881 sale of the painted portraits can be found in Charles E. Fairman, *Art and Artists of the Capitol of the United States of America* (Washington, D.C.: United States Government Printing Office, 1927), pp. 291, 321. According to Fairman, when Brady sold these paintings to the government, he insisted that Darby had been present in his studio, but worked independently, though earlier descriptions of these portraits prove Brady's 1881 story wrong.

19. Information on Brady's last years appears in several obituaries, including "Matthew [*sic*] B. Brady Dead," *Photo-American* 7 (February 1896): 114–15; "In Memoriam —M. B. Brady," *Wilson's Photographic Magazine* 33 (1896): 121–23.

20. "An Old Time Photographer and His Reminiscences," *Photographic Times* 25 (October 5, 1894): 226, from *Washington Evening Star*; George, "From Brady's Gallery," *The Times* (Philadelphia), February 12, 1893; and G. A. Townsend, "Brady: The Grand Old Man of American Photography," *Photographic Times* 21 (June 19, 1891): 301–3, reprinted from *New York World*, "Still Taking Pictures."

21. Samuel P. Avery, "Tribute to M. B. Brady's Memory," *New York Daily Tribune*, January 18, 1896, p. 4.

CHAPTER 3. "A PERFECT KALEIDOSCOPE": NEW YORK CITY

1. Many pleasures accompany research on New York City, not the least being the chance to consult the work of many gifted historians, most recently: Sean Wilentz, *Chants Democratic*, Christine Stansell, *City of Women*, Peter F. Buckley, *To the Opera House*, Elizabeth Blackmar, *Manhattan for Rent*, Iver Bernstein, *The New York City Draft Riots: Their Significance for American Society and Politics in the Age of the Civil War* (New York: Oxford University Press, 1990), and Seymour J. Mandelbaum, *Boss Tweed's New York* (1965; reprint, with a new introduction, Westport, Conn.: Greenwood Press, 1981). A less scholarly, but no less important, resource for this project has come from contemporary guides to architecture, especially David W. Dunlap, *On Broadway: A Journey Uptown over Time* (New York: Rizzoli, 1990), *The AIA Guide to New York City*, 3d ed. (San Diego: Harcourt, Brace, Jovanovich, 1988), and John A. Kouwenhoven's *Columbia Historical Portrait of New York* (1953; reprint, New York: Harper & Row, 1972). Older sources offer an important Victorian perspective on their subject, especially the authors of *The Memorial History of the City of New-York, from Its First Settlement to the Year 1892*, ed. James Grant Wilson, 4 vols. (New York: New-York History Company, 1893), and Isaac Newton Phelps Stokes, *The Iconography of Manhattan Island, 1498–1909*, 6 vols. (New York: Robert H. Dodd, 1915–1928).

2. See Wilson, ed., *Memorial History*, vol. 3, pp. 413–77; Mandelbaum, *Boss Tweed*, p. 12.

3. Cornelius Mathews, *The Pen and Ink Panorama of New-York City* (New York: J. S. Taylor, 1853), p. 15; Junius Henri Browne, *The Great Metropolis: A Mirror of New York* (1869; reprint, New York: Arno Press, 1975), p. 28.

4. *Home Journal*, August 27, 1859, p. 1.

5. Henry James, *A Small Boy and Others* (New York: Charles Scribner's Sons, 1913), p. 277.

6. Ibid., p. 68.

7. Ibid., pp. 67, 173.

8. James Fenimore Cooper, *Home as Found* (1838; reprint, with a new introduction by Lewis Leary, New York: Capricorn Books, 1961), p. 103.

9. Ibid., p. 118.

10. Mathews, *Pen and Ink Panorama*, p. 15.

11. Charles Baudelaire, *The Painter of Modern Life and Other Essays*, trans. and ed. Jonathan Mayne (1964; reprint, New York: Da Capo Press, 1986), p. 15.

12. "Pictures on Broadway," *Photographic and Fine Arts Journal* (November 1858): 344 ff.

13. The kaleidoscope was invented by David Brewster in 1816. For his history, see Sir David Brewster, *The Kaleidoscope, Its History, Theory, and Construction with its Application to the Fine and Useful Arts*, 3d ed. (London: J. Murray, 1858); also see Walter D. Yoder, *Kaleidoscopes: The Art of Mirrored Magic: An Overview of the Historical Development, Patent Literature, Design and Marketing of Kaleidoscopes* (Albuquerque, N.M.: W. D. Yoder, 1988).

14. F. Saunders, *New York in a Nutshell, or Visitor's Hand-book to the City* (New York: T. W. Strong, 1853), p. 101.

15. N. P. Willis, *Hurrygraphs, or, Sketches of Scenery, Celebrities and Society, Taken from Life* (Rochester, N.Y.: Alden and Beardsley, 1856), p. iii.

16. Ibid.

17. Browne, *Great Metropolis*, p. 92.

18. Charles Edwards Lester, *Glances at the Metropolis* (New York: Isaac D. Guyer, 1854), p. 9.

19. Ibid., p. 31. For more information on early advertising volumes, see Mary Panzer, "Merchant Capital: Advertising Photography Before the Age of Mechanical Reproduction," *Occasional Papers, International Museum of Photography at George Eastman House* 4 (1990): 20–39.

20. Mary Jane Windle McLane, *Life in Washington and Life Here and There* (Philadelphia: J. B. Lippincott, 1859), p. 108 ff.

21. G. G. Foster, *New York Naked* (New York: Dewitt & Davenport, 1852), p. 16; for more information on Foster and his career, see Stuart M. Blumin's introduction to G. G. Foster, *New York by Gaslight and Other Writings* (Berkeley: University of California Press, 1990). Brady's portrait of George G. Foster is in the Brady/Handy Collection at the Library of Congress.

22. G. G. Foster, *New York in Slices by an Experienced Carver, Being the Original Slices Published in the New York Tribune* (New York: W. F. Burgess, 1849), p. 4.

23. Ibid., p. 11.

24. Mathews, *Pen and Ink Panorama*, p. 332.

25. Saunders, *New York in a Nutshell*, p. 94.

26. *A Guide around New York and Its Vicinity: What to See and What Is to Be Seen, with Hints and Advice to Those Who Visit the Great Metropolis* (New York: W. H. Graham, 1853), p. 29.

27. Walt Whitman, *Leaves of Grass*, ed. Malcolm Cowley (New York: Viking Press, 1979), p. 31 (line 146).

28. *The Portable Walt Whitman* (New York: Viking Press, 1973), p. 400.

29. Walt Whitman, *New York Dissected; A Sheaf of Recently Discovered Newspaper Articles . . .* , ed. Emory Holloway and Ralph Adimari (1936; reprint, Folcroft, Pa.: Folcroft Library Editions, 1972), p. 22 n. 11.

30. Browne, *Great Metropolis*, pp. 341–42.

31. Foster, *New York in Slices*, p. 11.

32. Browne, *Great Metropolis*, p. 345.

33. Caleb Lyon, "Stanzas, Suggested by a Visit to Brady's Portrait Gallery," *Photographic and Fine Art Journal* 1 (1851): 63.

34. "The Visit of the Prince," *New York Times*, October 15, 1860, p. 1.

CHAPTER 4. THE MAKING OF A DAGUERREOTYPIST

1. By 1851, Powelson & Co. was at 177 Broadway; James Brown (a former operator for Brady) was at 181 Broadway; N. G. Burgess at 187; and Jeremiah Gurney, active since 1840, could be found at 189 Broadway. Edward Anthony's former partner, Victor Piard, had joined with Alexander Beckers at 201 Broadway; Martin M. Lawrence was located at 203 (where Gabriel Harrison joined him); William and Frederick Langenheim occupied 247; the Meade brothers were at 233; Marcus A. and Samuel Root were at 363; the Clark brothers were at 551; and J. R. Prod'homme was at 663.

2. In 1850, men earned $10 a week, women earned $5 a week, and boys earned $1 a week; cameras cost between $15 and $150. "Daguerreotyping in New York," *Daguerreian Journal* (November 15, 1850): 49; "The Daguerrean Art—Its Origin and Present State," *Photographic Art-Journal* (March 1851): 136–37, reprinted from *Sunday Courier;* "Photography in the United States," *Photographic Art-Journal* (June 1853): 338–39, reprinted from

New York Daily Tribune. On Brady, see "The Daguerrean Art."

3. Nathaniel Hawthorne, *The House of the Seven Gables*, with an introduction by James R. Mellon (1851; New York: New American Library, 1981), p. 156.

4. Ernest Lacan, "Photography, a Physiological Sketch," *Photographic Art-Journal* (April 1853): 213, reprinted from *La Lumière*.

5. For biographies of many of these photographers, see Marcus A. Root, *The Camera and the Pencil, or the Heliographic Art* (1864; reprint, Pawlet, Vt.: Helios Press, 1971), pp. 346–60.

6. Ibid., p. 366.

7. A nineteenth-century journalist asked, "Who are the men in . . . New York who are the most celebrated, and justly so, for producing fine pictures? Are they not Brady, Lawrence, Hass, A. Morand, Gurney, Beckers, Harrison, Piard, Mead, and Root? and who will . . . question their reputation and excellence?" See "Gossip," *Photographic Art-Journal* (May 1852): 317–18. Richard Rudisill tells the story of this generation in *Mirror Image* and cites most of the articles quoted in this chapter.

8. The great expansion of photography to hobbyists and snapshooters came in several waves. Smaller cameras and simpler technology led many amateurs to take up photography in the 1870s; a second, much greater, expansion took place with the arrival of the hand-held camera in the 1880s; and the greatest influx took place after 1889, when George Eastman introduced his Kodak and assumed all responsibility for processing film and photographs. From the 1880s onward, this expanding market supported vast new volumes of photographic publications, all of which fall outside the time frame of this essay.

9. This fits within the story of magazine publishing in America, which has been well set forth by Frank L. Mott, *A History of American Magazines*, 5 vols. (Cambridge, Mass.: Harvard University Press, 1938–1968). For an excellent history of photojournalism, see Carlebach, *Origins of Photojournalism*. The development of photomechanical reproduction is fully set forth in Estelle Jussim, *Visual Communication and the Graphic Arts: Photographic Technologies in the Nineteenth Century* (New York: R. R. Bowker, 1983).

10. On the photographic press, see William S. Johnson, "Introduction," *Nineteenth-Century Photography: An Annotated Bibliography, 1839–1879* (Boston: G. K. Hall, 1990), and Taft, *American Scene*, p. 469 ff.; on the emerging culture of the professional, see Burton Bledstein, *The Culture of Professionalism: The Middle Class and the Development of Higher Education in America* (New York: W. W. Norton, 1976).

11. Many writers compare the cultures of Broadway and the Bowery; for two interesting discussions, see Whitman, *New York Dissected*, p. 121 ff., and Buckley, *To the Opera House*.

12. Lester, *Glances*, p. 9. As Lester explained in the introduction, the object of the book itself was "to cluster together, into a string of pearls, the brightest and best American things. . . . The time will come, when this volume will be consulted as a *record of the progress of American genius and achievement*."

13. Bledstein, *Culture of Professionalism*; Stuart M. Blumin, "The Hypothesis of Middle-Class Formation in Nineteenth-Century America: A Critique and Some Proposals," *American Historical Review* 90, no. 2 (April 1985): 299–338.

14. "The Daguerrean Art," *Photographic Art-Journal* (March 1851): 136–37; "Personal and Fine Art Intelligence," *Photographic and Fine Art Journal* (August 1854): 256.

15. *Humphrey's Journal* 5, no. 5 (June 15, 1853): 73–74; quoted in Rudisill, *Mirror Image*, p. 202.

16. Translations appeared in *Daguerreian Journal* 3 (November 15, 1851): 19; and *Photographic Art-Journal* 3 (1852): 22; Robert Taft, in *American Scene*, p. 76, observes the similarity between this description and one given of Brady's 1853 studio in *Humphrey's Journal* 5 (June 15, 1853): 73.

17. For additional descriptions of New York studio interiors, see "Our Daguerrean Galleries—No. 1—The Meade Gallery, New York," *Photographic Art-Journal* (February 1853): 99–100 and "The Photographic Galleries of America Number One—New York," *Photographic and Fine Art Journal* (January 1856): 19. When C. D. Fredricks opened his new studio at 585 Broadway, it was the largest in the city, and the event was accompanied by "the usual soiree." See "Intelligence," *Photographic and Fine Art Journal* (September 1856): 288. Two years later, his former partner, Jeremiah Gurney, moved even further north to a veritable palace with an innovative first-floor

reception room, as described in "Intelligence," *Photographic and Fine Art Journal* (November 1858): 351, and "Pictures on Broadway" in the same issue, p. 344 ff. This list is far from complete.

18. Root, *Camera and Pencil*, p. 96 ff.; Editor, "The Difficulties of the Art," *Photographic Art-Journal* (February 1851): 92.

19. Rudisill quotes foreign and American observers who suggest that in England and Europe, daguerreotype studios were much less elaborate, and work less specialized. Root credits Boston photographer John A. Whipple with using steam-powered motors to polish daguerreotype plates. See *Camera and Pencil*, pp. 141, 364–65; Abraham Bogardus, "Reminiscences," *Anthony's Photographic Bulletin* 20 (March 9, 1889): 144–46; and Taft, *American Scene*, pp. 98–99.

20. Automatic shutters, which allowed split-second exposures, did not arrive until the end of the 1860s, when changes in the chemical composition of the emulsion made negatives much more sensitive to light. Children who were too young to use a metal stand posed in the arms of a mother or nurse. These supporting figures often wore a concealing drape that resembled upholstery; their small subjects sat in special chairs, the backs fitted with round holes through which the mothers' supporting hands could slide without intruding into the picture. I am grateful to Jo Tartt for calling attention to this convention. For examples of this and other posing furniture, see *The Studio: Life Library of Photography* (New York: Time-Life Books, 1971), pp. 48–49.

21. Rudisill, *Mirror Image*, p. 160, calls daguerreotypes "usefully reliable as sources of factual truth." On Peale's aesthetics, see Brandon Brame Fortune, "Charles Willson Peale's Portrait Gallery: Persuasions and the Plain Style," *Word and Image* 6 (October–December 1990): 308–24; also see David C. Ward, "Celebration of Self: The Portraiture of Charles Willson Peale and Rembrandt Peale, 1822–27," *Smithsonian Studies in American Art* 7, no. 1 (Winter 1993): 9–27.

22. *Humphrey's Journal* 4 (May 1, 1852): 28.

23. "Pictures on Broadway," *Photographic and Fine Art Journal* (November 1858): 344 ff.

24. The photographic press covered the Anthony prize with great detail throughout 1853 and 1854; for a summary, see Marder, *Anthony*, pp. 63–66.

25. M. A. Root, "Qualifications of a First-class Daguerreotypist," *Photographic Art-Journal* (August 1853): 113.

26. M. A. Root, "Some Thoughts on the Fitting up of Daguerrean Rooms," *Photographic Art-Journal* (June 1853): 361.

27. J. K. Fisher, "Photography, the Handmaid of Art," *Photographic Art-Journal* (January 1850): 19–20; Francis Wey, "Theory of Portraiture—Translated from *La Lumière*," *Photographic Art-Journal* (February 1853): 107–9.

28. Root, "Some Thoughts on the Fitting up of Daguerrean Rooms," *Photographic Art-Journal* (June 1853): 361.

29. Fisher, "Photography, the Handmaid of Art," *Photographic Art-Journal* (January 1850): 19–20.

30. "Webster, Clay, Calhoun and Jackson," *Harper's Monthly Magazine* 38 (May 1869): 788.

31. Grant Romer, "Gabriel Harrison: The Poetic Daguerrean," *Image* 22 (September 1979): 8–18, quoted from *Photographic Art-Journal* (1851).

32. "Making Light of Photography," *Photographic and Fine Art Journal* (October 1857): 291.

33. James, *A Small Boy*, p. 52.

34. "Gossip," *Photographic and Fine Art Journal* (February 1857): 63.

35. *Exhibition of the Works of Industry of All Nations, 1851: Reports by the Juries on the Subjects in the Thirty Classes in Which the Exhibition Was Divided* [Class X] (London: William Clowes & Sons, 1853), p. 276, quoted in Rudisill, *Mirror Image*, p. 208. Also see "A Visit to the Fair of the American Institute of 1855," *Photographic and Fine Art Journal* 8 (November 1855): 353.

36. Register, R. G. Dun & Co., New York Volume 368, p. 442, Baker Library, Graduate School of Business, Harvard University.

37. "Our Illustration," *Photographic and Fine Art Journal* (November 1855): 351.

38. "M. B. Brady, Esq.," *Frank Leslie's Illustrated Journal* (January 10, 1857): 86.

39. *Harper's Weekly* 7 (November 14, 1863): 722; Townsend, "Still Taking Pictures," *New York World*, April 12, 1891.

40. "M. B. Brady," *American Phrenological Journal* 27, no. 5 (May 1858): 65–67.

41. Jennifer Todd develops this thesis in great depth in "The Rigors of Business: Mathew Brady's Photography in Political Perspective," *Afterimage* 6 (November 1979): 8–12.

42. Arnold Hauser, *A Social History of Art*, 2 vols. (1952; reprint, 4 vols., New York: Vintage Books, 1960), vol. 3, p. 153.

CHAPTER 5. BUILDING A NATIONAL GALLERY

1. "Local Items, Daguerreotype Portraits," *Daily National Intelligencer* (Washington, D.C.), February 27, 1849, p. 4; "Editor's Table," *The Knickerbocker* (September 1849): 267.

2. C. E. Lester, "M. B. Brady," *Photographic Art-Journal* (1850): 39. Reviews and interviews attribute this moniker to Bayard Taylor, though I have found no original source.

3. Thomas Carlyle, "Project of the National Exhibition of Scottish Portraits (1854)," in *Critical and Miscellaneous Essays*, 7 vols. (London: Chapman & Hall, 1872), vol. 6, pp. 130–33.

4. A great deal has been written on Charles Willson Peale; for a good introduction see Edgar P. Richardson, Brooke Hindle, and Lillian Miller, *Charles Willson Peale and His World* (New York: Harry N. Abrams, 1982). On Peale's museum, see Sidney Hart and David C. Ward, "The Waning of an Enlightenment Ideal: Charles Willson Peale's Philadelphia Museum, 1790–1820," *Journal of the Early Republic* 8 (1988): 389–418; also see Fortune, "Peale's Portrait Gallery," *Word and Image* 6 (October–December 1990): 308–24.

5. On John Trumbull, see Irma B. Jaffe, *John Trumbull, Patriot-Artist of the American Revolution* (Boston: New York Graphic Society, 1975), and Helen A. Cooper, *John Trumbull: The Hand and Spirit of a Painter* (New Haven, Conn.: Yale University Art Gallery, 1983). For the story of Trumbull's paintings for the Capitol Rotunda, see Fairman, *Art and Artists of the Capitol*, pp. 34–63. On Samuel F. B. Morse, see William Kloss, *Samuel F. B. Morse* (New York: Harry N. Abrams, in association with the National Museum of American Art, 1988), and Paul Staiti, *Samuel F. B. Morse* (New York and Cambridge: Cambridge University Press, 1989).

6. Charles Henry Hart, *Brouwere's Life Masks of Great Americans* (New York: Doubleday and McClure Co., 1899), p. 19 ff.; also see David Meschutt, *A Bold Experiment: John Henri Isaac Brouwere's Life Masks of Prominent Americans* (Cooperstown, N.Y.: New York State Historical Association, 1988).

7. This discussion follows the material assembled in Reaves, ed., *American Portrait Prints*.

8. On the history of printed portrait galleries in America, see Gordon M. Marshall, "The Golden Age of Illustrated Biographies: Three Case Studies," in ibid., pp. 29–82.

9. See Marshall, "The Golden Age," and Barbara J. Mitnick and David Meschutt, *The Portraits and History Paintings of Alonzo Chappel* (Chadds Ford, Pa.: Brandywine River Museum, 1992), pp. 19–20.

10. On Hill and Adamson, see Helmut Gernsheim, *The Origins of Photography* (London: Thames and Hudson, 1982), pp. 186–94. Also see the recent work by Sara Stevenson, including *Hill and Adamson's the Fishermen and Women of the Firth of Forth* (Edinburgh: Trustees of the National Galleries of Scotland, 1991).

11. The usually reliable Robert Taft conflates two separate engravings in his discussion, confusing the *United States Senate*, engraved by Thomas Doney in 1846, and *Henry Clay's Farewell*, engraved by Robert Whitechurch in 1855. See *American Scene*, p. 54. For a more accurate discussion, see Root, *Camera and Pencil*, pp. 361–62; "Critical Notices," *American (Whig) Review* 4 (October 1896): 431–32; and "A New Specimen of American Art," *Evening Post* (New York), August 14, 1846, in which the author declares "this picture marks the second age of our country, as Trumbull's 'Declaration of Independence' did the first."

12. For biographical information on Anthony, see Marder, *Anthony*, and Welling, *Photography in America*, pp. 150, 160, 265. On Adams's posing for his portrait, see *Memoirs of John Quincy Adams*, vol. 12, p. 8, quoted in Taft, *American Scene*, p. 53. The gallery was destroyed on February 7, 1852. It was begun in 1843 by Anthony, Edwards & Chilton, operated by Anthony & Edwards, then Anthony, Clark & Co. Anthony then sold the collection to "Mr. J. R. Clark or Clarke, then to Mr. E. White . . . although we feel that the gallery did not improve to any great extent under Mr. White yet we cannot

say that it depreciated in interest." After two years, it was sold again to William and Frederick Langenheim, who made some valuable additions to the collection with their Talbotypes, Hyalotypes, pictures on plate glass, and pictures on ivory. Around 1851, Mr. D. E. Gavit, "long . . . known to our citizens and Daguerreotypists," purchased the entire gallery. According to a contemporary account, "a singular and interesting face connected with the fire . . . looking over the ruins, someone discovered 'a perfect specimen'. . . the likeness of John Quincy Adams" ("Burning of the National Daguerreotype Miniature Gallery," *Humphrey's Journal* [April 15, 1852]: n.p.).

13. On John Plumbe, see Taft, *American Scene*, pp. 49–52, and Reese Jenkins, *Images and Enterprise: Technology and the American Photographic Industry, 1839–1925* (Baltimore, Md.: Johns Hopkins University Press, 1975), pp. 10–35, Trachtenberg, *Reading American Photographs*, pp. 61 ff., and Rudisill, *Mirror Image*. I am also grateful to Clifford Krainik for sharing his research on Plumbe.

14. In 1853, the Meade brothers gallery on Broadway exhibited more than a thousand pictures, including views of Niagara Falls, Shakespeare's house, and a panorama of San Francisco, but the vast majority were portraits. One dazzled visitor recognized "American Statesmen, Actors, Poets, Divines, embracing nearly all persons, male and female, of celebrity of modern times," such as Kit Carson, Billy Bowlegs, the Emperor and Empress of Haiti, Commodore Perry, and Edwin Forrest. The Meades were justifiably proud of their European successes, including the newly crowned Louis-Napoléon, Lola Montez, Louis Kossuth, Jenny Lind, and their unique portrait of the inventor Louis-Jacques-Mandé Daguerre.

Martin M. Lawrence also assembled a fine collection of portraits of well-known sitters, though his clients apparently differed from those that others favored. While others exhibited politicians and military figures, "the Gallery of Mr. Lawrence is adorned with the real and life like portraiture of men, who are illustrious champions on the moral arena, and are battling hard and hero-like for the recovery of a world!" Along with "the patriotic, the good, and the brave," Lawrence displayed portraits of "the great Apostle of Temperance from the Emerald Isle . . . the ablest divines of this favored land, and a whole army of missionaries." Because these collections have been dispersed, and engravers rarely credited their photographic sources by name, it is impossible to know how many portraits by Meade or Lawrence were seen outside the crowded walls of their studios.

On Meade, see Volina Lyons, "The Brothers Meade," *History of Photography* 14, no. 2 (April–June 1990): 113–34; and "The Brothers Meade and the Dageurrean [*sic*] Art," *Photographic Art-Journal* (May 1852): 293–95. On Lawrence, see Rev. S. D. Blanchard, "Martin M. Lawrence and the Daguerrean Art," *Photographic Art-Journal* (February 1851): 104; plentiful references to Lawrence also appear in omnibus articles on New York's galleries in the photographic press during the 1850s.

15. In *Imagined Communities: Reflections on the Origin and Spread of Nationalism*, 2d ed. (London and New York: Verso, 1991), Benedict Anderson provides an important intellectual model for studying the dissemination of New York culture and the creation of a national public sphere through publications sent along the waterways and railroads of mid-nineteenth-century America.

16. This discussion follows Charles Edwards Lester's "Introduction," in *Gallery of Illustrious Americans* (New York: Brady, D'Avignon & Co., 1850):

Neither Art nor Literature can afford to give up to party what belongs to mankind. In our judgments of public men we shall endeavor to anticipate the awards of posterity. . . . Mr. Brady has been many years collecting portraits of a National Gallery, and in the accomplishment of his object he has experienced the utmost courtesy and encouragement from eminent men. His reputation in his art has been too long established to need commendation. . . . The Biographical Sketches will be written with brevity, impartiality, and truth.

17. Ibid.

18. Ibid.

19. Alan Trachtenberg interprets this document differently, placing less emphasis on references to the approaching crisis; see *Reading American Photographs*, pp. 45–60.

20. See Van Deren Coke, *The Painter and the Photograph*

(Albuquerque: University of New Mexico Press, 1964), p. 25.

21. For an informative and long-overdue discussion of Chappel and his career, see Mitnick and Meschutt, *Alonzo Chappel.*

22. "Personal," *Home Journal,* August 21, 1858, p. 3; "Brady's Portrait Gallery," *Boston Transcript,* August 30, 1858, p. 2; September 27, 1858, p. 2; November 5, 1858, p. 2.

CHAPTER 6. PHOTOGRAPHY AND AMERICAN ART AT MIDCENTURY

1. Brady to Samuel F. B. Morse, February 15, 1855, Morse Papers, Library of Congress.

2. Brady's portraits of Cole, Durand, and Elliott later appeared in the form of woodcut illustrations to a long series of articles on "Art and Artists in America" by E. Anna Lewis, which appeared in *Graham's Magazine* and Nathaniel Parker Willis's *Home Journal* from 1854 through 1856. Imperial photographs of Palmer, Thompson, Sartain, Hosmer, and other figures from the New York art world can be found in the Wendell Collection at the Fogg Art Museum, Harvard University.

3. Modernist Sadakichi Hartmann located an "astonishingly large" number of excellent portrait painters in New York, where the native talent of men like Charles Loring Elliott, Daniel Huntington, and William Page blossomed, thanks to the large local demand for portraits; in New York they also enjoyed easy access to fine photographic images. See *A History of American Art,* 2 vols. (London: Hutchinson & Co., 1903), vol. 1, p. 137. Also see Charles P. Daly, *In Memory of Henry Peters Gray* (New York: The Century, 1878), 6; T. B. Thorpe, "Reminiscences of Charles L. Elliott, Artist," *Evening Post* (New York), September 30, 1868. A dense web of connections unites these men. Huntington first studied with Elliott when they both attended Hamilton College, where Gray also studied with Huntington in 1838; Gray and Huntington traveled together in Italy in 1839 and 1840; Huntington returned home a year later, but Gray stayed on. Page and Huntington studied with Morse in the 1830s, when Morse was also studying electricity and chemistry; Morse's open-minded attitude surely influenced their easy embrace of photography after he had helped introduce the new medium to America. These painters are well represented in the collection of the Metropolitan Museum of Art in their catalogue *American Paintings in the Metropolitan Museum of Art,* 3 vols. (New York: Metropolitan Museum of Art, in association with Princeton University Press, 1985–1994); see "Charles Loring Elliott," vol. 1, pp. 554–61; "Henry Peters Gray," vol. 2, pp. 100–106; "Daniel Huntington," vol. 2, pp. 56–73.

4. For the story of the committee, see Lillian B. Miller, *Patrons and Patriotism: The Encouragement of the Fine Arts in the United States, 1790–1860* (Chicago: University of Chicago Press, 1966), pp. 79–89. See also Josephine Cobb, "The Washington Art Association: An Exhibition Record, 1856–1860," *Records of the Columbia Historical Society* 63–65 (1963–1965): 122–37.

5. Ibid., p. 157; for a full discussion of the ideological currents that shaped the quest for a national aesthetic, see pp. 144–59, 221–30.

6. Francis Parkman, "James Fenimore Cooper (January 1852)," *Essays from the North American Review,* ed. A. T. Rice (New York: D. Appleton & Co., 1879), p. 376.

7. "Development of Nationality in American Art," *Photographic Art-Journal* (January 1852): 39. This journal's broad understanding of photography makes it a valuable source for contemporary art criticism, though almost all its authors are anonymous.

8. "History in Art," [circa 1870], MBS/LC; also see E. Anna Lewis, "Charles Loring Elliott, N.A.," *Graham's Magazine* 44 (June 1854): 564–68, reprinted in *Home Journal* 1 (June 24, 1864): 1: "This is an unartistic, unpoetical age—a period antagonistic to the fine arts—an *utilitarian cycle*— the golden age of steam and electricity." William Page also said, "We have arrived at a time when by the advance of science tools are put into our hands . . . we mean the drawing and grouping of objects together which is given us by photography" (quoted in Coke, *The Painter and the Photograph,* p. 41).

9. G. W. Sheldon, *American Painters* (New York: D. Appleton, 1881), p. 105.

10. "Gossip," *Photographic Art-Journal* (December 1851): 378.

11. The classic source on the realist movement remains Linda Nochlin, *Realism* (New York: Penguin, 1971); for a broad account of the realist aesthetic beyond Courbet, see Gabriel P. Weisberg and Petra ten-Doesschate Chu, *The Realist Tradition: French Painting and Drawing, 1830–1900* (Cleveland: Cleveland Museum of Art, 1980).

12. On the reception of Courbet's work in America, see Douglas Eric Edelson, "Patronage and Criticism of Gustave Courbet in Nineteenth-Century America" (master's thesis, Queens College, City University of New York, 1990).

13. Excellent examples of the work of American Pre-Raphaelites can be found in Linda S. Ferber and William S. Gerdts, *The New Path: Ruskin and the American Pre-Raphaelites* (Brooklyn: The Brooklyn Museum, 1985).

14. "Hawkeye," "Washington Correspondence—Relating to Art," unidentified journal, March 25, 1867, A. H. Ritchie scrapbook, John Hay Library, Brown University.

15. "Gossip—on Emanuel Leutze," *Photographic Art-Journal* (December 1851): 378.

16. "The National Academy of Design," *Photographic and Fine Art Journal* (April 1856): 116–17.

17. "M. B. Brady," *Frank Leslie's Illustrated Newspaper* 3, no. 57 (January 10, 1857): 86, 96. For a fresh, complete account of the emergence of the illustrated press, see Carlebach, *Origins of Photojournalism,* especially p. 62 ff.

18. "American Painters—Their Errors as Regards Nationality," *Photographic and Fine Art Journal* (August 1857): 231–33, reprinted from the *Cosmopolitan Art Journal.*

19. Ibid.

20. Ibid., p. 233.

21. Beginning in 1856, Maull and Polyblank issued portraits of well-known contemporaries on a monthly basis, in a series titled *Photographic Portraits of Living Celebrities;* each portrait was accompanied by a brief biographical essay. See Helmut Gernsheim, *The History of Photography, Volume 2: The Rise of Photography, 1850–1880: The Age of Collodion* (London: Thames and Hudson, 1987), pp. 26, 31, 33.

22. Some scholars attribute this sophistication to Alexander Gardner, who was an early master of the technology needed to make the Imperial portraits; however, Brady's studio produced these images in 1855, well before Gardner joined Brady's staff.

23. "Daguerreotypes—The Art Perfected," *The Spirit of the Times* (New York), July 4, 1846, p. 228; "Brady's Daguerreotype Portraits and Family Groups," *Evening Post* (New York), August 1, 1848, p. 3.

24. "Personal and Art Intelligence," *Photographic and Fine Art Journal* (May 1854): 160. Also see the memoirs of a colorist who worked for several New York studios, John Werge, *The Evolution of Photography, with a Chronological Record of Discoveries, Inventions, Etc.* (London: Piper & Carter, 1890), pp. 33–77.

25. From the late 1850s onward, numerous manuals described the method for coloring photographs. See, for example, Montgomery P. Simons, *Plain Instructions for Colouring Photographs in Water Colours and India Ink* (Philadelphia: T. K. Collins, 1857); and George B. Ayres, *How to Paint Photographs in Water Colors and in Oil . . .* (Philadelphia: Bennerman & Wilson, 1871).

26. Rembrandt Peale, "Portraiture," *Crayon* 4, no. 2 (February 1857): 44–45.

27. "Progress in Photography," *Harper's Weekly* 1, no. 42 (October 17, 1857): 659.

28. Col. T. B. Thorpe, "Reminiscences of Charles L. Elliott, Artist," *Evening Post* (New York), September 30, 1868, p. 28. Also see Theodore Bolton, "Charles Loring Elliott, An Account of His Life and Work," *Art Quarterly* 5 (winter 1942): 58–96; and Henry T. Tuckerman, *Book of the Artists* (New York: G. P. Putnam & Sons, 1867), pp. 300–305.

29. Sheldon, *American Painters,* p. 255.

30. S. G. W. Benjamin, *Art in America: A Critical and Historical Sketch* (New York: Harper & Bros., 1880), p. 50; for information on Elliott's uses of daguerreotype portraits, see Beaumont Newhall, "The Daguerreotype and the Painter," *Magazine of Art* 42, no. 7 (November 1949): 249–51; also see Library of Congress World Wide Web site (http://lcweb.loc.gov); Harold Francis Pfister, *Facing the Light: Historic American Portrait Daguerreotypes* (Washington, D.C.: Smithsonian Institution Press for the National Portrait Gallery, 1978), p. 329; C. Edwards Lester, *The Artists of*

America: A Series of Biographical Sketches of American Artists (New York: Baker & Scribner, 1846); William H. Gerdts, *The Art of Henry Inman* (Washington, D.C.: National Portrait Gallery, 1987), p. 183, reproduces the portrait of Inman by Elliott owned by the Century Association. This exchange is also discussed in Coke, *The Painter and the Photograph*.

31. This topic offers a large, rich field for research. Far too little is known about the technique of successful academic painters such as Chester Harding, Daniel Huntington, Thomas Hicks, and even Emanuel Leutze, who all relied on portrait commissions. However, this genre, and this period in American art, have received little attention from historians and critics. See Michael Quick et al., *American Portraiture in the Grand Manner, 1720–1920* (Los Angeles: Los Angeles County Museum of Art, 1981), especially the essay by William Gerdts, which includes many important observations on this generation of American artists. Also see the memoir by John Werge, *Evolution of Photography*, pp. 48–54, 70–74.

32. "Brady's Gallery in New York," *Photographic and Fine Art Journal* (December 1858): 378–79, reprinted from the *New York Daily Times*.

33. Gail Hamilton, "Brady's Gallery," *National Era* 13 (March 24, 1859): 46.

34. Little more is known about Henry F. Darby, who enjoyed some success as an art teacher and itinerant portraitist before his work with Brady began. In 1858, he and Brady both served on the National Arts Committee in Washington, along with G. P. A. Healy, Clark Mills, and Charles Loring Elliott. At the end of 1859, Darby went to England, where he was ordained as a clergyman; he later returned to America and enjoyed a long career teaching art in a church-run school for girls. He continued to paint pictures with religious themes, and also designed altarpieces and clerical garb. Darby's work can be found in several collections, including the Museum of Fine Arts, Boston, the United States Capitol, Sunnyside Restoration, and the Munson-Williams-Proctor Institute Museum of Art in Utica, New York. For an account of Darby's early career, and an excerpt from his autobiography, see Ian Hacker, "Discovery of a Prodigy,"

Boston Museum Bulletin 61 (1963): 23–43. Many thanks to Barbara Franco, who generously shared her research and insights on Darby.

35. "Art Items," *New-York Tribune* March 21, 1860, p. 6; March 19, 1860, p. 7; "Portraits of Irving," *Home Journal* 2 (May 5, 1860): 1–2; "Letter from New York," *Boston Transcript*, March 29, 1860, p. 4.
"Topics Astir," *Home Journal* 2 (March 31, 1860): 5. The Plumbe daguerreotype is in the collection of the New-York Historical Society; two daguerreotype copies, presumed to be by Brady, are in the Brady-Handy Collection at the Library of Congress. Henry F. Darby's portrait is now in the collection of Sleepy Hollow Restorations, in Irvington, New York. Alonzo Chappel's painting from this portrait is now at the Chicago Historical Society; F. O. C. Darley also made an engraving based on this painting. See Mitnick and Meschutt, *Alonzo Chappel*, pp. 30–31. I owe the contemporary references to the Brady-Darby Irving portrait collaboration to the fine, original, and persistent research of Colonel Merl M. Moore.

36. Taft also notes that Polk sat for Brady in 1849, and recorded the event in his diary; see *American Scene*, pp. 58 and 465 n. 68.

37. The most thorough discussion of Healy's use of photography is by Van Deren Coke, in *The Painter and the Photograph*, as part of a larger essay on the uses of photography in portrait painting in nineteenth-century America, pp. 22–36. Coke has assembled a complete set of images, which show the precise correspondence between photographic sources and finished paintings.

38. The Virginia Museum, *Healy's Sitters* (Richmond, Va.: The Virginia Museum of Fine Arts, 1950), p. 65. No modern biographical study of Healy and his portraits exists, and few papers survived the Chicago fire of 1871. See Marie De Mare research material on G. P. A. Healy, reels D130 and 1209–10, Archives of American Art.

39. Hamilton, "Brady's Gallery," *National Era* 13 (March 24, 1859).

40. Horace Traubel, *With Walt Whitman in Camden*, 4 vols. (1907; reprint, New York: Rowman and Littlefield, 1961), vol. 3, p. 553.

41. *Brady's National Photographic Collection of War Views* (New York: 1867), p. 6.

42. For a complete account of Leutze's career, see Barbara Groseclose, *Emanuel Leutze, 1816–1868: Freedom Is the Only King* (Washington, D.C.: Smithsonian Institution Press for the National Collection of Fine Arts, 1975).

43. Van Deren Coke discusses this painting and its photographic origins in *The Painter and the Photograph*, pp. 30–36.

44. Mathew Brady to Abraham Lincoln, Lincoln Manuscript Collection, Library of Congress.

45. Isaac N. Arnold, *Sketch of the Life of Abraham Lincoln* (New York: John B. Bachelder, 1869), p. 52.

46. John B. Bachelder, "The Last Hours of Lincoln, Origin of this Historical Painting," in Arnold, *Sketch of the Life of Abraham Lincoln*. Most of the negatives for these photographs became part of the collection now at the National Archives. Also see Harold Holzer, "How the Printmakers Saw Lincoln: Not-So-Honest Portraits of 'Honest Abe,'" *Winterthur Portfolio* 14, no. 2 (summer 1979): 143–70; and Mitnick and Meschutt, *Alonzo Chappel*, pp. 56–65.

47. One copy of the Bachelder order book now belongs to the Chicago Historical Society.

48. Chappel's two versions of the painting *The Last Hours of Lincoln* can be found at the John Hay Library of Brown University and the Chicago Historical Society.

49. Bachelder advertisement, in Arnold, *Life of Lincoln*.

CHAPTER 7. WASHINGTON AND THE WAR YEARS

1. Nathaniel Hawthorne, "Chiefly about War Matters," *Complete Works of Nathaniel Hawthorne*, ed. George Parsons Lathrop, 12 vols. (Boston: Houghton, Mifflin & Co., 1883), vol. 12, p. 340. This essay also appeared in the *Atlantic Monthly* (July 1862), in a slightly different form.

2. Hawthorne, "Chiefly about War Matters," in *Complete Works of Nathaniel Hawthorne*, vol. 12, pp. 341–42.

3. Mrs. E. F. Ellet, *The Court Circles of the Republic, or the Beauties and Celebrities of the Nation* (Hartford, Conn.: The Hartford Publishing Co., 1869), pp. 585–86; McLane, *Life in Washington*, p. 136 ff.

4. A. D. White, *Autobiography*, 2 vols. (New York: The Century Co., 1905), vol. 1, p. 78.

5. Henry Adams, *The Education of Henry Adams* (1907; reprint, Boston: Houghton, Mifflin & Co., 1973), p. 100.

6. Virginia Clay-Clopton, *A Belle of the Fifties: Memoirs of Mrs. Clay, of Alabama* . . . (New York: Doubleday, Page & Co., 1904), p. 27.

7. Ibid., p. 58.

8. Ibid., p. 86.

9. Forgie, *Patricide in the House Divided*, pp. 159–99; Charles Dickens, *American Notes* (1842; reprint, Gloucester, Mass.: Peter Smith, 1968), p. 140.

10. Clay-Clopton, *Belle of the Fifties*, pp. 77, 85.

11. James Parton, *Famous Americans of Recent Times* (Boston: Ticknor and Fields, 1867), pp. 57–58.

12. *The Correspondence of John Lothrop Motley*, ed. G. W. Curtis, 3 vols. (New York & London: Harper & Bros., 1900), vol. 1, p. 191.

13. "M. B. Brady," *Frank Leslie's Illustrated Newspaper* 3, no. 57 (January 10, 1857): 86.

14. Hamilton, "Brady's Gallery," *National Era*, March 24, 1859, p. 46.

15. Ibid.

16. "A Broadway Valhalla," *American Journal of Photography and Allied Arts and Sciences*, n.s., 3, no. 10 (October 15, 1860): 151–53, reprinted from the *New York Times*, October 6, 1860.

17. Ibid.

18. "Mr. Brady's Photographic Picture of the House of Representatives," *American Journal of Photography and the Allied Arts and Sciences*, n.s., 3, no. 4 (July 15, 1860): 51; reprinted from the *New York Times*; date uncertain, dispatch dated June 25, 1860.

19. David M. Potter, *The Impending Crisis, 1848–1861*, ed. Don E. Fehrenbacher (New York: Harper & Row, 1976), pp. 405–48.

20. Clay-Clopton, *Belle of the Fifties*, p. 147; Adams, *Education*, p. 99.

21. "American Photographs," *Photographic News* 6 (September 5, 1862): 428, reprinted from the *New York Times*. Also, "Photography at the Seat of War," *Photographic News* 7 (February 20, 1863): 96 quotes the *Corinth Tribune*:

 one of the institutions of our army is the travelling portrait gallery. A camp is hardly pitched before one of the omnipresent artists in collodion and amber-varnish pitches his canvas gallery and unpacks his chemicals. . . . Their tents are thronged from morning to night . . . [the

Bergstresser brothers] . . . have followed the army for more than a year, and taken, the Lord only knows, how many thousand portraits.

22. "American Photographs," *Photographic News* 6 (September 5, 1862): 428.

23. "Photographic Views of the Army," *Boston Transcript*, June 10, 1861, p. 2.

24. "Photographs of War Scenes," *Humphrey's Journal* 13 (September 15, 1861): 159.

25. "Photographs of War Scenes," *Humphrey's Journal* 13 (September 1, 1861): 133.

26. For a discussion of the documentation of Bull Run, see Carlebach, *Origins of Photojournalism*, pp. 76–78.

27. "Photographs of War Scenes," *Humphrey's Journal* 13 (September 1, 1861): 133.

28. Experts on Civil War photographic practice may well disagree with much of this discussion. I am indebted to the work of Keith F. Davis. In "'A Terrible Distinctness': Photography of the Civil War Era" in *Photography in Nineteenth-Century America*, pp. 130–79, and in *George N. Barnard, Photographer of Sherman's Campaign* (Kansas City: Hallmark Cards, Inc., 1990), Davis shows how to track the activities of one photographer, using archival sources and images to trace his movements. I also gratefully acknowledge Michael Carlebach's work on war photography as it appeared in the illustrated press, in *Origins of Photojournalism*, pp. 62–101. William Gladstone's research on war photographers and carte-de-visite publications has been of great help, as has the work of Henry Deeks; both generously shared their research for this project.

29. Undated clipping, MBS/LC.

30. "American Photographs," *Photographic News* 6 (September 5, 1862): 428.

31. "Brady's Photographs," *New York Times*, October 20, 1862, MBS/LC.

32. Davis, "Terrible Distinctness," in *Photography in Nineteenth-Century America*, p. 142.

33. "Reminiscences of Gettysburg," *Harper's Weekly* (August 22, 1863): pp. 529, 532, 534.

34. Undated clipping, MBS/LC.

35. "Photographs of the Virginia Campaign," *Harper's Weekly* 8 (August 6, 1864): 499.

36. Rose Greenhow, *My Imprisonment and the First Year of the War* (London: R. Bentley, 1863), p. 3.

37. Parton, *Famous Americans*, p. 3.

CHAPTER 8. HISTORY AS IMAGE, PHOTOGRAPHY AS ART

1. Parton, *Famous Americans*, p. 5.

2. Nathaniel Parker Willis, *The Convalescent* (New York: Charles Scribner, 1859), pp. 289–90.

3. "American Photographs," *American Journal of Photography* 5, no. 7 (October 1, 1862): 145–50.

4. "Editorial Department," *American Journal of Photography* 5, no. 7 (October 1, 1862): 167.

5. "Brady's Gallery," *Harper's Weekly* 7 (November 14, 1863): 722.

6. Untitled clipping, MBS/LC.

7. "Brady's Collection of War Views," *Evening Post* (New York), February 23, 1866, p. 2; "Brady's War Views," *Evening Post* (New York), March 8, 1866, p. 2; "Brady's Gallery of the War," *New York Herald*, February 10, 1869; "Brady's Gallery of National Personages, Suggestions as to Its Preservation," *New York Times*, March 1, 1869, p. 5. See also Zinkham, "Pungent Salt," *History of Photography* (January–March 1986).

8. "Fine Arts," *Evening Post* (New York), November 30, 1866, p. 2.

9. Oliver Wendell Holmes, "Doings of the Sunbeam," *Atlantic Monthly* 12, no. 69 (July 1863): 12.

10. Ibid.

11. Hawthorne, "Chiefly about War Matters," in *Complete Works*, ed. Lathrop, vol. 12, p. 306.

12. James, *A Small Boy*, pp. 151–52.

13. Mr. Brady's Photographic Picture of the House of "Representatives," *American Journal of Photography*, n.s., 3 (July 15, 1860): 51, reprint from *New York Times*, June 25, 1860; "Historical Photography," *New York Times*, March 29, 1867, p. 8.

14. Gossip by Roberts," *The Capital*, February 18, 1877, "MBS/LC.

15. A Broadway Valhalla," *American Journal of "Photography* 3, no. 109 (October 15, 1860): 151–53.

16. Untitled clipping, MBS/LC.

17. History in Art," unidentified clipping, MBS/LC.

18. "Ibid.

A Gallery of Images

PLATE 40

Thomas Cole

Daguerreotype, circa 1846.

National Portrait Gallery,
Smithsonian Institution,
Washington, D.C.; gift of Edith
Cole Silberstein

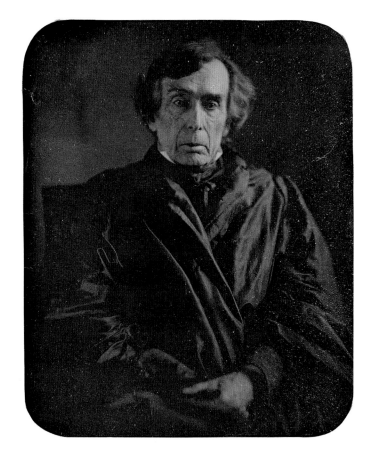

PLATE 41

Zachary Taylor

Daguerreotype, 1849.

The Beinecke Rare Book and
Manuscript Library, Yale
University, New Haven,
Connecticut

PLATE 42

Roger Taney

Daguerreotype, circa 1848.

The Beinecke Rare Book and
Manuscript Library, Yale
University, New Haven,
Connecticut

PLATE 43

George Peter
Alexander Healy

Daguerreotype, circa 1850.

Library of Congress,
Washington, D.C.

PLATE 44

James Gordon Bennett

Daguerreotype, circa 1851.

Library of Congress,
Washington, D.C.

PLATE 45

Junius Brutus Booth

Daguerreotype, circa 1850.

Library of Congress,
Washington, D.C.

PLATE 46

Jenny Lind

Daguerreotype, 1852.

The Chrysler Museum of
Art, Norfolk, Virginia; museum
purchase with assistance from
Kathryn K. Porter and Charles
and Judy Hudson, 89.75

PLATE 47

Mathew Brady with Juliette Handy Brady and Mrs. Haggerty

Daguerreotype, circa 1851.

National Portrait Gallery,
Smithsonian Institution,
Washington, D.C.

PLATE 48

Felicita Vestvali

Ambrotype, circa 1855.

Private collection

PLATE 49

John C. Frémont

Ambrotype, circa 1856.

National Portrait Gallery,
Smithsonian Institution,
Washington, D.C.

PLATE 50

Julia Holnus

Ambrotype, 1854–1856.

Chicago Historical Society,
Illinois

PLATE 51

Charlotte Cushman

Imperial salted-paper print,

1857.

Harvard Theatre Collection,
The Houghton Library,
Cambridge, Massachusetts

PLATE *52*

William L. Marcy

Imperial salted-paper print, circa 1856.

Fogg Art Museum, Harvard University Art Museums, Cambridge, Massachusetts, on deposit from Harvard College Library

PLATE 53

Simon Cameron

Imperial salted-paper print,
circa 1858.

Chicago Historical Society,
Illinois

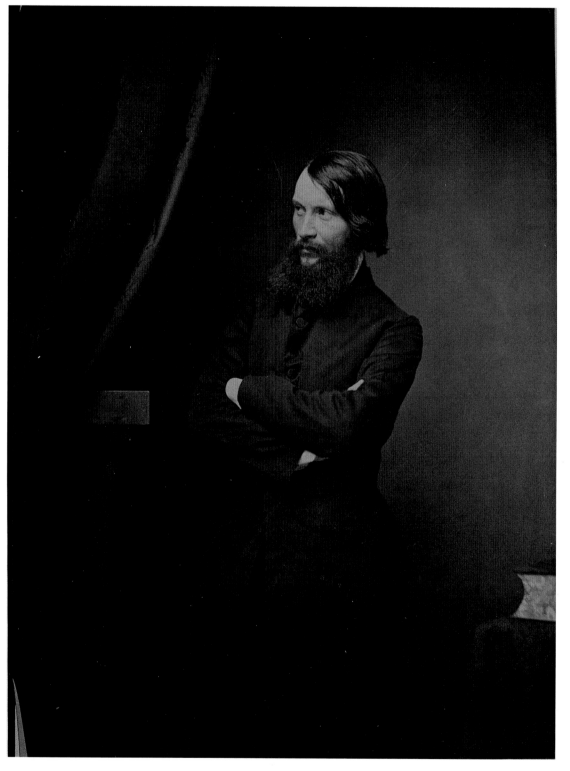

PLATE 54

Thaddeus Hyatt

Imperial salted-paper print,
1857.

Fogg Art Museum, Harvard
University Art Museums,
Cambridge, Massachusetts, on
deposit from Harvard College
Library

PLATE 55

Miss Garnier

Imperial salted-paper print,
circa 1858.

Fogg Art Museum, Harvard
University Art Museums,
Cambridge, Massachusetts, on
deposit from Harvard College
Library

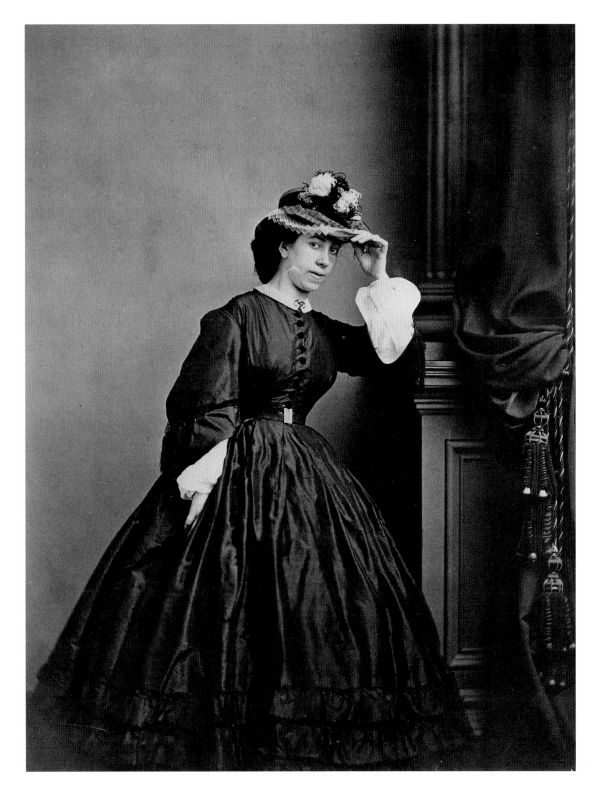

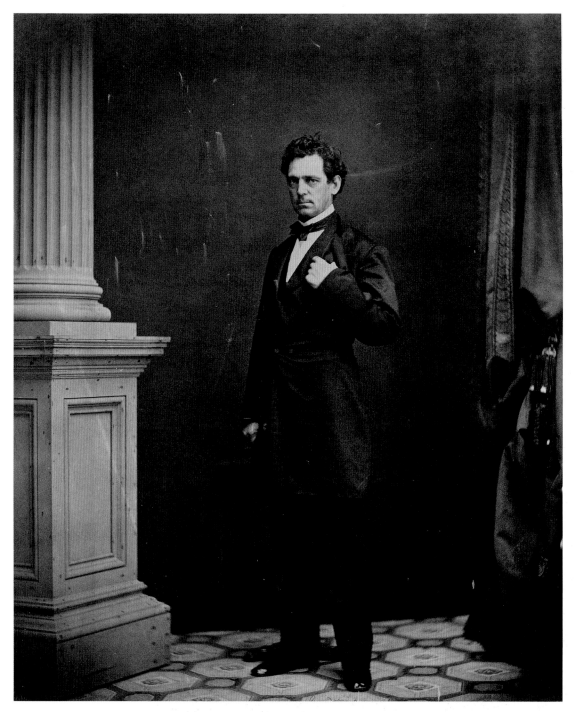

PLATE 56

Thomas DeKay Winans

Imperial salted-paper print,
circa 1857.

Fogg Art Museum, Harvard
University Art Museums,
Cambridge, Massachusetts, on
deposit from Harvard College
Library

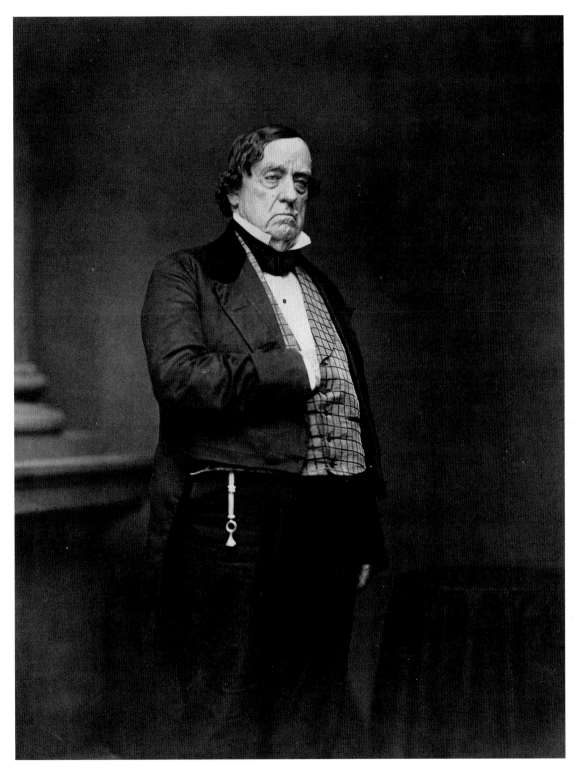

PLATE 57

Lewis Cass

Imperial salted-paper print, circa 1857.

Fogg Art Museum, Harvard University Art Museums, Cambridge, Massachusetts, on deposit from Harvard College Library

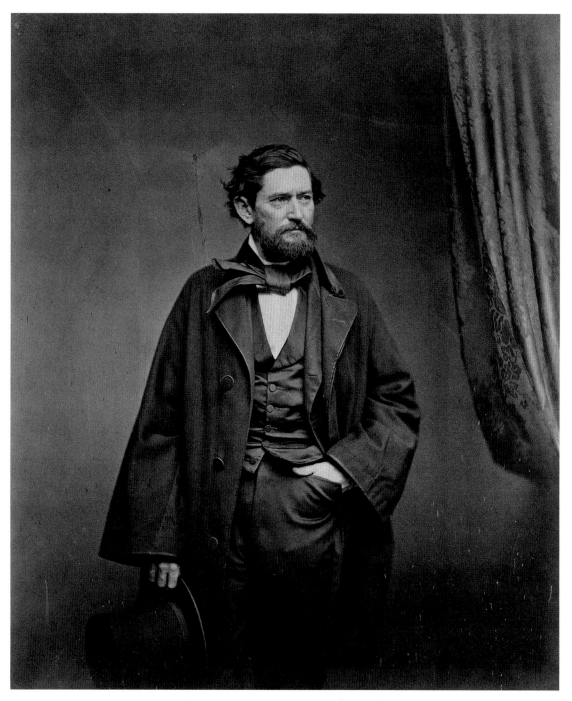

Jack Hays

Imperial salted-paper print,
circa 1857.

Fogg Art Museum, Harvard
University Art Museums,
Cambridge, Massachusetts, on
deposit from Harvard College
Library

Maximilian,
Emperor of Mexico

Imperial salted-paper print,
1864.

Chicago Historical Society,
Illinois

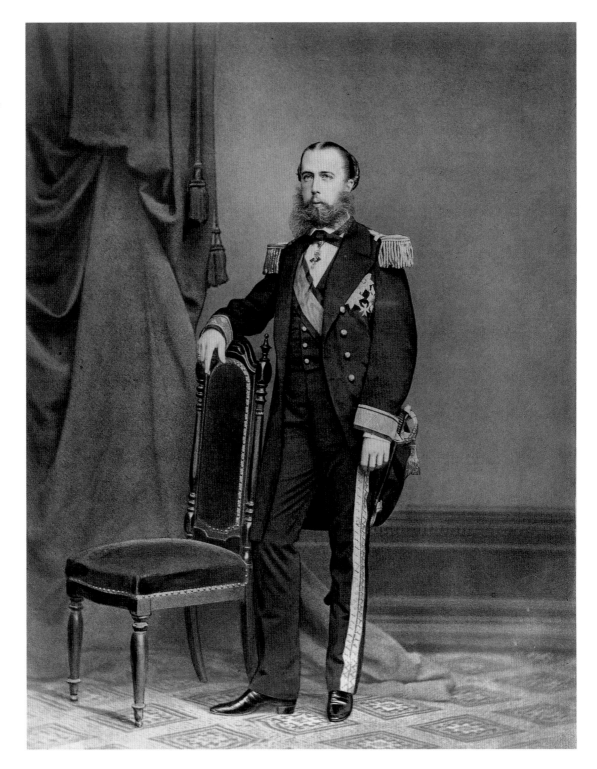

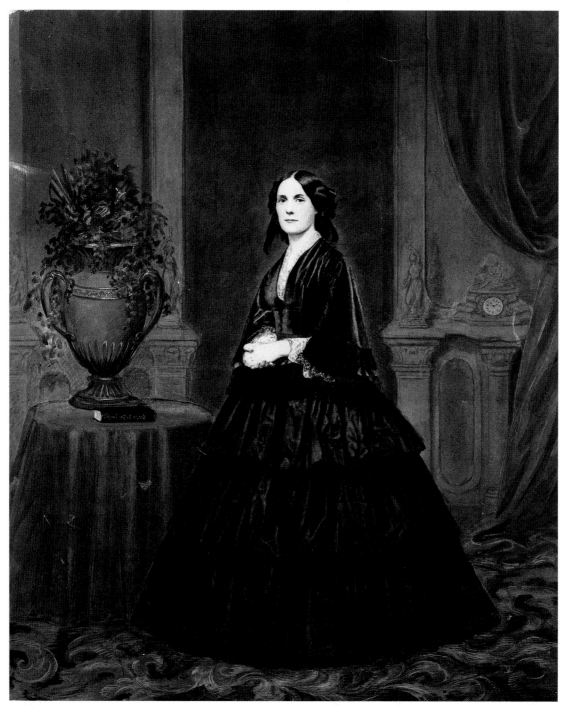

PLATE 60

Mrs. Williams

Imperial salted-paper print
with hand-coloring, circa
1856.

Fogg Art Museum, Harvard
University Art Museums,
Cambridge, Massachusetts, on
deposit from Harvard College
Library

PLATE 61
William Cullen Bryant
Imperial salted-paper print,
circa 1860.

Fogg Art Museum, Harvard
University Art Museums,
Cambridge, Massachusetts,
on deposit from Harvard College
Library

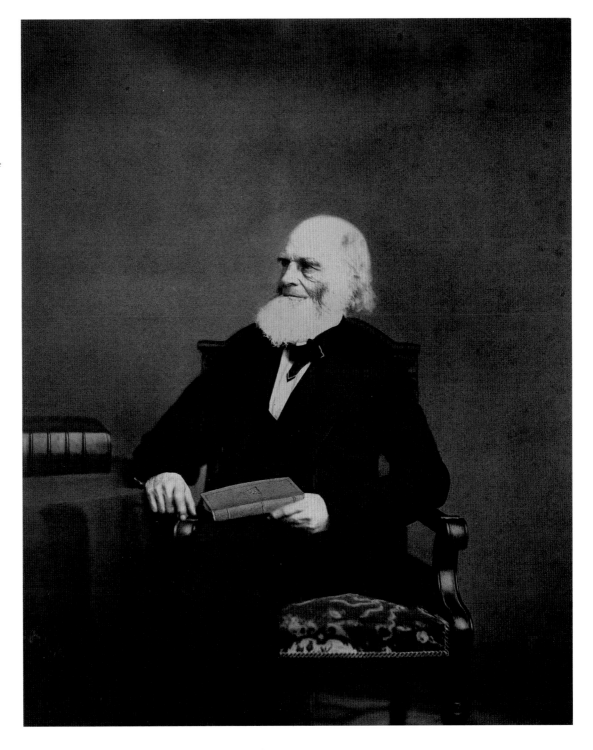

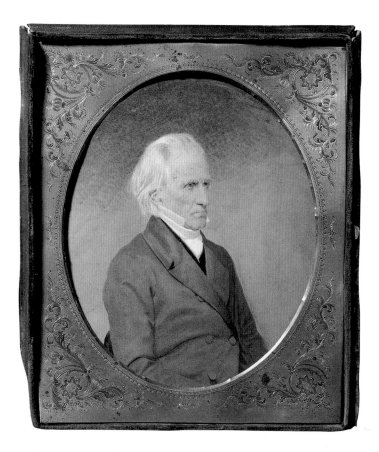

PLATE 62 (left)

Lyman Beecher

Hand-colored photograph, circa 1856.

George Sullivan

PLATE 63 (below)

General Orlando Willcox and His Staff in the Field, Army of the Potomac, Virginia

Albumen silver print (stereo view), circa 1861.

Don P. Parisi

PLATE 64 (opposite, above)

Admiral John Dahlgren

Albumen silver print (stereo view), 1863–1865.

National Portrait Gallery, Smithsonian Institution, Washington, D.C.

PLATE 65 (opposite, below)

General McClellan and His Staff

Albumen silver print, circa 1862.

National Archives, Washington, D.C.

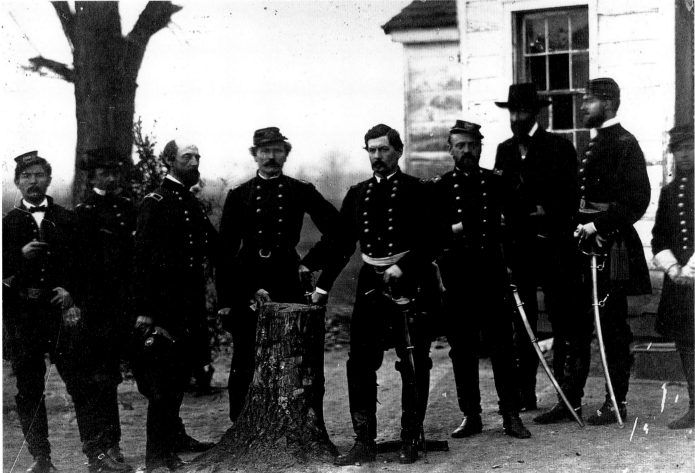

PLATE 66

Officers of Rhode Island First Regiment

Albumen silver print, 1861.

Library of Congress,
Washington, D.C.

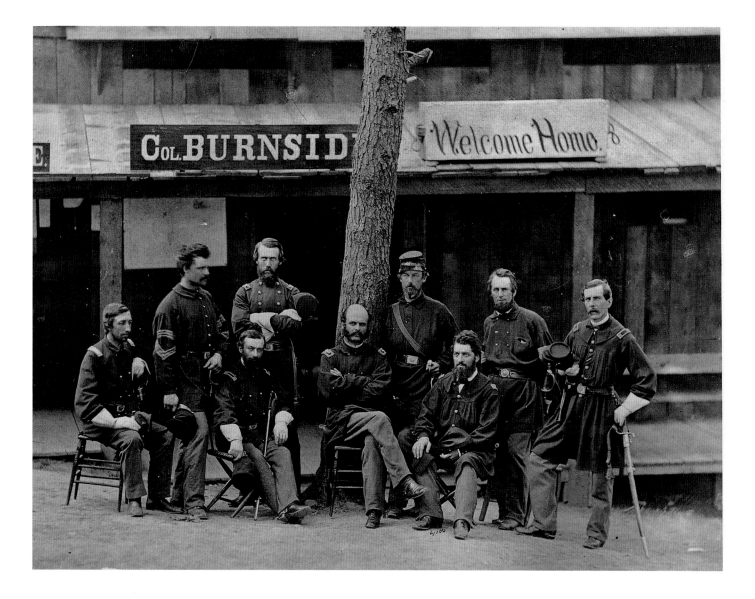

PLATE 67

Brigadier General Charles Francis Adams Jr.

Albumen silver print, 1864.

Library of Congress,
Washington, D.C.

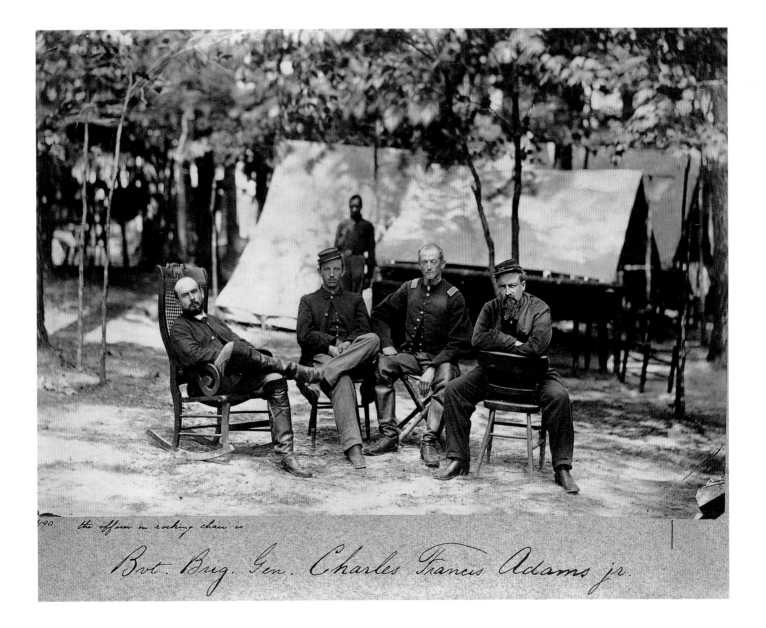

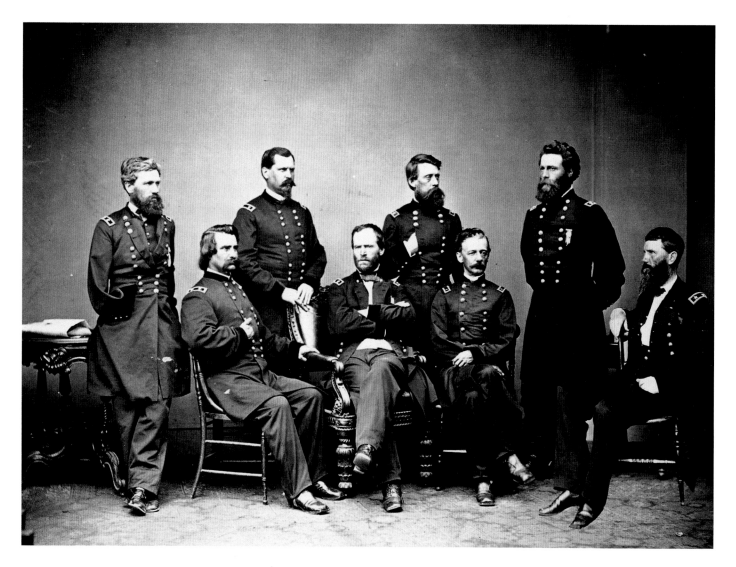

PLATE 68

Sherman and His Generals

Albumen silver print, 1865.

Chicago Historical Society,
Illinois

PLATE 69

Robert E. Lee

Albumen silver print, 1865.

National Portrait Gallery,
Smithsonian Institution,
Washington, D.C.

PLATE 70

Sister Cecelia

Albumen silver print, circa
1862.

National Archives,
Washington, D.C.

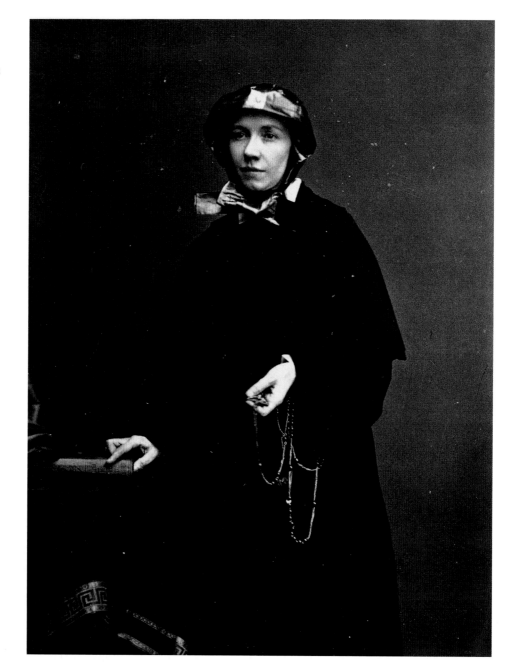

PLATE 71

Clara Barton

Albumen silver print, circa
1866.

National Archives,
Washington, D.C.

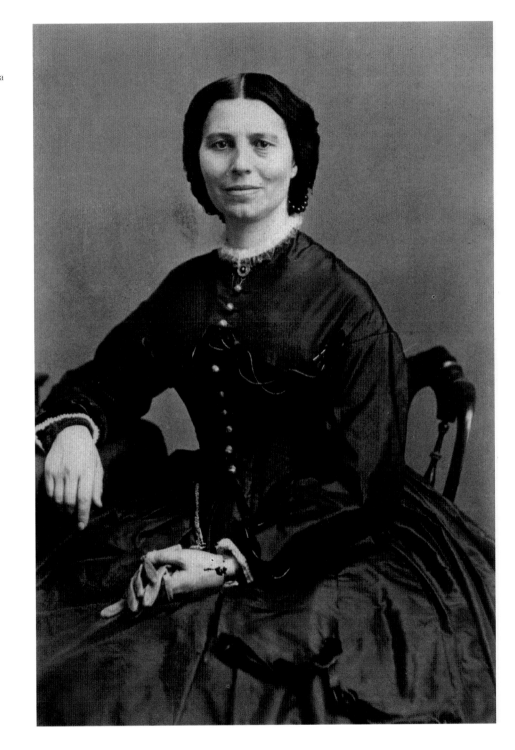

PLATE 72

Stephen A. Douglas

Albumen silver print (carte
de visite), circa 1860.

National Portrait Gallery,
Smithsonian Institution,
Washington, D.C.

PLATE 73

Mary Todd Lincoln

Albumen silver print (carte
de visite), circa 1863.

National Portrait Gallery,
Smithsonian Institution,
Washington, D.C.

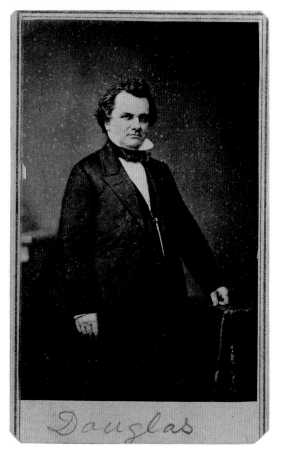

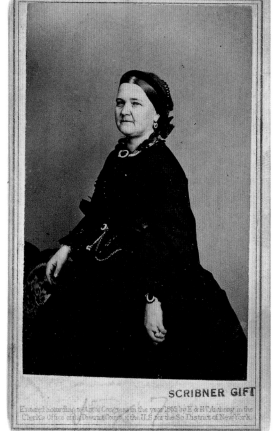

SCRIBNER GIFT

PLATE 74

Joseph Henry

Albumen silver print (carte
de visite), circa 1862.

National Portrait Gallery,
Smithsonian Institution,
Washington, D.C.

PLATE 75

Margaret Julia
"Maggie" Mitchell

Albumen silver print (carte
de visite), circa 1862.

National Portrait Gallery,
Smithsonian Institution,
Washington, D.C.; gift of
Claire Kaland

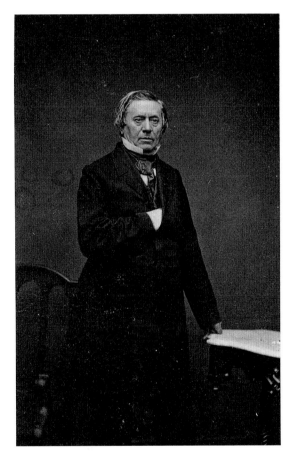

PLATE 76

Charles and Lavinia Stratton ("Mr. and Mrs. General Tom Thumb")

Albumen silver print (carte de visite), circa 1863.

National Portrait Gallery, Smithsonian Institution, Washington, D.C.

PLATE 77

Edwin Booth and His Daughter, Edwina

Albumen silver print (carte de visite), circa 1864.

National Portrait Gallery, Smithsonian Institution, Washington, D.C.

PLATE 78

Anna Elizabeth Dickinson

Albumen silver print (carte
de visite), circa 1863–1864.

National Portrait Gallery,
Smithsonian Institution,
Washington, D.C.; gift of
Laurie A. Baty

PLATE 79

Mathew Brady

Albumen silver print (carte
de visite), circa 1861.

National Portrait Gallery,
Smithsonian Institution,
Washington, D.C.

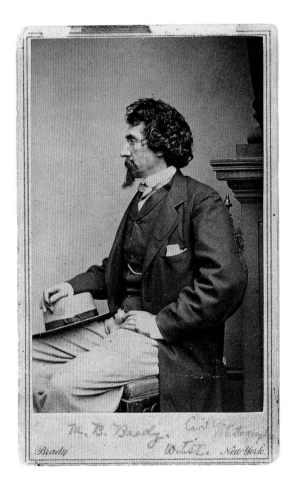

Plate Captions and Subject Biographies

Our knowledge about these portraits remains frustratingly small, when judged by modern standards. We do not know the name of the artist responsible for each picture. For the most part, Brady's staff worked without receiving explicit credit, as did the operators, posers, and finishers at other photographic studios. Also, few, if any, of these images came with any precise date attached; research for this exhibition led to the conclusions that are published here. However, one can easily and confidently place images in broad categories according to technique: Brady made daguerreotypes between 1844 and 1855, Imperials between 1855 and 1860, and albumen prints (in all formats) between 1860 and 1885. Unless otherwise noted, measurements record only the image, without a sheet or mount.

PLATE 1

SITTER: Rose O'Neal Greenhow (1817–1864) and Daughter

DATE: 1862

MEDIUM: Albumen silver print

DIMENSIONS: 24.1 x 15.9 cm (9½ x 6¼ in.)

OWNER: National Portrait Gallery, Smithsonian Institution

BIOGRAPHY: In the 1840s, Rose O'Neal Greenhow was a Washington hostess to diplomats and pro-slavery politicians. After a move west, the widowed Greenhow returned to Washington, finding her old friend James Buchanan in the White House. She enjoyed great social power with friends of varying political convictions, but after the war began, Greenhow vigorously supported the Confederate cause. Her most important act took place in July 1861, when she alerted the Confederate army to Union plans for the Battle of Bull Run. Soon after, detective Allan Pinkerton sent her and her young daughter to Washington's Old Capitol Prison, making Mrs. Greenhow a famous martyr. After her release, she moved south, and then to England, where publication of her prison memoirs turned her into an international celebrity. In 1864, on her return to Virginia, Greenhow died in a shipwreck, weighed down by the gold she earned from her book. While Mrs. Greenhow and her daughter Rose were still in prison, they posed for Brady's photographer Alexander Gardner. Brady published their portrait as part of his series *Brady's Incidents of the War.*

PLATE 2

SITTER: Daniel Webster (1782–1852)

DATE: Circa 1849

MEDIUM: Daguerreotype

DIMENSIONS: 13.9 x 11.4 cm (5½ x 4½ in.)

OWNER: National Museum of American History, Smithsonian Institution

BIOGRAPHY: For his contemporaries, Daniel Webster embodied the very spirit of the nation. As John Lothrop Motley said, "Thinking of America without Webster . . . seems like thinking of her without Niagara, or the Mississippi." Webster represented Massachusetts in Congress, argued before the Supreme Court, and eventually served as secretary of state. Despite great effort over three decades of public life, Webster failed to become President, but his sustained power and charismatic rhetoric made him a treasured national figure. One biographer explained, "There seemed one solid thing in America, so long as he sat in an arm-chair of the Senate-chamber." In 1830, in a famous debate with Robert Hayne, Webster supported the Union over the rights of the individual states. Twenty years later, he defended the Compromise of 1850, upholding slavery in the South in order to prevent secession, and effectively eroding his support in Massachusetts and the nation. Ralph Waldo Emerson called him "a man of the past." But as Henry James remembered, for the first half of the nineteenth century, Webster "filled the sky of public life from pole to pole." Late in his life, Brady fondly recalled Webster's docile temperament before the camera: "'Use me as the potter would the clay, Mr. Brady,' he said to

me, and he was more than pleased with
the result."

PLATE 3
SITTER: Harriet Hosmer (1830–1908)
DATE: 1857
MEDIUM: Imperial salted-paper print with
ink enhancements
DIMENSIONS: 45.5 x 36.5 cm
(17⅞ x 14⅜ in.)
OWNER: Fogg Art Museum, Harvard
University Art Museums, on deposit from
Harvard College Library
BIOGRAPHY: Sculptor Harriet Hosmer
moved to Rome in 1852, where she joined the
large international circle of artists and writers
that included actress Charlotte Cushman,
poets Robert and Elizabeth Barrett Browning,
fellow American sculptor William Wetmore
Story, and writers Nathaniel Hawthorne and
Henry James. Hosmer's talent for friendship
and her independent spirit propelled an ambi-
tious, successful career. Her originality also
inspired her eccentric, practical style, shown
in her man-tailored jackets and short hair.
Hosmer's art struck a more conventional
chord, however. She first won wide notice for
a humorous figure of Puck, of which she even-
tually sold fifty replicas, including one to the
Prince of Wales. Her sensual depiction of
heroines such as Beatrice Cenci and Zenobia,
Queen of Palmyra, earned notoriety and
acclaim. Today, Hosmer also remains impor-
tant as the model for Hilda in Nathaniel
Hawthorne's novel *The Marble Faun*, and as
the leader of a group of American women
artists in Rome. Hosmer posed for Mathew
Brady in October 1857, on a brief, triumphant
visit back to the United States.

PLATE 4
SITTER: A Colorist at His Easel
DATE: Circa 1860
MEDIUM: Albumen silver print
(carte de visite)
DIMENSIONS: 8.6 x 5.4 cm (3⅜ x 2⅛ in.)
OWNER: Keith de Lellis

BIOGRAPHY: This carte-de-visite portrait
showing an artist at his easel offers a tantaliz-
ing glimpse inside Brady's studio. Painters
like Henry F. Darby and Alonzo Chappel
worked closely with Brady, adding color and
definition to his photographic portraits. Many
of Brady's colleagues, such as C. D. Fredricks,
Jeremiah Gurney, and the Meade brothers, all
employed artists. John Werge, an Englishman
and a colorist, first worked for the Meade
brothers in 1854. He returned to New York in
1860 to find that "a mania of magnificence had
taken possession of most of the photogra-
phers." At the Fredricks studio, Werge
admired a huge plate-glass window filled with
life-sized portraits painted in oil, while inside,
the walls were covered with portraits of "emi-
nent men and beautiful women." Werge also
reported that Brady's studio at Tenth Street
and Broadway had "elegant and expensive"
decor that rivaled any studio in Paris
or London.

PLATE 5
SITTER: Jefferson Davis (1808–1889)
DATE: 1858–1860
MEDIUM: Modern albumen silver print from
a collodion glass-plate negative
DIMENSIONS: 8.4 x 5.4 cm (3⁵⁄₁₆ x 2⅛ in.)
OWNER: National Portrait Gallery,
Smithsonian Institution
BIOGRAPHY: Jefferson Davis graduated
from West Point in 1828 but left the army in
1835, when he eloped with Sarah, the daugh-
ter of his commander, Zachary Taylor. He was
soon widowed and spent the next ten years as
a Mississippi planter. In 1845, Davis entered
politics, interrupting his term in Congress to
serve again under Taylor in the Mexican
American War. A popular hero, he was named
to the United States Senate in 1847, then
became secretary of war under Franklin
Pierce in 1853. Carl Schurz recalled that
Davis met every expectation of what "a grand
personage the War Minister of this great
Republic must be." Upon his return to the
Senate, Davis continued to be a strong advo-

cate for states' rights. After 1861, Davis hoped
to serve in the Confederate army, but instead
became the Confederacy's first and only Presi-
dent. He was an imperious, opinionated, and
often unpopular leader. After the war ended,
Davis lived as an exile in his own land, having
refused to request the official pardon that
would restore his citizenship. Brady made this
portrait during Davis's second term in the
Senate. It became his official image when
newspapers, publishers, and the public came
to Brady in search of portraits of southern
politicians.

PLATE 6
SITTER: Abraham Lincoln (1809–1865)
DATE: 1860
MEDIUM: Salted-paper print
(carte de visite)
DIMENSIONS: 8.6 x 5.4 cm (3⅜ x 2⅛ in.)
OWNER: National Portrait Gallery,
Smithsonian Institution
BIOGRAPHY: Mathew Brady first pho-
tographed Abraham Lincoln on February 27,
1860, the day Lincoln addressed a large
Republican audience in the modern lecture
hall at Cooper Union in New York. Over the
following weeks, newspapers and magazines
gave full accounts of the event, noting the
high spirits of the crowd and the stirring
rhetoric of the speaker. Artists for *Harper's
Weekly* converted Brady's photograph to a full-
page woodcut portrait to illustrate their story
of Lincoln's triumph, and in October 1860,
Frank Leslie's Illustrated Weekly used the same
image to illustrate a story about the election.
Brady himself sold many carte-de-visite pho-
tographs of the Illinois politician who had
captured the eye of the nation. Brady remem-
bered that he drew Lincoln's collar up high to
improve his appearance; subsequent versions
of this famous portrait also show that artists
smoothed Lincoln's hair and subtly refined his
features. After Lincoln secured the Republican
nomination and the presidency, he gave credit
to this speech and this portrait, saying, "Brady
and the Cooper Institute made me President."

PLATE 7

SITTER: General Philip Henry Sheridan
(1831–1888)

DATE: 1864

MEDIUM: Albumen silver print

DIMENSIONS: 15.3 x 11.6 cm (6¹⁄₁₆ x 4⁹⁄₁₆ in.)

OWNER: National Portrait Gallery,
Smithsonian Institution

BIOGRAPHY: At the beginning of the war,
Philip Sheridan served in Missouri as a quar-
termaster, a post he disliked. But with his
appointment as colonel of the Second Michi-
gan Cavalry in May 1862, Sheridan began a
series of important victories that proved his
daring in battle, leading Lincoln to observe,
"This Sheridan is a little Irishman, but he is a
big fighter." In the spring of 1864, Grant put
Sheridan in command of the entire cavalry of
the Army of the Potomac. That summer, as
commander of the Army of the Shenandoah,
Sheridan oversaw the ruthless destruction of
the valley, which provided the Confederate
army with food and supplies. In October 1864,
he rode more than twenty miles to rally his
troops to victory after a surprise attack, and
his ride became the subject of many patriotic
prints and paintings. Sheridan's military
career continued in a series of positions on the
Mexican border, in the Reconstruction gov-
ernment, and in brutal operations against
many Indian tribes, including the Cheyenne,
Comanche, and Arapahoe. In 1884 he suc-
ceeded William T. Sherman as commander of
the army. Brady photographed Sheridan in
1864, around the time he assumed command
of the cavalry for the Army of the Potomac.

PLATE 8

SITTER: Ute Delegation of 1868

DATE: 1868

MEDIUM: Albumen silver prints

DIMENSIONS: 17.8 x 49.8 cm (7 x 19⅝ in.)

OWNER: National Portrait Gallery,
Smithsonian Institution

BIOGRAPHY: In February 1868, eight repre-
sentatives of the Ute tribe arrived in Wash-
ington to negotiate a treaty with the United

States government. President Andrew John-
son appointed Ouray their leader, thanks to
his mastery of Spanish and English and his
skills as a negotiator, which had already
earned him the esteem of many Indian agents,
including Kit Carson. At the bargaining table,
Ouray secured fifteen million acres "forever,"
as well as annual provisions from the govern-
ment for thirty years, though he compared all
agreements between the Indians and the gov-
ernment to "the agreement a buffalo makes
with his hunter when pierced with arrows."
Over the next twenty years, the treaty eroded:
gold and silver were found in Ute territory,
white settlement increased throughout the
West, and dissension also arose within the
tribe, as many Utes believed Ouray to be a
traitor. By 1880, the land was divided, and the
Ute nation had dispersed to different reserva-
tions. This photograph, made by Brady in
Washington, commemorates a brief moment
of harmony between the Ute delegation,
Indian agents, interpreters, and Colorado
Territory officials. Brady's studio may have
been too small to accommodate the large dele-
gation, for the group posed in three discrete
groups, and the photographer reassembled the
delegation in a panorama made from three
photographs.

PLATE 9

SITTER: Edwin Forrest (as Metamora)
(1806–1872)

DATE: 1861

MEDIUM: Modern albumen silver print from
collodion glass-plate negative

DIMENSIONS: 50.8 x 43.2 cm (20 x 17 in.)

OWNER: National Portrait Gallery,
Smithsonian Institution

BIOGRAPHY: At the age of twenty, Edwin
Forrest made his debut on the New York
stage as Othello. His dashing, athletic perfor-
mance won a loyal following, especially from
the lowbrow Bowery crowd; more refined the-
atergoers preferred the British actor William
Macready, who was also touring on Broadway.
Forrest quickly became this country's leading

actor, famous for his outsized heroes and his
wealth, and he never altered the formula that
brought his first success. At the height of his
powers, playing Spartacus, the Gladiator, a
role written for him, actress Fanny Kemble
declared Forrest "a mountain of a man!" For-
rest's twenty-year rivalry with Macready
turned tragic in 1849, when their competing
New York productions of *Macbeth* ignited
nativist sentiment and caused a riot at Astor
Place, which lasted three days and killed
twenty-two people. In 1861, Forrest commis-
sioned Brady to photograph him in his most
famous roles. Marcus Aurelius Root com-
mended the "artistic effects, and . . . *expression*"
of these portraits, and called them Brady's
"most remarkable productions." Today these
portraits of Forrest as Hamlet, Shylock, Lear,
Macbeth, Brutus, and the Indian prince Meta-
mora show how he effectively used togas, vel-
vet cloaks, ermine robes, and chains to adorn a
single, heroic image.

PLATE 10

SITTER: Edwin Forrest (as Spartacus, the
Gladiator) (1806–1872)

DATE: 1861

MEDIUM: Modern albumen silver print from
collodion glass-plate negative

DIMENSIONS: 50.8 x 43.2 cm (20 x 17 in.)

OWNER: National Portrait Gallery,
Smithsonian Institution

BIOGRAPHY: See Plate 9

PLATE 11

SITTER: Cornelius Mathews (1817–1889)

DATE: Circa 1850

MEDIUM: Daguerreotype

DIMENSIONS: 13.9 x 10.8 cm (5½ x 4¼ in.)

OWNER: Library of Congress

BIOGRAPHY: Cornelius Mathews belonged
to the nationalistic group of writers and
politicians known as "Young America," who
strove to establish an independent form of
American culture in the years between 1830
and 1860. Mathews contributed criticism and
fiction to journals such as *American Monthly*

Magazine and the *Knickerbocker Review* and helped establish *Arcturus*, a short-lived journal of criticism, and *Yankee Doodle*, New York's first humor magazine. His fiction embellished epic themes from the American past, or attacked modern urban manners. Mathews campaigned vigorously for an international copyright agreement to prevent foreign publishers from dumping cheap editions of British works on the American market. He was also an advocate for modern British letters, and introduced the poetry of Elizabeth Barrett Browning to this country. He was not well liked. In *A Fable for Critics*, James Russell Lowell described Mathews as "a small man in glasses . . . dodging about, muttering 'Murderers! asses!'" Mathews, like Brady, was a friend and associate of publisher Evert A. Duyckinck. An engraving based on Brady's portrait of Mathews appears in Duyckinck's *Cyclopaedia of American Literature*.

PLATE 12

SITTER: Nathaniel Parker Willis (1806–1867)

DATE: Late 1850s

MEDIUM: Imperial salted-paper print

DIMENSIONS: 55.3 x 43.2 cm (21¾ x 17 in.)

OWNER: National Portrait Gallery, Smithsonian Institution

BIOGRAPHY: Magazine editor, journalist, and talented author of ephemeral essays, Nathaniel Parker Willis brought a rare, modern sensibility to his reports on contemporary life. From 1829, when he founded the *New York Mirror*, until his death in 1867, Willis worked continually as an editor and journalist. He was the *Mirror*'s foreign correspondent from 1829 until 1836, when he returned to the United States and continued to write on fashionable life for a series of magazines, including the weekly *Home Journal*, which he founded in 1846 and edited until his death. Willis was a popular figure in New York society. Walt Whitman called him a "good natured bright fellow," but also remembered his vanity, which made him "the horror of photogra-

phers." Willis wrote often about Brady's New York gallery, and posed for this Imperial photograph in New York in the late 1850s.

PLATE 13

SITTER: Charles Edwards Lester (1815–1890)

DATE: Circa 1850

MEDIUM: Daguerreotype

DIMENSIONS: 21.6 x 16.5 cm (8½ x 6½ in.)

OWNER: Library of Congress

BIOGRAPHY: Charles Edwards Lester studied law and was ordained as a Congregational minister before traveling to London as a delegate to the World Anti-Slavery Convention at Exeter Hall in 1840. An active Democrat, he was named American consul in Genoa by James K. Polk, where he served from 1842 to 1847. On his return, Lester settled in New York and began a long, prolific career as a popular writer, drawing material from his experience in Europe, his wide political connections, and his taste for history and contemporary culture. Along with biographies of Sam Houston, Peter Cooper, Charles Sumner, Napoleon Bonaparte, the Medici princes, and Italian navigator Amerigo Vespucci, Lester wrote a history of the United States, a history of Mexico, several volumes of memoirs, a book on American art, and compiled *Glances at the Metropolis*, a large, lavish volume advertising the wares of New York merchants. In 1851, Lester joined his interests in nationalism, heroism, art, and enterprise when he collaborated with Mathew Brady on the *Gallery of Illustrious Americans*, providing fulsome biographies to accompany Brady's portraits. In 1863, Lester was arrested in Harpers Ferry under suspicion of treason, but he was quickly released, the cause of his actions being delicately described as "a temporary absence of mind not uncommon among frequenters of Washington hotels."

PLATE 14

SITTER: Edward Albert, Prince of Wales (1841–1910)

DATE: 1860

MEDIUM: Albumen silver print (carte de visite)

DIMENSIONS: 10.2 x 5.1 cm (4 x 2 in.)

OWNER: Clifford and Michele Krainik

BIOGRAPHY: Edward, the Prince of Wales, was only nineteen when he came to the United States and Canada in the fall of 1860, the first member of the British royal family ever to visit North America. Huge celebrations welcomed him wherever he went, and crowds followed him in the streets. In New York, the prince received several parades, a nighttime procession illuminated by "torches, lamps, lanterns, transparencies and other luminosities," and an exclusive ball at the Academy of Music. In Washington, he was the guest of President James Buchanan in the White House. The visit prompted a period of warm diplomatic relations between Britain and the United States, which quickly ended with the onset of the Civil War. When Brady photographed the prince on October 13, 1860, a touching incident showed Brady's talent for establishing ties to all his sitters. Just before the prince left the gallery, Brady introduced him to Stevens, one of his framers, explaining that the old man had once lived in London and was working in Buckingham Palace on the day the prince was born. According to the *New York Times*, "The Prince seemed greatly pleased, and shook Stevens by the hand."

PLATE 15

SITTER: Henry Clay (1777–1852)

DATE: Circa 1849

MEDIUM: Daguerreotype

DIMENSIONS: 13 x 9.7 cm (5⅛ x 3¹³⁄₁₆ in.)

OWNER: The Museum of Modern Art; gift of A. Conger Goodyear

BIOGRAPHY: Before he was thirty, Henry Clay had become not only one of the richest men in Kentucky but also a United States senator. As a self-made man, he personified an optimistic, successful generation of Americans. In Washington, Clay became the "Great Conciliator" and a leader of the Whig Party, loved

for his eloquence, his ability to forge alliances, and his commitment to the Union, though today many of his policies seem difficult to defend. In 1820, Clay drafted the Missouri Compromise, the first of many measures that sought to balance power between free states, slaveholding states, and the territories. While Clay called slavery the "greatest of human evils," he believed that African Americans could not live in the United States as free men, and in 1816 he helped found the American Colonization Society, which established the African colony of Liberia as a place to which emancipated slaves could emigrate. Clay insisted that he would "rather be right than be President," but was a perpetual candidate, running against John Quincy Adams in 1824, Andrew Jackson in 1832, and James K. Polk in 1844. His final speech before the Senate in January 1850 appealed—successfully—for preservation of the Union. When Clay died in 1852, the entire nation mourned.

PLATE 16

SITTER: Henry James Sr. (1811–1882) and Henry James Jr. (1843–1916)
DATE: 1854
MEDIUM: Daguerreotype
DIMENSIONS: 13.8 x 10.8 cm (5⁷⁄₁₆ x 4¼ in.)
OWNER: James Family Photographs, Houghton Library, Harvard University, bMSAm 1092.9 (4597.6)
BIOGRAPHY: Henry James Sr. used his independent wealth to support an idiosyncratic, intellectual career as a lecturer, theologian, and philosopher. In search of education and culture, he took his family on a nomadic course from Albany, to Europe and New York, back to Europe, and finally to Boston. He is best known today as the father of two important American writers, Henry James Jr., the novelist (pictured here), and William James, the philosopher and the major voice of Pragmatism. The elder James and his son came to Brady's studio to pose for this daguerreotype in 1854.

PLATE 17

SITTER: Horace Greeley (1811–1872)
DATE: Circa 1851
MEDIUM: Daguerreotype
DIMENSIONS: 13.9 x 10.8 cm (5½ x 4¼ in.)
OWNER: Library of Congress
BIOGRAPHY: In 1869, *Harper's Weekly* called Horace Greeley "the most perfect Yankee the country has ever produced," commending his "aims, his methods, his philosophy, his character, and his success." Editor, politician, and founder of the *New York Tribune*, Greeley began his career as a Whig and colleague of Albany politicians Thurlow Weed and William H. Seward. In 1856 he helped establish the new Republican Party. Greeley advocated reform in every arena—he was a disciple of French socialist Charles Fourier and dietary specialist Sylvester Graham, and a supporter of temperance, labor unions, spiritualism, Transcendentalism, and the Young America movement. Greeley's ability to express idealistic, moral positions in clear, memorable prose won loyal readers for the *Tribune*. In the 1840s, he urged a generation to "Go West, young man," and his own restless energy propelled him to travel throughout the country, to Europe, and to Washington as both a candidate and a lobbyist. Under his leadership, the *Tribune* became the first national newspaper, circulating by rail and steamboat lines to unite the country around Greeley's moderate, antislavery position. After the war, as the *Tribune* outgrew his personal control, Greeley's influence declined, and his idiosyncratic blend of personal morality and national policy lost its broad appeal. Brady made many portraits of Greeley. This daguerreotype was made around 1851, when Greeley served on the jury for the great exhibition in the Crystal Palace in London, where Brady won a medal for his work.

PLATE 18

SITTER: John C. Calhoun (1782–1850)
DATE: 1848–1849
MEDIUM: Daguerreotype

DIMENSIONS: 21.6 x 16.2 cm (8½ x 6⅜ in.)
OWNER: The Beinecke Rare Book and Manuscript Library, Yale University
BIOGRAPHY: John C. Calhoun devoted most of his political career to protecting the interests of the South while maintaining the Union. In January 1849, in a fervent call for unity among all southern politicians regardless of party, Calhoun described the growing northern support for abolition, anticipated southern resistance, and predicted social chaos as the inevitable result. But Calhoun never established a formal southern coalition, and a decade later, when most of the events he predicted had come about, the Union had dissolved. Calhoun came to Washington in 1811 as a congressman from South Carolina, quickly attaining recognition for his powerful support for war against Britain. He became secretary of war under James Monroe and was elected Vice President twice—under John Quincy Adams in 1824 and Andrew Jackson in 1828. But in 1832 his support for states' rights caused a rift with Jackson, and Calhoun resigned the vice presidency for the Senate. Calhoun remained a powerful and charismatic figure in Washington throughout his career, the perpetual Democratic opponent of Whig politicians Daniel Webster and Henry Clay. Mathew Brady photographed Calhoun around the winter of 1849, and used this image to create many more portraits, including a lithograph and a large, majestic painting that hung in his studio.

PLATE 19

SITTER: General John Ellis Wool (1784–1869)
ARTIST: Alonzo Chappel (1828–1887)
DATE: Circa 1858
MEDIUM: Oil on canvas
DIMENSIONS: 59.1 x 44.5 cm (23¼ x 17½ in.)
OWNER: National Portrait Gallery, Smithsonian Institution
BIOGRAPHY: General John E. Wool served more than fifty years in the United States

Army. In 1812 he organized a volunteer brigade in the war against England, and ended his career in 1863, as the army's fourth-ranking general, head of the Department of the East. Wool was known for his severe discipline, while his "audacity and control" inspired comparisons to the Roman general Xenophon. In 1838, Wool led the Cherokee Nation west over the "Trail of Tears," and from 1854 to 1857, as commander of the Department of the Pacific, he suppressed Indian uprisings. Wool organized more than 12,000 troops for Zachary Taylor during the Mexican American War, where his service in the Battle of Buena Vista won an official thanks from Congress. In 1861, Wool secured Fortress Monroe for the Union; in 1863, while stationed in New York, he successfully called on veterans to quell the draft riots there. Brady and Alonzo Chappel collaborated on this colorful portrait around 1858, when Wool was a well-known war hero. Chappel also engraved this image for *Battles of the United States by Sea and Land*, a deluxe two-volume illustrated history. With its showy display of costume and rigorous rendering of features, this image exemplifies the distinctive style of painted photographic portraiture that Brady and Chappel developed to serve commercial publishers and patriotic audiences.

PLATE 20
SITTER: Cyrus West Field (1819–1892)
DATE: 1858
MEDIUM: Imperial salted-paper print
DIMENSIONS: 44.8 x 35.7 cm (17⅝ x 14¹/₁₆ in.)
OWNER: National Portrait Gallery, Smithsonian Institution
BIOGRAPHY: Cyrus Field began work at age fifteen, as an office boy for A. T. Stewart & Co., New York City's first department store. By age twenty, Field was a partner in a paper manufacturing company, and before he was forty, he was wealthy enough to retire from business. In 1854 Field began the New York, Newfoundland, and London Telegraph Com-

pany to finance the laying of a telegraphic cable across the Atlantic Ocean. He consulted the country's leading scientists, including Matthew Fontaine Maury at the United States Naval Observatory in Washington and Samuel F. B. Morse in New York, and formed a stock company with the support of New York's most prominent bankers and politicians. After several failed attempts, in August 1858 Field arranged for Queen Victoria to send the first transatlantic message to President Buchanan, and New York erupted in celebrations, lauding Field, Morse, modern technology, and American ingenuity in general. But when the cable broke after just three weeks, skepticism blossomed, along with repeated rumors of fraud. Field did not successfully complete the cable until 1866. He posed for his portrait in 1858, and in an unusual departure, Brady added two telling props—a length of wire cable and a globe.

PLATE 21
SITTER: William Seward (1801–1872)
DATE: Circa 1860
MEDIUM: Albumen silver print (carte de visite)
DIMENSIONS: 8.6 x 5.5 cm (3⅜ x 2³/₁₆ in.)
OWNER: National Portrait Gallery, Smithsonian Institution
BIOGRAPHY: William Seward's political career began in 1830, when he joined Thurlow Weed's political machine as a state senator in Albany, New York. From 1838 until 1842, he served as governor but then stepped aside, in part because his growing opposition to slavery seemed to be a political liability. By 1848 Seward had entered the Senate, where he opposed Henry Clay's compromise measures of 1850, supported admission of California as a free state, voiced strong opposition to the Fugitive Slave Act, and argued against extension of slavery into the territories. After Winfield Scott's defeat in the presidential campaign of 1852, Weed and Seward astutely merged their old political alliances with the Know-Nothing Party and the new Republi-

cans, supporting John C. Frémont and the Republican ticket in 1856. When Seward failed to win the 1860 Republican nomination for President, he campaigned actively for Lincoln and became his secretary of state. An able and successful diplomat, Seward deterred European entry in the Civil War, opposed French intervention in Mexico, and in 1867, under Andrew Johnson, negotiated the Russian treaty for the sale of the Alaska territory.

PLATE 22
SITTER: "Artist's Souvenir," maquette for cartes de visite
DATE: Circa 1864
MEDIUM: Cartes de visite mounted on board
DIMENSIONS: 51.8 x 41.8 cm (20⅜ x 16⁷/₁₆ in.)
OWNER: National Portrait Gallery, Smithsonian Institution
BIOGRAPHY: Throughout his career, Mathew Brady used many techniques to create composite portraits, combining images from his inventory to celebrate notable individuals or events. Composites were photographed again to create new commercial images for sale. This image, made to create a carte de visite, may have celebrated the 1864 Metropolitan Fair, which raised funds for the United States Sanitary Commission. There, Brady, along with many of the pictured artists, organized an exhibition of American art. A comparison of backgrounds and props suggests that Brady used old portraits of William Page, Rembrandt Peale, Frederic E. Church, and Charles Loring Elliott, and made new ones of F. O. C. Darley, William Sidney Mount, Henry Peters Gray, and Regis Gignoux (although careless lettering of Gignoux's name may have spoiled this effort).

PLATE 23
SITTER: Charles Loring Elliott (1812–1868)
DATE: Circa 1850
MEDIUM: Daguerreotype
DIMENSIONS: 13.9 x 10.8 cm (5½ x 4¼ in.)
OWNER: National Portrait Gallery, Smithsonian Institution

BIOGRAPHY: Charles Loring Elliott tried and rejected a career in architecture before coming to New York City to study painting with John Trumbull and John Quidor in 1834. On receiving Trumbull's grudging blessing, Elliott spent the next decade as an itinerant portraitist. He returned to New York around 1845, began to exhibit his work at the National Academy of Design, and within five years was called the finest portrait painter of his time. Elliott painted more than seven hundred portraits, including many of the period's most successful businessmen, such as glass manufacturer Erastus Corning, Hartford gun magnate Samuel Colt, millionaires William Thompson Walters of Baltimore and William Wilson Corcoran of Washington, as well as writers, artists, and prominent New York politicians. Critic Henry T. Tuckerman insisted that Elliott's best work provided "a perfect illustration of American life," and that his sitters seemed "the epitome of a progressive, locomotive race, born for office and action." Elliott was also a frank admirer of photography, comparing the high contrasts and mysterious shadows of daguerreotypes to etchings by Rembrandt. He openly acknowledged painting James Fenimore Cooper's portrait from a daguerreotype by Brady. Later historians did not share the glowing contemporary assessment of Elliott's work, lamenting his use of contrast, detail, and intense verisimilitude—the very photographic qualities that had won him high praise.

PLATE 24
SITTER: Winfield Scott (1786–1866)
DATE: Circa 1861
MEDIUM: Imperial salted-paper print
DIMENSIONS: 47 x 40 cm (18½ x 15¾ in.)
OWNER: National Portrait Gallery, Smithsonian Institution
BIOGRAPHY: Winfield Scott achieved great early fame as a hero of the War of 1812. As a peacetime officer, Scott sought to bring professional discipline and training to the army.

Throughout the 1830s, he was active in the Indian wars, fighting the Seminole and Creek in Florida and forcing the Cherokee Nation to move west of the Mississippi in 1838. He was also an important negotiator in the 1842 treaty with Britain that established the boundary with Canada. As commander of the United States Army, Scott again led it to victory against Mexico in 1848. To his disappointment, Scott's military triumphs never brought political success. In 1852, when he ran for President on the Whig ticket, Franklin Pierce won an overwhelming victory. Following the election, Scott moved his headquarters to New York, where he was a much-admired local celebrity. Scott finally resigned his post in October 1861, when Lincoln honored him, acknowledging "how faithfully, ably, and brilliantly he has served his country, from a time far back in our history when few of the now living had been born." Scott posed for Mathew Brady many times, and Brady was clearly proud to have the nation's greatest military hero as his patron. This Imperial portrait, made around 1861, shows Scott at the end of his career.

PLATE 25
SITTER: Robert Todd Lincoln (1843–1926), from Alonzo Chappel's subscription book
DATE: 1865
MEDIUM: Albumen silver print
DIMENSIONS: 20.5 x 11.9 cm (8⅛ x 4¹¹⁄₁₆ in.)
OWNER: Private collection, the eastern collector
BIOGRAPHY: Robert Lincoln entered Harvard in the fall of 1860, where he spent most of the war. He joined Grant's staff in February 1865, was present at the surrender at Appomattox, and quickly returned to Washington to relay news of the event to his father at breakfast on April 14. After Abraham Lincoln's death, the Lincoln family, including Robert, his mother, and his brother Thomas, returned to Illinois. Robert Lincoln became a wealthy and successful Chicago lawyer and businessman, who served as secretary of war

under Presidents Garfield and Arthur, and as Benjamin Harrison's minister to Britain. He also carefully watched over historical representations of his father, favoring G. P. A. Healy's portraits. He opened his father's papers only to biographers John Nicolay and John Hay, though he willed the entire collection to the Library of Congress.

PLATE 26
SITTER: Clara Harris (died 1894) and Joseph Barnes (1817–1883), from John Bachelder's subscription book
DATE: 1865
MEDIUM: Albumen silver prints
DIMENSIONS: 21.4 x 26.4 cm (8⁷⁄₁₆ x 10⅜ in.) sheet
OWNER: Private collection, the eastern collector
BIOGRAPHY: Clara Harris and her fiancé, Henry R. Rathbone, joined President Lincoln and his wife in their box at Ford's Theatre on April 14, 1865. Mary Lincoln was fond of Harris, the young daughter of New York Senator Ira T. Harris, and Lincoln had recently appointed Major Rathbone assistant adjutant general of volunteers. Although Rathbone was stabbed while trying to stop John Wilkes Booth's escape, the young major never forgave himself for failing to prevent Lincoln's death. Harris and Rathbone married in 1867; Rathbone was discharged from the army in 1870; and in 1887 President Grover Cleveland named him consul to Hanover, Germany, where the Rathbones and their children lived for the next seven years. Clara Harris Rathbone died in 1894, murdered by her husband, who grew jealous of her attention to the family. He spent the rest of his life in an asylum for the criminally insane. Their son Henry became a Democratic congressman for Illinois and in 1926 introduced the bill to purchase the Oldroyd Lincoln collection, which provided the foundation for the museum at Ford's Theatre.

Joseph Barnes received his medical training at the University of Pennsylvania. After prac-

ticing for two years, he joined the army in 1840, serving at West Point, in the Seminole Wars in Florida, and in the Mexican American War. In 1861, Barnes came to Washington, where he joined Surgeon General William A. Hammond's efforts to reform army medical practice. Barnes succeeded Hammond in 1862 and continued his program, greatly improving the efficiency and effectiveness of army medicine over the next twenty years. Under Barnes, the army began research in the treatment and diagnosis of gunshot wounds, collecting drawings, photographs, anatomical specimens, and detailed accounts from both doctors and their patients. Barnes also presided over the publication of the six magisterial volumes, *Medical and Surgical History of the War of the Rebellion.* On the evening of April 14, 1865, Barnes was called to attend President Lincoln. Nine hours later, at 7:22 a.m. on April 15, 1865, he pronounced the President dead.

PLATE 27
SITTER: Gideon Welles (1802–1878) and John P. Usher (1816–1889), from John Bachelder's subscription book
DATE: 1865
MEDIUM: Albumen silver prints
DIMENSIONS: 21.4 x 26.4 cm (8⁷⁄₁₆ x 10⅜ in.) sheet
OWNER: Private collection, the eastern collector
BIOGRAPHY: A newspaperman and Connecticut politician, Gideon Welles began his career as a supporter of Andrew Jackson. But Welles finally left the Democratic Party when he could not support the Kansas-Nebraska Bill, which left the door open to slavery in the territories. In 1856, Welles established the Republican *Hartford Evening Press* and began to contribute influential articles to the *New York Evening Post* and the Washington *National Intelligencer.* He led Connecticut's support for Lincoln at the Republican convention in 1860, and was rewarded with the post of secretary of the navy. With the onset of

secession, Welles lost most of his officers and faced shipyards that were out of date and virtually empty. His efforts to build a new fleet brought him into conflict with politicians who sought his profitable contracts, as well as career officers such as David Dixon Porter and Samuel F. Dupont. He personally campaigned for the appropriation of funds to build new ironclad ships, like the *Monitor,* when many Americans still doubted the new technology. After the war, even Admiral Porter acknowledged that Welles had "served his country . . . with fidelity and zeal."

John Palmer Usher was a prominent Indiana lawyer before he joined Lincoln's Department of the Interior in 1862. In 1863, he became secretary and served until May 1865. Brady photographed Usher and Welles in 1865, as part of a large commission from John Bachelder, who sought portraits of all of the mourners at Lincoln's deathbed for his depiction, *The Last Hours of Lincoln.*

PLATE 28
SITTER: Judah Philip Benjamin (1811–1884)
DATE: Circa 1858
MEDIUM: Imperial salted-paper print with ink and pencil
DIMENSIONS: 50 x 43.1 cm (9¹¹⁄₁₆ x 17 in.)
OWNER: Chicago Historical Society (ICHi-26739)
BIOGRAPHY: Born of English-Jewish parents, Judah P. Benjamin entered Yale at age fourteen and studied law in New Orleans, where he was admitted to the Bar in 1832. After a successful career in private practice, he was elected to the United States Senate in 1852 as a Whig candidate from Louisiana, but by the end of the decade he had become a strong supporter of Buchanan and a Democrat. After Lincoln's election, he became one of the first to call for the secession of the southern states. He became close friends with Confederate President Jefferson Davis and held several important cabinet posts in the Confederacy, including secretary of war and secretary of state. At the collapse of the Con-

federacy, Benjamin fled to England, where he practiced law with great success.

PLATE 29
SITTER: Thaddeus Stevens (1792–1868)
DATE: Circa 1858
MEDIUM: Imperial salted-paper print with ink and pencil
DIMENSIONS: 54.9 x 45.3 cm (21⅝ x 17¹³⁄₁₆ in.)
OWNER: Chicago Historical Society (ICHi-12569)
BIOGRAPHY: Thaddeus Stevens was a wealthy Pennsylvania lawyer when he entered the House of Representatives as a Whig in 1848. Early in 1850, he delivered his first speech against slavery, and immediately drew the admiration of his adversaries. "Our enemy . . . has a general now. This man is rich, therefore we cannot buy him. . . . We cannot seduce him. . . . We cannot allure him. . . . He is in earnest. He means what he says. He is bold. He cannot be flattered or frightened." Growing impatient with the Whig Party's moderate positions, Stevens lost his congressional seat in 1853. He supported John C. Frémont's presidential campaign in 1856, and returned to Congress in 1859 as a Republican. Under Lincoln, Stevens served as chairman of the House Ways and Means Committee, appropriating the resources needed to support the war effort. As a leader of the Radical Republicans, he differed from Lincoln, and then Johnson, in policy toward the South, favoring military occupation, as of a conquered nation. He also insisted on rigid enforcement of new rights for African Americans, guiding the passage of the Thirteenth and Fourteenth Amendments. When Johnson opposed the Fourteenth Amendment, Stevens led the call for his impeachment, which finally failed by a single vote.

PLATE 30
SITTER: Composite of 1860 Senate
DATE: 1860
MEDIUM: Albumen silver print
DIMENSIONS: 44 x 36.5 cm (17⁵⁄₁₆ x 14⅜ in.) sheet

OWNER: Library of Congress

BIOGRAPHY: In July 1860, Mathew Brady published a pair of composite images portraying members of the Senate and the House of Representatives of the Thirty-sixth Congress. He followed the old engraver's custom of copying daguerreotype portraits into new tableaux, but instead used his camera and his own large inventory, avoiding the need for an additional artist. On a five-by-six-foot board, Brady assembled portraits of each group's members in a series of concentric circles, with a portrait of the appropriate official at the center—Vice President John C. Breckinridge for the Senate, and Speaker William Pennington for the House. Brady then photographed each construction and sold the resulting print for five dollars. For its first audiences, this chaotic mosaic of unrelated heads and features accurately reflected the discordant government on the eve of secession. As the *New York Times* reported, "We have before us the actors in the political drama now enacting on the federal stage, grouped with all the stars, stock and supernumerary performers. . . . We see them in contrast with each other, and never tire of the study."

PLATE 31

SITTER: Elmer Ephraim Ellsworth (1837–1861)

DATE: 1861

MEDIUM: Albumen silver print (carte de visite)

DIMENSIONS: 8.6 x 5.6 cm (3⅜ x 2³⁄₁₆ in.)

OWNER: National Portrait Gallery, Smithsonian Institution

BIOGRAPHY: Although Elmer Ellsworth could not afford to attend West Point, he eagerly aspired to a military career. While a young lawyer in Chicago, he brought discipline and energy to a volunteer military company, the National Guard Cadets, whose elaborate drills and bright Zouave uniforms attracted large crowds. In 1860 Ellsworth became an officer in the Illinois National Guard and also entered the Springfield law

office of Abraham Lincoln. In 1861, he followed Lincoln to Washington; when war broke out, he organized a new Zouave company, which joined the Union troops that occupied Alexandria. On May 24, 1861, Ellsworth tore a Confederate flag from the roof of an Alexandria hotel and was shot down by the hotel's proprietor, who was in turn killed by one of Ellsworth's men. The incident brought Ellsworth enormous fame. His story was published everywhere; relic-hunters virtually destroyed the Alexandria tavern; and Brady sold thousands of carte-de-visite portraits of the young martyr, who had posed in his studio on several occasions.

PLATE 32

SITTER: Ulysses S. Grant (1822–1885)

DATE: 1864

MEDIUM: Albumen silver print

DIMENSIONS: 11.6 x 12.1 cm (4⁹⁄₁₆ x 4¾ in.)

OWNER: National Portrait Gallery, Smithsonian Institution

BIOGRAPHY: In June 1864, Mathew Brady photographed Ulysses S. Grant at City Point in Virginia. That spring, Brady had petitioned the army to travel behind the lines, but received permission only when his wife asked Mrs. Grant for help. On June 19, Grant wrote home, reporting, "Brady is along with the Army and is taking a great many views and will send you a copy of each." Records suggest that Brady had a second mission, sending coded messages to friends on Wall Street, who used knowledge of the army's plans to manipulate the stock market in their favor. A young colonel discovered the scheme, and asked Assistant Secretary of War Charles Dana to tell Grant "how he is being deceived by one to whom he has granted various privileges and favors." There is no record of Grant's response.

PLATE 33

SITTER: Officers of the Sixty-ninth New York State Militia, Fort Corcoran, Virginia

DATE: 1861

MEDIUM: Albumen silver print

DIMENSIONS: 27.9 x 35.6 cm (11 x 14 in.)

OWNER: Library of Congress

BIOGRAPHY: In the late spring of 1861, Mathew Brady photographed the soldiers of the Sixty-ninth New York Irish Infantry on the ramparts of the fort protecting the Virginia end of the Aqueduct Bridge, just south of the Potomac River. The men of the Sixty-ninth posed around their powerful modern howitzer cannon with regal pride. One of the earliest forts constructed to protect the capital, this one was soon named for its first commander, Colonel Michael Corcoran, who was taken prisoner the following July during the Battle of Bull Run. Later historians looked back on photographs like this one with bitter nostalgia, for they portrayed men who believed that the war would soon be over, though it had barely begun.

PLATE 34

SITTER: Joseph Hooker (1814–1879)

DATE: 1863

MEDIUM: Albumen silver print

DIMENSIONS: 15.2 x 18.1 cm (6 x 7⅛ in.)

OWNER: National Portrait Gallery, Smithsonian Institution

BIOGRAPHY: After General Ambrose Burnside's defeat at Fredericksburg in the winter of 1863, Lincoln named handsome, charismatic Joseph Hooker to the command of the Army of the Potomac. With signature bravado, Hooker announced, "May God have mercy on General Lee, for I will have none." But at the end of April 1863, he marched his troops to Chancellorsville, where over the course of six days, Lee and Stonewall Jackson defeated the Union army, though they were outnumbered nearly two to one. But even Lee's victory was costly, for among his 14,000 casualties was the gifted General Jackson. At the end of June, just before the Battle of Gettysburg, Hooker handed his command to General George G. Meade. He went on to serve ably under Generals William T. Sherman and George Henry Thomas in the Department of Cumberland.

This portrait was probably made in the spring of 1863, just before Hooker relinquished command of the Army of the Potomac.

PLATE 35

SITTER: Scenes of Camp Life—Army of the Potomac

DATE: 1862

MEDIUM: Albumen silver prints mounted on card

DIMENSIONS: 8.3 x 8.9 cm (3¼ x 3½ in.) each; on board 27.9 x 35.6 cm (11 x 14 in.)

OWNER: Library of Congress

BIOGRAPHY: When Mathew Brady sent his photographers to the camp and battlefield, he expected them to return with portraits of famous generals for his gallery. But Brady's photographers recognized that many aspects of military life commanded great interest, and they regularly portrayed groups of ordinary soldiers, as well as the special corps, such as mapmakers, scouts, and engineers, who provided essential aid to the army. The unpredictable nature of war provided Brady with another incentive to assemble a thorough record of soldiers and officers, for the overnight fame that distinguished any new hero (or martyr) also gave his portrait enormous value. Brady's documents continued to have value after the war ended, as shown by this group of images, assembled sometime after 1865, which includes a portrait of George Armstrong Custer, best known for his 1876 defeat at the Battle of Little Big Horn.

PLATE 36

SITTER: Gentlemen's Committee on the Fine Arts for the Metropolitan Fair in Aid of the U.S. Sanitary Commission

DATE: 1864

MEDIUM: Albumen silver print

DIMENSIONS: 14.6 x 22.9 cm (5¾ x 9 in.)

OWNER: National Portrait Gallery, Smithsonian Institution

BIOGRAPHY: On March 28, 1864, the United States Sanitary Commission mounted

the Metropolitan Fair, exhibiting "all the material resources of the great City of New York"—from sophisticated manufactured goods to handwork by ordinary artisans—for sale to support hospitals and medical care for Union soldiers. The show lasted two weeks and raised more than $1 million, exceeding the amounts raised at similar fairs in Boston, Cincinnati, Chicago, and Philadelphia. A special committee also solicited contributions from painters, sculptors, dealers, and collectors to create a comprehensive gallery of American art, to which financier Marshall O. Roberts contributed the gem of his collection, Emanuel Leutze's *Washington Crossing the Delaware*. Mathew Brady photographed the fair's many organizers, including the Gentlemen's Committee on the Fine Arts, of which he was also a member. (Brady poses in the center of the composition, seated behind the chairman, landscape painter John Frederick Kensett.)

PLATE 37

SITTER: Abraham Lincoln (1809–1865)

DATE: 1864

MEDIUM: Albumen silver print (carte de visite)

DIMENSIONS: 8.5 x 5.4 cm (3⅜ x 2⅛ in.)

OWNER: National Portrait Gallery, Smithsonian Institution

BIOGRAPHY: On January 8, 1864, Abraham Lincoln posed for this portrait in Brady's Washington studio. A week before, Lincoln had welcomed the first African Americans to ever attend the President's annual New Year's Day reception at the White House, one of many sparkling celebrations that took place in that winter. Looking ahead to the Republican convention, Lincoln used public events as well as private influence to counter challenges from opponents like Charles Sumner and his own secretary of the treasury, Salmon P. Chase. In February, Harriet Beecher Stowe published a warm, favorable interview, reporting the President's reflections on the war and his career, and his "dry, weary, patient pain."

Stowe's article also contained Lincoln's chilling comment, "'Whichever way it ends . . . I have the impression that *I* sha'n't last long after it's over.'"

PLATE 38

SITTER: Winfield Scott Hancock (1824–1886), David Bell Birney (1825–1864), and Their Staffs

DATE: 1863–1864

MEDIUM: Albumen silver print

DIMENSIONS: 12.7 x 20.1 cm (5 x 7⅞ in.)

OWNER: National Portrait Gallery, Smithsonian Institution

BIOGRAPHY: Named for the hero of the War of 1812, Winfield Scott Hancock graduated from West Point in 1844, where his colleagues included Ulysses S. Grant, George Brinton McClellan, John F. Reynolds, James Longstreet, George E. Pickett, and Stonewall Jackson. Hancock fought under General Scott in Mexico, and over the next fifteen years served in many important frontier battles in Florida, Kansas, and Utah. When the Civil War began, McClellan named him brigadier general of the volunteers. As an experienced and effective officer, Hancock helped McClellan organize the Army of the Potomac. Just before the Battle of Gettysburg, Hancock was named commander of the II Army Corps, where General Meade gave him broad authority, and throughout all four days of fighting, he played a crucial role in the defeat of Lee's forces. Hancock remained a commander throughout the war, fighting under Grant in the battles of Wilderness, Spotsylvania, and Cold Harbor. Hancock's gallant good looks were backed by genuine talent, and in his *Memoirs*, Grant commended Hancock's "personal courage and his presence with his command in the thickest of the fight, [which] won for him the confidence of [his] troops." At Gettysburg, and in the battles of Wilderness and Spotsylvania, Hancock was supported by General David Bell Birney, who appears in this photograph to Hancock's immediate left. This group portrait was made between November

1863 and October 1864, though the precise location is not known.

PLATE 39

SITTER: McPherson's Woods—Wheat Field in Which General Reynolds was Shot
DATE: 1863; printed later
MEDIUM: Albumen silver print
DIMENSIONS: 12.1 x 21.7 cm (4¾ x 8⁹⁄₁₆ in.)
OWNER: National Archives
BIOGRAPHY: At Gettysburg, Mathew Brady posed for his portrait along a graceful, curving rail fence, and stared in the direction of McPherson's Woods, where Union General John F. Reynolds had fallen to a Confederate sniper's bullet on the first day of the battle. When Brady instructed the camera operator to expose a series of negatives to create this wide panorama, he strived for an emotional effect that transcends the simple record of a early casualty in an important battle. Nearly all of Brady's views of Gettysburg depict significant battle sites as empty landscapes, inviting melancholy speculation without the painful intrusion of shocking detail.

PLATE 40

SITTER: Thomas Cole (1801–1848)
DATE: Circa 1846
MEDIUM: Daguerreotype
DIMENSIONS: 13.7 x 10.2 cm (5⅜ x 4 in.)
OWNER: National Portrait Gallery, Smithsonian Institution; gift of Edith Cole Silberstein
BIOGRAPHY: Thomas Cole had already trained as a wood engraver in Liverpool when he and his family arrived in Philadelphia in 1819. After working in a variety of trades, Cole came to New York in the early 1820s and began to sell his landscape paintings to important patrons, including John Trumbull and William Cullen Bryant. His success was immediate, and, as Asher B. Durand remembered, "His fame spread like wildfire." Cole's romantic images combined the sensibility of British romantic poets with the rough beauty of American scenery, to create a new form of painting that Americans claimed for their own. After 1836, he also began to paint landscapes in series, including *Course of Empire*, the five-part essay on civilization, and *Voyage of Life*, the lyrical essay on individual morality. When Brady made this daguerreotype portrait in the late 1840s, Cole was one of the best-known artists in America.

PLATE 41

SITTER: Zachary Taylor (1784–1850)
DATE: 1849
MEDIUM: Daguerreotype
DIMENSIONS: 16.2 x 14.6 cm (6⅜ x 5¾ in.)
OWNER: The Beinecke Rare Book and Manuscript Library, Yale University
BIOGRAPHY: Zachary Taylor first distinguished himself in the War of 1812, and by the end of the 1830s had become a brigadier general, thanks to his many frontier victories against the Indians. He was over sixty when he achieved fame in the Mexican American War. When Taylor and his 5,400 troops prevailed over 20,000 Mexican soldiers at the Battle of Buena Vista, their victory secured the Rio Grande frontier and marked the turning point of the war. By the time "Old Rough and Ready" returned home in November 1847, he was the most beloved hero in America. The following June, Taylor became the Whig nominee for President, a compromise candidate over perpetual favorites Henry Clay, Daniel Webster, and Winfield Scott, and the winner over Democrat James K. Polk. Though a southerner and a slaveholder, Taylor surprised many politicians when he expressed support for the Wilmot Proviso, which restricted the extension of slavery into the territories. But the nation never felt the true impact of his leadership; Taylor died from food poisoning in July 1850. Brady photographed Taylor in Washington in 1849, around the time of his inauguration, and this portrait became the basis for the opening plate in his *Gallery of Illustrious Americans.*

PLATE 42

SITTER: Roger Taney (1777–1864)
DATE: Circa 1848
MEDIUM: Daguerreotype
DIMENSIONS: 20.3 x 16.5 cm (18 x 6½ in.)
OWNER: The Beinecke Rare Book and Manuscript Library, Yale University
BIOGRAPHY: In 1857, as the author of the majority opinion in *Dred Scott v. Sanford*, Roger Taney ruled that the Constitution did not recognize the citizenship of an African American who had been born a slave. This decision sparked bitter opposition from northern politicians and a heated defense from the South, and was one of the most important events leading up to war. This single opinion cast a shadow over Taney's distinguished legal career, and his personal reputation for integrity. In the 1820s, as a Maryland litigator, Taney had declared, "Slavery is a blot on our national character, and every real lover of freedom confidently hopes that it will be effectually, though it must be gradually, wiped away." As Andrew Jackson's attorney general, Taney helped close down the Second Bank of the United States, bringing him in direct conflict with powerful leaders of the Senate, including Daniel Webster and Henry Clay. Despite their opposition, in 1837 Jackson rewarded Taney by naming him chief justice of the Supreme Court. When Brady made this portrait of Taney around 1848, he had presided over the Court for two decades and was one of the most respected figures in Washington.

PLATE 43

SITTER: George Peter Alexander Healy (1813–1894)
DATE: Circa 1850
MEDIUM: Daguerreotype
DIMENSIONS: 13.9 x 10.8 cm (5½ x 4¼ in.)
OWNER: Library of Congress
BIOGRAPHY: Thanks to the encouragement of Thomas Sully, G. P. A. Healy embarked on a career as a portrait painter while still in his teens. He traveled to Europe in 1834, but

unlike most American artists, who went to Rome or Düsseldorf, he studied in Paris under Baron Gros. Healy's natural charm brought him many important patrons, including French politicians Marshal Soult and François Guizot, American minister Lewis Cass, and the French King Louis-Philippe, who commissioned Healy to paint a series of portraits of distinguished Americans for the official gallery in Versailles. After Louis-Philippe was overthrown in 1848, Healy turned again to America, settling in Chicago from 1855 to 1865. During this extraordinarily prolific decade, he produced more than five hundred portraits, including numerous official presidential images and, after the war began, those of military figures Ulysses S. Grant, William T. Sherman, George B. McClellan, and Admiral David Dixon Porter. In 1867, Healy returned to Europe, settling in Rome, where he painted such international figures as Henry Wadsworth Longfellow, Franz Liszt, and Pope Pius IX. Healy sat for this daguerreotype by Brady around 1850. Plentiful evidence suggests that Healy often turned to photographic images when creating his portraits.

PLATE 44
SITTER: James Gordon Bennett (1795–1872)
DATE: Circa 1851
MEDIUM: Daguerreotype
DIMENSIONS: 13.9 x 10.8 cm (5½ x 4¼ in.)
OWNER: Library of Congress
BIOGRAPHY: Born in Keith, Scotland, James Gordon Bennett was sent to a Catholic seminary in Aberdeen to be educated for the priesthood. In 1819 he abandoned the ministry and left for America, where he traveled from Boston to New York to Charleston, working as a proofreader and translator. In 1827 he became the Washington, D.C., correspondent for the *New York Enquirer*; there he made a reputation for himself and the *Enquirer* with his accurate accounts of the proceedings of Congress and his interesting descriptions of Washington life and people. In 1835, Bennett issued the first number of the *New York Her-*

ald. He wrote the entire paper, and made up for the lack of news with his own imagination. The *Herald* obtained an immense circulation and advertising patronage. Bennett originated, through the incident of the great fire in New York on December 16, 1835, the reporting in detail of public occurrences, and he engaged special correspondents throughout the world. Upon his death, the *Herald* was one of the most profitable journals in the world.

PLATE 45
SITTER: Junius Brutus Booth (1796–1852)
DATE: Circa 1850
MEDIUM: Daguerreotype
DIMENSIONS: 13.9 x 10.8 cm (5½ x 4¼ in.)
OWNER: Library of Congress
BIOGRAPHY: British actor Junius Booth made his American debut in 1821, playing Richard III. Audiences admired his passion and intensity, Walt Whitman called him "the grandest historian of modern times," and Mrs. John Drew called his acting "beautiful; he made the figure stand before you! It was infinitely tender." In his New York debut, one critic admired his open, expressive face, "well adapted to display the workings of a distorted mind." Booth carefully chose roles that he felt suited his relatively small, lean frame. In addition to Richard III, he often played Iago, Hamlet, Shylock, and Macbeth. Personal sorrow, including an unhappy marriage and the death of two children, led to his emotional instability and alcoholism, but audiences never lost their affection for him. At the end of his career, some critics insisted that he had reached new heights of grandeur when he was most troubled. Booth died on a Mississippi riverboat, while on tour.

PLATE 46
SITTER: Jenny Lind (1820–1887)
DATE: 1852
MEDIUM: Daguerreotype
DIMENSIONS: 8.3 x 7 cm (3¼ x 2¾ in.)
OWNER: The Chrysler Museum of Art, Norfolk, Virginia; museum purchase with

assistance from Kathryn K. Porter and Charles and Judy Hudson; 89.75
BIOGRAPHY: In September 1850, impresario P. T. Barnum brought Jenny Lind, the "Swedish nightingale," to New York to begin her first American concert tour. Barnum devised skillful publicity to generate interest in the foreign star, and by the time Lind arrived, excitement was high, crowds (holding banners prepared by Barnum) met her at the dock, firemen staged a torchlight parade, and special charity auctions sold concert tickets for hundreds of dollars—what a working man made in a year. Lind's name was eventually tied to every kind of commodity, from songs to gloves, bonnets, chairs, sofas, and even pianos. Some objected to the rampant "Lindomania" that followed her everywhere, but Barnum and Lind continued to pack concert halls for nearly a year, until their partnership soured. Lind eventually settled in England, where she was known for her philanthropy. Like daguerreotypists in every city where Lind toured, Brady competed for the chance to add her portrait for his gallery. Contemporaries often remarked that Lind was very plain, and popular representations so thoroughly changed her appearance that despite her celebrity, Lind's face was relatively unknown.

PLATE 47
SITTER: Mathew Brady with Juliette Handy Brady (1822–1887) and Mrs. Haggerty (lifedates unknown)
DATE: Circa 1851
MEDIUM: Daguerreotype
DIMENSIONS: 10.8 x 8.3 cm (4¼ x 3¼ in.)
OWNER: National Portrait Gallery, Smithsonian Institution
BIOGRAPHY: Like so many events in Mathew Brady's life, the exact date of this portrait remains uncertain. It may have been made to celebrate the Bradys' marriage, which probably took place in 1851. By July of that year, Mr. and Mrs. M. B. Brady applied for a passport and sailed for London to see the

"Exhibition of the Industry of all Nations" at the Crystal Palace, where Brady's daguerreotypes had won a medal. This image demonstrates the qualities that Brady's contemporaries admired, including careful lighting, pleasing symmetry, and natural expressions on the sitters' faces.

PLATE 48
SITTER: Felicita Vestvali (1824–1880)
DATE: Circa 1855
MEDIUM: Ambrotype
DIMENSIONS: 8.9 x 6.9 cm
(3½ x 2¾ in.)
OWNER: Private collection
BIOGRAPHY: From 1855 through 1867, Felicita Vestvali was a familiar New York opera star who specialized in singing contralto "trouser roles." She debuted in New York as Romeo in Bellini's *I Capuleti ed i Montecchi*, played Maffeo Orsini in Donizetti's *Lucrezia Borgia*, and in 1864 sang Orfeo in the first New York performance of Gluck's *Orfeo ed Euridice*. After her return to Europe, Vestvali left opera for a stage career, and often appeared as Hamlet. New York photographers C. D. Fredricks and Jeremiah Gurney both photographed her in elaborate stage costumes. Brady's portrait, a double-sided ambrotype made around the time of her New York debut, portrays Vestvali as she appeared offstage. Vestvali was well known as a lesbian. Here, her mannish attire and severe hairstyle create a distinctively androgynous image.

PLATE 49
SITTER: John C. Frémont (1813–1890)
DATE: Circa 1856
MEDIUM: Ambrotype
DIMENSIONS: 14.1 x 10.9 cm (5⁵⁄₁₆ x 3¼ in.)
OWNER: National Portrait Gallery, Smithsonian Institution
BIOGRAPHY: John C. Frémont's bright early career combined army life, politics, exploration, investment, and adventure. His transcontinental expeditions united scientific investigation with the practical search for a

railroad route across the Rocky Mountains, earning him the title "The Pathfinder." His lively reports (written with the help of his wife, Jessie Benton Frémont) won a popular audience and international acclaim. In the 1840s, Frémont acquired a profitable estate in northern California, and embarked on a political career, becoming one of the state's first senators in 1851. As an open supporter of antislavery causes, Frémont became the Republican Party's first presidential candidate in 1856, but after his loss to James Buchanan, he returned to California. When war began, Lincoln named Frémont commander of the western division of the army, with headquarters in St. Louis, where Frémont found himself surrounded by secessionists. When he independently emancipated all Missouri slaves in August 1861, in advance of federal policy, Lincoln removed him from his command, and his public life came to an abrupt end. Frémont's career coincided precisely with Brady's quest for American political celebrities. In 1851, Brady included Frémont's portrait in his *Gallery of Illustrious Americans.* He made this elaborate, double-sided ambrotype portrait around 1856, during Frémont's presidential campaign, and made carte-de-visite photographs of him and his wife during the war.

PLATE 50
SITTER: Julia Holnus (lifedates unknown)
DATE: 1854–1856
MEDIUM: Ambrotype
DIMENSIONS: 14 x 10.2 cm (5½ x 4 in.)
OWNER: Chicago Historical Society (ICHi-26740)
BIOGRAPHY: This portrait of Julia Holnus demonstrates the style that Brady brought to portraits of ordinary, middle-class customers. It also shows Brady's ability to exploit the formal properties of a new photographic medium—the ambrotype, which was introduced in 1854. Where daguerreotypes were shiny and shifting, with subtle, silvery shades of black and white, the ambrotype was stable, and the tones were flat. Brady used the result-

ing high contrast to create an image that celebrates the fine, abstract pattern of the sitter's dark lace shawl on her pale dress.

PLATE 51
SITTER: Charlotte Cushman (1816–1876)
DATE: 1857
MEDIUM: Imperial salted-paper print
DIMENSIONS: 48.3 x 40.6 cm (19 x 16 in.)
OWNER: Harvard Theatre Collection, The Houghton Library
BIOGRAPHY: In 1836, Charlotte Cushman made her stage debut as Lady Macbeth in New Orleans. That year she also played Romeo, beginning a career-long tradition of playing both male and female roles. On the recommendation of British tragedian William Macready, Cushman made her London debut in 1845 opposite Edwin Forrest and was immediately hailed as the greatest actress of her time. She remained in Europe for several years, returning to America in 1849 for a three-year tour, during which she played conventional tragic heroines, as well as Hamlet, and Romeo to her sister Susan's Juliet. In 1852 Cushman returned to England, moving to Rome in 1858, where she joined a large international community of artists and writers. Cushman came to America for the first of a series of farewell tours in 1857, which she repeated in 1860 and again in 1874. Like her colleague and contemporary Edwin Forrest, Cushman's performances were marked by melodramatic force. One critic compared her style to a "stream of fire," and another admired her androgynous ability to convey "all the power and energy of manhood." Brady photographed Cushman in New York during her first farewell tour.

PLATE 52
SITTER: William L. Marcy (1786–1857)
DATE: Circa 1856
MEDIUM: Imperial salted-paper print
DIMENSIONS: 38.5 x 30.5 cm
(15⅜ x 12 in.)
OWNER: Fogg Art Museum, Harvard

University Art Museums, on deposit from Harvard College Library

BIOGRAPHY: In the second decade of the nineteenth century, William L. Marcy joined Martin Van Buren, Benjamin F. Butler, Samuel J. Tilden, and other New York politicians in a group known as the "Holy Alliance" or the "Albany Regency." For nearly thirty years, this powerful Democratic machine influenced policy and politics in the state and throughout the country. In 1829, Governor Van Buren appointed Marcy to the New York State Supreme Court, a post he left in 1831 for the United States Senate. Marcy returned to New York as governor in 1833, serving three terms. After Van Buren became President in 1840, Marcy became a familiar figure in Washington, serving as secretary of war under James K. Polk and secretary of state under Franklin Pierce. Like Silas Wright, Lewis Cass, and James Buchanan, Marcy was a well-known and powerful Democrat who aspired to be President. Although Cass secured his party's nomination, only Buchanan reached the White House. Brady photographed Marcy in New York around the time he returned to private life.

PLATE 53
SITTER: Simon Cameron (1799–1889)
DATE: Circa 1858
MEDIUM: Imperial salted-paper print
DIMENSIONS: 55.4 x 42.9 cm (21¹³⁄₁₆ x 16⅞ in.)
OWNER: Chicago Historical Society (ICHi-26735)
BIOGRAPHY: A consummate machine boss who "never forgot a friend or forgave an enemy," Simon Cameron spent many years behind the scenes in Pennsylvania politics. Thanks to his early, effective support for Andrew Jackson, Cameron was put in charge of patronage for the state in the 1830s. He served as a printer, Indian claims adjuster, railroad builder, and banker before running for the Senate in 1845, replacing James Buchanan, who had joined James K. Polk's

cabinet. By 1856, Cameron had shifted from the Democratic to the Know-Nothing Party, and then joined the Republicans. In exchange for his support of Lincoln at the Republican Convention of 1860, Cameron was named secretary of war. Rampant corruption forced his resignation early in 1862, and Lincoln named him ambassador to Russia. After a year abroad, Cameron ran unsuccessfully for the Senate, finally regaining his seat in 1867. For the following decade, he enjoyed great power in Washington and throughout Pennsylvania; after he retired from office, his son succeeded him in the Senate. Brady photographed Cameron in Washington around 1858, when he became the first Republican senator from Pennsylvania.

PLATE 54
SITTER: Thaddeus Hyatt (1817?–1901)
DATE: 1857
MEDIUM: Imperial salted-paper print
DIMENSIONS: 46 x 34.5 cm (18⅛ x 13⅝ in.)
OWNER: Fogg Art Museum, Harvard University Art Museums, on deposit from Harvard College Library
BIOGRAPHY: Affluent, flamboyant inventor and committed abolitionist Thaddeus Hyatt came to Kansas in 1856 as president of the National Kansas Committee, one of many groups that raised funds for antislavery immigrants to the territory. Hyatt's group amassed more than $100,000, but was touched with scandal in December 1856, when he and his vice president, W. M. Arny, attempted to found the new Kansas town of Hyattsville in Arny County as a haven for abolitionists, and it appeared both men would make large personal profits before the settlement took shape. Still, Hyatt's generous and flamboyant spirit prevailed. In April 1857, he built a steamboat for travel between Lawrence and Kansas City. In 1859 he helped raise money for John Brown's widow after the raid on Harpers Ferry, and in 1860 he again led a national campaign to help Kansas settlers whose farms had

been virtually destroyed by a two-year drought. Hyatt's extraordinary investigative report on the drought combined statistics and eyewitness accounts with strong rhetoric, inspiring President James Buchanan to contribute $100 to the relief fund, insuring its success. Hyatt served as American consul to La Rochelle, France, from 1864 to 1865 and eventually settled in England. This photograph was probably made in January 1857, when Hyatt and the National Kansas Committee met for the first and only time in New York City.

PLATE 55
SITTER: Miss Garnier (lifedates unknown)
DATE: Circa 1858
MEDIUM: Imperial salted-paper print
DIMENSIONS: 36.5 x 28.5 cm (14⅜ x 11¼ in.)
OWNER: Fogg Art Museum, Harvard University Art Museums, on deposit from Harvard College Library
BIOGRAPHY: The unusual, dramatic pose suggests that Miss Garnier was an actress. Throughout his career, Brady photographed many stage personalities, both in and out of character.

PLATE 56
SITTER: Thomas DeKay Winans (1820–1878)
DATE: Circa 1857
MEDIUM: Imperial salted-paper print
DIMENSIONS: 45.5 x 37 cm (17⅞ x 14⁹⁄₁₆ in.)
OWNER: Fogg Art Museum, Harvard University Art Museums, on deposit from Harvard College Library
BIOGRAPHY: Thomas Winans, an engineer and inventor, was the son of Ross Winans, an important railroad pioneer. Thomas and his brother William traveled to Russia in 1843, embarking on a six-year contract to help supervise the construction of a railroad from St. Petersburg to Moscow. In the process, they became millionaires. In 1851, Thomas and his

Russian-French bride returned to America, while William stayed on to complete their work. Within two years, he had purchased a large Baltimore estate and built an imposing mansion. Winans devoted the rest of his life to creating a series of ingenious inventions, including improvements in organs, pianos, ventilation, and plumbing. He emerged from retirement in 1859 to serve as the first director of the Baltimore & Ohio Railroad. After the outbreak of the Civil War, he set up a soup kitchen outside his home, which fed four thousand soldiers daily. Brady photographed this successful, affluent private citizen in the late 1850s.

PLATE 57

SITTER: Lewis Cass (1782–1866)
DATE: Circa 1857
MEDIUM: Imperial salted-paper print
DIMENSIONS: 45 x 33.5 cm
(17¾ x 13³⁄₁₆ in.)
OWNER: Fogg Art Museum, Harvard University Art Museums, on deposit from Harvard College Library
BIOGRAPHY: A New Hampshire schoolmate of Daniel Webster, Lewis Cass moved to Ohio at the turn of the century, where his opposition to Aaron Burr in the Ohio legislature led Thomas Jefferson to appoint him marshal of the state. Thanks to his distinguished performance against the British in 1812, Cass was named governor of Michigan Territory in 1813, a post he held until 1831. During his tenure, Cass amassed a personal fortune, secured the territory around the Great Lakes, built roads, and negotiated treaties with the Chippewa and other Indian tribes. Cass served as secretary of war under Andrew Jackson, who named him minister to France in 1836, and he remained in Paris until 1842. Cass spent the remainder of his career in the Senate, where he was a leader of the Democratic Party. In 1848 he was the Democratic nominee for President, though he lost to Zachary Taylor; in 1857 James Buchanan named him secretary of state, a position he relished. But

in 1860, Cass resigned to protest Buchanan's failure to secure the Union forts in Charleston harbor. Brady photographed Cass on several occasions, including this majestic portrait, made around the time he joined Buchanan's cabinet.

PLATE 58

SITTER: Jack Hays (1817–1883)
DATE: Circa 1857
MEDIUM: Imperial salted-paper print
DIMENSIONS: 47.5 x 39.5 cm
(18¹¹⁄₁₆ x 15⁹⁄₁₆ in.)
OWNER: Fogg Art Museum, Harvard University Art Museums, on deposit from Harvard College Library
BIOGRAPHY: Indian fighter Jack Hays was born in Tennessee and trained as a surveyor. He first came to Texas in 1836, settling in San Antonio, and in the early 1840s fought numerous border battles against Mexicans and Indians as a captain of one of the irregular bands known as the Texas Rangers. Thanks to Hays's discipline, military skill, and leadership, he exemplified the Ranger ideal. According to legend, he introduced the Colt revolver to the West. In 1846, Hays served under Zachary Taylor in the Mexican American War, becoming a national hero when he stormed Independence Hill and the Bishop's Palace at Monterrey. Hays moved to San Francisco, where he served as county sheriff from 1850 to 1853. President Franklin Pierce appointed Hays surveyor-general for the state of California, and after one term, Hays devoted himself to a career in business and real estate. Brady photographed him about the time he entered private life, one of many heroes of the Mexican American war who drew visitors to Brady's National Portrait Gallery.

PLATE 59

SITTER: Maximilian, Emperor of Mexico (1832–1867)
DATE: 1864
MEDIUM: Imperial salted-paper print

DIMENSIONS: 48.5 x 38 cm (19⅛ x 15 in.)
OWNER: Chicago Historical Society (ICHi-26736)
BIOGRAPHY: Ferdinand Maximilian Joseph, Archduke of Austria, became Emperor of Mexico when Napoleon III sought to extend French imperial power. Assured a French army, and believing his appointment had a popular base, the idealistic young aristocrat and his wife, Carlota, were crowned in Mexico City on June 10, 1864. Almost immediately, Maximilian began to pursue policies that antagonized his backers. He upheld Benito Juarez's land reforms, which had taken property from the Church; proposed an end to peonage; devised schemes to educate the Indians and the poor; encouraged Confederates to immigrate to Mexico; and acknowledged—too late—that his government was bankrupt. By the spring of 1865, Napoleon recognized that the venture had failed. With the end of the Civil War, United States Secretary of State William H. Seward demanded the removal of French troops from Mexico. Soon after, Carlota fled to Europe, where she met with Napoleon and the Pope in an effort to save her husband. But when the French left in March 1867, Maximilian remained behind, refusing to desert "his people" when Juarez and his army returned. Despite pleas by figures such as Garibaldi and Victor Hugo, Maximilian was court-martialed in June 1867 and condemned to death. Late in 1864, Brady's operator Andrew Burgess set up shop in Mexico City, where he made several portraits of Maximilian and eventually furnished the United States government with documents of the emperor's defeat by Juarez.

PLATE 60

SITTER: Mrs. Williams (lifedates unknown)
DATE: Circa 1856
MEDIUM: Imperial salted-paper print with hand-coloring
DIMENSIONS: 49.5 x 39.5 cm
(19½ x 15⁹⁄₁₆ in.)
OWNER: Fogg Art Museum, Harvard

University Art Museums, on deposit from Harvard College Library

BIOGRAPHY: This portrait of Mrs. Williams, a New York matron, shows off an elaborate form of portraiture that the most advanced Broadway studios produced in the late 1850s. At Brady's, C. D. Fredricks', and others, artists applied oil color to salted-paper photographs to produce portraits that nearly rivaled paintings. Some critics disliked these images, for paint concealed their photographic qualities, while the overall artistry seemed inferior to work by such portraitists as Charles Loring Elliott or William Page. Others lamented the fact that colorists worked anonymously and photographers received all the credit.

PLATE 61

SITTER: William Cullen Bryant (1794–1878)
DATE: Circa 1860
MEDIUM: Imperial salted-paper print
DIMENSIONS: 44 x 35.5 cm (17 5/16 x 14 in.)
OWNER: Fogg Art Museum, Harvard University Art Museums, on deposit from Harvard College Library
BIOGRAPHY: William Cullen Bryant was a young lawyer when his poem "Thanatopsis" first appeared in the *North American Review* in 1817. Inspired by the romantic lyrics of William Wordsworth, Bryant found his subject in the American landscape, especially that of New England. By 1825, critics on both sides of the Atlantic called him the finest poet in the United States. But reputation alone could not support his family, and after spending a precarious year in New York as a freelance writer, Bryant joined the *New York Evening Post* in 1826, becoming editor and part owner of the paper in 1829. By 1840, Bryant had largely abandoned poetry to become one of the country's leading newspapermen, and a forceful advocate for abolition. From 1856 on, the *Evening Post* was a Republican paper, supporting the arming of abolitionist settlers in Kansas, deriding the Dred Scott decision, and celebrating John Brown as

a martyr. In 1860, Bryant introduced Abraham Lincoln before the audience at Cooper Union in New York. Later, Bryant and the *Evening Post* influenced Lincoln's decision to issue the Emancipation Proclamation. Bryant was widely respected by his contemporaries, but despite his political power, many lamented the loss of their talented poet. Brady photographed him in New York around 1860.

PLATE 62

SITTER: Lyman Beecher (1775–1863)
DATE: Circa 1856
MEDIUM: Hand-colored photograph
DIMENSIONS: 18.4 x 15.2 cm (7 1/4 x 6 in.)
OWNER: George Sullivan
BIOGRAPHY: Congregational minister, educator, and vocal leader of the American Protestants, Lyman Beecher embodied the shift from the harsh, demanding Puritan faith of the Second Great Awakening to a religion that found its expression in larger society. Beecher first received wide public recognition in 1806, with a sermon against dueling, after the death of Alexander Hamilton in a duel with Aaron Burr. From 1810 to 1826, as a minister in Litchfield, Connecticut, Beecher and his wife also ran a school for girls, with an unusually practical and serious curriculum. In 1833, Beecher and his family moved to Cincinnati, where he became president of the Lane Theological Seminary, a training ground for the religious leaders of the abolition movement. Beecher's ability to carry religious principles into daily life deeply influenced his children, especially Catharine Beecher, who became a national voice for practical domestic management, and Harriet Beecher Stowe, the best-selling author of *Uncle Tom's Cabin*. The widespread fame of this virtuous family led a contemporary to joke, "This country is inhabited by saints, sinners, and Beechers."

PLATE 63

SITTER: General Orlando Willcox (1823–1907) and His Staff in the Field, Army of the Potomac, Virginia

DATE: Circa 1861
MEDIUM: Albumen silver print (stereo view)
DIMENSIONS: 8.4 x 18.1 cm (3 5/16 x 7 1/8 in.)
OWNER: Don P. Parisi
BIOGRAPHY: Orlando Willcox graduated from West Point in 1847, fought in the Mexican American War and the Seminole War, and resigned from the army in 1857 to practice law in Detroit. In May 1861, he was appointed colonel of the First Michigan Regiment, which participated in some of the earliest campaigns of the Civil War, including the capture of Alexandria and the Battle of Bull Run, where he was taken prisoner. Willcox was exchanged in the summer of 1862 and promoted to the rank of brigadier general of volunteers. He returned to battle as part of Burnside's army, fighting at Antietam, Fredericksburg, and in the final campaigns at Wilderness, Spotsylvania, Cold Harbor, and Petersburg. After the war, Willcox remained with the army for the next twenty-one years. This portrait of Willcox and his staff was probably made soon after the Michigan regiment arrived in Washington.

PLATE 64

SITTER: Admiral John Dahlgren (1809–1870)
DATE: 1863–1865
MEDIUM: Albumen silver print (stereo view)
DIMENSIONS: 7.9 x 15.9 cm (3 1/8 x 6 1/4 in.)
OWNER: National Portrait Gallery, Smithsonian Institution
BIOGRAPHY: John Dahlgren began his career as a common sailor, before joining the navy as a midshipman in 1826. Thanks to his skill as a mathematician, Dahlgren was sent to work for the Coastal Survey from 1834 to 1837. He came to the Washington Navy Yard in 1847 as an ordnance officer and began to modernize the procurement, maintenance, and distribution of weapons, eventually becoming chief of the navy's Bureau of Ordnance. Under Dahlgren's direction, the navy established its own foundry to manufacture new equipment, including, in 1848, his "Boat Howitzer," a

light, accurate gun that could also be used in the field. Today, he is best known for developing a cast-iron gun called a Dahlgren, which became a standard armament on navy ships after 1856. In 1861, when Dahlgren's commander resigned to join the Confederate navy, Lincoln placed him in charge of the Washington Navy Yard. On requesting active service, Dahlgren took command of the South Atlantic Blockading Squadron in July 1863, secured Charleston's harbor, and aided Sherman's capture of Savannah in 1864. Dahlgren returned to the Washington Navy Yard in 1869, where he served as commander until his death. Brady's photographers made a series of portraits of Dahlgren and his crew aboard the U.S.S. *Pawnee* in Charleston harbor. In this stereo view, Dahlgren posed before one of his cast-iron guns.

PLATE 65

SITTER: General George Brinton McClellan (1826–1885) and His Staff

DATE: Circa 1862

MEDIUM: Albumen silver print

DIMENSIONS: 38.7 x 45.7 cm (15¼ x 18 in.)

OWNER: National Archives

BIOGRAPHY: According to one source, Mathew Brady made this photograph of General George Brinton McClellan and his men at Upton's Hill, near Centreville, Virginia, the most distant of the forts protecting the capital, near Confederate lines. One officer remembered that after he and his troops met McClellan here in August 1862, they clearly heard the cannons of the second Battle of Bull Run, where General John Pope's federal troops were defeated. Most accounts suggest that McClellan held back expected support, while McClellan himself described the warm welcome he received after the battle as he led the Army of the Potomac back to Washington. Within a few weeks, McClellan successfully defended the capital from Lee's attack, then led the bloody, indecisive Battle of Antietam. In November, after McClellan repeatedly failed to engage Lee's army, Lincoln turned

the command over to General Ambrose Burnside. McClellan's reluctance to fight greatly troubled Lincoln, and remains a central problem for historians of the war.

PLATE 66

SITTER: Officers of Rhode Island First Regiment

DATE: May–July 1861

MEDIUM: Albumen silver print

DIMENSIONS: 27.9 x 35.6 cm (11 x 14 in.) board

OWNER: Library of Congress

BIOGRAPHY: In the West Point class of 1847, Ambrose Burnside (1824–1881) studied with future generals George B. McClellan, Winfield Scott Hancock, and T. J. "Stonewall" Jackson. He left the army in 1852, settled in Rhode Island, and began to manufacture rifles based on his own design. When war was declared in April 1861, the governor of Rhode Island called on him to command the state's first militia regiment. Burnside's troops were among the first to reach Washington; they fought in the Battle of Bull Run and then disbanded. In August, Burnside assumed command of a new group of three-year regiments being assembled in Washington, leading a successful campaign on the North Carolina coast in the first half of 1862. But Burnside knew that he could not lead a large army. He twice refused command of the Army of the Potomac, and when forced to accept the post, his troops suffered heavy losses. After the war, Burnside became a successful politician, serving Rhode Island as both governor and senator. Brady made this group portrait between May and July 1861, when Burnside held the rank of colonel, in command of the First Rhode Island regiment.

PLATE 67

SITTER: Brigadier General Charles Francis Adams Jr. (1835–1915)

DATE: 1864

MEDIUM: Albumen silver print

DIMENSIONS: 16.5 x 23.8 cm (6½ x 9⅜ in.);

on board 20.3 x 25.4 cm (8 x 10 in.)

OWNER: Library of Congress

BIOGRAPHY: The grandson of John Quincy Adams and son of Lincoln's ambassador to Britain, Charles Francis Adams joined the First Massachusetts Cavalry in 1861. At the end of the war, he commanded the Fifth Massachusetts Cavalry, an African American regiment, and left the army in 1865 as a brigadier general. Adams fought at Antietam and Gettysburg, where he came to respect the skills of the Confederate army. After the war, he became a historian, writing about the war from a position of unusual generosity and insight, which strongly influenced the country's subsequent view of the Civil War. In 1907 Adams, the exemplary Yankee, was invited to speak at the centennial of Robert E. Lee's birth. On that occasion he remembered Lee's dignity and valor, and called Lee and Jackson glorious adversaries, "worthy of the best of steel. I am proud now to say I was their countryman." Brady photographed Adams (on the far left in the picture) and his men in August 1864, before the Battle of Petersburg.

PLATE 68

SITTER: Sherman (1820–1891) and His Generals

DATE: 1865

MEDIUM: Albumen silver print

DIMENSIONS: 34.6 x 43.8 cm (13⅝ x 17¼ in.)

OWNER: Chicago Historical Society (ICHi-12473)

BIOGRAPHY: In 1865, shortly after the war ended, Mathew Brady offered to photograph William Tecumseh Sherman along with all of his generals. According to Brady, Sherman doubted that his staff would remain in Washington for the picture, but with characteristic energy, the photographer appointed an hour and notified all seven men (Oliver Otis Howard, John A. Logan, William B. Hazen, Jefferson C. Davis, Henry Warner Slocum, Joseph A. Mower, and Francis P. Blair). Blair

alone missed the sitting, but Brady arranged to photograph him separately. He used darkroom techniques to add him to later versions of the portrait, of which this is one.

PLATE 69
SITTER: Robert E. Lee (1807–1870)
DATE: 1865
MEDIUM: Albumen silver print
DIMENSIONS: 20.8 × 15.2 cm (8³⁄₁₆ × 6 in.)
OWNER: National Portrait Gallery, Smithsonian Institution
BIOGRAPHY: Robert E. Lee was known as an exemplary military commander when Abraham Lincoln asked him to command the Union army in 1861. He had graduated with distinction from West Point, served on Winfield Scott's staff during the Mexican American War, modernized the West Point curriculum in the early 1850s, and led the recapture of the Harpers Ferry arsenal from John Brown and his army in 1859. Though he opposed secession and favored an end to slavery, Lee declined Lincoln's appointment to support Virginia and the Confederacy. Under his leadership, Confederate forces scored important victories, despite the superior numbers and richer resources of the Union army. But Lee's defeat at Gettysburg in July 1863 marked a turning point. Under Grant's assault, Lee's armies retreated south into Virginia. Yet even when forced into a siege at Richmond and Petersburg, his troops held on for nearly ten months before the final surrender at Appomattox in April 1865. Brady photographed Lee on the porch of his home in Richmond shortly after the surrender. As he recalled in 1891,

It was supposed that after his defeat it would be preposterous to ask him to sit, but I thought that to be the time for the historical picture. He allowed me to come to his house and photograph him on his back porch in several situations. Of course I had known him since the Mexican War when he was upon Gen. Scott's staff, and my request was not as from an intruder.

PLATE 70
SITTER: Sister Cecelia (lifedates unknown)
DATE: Circa 1862
MEDIUM: Albumen silver print
DIMENSIONS: 14.4 × 11.1 cm (5¹¹⁄₁₆ × 4³⁄₈ in.)
OWNER: National Archives
BIOGRAPHY: Both northern and southern politicians had prepared to raise armies even before secession began in the spring of 1861, but virtually no advance preparations had been made for the care of wounded and sick soldiers. With the declaration of war, military and civilian groups began to organize relief efforts to build hospitals and train the volunteers who provided much nursing care. Catholic women's communities, which had a tradition of teaching and caring for orphans and the sick, provided trained nurses, and many doctors preferred their help to that of other female workers. More than six hundred sisters worked in hospitals throughout the North and South, the largest number coming from the Daughters of Charity, based in Emmitsburg, Maryland. By 1862, many nuns from this order had come to Washington, where thousands of soldiers were housed in hospitals made from federal buildings, churches, and newly constructed sheds. In this photograph, Sister Cecelia wears a black woolen dress, white muslin cap, and black veil, the typical habit of the Daughters of Charity.

PLATE 71
SITTER: Clara Barton (1821–1912)
DATE: Circa 1866
MEDIUM: Albumen silver print
DIMENSIONS: 15.4 × 10.8 cm (6¹⁄₁₆ × 4¼ in.)
OWNER: National Archives
BIOGRAPHY: When Clara Barton was sixteen, phrenologist Lorenzo Fowler advised her to become a teacher to cure her shyness. For ten years, Barton taught in a small Massachusetts town where her brother owned a factory. After she was invited to teach in a private school in Bordentown, New Jersey, Barton recognized the community's need for free education, and despite opposition, she set up

one of the first free public schools in the state. After officials appointed a male principal in her place, Barton resigned. In 1854, she moved to Washington, where she became the first woman to work at the Patent Office. Barton's war work began in April 1861. After the Battle of Bull Run, she established an agency to obtain and distribute supplies to wounded soldiers. In July 1862, she obtained permission to travel behind the lines, eventually reaching some of the grimmest battlefields of the war and serving in the sieges of Petersburg and Richmond. Barton delivered aid to soldiers of both the North and South. After the war, she became a popular and widely respected lecturer. While in Geneva in 1869, Barton learned of the articles of the Geneva Convention and vowed to bring the International Red Cross to America. Her campaign began in 1877, and finally succeeded in 1882. For the next twenty-three years, she directed the American Red Cross. Brady photographed Clara Barton in Washington during the 1860s.

PLATE 72
SITTER: Stephen A. Douglas (1813–1861)
DATE: Circa 1860
MEDIUM: Albumen silver print (carte de visite)
DIMENSIONS: 8.6 × 5.6 cm (3³⁄₈ × 2³⁄₁₆ in.)
OWNER: National Portrait Gallery, Smithsonian Institution
BIOGRAPHY: Stephen A. Douglas became a leader of the Illinois Democratic Party while still in his twenties. In 1843 he was elected to the U.S. House of Representatives, where his small stature and powerful rhetoric earned him the nickname "The Little Giant." In 1847, when he entered the Senate, Douglas became chairman of the Committee on Territories. He supported the increasingly untenable doctrine of popular sovereignty, which allowed each territory to settle the legality of slavery by popular vote; he also worked hard to create a transcontinental railroad. Douglas had a national following and was an acknowledged contender for the presidency throughout the

1850s, even after he condemned President Buchanan and the controversial, pro-slavery Lecompton Constitution in Kansas in 1857. In 1858, Republican Abraham Lincoln considerably widened his own reputation when he challenged Douglas for his Senate seat in a statewide series of debates. The men met again in the presidential election of 1860. Following his defeat, Douglas supported Lincoln, speaking as his emissary in the West and in the border states. Brady photographed Douglas several times in Washington between 1858 and 1861.

PLATE 73

SITTER: Mary Todd Lincoln (1818–1882)

DATE: Circa 1863

MEDIUM: Albumen silver print (carte de visite)

DIMENSIONS: 8.6 x 5.4 cm (3⅜ x 2⅛ in.)

OWNER: National Portrait Gallery, Smithsonian Institution

BIOGRAPHY: Mary Todd was born to an affluent Kentucky family and received a genteel education at private academies near Lexington. She met Abraham Lincoln in 1839 in Springfield, Illinois, at the home of her sister and brother-in-law. Over their objections, she became engaged to the ambitious lawyer, and the Lincolns married in 1842. Mary Todd Lincoln lived happily in Springfield, as her husband rose in the ranks of the Whig Party. She enthusiastically supported her husband's presidential ambitions, yet as first lady she found herself constantly under attack. She disappointed southerners, who felt betrayed by her opposition to slavery; northerners distrusted her; and many of Lincoln's colleagues disliked her. Unfriendly memoirs describe her temper, her extravagance, and her sarcasm, but Lincoln's own letters show a consistent, affectionate regard for his wife and family. This portrait was made in the Brady studio around 1863, when Mrs. Lincoln was still in mourning for her son, Willie, who had died in the White House in February 1862.

PLATE 74

SITTER: Joseph Henry (1797–1878)

DATE: Circa 1862

MEDIUM: Albumen silver print (carte de visite)

DIMENSIONS: 8.6 x 5.4 cm (3⅜ x 2⅛ in.)

OWNER: National Portrait Gallery, Smithsonian Institution

BIOGRAPHY: As a student in Albany in the 1820s, Joseph Henry received an unusually broad scientific education. He began as a medical student, shifted his goals to engineering, and finally became a teacher of mathematics and natural philosophy at Albany Academy, where he had first attended school. His wide research on electromagnetism included studies on the structure of currents that rivaled the work of Michael Faraday in England. In 1832, Henry moved to the College of New Jersey (later Princeton University), where he lectured on physics, mathematics, chemistry, mineralogy, geology, astronomy, and architecture. In 1846, Henry was appointed first Secretary and director of the new Smithsonian Institution. Through his efforts, the Smithsonian became more than a simple repository of artifacts, and he actively supported a program of research and publication to promote the Smithsonian's mandate of "the increase and diffusion of knowledge." Henry's efforts to collect and interpret meteorological data led to the creation of the United States Weather Bureau. In addition, through organizations such as the National Academy of Science and the American Association for the Advancement of Science, he worked to establish professional standards in all scientific fields. Mathew Brady photographed Joseph Henry in Washington in the early 1860s.

PLATE 75

SITTER: Margaret Julia "Maggie" Mitchell (1832–1918)

DATE: Circa 1862

MEDIUM: Albumen silver print (carte de visite)

DIMENSIONS: 9 x 5.4 cm (3⁹⁄₁₆ x 2⅛ in.)

OWNER: National Portrait Gallery, Smithsonian Institution; gift of Claire Kaland

BIOGRAPHY: Maggie Mitchell first appeared onstage playing children and young boys, and achieved her first real success as the star in Oliver Twist. Small, agile, and energetic, Mitchell specialized in roles that showed off her talent for piquant comedy. She traveled widely and earned an especially faithful following in the South. In 1860, Mitchell appeared in New Orleans in a new play, Fanchon, the Cricket, adapted for her from a novel by George Sand. The role of Fanchon, an elfin outcast saved by a rich young man, became her signature until she retired from the stage in the 1880s. As manager of her own successful company, Mitchell was intense, hardworking, and severe. Brady photographed her in New York around 1862, when Mitchell first brought Fanchon to that city.

PLATE 76

SITTER: Charles S. (1838–1883) and Lavinia Warren Stratton (1841–1919) ("Mr. and Mrs. General Tom Thumb")

DATE: 1863

MEDIUM: Albumen silver print (carte de visite)

DIMENSIONS: 8.6 x 5.6 cm (3⅜ x 2³⁄₁₆ in.)

OWNER: National Portrait Gallery, Smithsonian Institution

BIOGRAPHY: On February 10, 1863, "The Little Queen of Beauty" married international celebrity "General Tom Thumb" in a lavish ceremony at New York's fashionable Grace Church. The two performers met by accident and enjoyed a true romance before announcing their engagement, which Tom Thumb's employer, P. T. Barnum, promoted to the hilt. For weeks before the wedding, crowds of 20,000 or more paid $3,000 a day to see the bride-to-be and her engagement ring. Barnum received 15,000 requests for tickets to the reception (which cost $75 apiece). On the wedding day, crowds blocked Broadway for hours, and newspapers published pages of detailed descriptions of the "Fairy Wedding,"

including the gifts and the guests, who included New York's most fashionable families. Barnum completed the wedding party with best man "Commodore" George Nutt and Minnie Bump, Lavinia's actual sister, and for years the group toured the globe, eventually reaching Japan, China, Australia, and India. Brady made many carte-de-visite photographs in preparation for the wedding, an arrangement that doubtless profited everyone, including the performers, who sold portraits wherever they appeared.

PLATE 77

SITTER: Edwin Booth (1833–1893) and His Daughter, Edwina
DATE: Circa 1864
MEDIUM: Albumen silver print (carte de visite)
DIMENSIONS: 8.6 x 5.4 cm (3⅜ x 2⅛ in.)
OWNER: National Portrait Gallery, Smithsonian Institution
BIOGRAPHY: According to one historian, "No actor of his time so completely filled the eye, the ear and the mind with the ideal of romantic tragedy as Edwin Booth." Another called his acting "a spell from which you can not escape." The son of Shakespearean actor Junius Brutus Booth, and named for Edwin Forrest, Edwin Booth had little in common with his forebears. Where they had been loud and bombastic, Booth was subtle, with a psychological approach to character. Booth learned his craft in traveling companies, and made his debut in New York in 1857. In 1863, he brought modern Shakespeare to the Ameri-

can stage, using full, accurate scripts for the first time. That year he performed *Hamlet* for one hundred consecutive nights, setting a record that stood until 1923. After his brother John Wilkes Booth assassinated Abraham Lincoln, Edwin Booth retired from the stage, but his audience soon welcomed him back. The great actor was a poor businessman. In 1869, he built a large fireproof theater for his New York company, but the depression of 1873 left him bankrupt. He spent the last decades of his career touring the world in his famous tragic roles. Booth had married actress Mary Devlin in 1860, and she died in 1863, leaving him with a two-year-old daughter, Edwina. Edwin and Edwina Booth posed for Brady around 1864.

PLATE 78

SITTER: Anna Elizabeth Dickinson (1842–1932)
DATE: 1863–1864
MEDIUM: Albumen silver print (carte de visite)
DIMENSIONS: 8.6 x 5.4 cm (3⅜ x 2⅛ in.)
OWNER: National Portrait Gallery, Smithsonian Institution; gift of Laurie A. Baty
BIOGRAPHY: Anna Dickinson was born in Philadelphia to an orthodox Quaker family. The death of her father, a fervent abolitionist and unsuccessful merchant, forced Dickinson and her sister to help support the family while still in their teens. Following the convictions of her family, Dickinson contributed an essay to William Lloyd Garrison's *Liberator* in 1856, and addressed the Pennsylvania Anti-Slavery

Society in 1860. Her intensity, youth, and dedication to emancipation attracted curious, sympathetic audiences, as well as noted abolitionists Hannah Longshore and Lucretia Mott. But Dickinson's greatest success came in 1863, when the Republican Party asked her to tour on behalf of its candidates. When Dickinson reached New York, an audience of 5,000 greeted her as the Joan of Arc of the abolition cause. Throughout the 1860s, Dickinson continued to lecture on the rights of women and African Americans. When popular taste shifted to light entertainment, she began a largely unsuccessful career as a playwright and actress, eventually dying in obscurity in New York. This carte-de-visite portrait of Dickinson was made on her triumphant Republican Party tour of 1863–1864.

PLATE 79

SITTER: Mathew Brady
DATE: Circa 1861
MEDIUM: Albumen silver print (carte de visite)
DIMENSIONS: 8.6 x 5.5 cm (3⅜ x 2 3/16 in.)
OWNER: National Portrait Gallery, Smithsonian Institution
BIOGRAPHY: This carte de visite was made around 1861. Below the image a handwritten caption—"M. B. Brady. artist. Civil War photographer"—echoes Brady's own views. Throughout his life, Brady claimed two complementary professions, and never saw the need to choose between them.

9

Recollecting the Past

A COLLECTION CHRONICLE OF MATHEW BRADY'S PHOTOGRAPHS

JEANA K. FOLEY

Brady had galleries in Washington: his headquarters were in New York. We had many a talk together: the point was, how much better it would often be, rather than having a lot of contradictory records by witnesses or historians—say of Caesar, Socrates . . . others—if we could have three or four or half a dozen portraits . . . of the men: that would be history—the best history—a history from which there could be no appeal.[1]

WALT WHITMAN

The paradox: the same century invented History and Photography. But History is a memory fabricated according to positive formulas, a pure intellectual discourse which abolishes mythic Time; and the Photograph is a certain but fugitive testimony.[2]

ROLAND BARTHES, *CAMERA LUCIDA*

In his poignant text on photography, *Camera Lucida*, Roland Barthes writes that earlier societies built monuments to make memory impervious to the ravages of time. Today, we have come to rely on photographs to act as history's witness. The photograph, however, is not as enduring as recounted epics, stories carved into stone, or bronze horses standing proudly on three legs or four to tell us how their brave riders met their end. Fading, weakening, and ruining over time, the photograph, having become a cultural substitute for memory, acts simultaneously as a fallible harbinger of what has been. It is not, as Walt Whitman hoped, a history from which "there could be no appeal."

Mathew Brady's ambitions and obsessions for his historical legacy were stifled by what Barthes described as photography's "fugitive testimony." Brady's collection, comprising Civil War views and portraits of important wartime politicians, military officials, and citizens, was meant to capture and commemorate the essence of his era. Brady and his contemporaries saw that, for the first time, history could be collected, preserved, savored, and remembered in the most concrete way: as a visual document. As a photographer and a historian, Brady devoted his life and his entire career to making this a reality for his country.

But these were difficult days. With the bloody end of the war, America had lost its innocence, and perhaps its desire to remember. As the nation strived to reinvent itself through avenues such as politics and industry, Brady's beloved portrait of America seemed like a hindrance, a too-direct link to an obsolete past. While Brady ceaselessly reminded his audience of his creation, and endlessly attempted to get the government to understand its value, the public seemed to politely nod but then turn away from his display of the past.

FIGURE 9–1

Brady in the field

Albumen silver print, circa 1864.

National Archives, Washington, D.C.

When Brady could no longer promote his photographic legacy, the collection suffered in recurring oblivion, constantly being remembered and then forgotten, as it was divided again and again among many different owners. With each owner came additional details and losses of information, adding and subtracting from the history of Brady's collection until it was nearly obliterated. What remains of the collection is today spread across several institutions, well cared for but stored in relative obscurity. What remains of the collection's history is part fact, part fable, and part mystery.

There exists no one complete collection history or catalogue raisonné of Mathew Brady's work. This absence of documentation is in part due to Brady's habit of appropriating the work of other photographers in his employ (or not in his employ), bad record-keeping on Brady's part, and the very nature of the photograph itself, with its infinite reproducibility. Accurate information about all aspects of Mathew Brady's history, from his birthdate to his studio practices, is difficult to come by.

This essay attempts to chronicle, in part, the connections between images and collections—a task that will never be wholly and accurately complete, for there are gaps in information that can never be filled: an ironic end for what Brady intended to be his monument and contribution to history.

The major public collections of Brady photographs include the National Portrait Gallery, Harvard University, the Chicago Historical Society, the National Archives, and the Library of Congress. All of the objects in these collections can be connected in some way to a chain of events that occurred beginning in the early 1860s, when Brady's financial difficulties also began.

Brady's financial reports from R. G. Dun & Company auditors suggest that he began to overextend his credit in 1856 by not promptly paying off long-standing debts. In 1859, Brady mortgaged his property in Brooklyn to meet his other financial obligations. Soon after moving his New York gallery to a more fashionable address in October of 1860, Brady's money shortage (and poor business sense) caused him to mortgage the contents of the new gallery at 785 Broadway almost immediately. The Dun & Company report from January 1861 states that Brady was judged not creditworthy at that time.[3]

When Brady began to document the Civil War by sending photographic operators into the field [Figure 9–1], he was simultaneously running two studios—one in New York and one in Washington, D.C. Though he incurred additional debt to outfit and employ his photographic emissaries, Brady expected that revenue from his war photographs would offset his expenditures. He anticipated sales to discharged soldiers and their families, the public, and most important, the government.

Brady acquired financial backing and photographic supplies from his longtime associates, E. & H. T. Anthony & Company, by using his negatives as a form of collateral. The Anthonys had an arrangement with him whereby their company retained his negatives, from which they published cartes de visite. Brady, in turn, would receive royalties from the use of the negatives for publication. The number of carte-de-visite negatives in the Anthonys' possession grew as Brady's financial problems escalated.

While Brady relinquished thousands of negatives to E. & H. T. Anthony & Company, he retained many others. Brady and his photographers regularly took multiple shots of scenes and sitters, both in the studio and on the battlefield. About the time Brady gave up the rights to the Anthony negatives, he placed another set of negatives in storage in Washington and kept thousands more negatives and other photographic materials in his New York and Washington galleries.[4]

In 1866, Anthony's secured an attachment on another set of Brady negatives (mostly stereograph size) in lieu of the money Brady owed.[5] The Anthonys used the negatives for many years to create cartes de

visite, as well as stereo views. Eventually, the negatives, totaling more than seven thousand, ended up in the company's storage space in New York City.

In early 1867, Brady was forced to sell half of his Washington gallery to James F. Gibson, the establishment's manager. Gibson ran the business into ruin, causing Brady to declare bankruptcy by 1868. After selling his house in New York, Brady was able to buy back the Washington studio at auction, although he still had other creditors at the time, E. & H. T. Anthony among them.[6]

Brady hoped that the United States government would soon purchase his impressive collection of Civil War photographs for the nation. Despite the fact that in 1871 the Joint Committee on the Library recommended to the House of Representatives that the government purchase 2,000 portraits from Brady's "National Collection of Portraits of Eminent Americans," the motion never came to a vote and eventually fell through.[7] By 1873, upwards of ninety-four creditors sued Brady; he lost the New York and Washington galleries, along with most of his property and possessions, though he managed to liberate some photographic materials before the sheriff arrived.[8]

In July of 1874, a New York warehouse owner, Charles McEntee, sold Brady's stored property at a public auction.[9] William Barnard, an agent representing Secretary of War William Belknap, purchased approximately 2,250 negative plates for the price of Brady's unpaid storage bill, $2,500. An additional $340 was paid by the government for packing, shipping, and to pay for Barnard's services. The official bill of sale between McEntee and Belknap, dated July 30, 1874, describes the purchased items as "photographic negatives of battle fields, war views & other views & apparatus." In November of that year, Barnard wrote to Belknap describing the content and conditions of the negatives that had arrived in Washington. According to Barnard, many of the acquired negatives "were damaged from careless packing and transportation. . . . Another serious cause of damage arises from the fact that where one plate would break, the fragments would mutilate the impressions on twenty or thirty others." After examining all the negatives, Barnard concluded that "the Military pictures are about 2250 in number of these about 1000 are photographs of persons, the remainder are War views ranging in size from 17 × 20 down to stereoscopic plates. . . . Many have no inscription on them." If any other inventory or list was made at the time of the purchase, it has not survived.[10]

Brady wanted his collection in the care of an appreciative owner, but felt shortchanged that the government purchased the collection, seemingly out from under him, during his financial duress. Late in September 1874, Brady accosted Belknap in the vestibule of New York City's Fifth Avenue Hotel. Belknap wrote, in his account of the incident, that Brady

told me that he thought I had treated him unfairly and unkindly in purchasing certain negatives which were his property, and which he intended to redeem . . . in a short time. I told him that I had not treated him unfairly: that I had waited a very long time to hear whether he would be able to do as he had hoped: that I had consulted with persons who I believed to be familiar with his financial ability to raise the requisite amount and that I learned from them that he was utterly unable to do so. . . . Fearing that this property should get into the hands of other persons, and anxious that the War Department should have them, I became purchaser. . . . [Brady] stated that he had possession of a large number of pictures, engravings and photographs which he desired to dispose of to Congress, and wished to know whether I would or would not help him in that direction. I told him I would help him with great pleasure, and would be glad to purchase them myself for the War Department, asking him his price. He said I would not be willing to give the price that he asked as the amount would be so large it required

a Congressional appropriation. On his begging me to assist him in a Congressional application, I told him that if he would address me a communication stating the facts, I would do what I could to assist him in that direction, as I was satisfied the government should have them. As Mr. Brady made me no favorable reception to my proposition to take the negatives at the price I paid for them, I told him that I considered that matter ended: that I had no idea that he could raise the necessary money [to have purchased them himself].[11]

Brady did as Belknap suggested. In a letter dated October 30, 1874, Brady explained his proposal to the secretary of war:

I have the honor to address you on the subject of my "National Collection of Historical Portraits, War Views and etc." The facts regarding the existence of this collection—its great importance in the history of the country and also my labors and sacrifices in obtaining it, are partially known to you and I trust you may regard it as a public service to recommend, in your annual report to Congress, the purchase of the collection by the government.

The press has been especially earnest in recommending the purchase of the collection and there is on the part of artists, historians, military and naval men, and men of letters, and distinction, in all parts of the Country, a general concurrence in the proposition.

I have spent a life-time in collecting the works I now offer; I have kept an open gallery at the Capital of the nation for more than a quarter of a century, to assist in obtaining historical portraits and have spent time and money enough, dictated by pride and patriotism, to have made me independently wealthy. In my exertions to save the collection entire, I have impoverished myself and broken up my business and although not commissioned by the Government to do the work I did, still, I was elected by the general consent of the officers of the Government, from the President down, to do the work.

I have never received a dollar, for any of this labor, from the Government and have steadfastly refused to sell any portion of the collection, although I had years ago large offers for many objects in it.

In conclusion I would beg to say, that your approval is now only needed to insure the purchase of the whole collection by Congress and that recommendation I have the honor to respectfully ask at your hands in common justice.

Remaining Sir, Your most obedient servant, M. B. Brady.[12]

Brady found other supporters to act on his behalf in Congress. On February 18, 1875, Ohio Representative General James A. Garfield wrote to Belknap to indicate his pleasure that Brady's materials had been purchased by the government. Garfield suggested that the government pay Brady an additional amount, to bring his compensation closer to "what would be a reasonable sum if the purchase had been made in the ordinary way."[13] Speaking before Congress on March 3, Garfield supported his letter with some figures. He explained that the government had paid $2,500 for negatives that had a commercial value estimated to be $150,000; moreover, the negatives did not include Brady's entire collection.

In response, General Benjamin F. Butler, representative from Massachusetts, moved that a paragraph

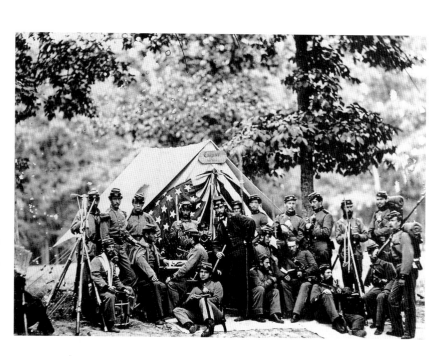

be inserted into the Sundry Civil Appropriation Bill enabling "the Secretary of War to acquire a full and perfect title to the Brady Collection of photographs of the War, and to secure and purchase the remainder now in the possession of the artist, $25,000."[14] Congress approved the bill.

Brady's attorney, John Cassels, informed Belknap on March 30, 1875, that "the remainder of the Brady collection of photographs of the War, now in possession of the artist, are ready for delivery."[15] While Belknap seemed anxious to acquire the remaining negatives, on April 9, 1879, he wrote to Judge Advocate General Mott with second thoughts. Were the negatives really worth $25,000?

> I was informed by Mr. M. B. Brady that he had at his disposal a large collection of similar negatives, to those purchased by the Department. We could not agree on a price.
>
> During the last session of Congress the friends of Mr. Brady interested themselves in his behalf and the following clause was inserted in the Sundry Civil Appropriation Bill: 'To enable the Secretary of War to acquire a full and perfect title to the Brady collection of photographs of the late war and to secure by purchase the remainder now in possession of the artist $25,000.'
>
> Under this law Mr. Brady has presented to the Department a schedule of the pictures in his possession; has submitted the said pictures at the Department for inspection: they have been inspected and are found to be fully equal to what he represents them to be.
>
> I desire your opinion as to whether, under the law above quoted it is my duty—Mr. Brady having complied with the directions of the Department regarding such a sale—to pay him the sum of $25,000; or whether it is within the discretion of the Secretary . . . to pay him a less sum, should the Secretary not consider the value of the pictures still in Mr. Brady's possession, to be $25,000.

Mott quickly responded that Belknap could indeed decide how much money to give Brady, up to the $25,000 limit. Mott, however, also pointed out that

> in estimating what shall be an adequate compensation, the Secretary should, in my opinion, mainly take into consideration two matters, to wit, the pecuniary value of the time, labor etc. extended by Mr. Brady and his agents, in taking the views, preparing the negatives, etc, and the value of the articles to the United States. This latter element . . . should enter into the estimate, rather than the commercial value. For Congress, in providing for the purchase, may well be supposed to have considered not only that the pictures were of national interest and importance but that they were secured at a time of war and under circumstances of unusual difficulty and danger. The fact therefore that they may be of comparatively little pecuniary worth . . . should . . . not avail to depress the valuation to be fixed by the Secretary of War.[16]

Also on April 9, Belknap received William Barnard's report on the examination of the latest lot of Brady materials. Brady furnished the government with an inventory, now lost, of 3,200 negatives and some other photographic materials sold to the government. Barnard noted that 347 of the listed negatives were missing. However, he found an additional 614 plates not specified on Brady's inventory, bringing the total number of negatives acquired to 3,467. About 750 of the negatives were war views, while those remaining depicted portraits of distinguished officers and private citizens [Figure 9–2]. Barnard's letter also includes a count by plate size: 439 were 17 × 20-inch Imperials, 89 were 13 × 17-inch cabinet-size, and the rest were primarily 8 × 10-inch negatives. Barnard reported that these plates were in very good condition upon arrival, unlike the first batch from New York. From all indications, this lot of material came from the negatives Brady had stored in Washington. Besides this letter, no other inventory from the time of purchase

has surfaced. The War Department did not publish a reliable and identifiable list until 1897. By that time, it was impossible to distinguish the negatives acquired in the New York auction purchase from those acquired later in Washington.

As to the question of their value, William Barnard commented in his letter of April 9, 1875:

> If the probable intention of Congress in making the appropriation to reimburse Mr. Brady for the time, labor and expense of making the large collection now in the hands of the Department is ignored and no consideration given to the previous purchase of plates in New York, it may be said that the plates now presented for purchase would cost about $7.22 a piece; adding to these the Military part of pictures purchased in New York and the price paid for that collection, the total cost per plate (military) would be about $4.50—a large price to pay for small plates, but a very small one for the large negatives.
>
> It is a very embarrassing thing to endeavor accurately to estimate the value of these negatives in money. As pictures, they would only be valuable to those interested in the subjects they represent, and then, if purchased at private sale, probably very few would be sold for less than the price the Department is asked to pay.

These three letters alone document the controversy surrounding Brady's compensation by the United States government. On April 15, 1875, the government paid John Cassels, Brady's attorney, the $25,000 in question.[17]

Once the War Department acquired the negatives, the problems of printing and storing Brady's images began. In 1875, William Barnard wrote on behalf of the department to the United States Treasury to request funds to print a full set of images.[18] The second comptroller of the Treasury ruled that the proofs could be considered official historical records, making it possible for the Treasury to pay for the printing out of a fund reserved for publishing the official records of the war.[19]

The printing project took many years and created thousands of prints. There is no indication which negatives were printed when, and by whom. If accurate records were ever made, they no longer exist. Because the government lacked appropriate laboratory facilities to complete the printing, photographer William R. Pywell was hired to print the proofs.[20] Pywell was a field photographer during the war, as well as a former employee of Brady's Washington studio, so it is speculated that his printing style would have been similar to Brady's.[21] Although Pywell successfully printed a portion of the negatives, he was relieved of his position in May 1876 after valuable printing supplies belonging to the government disappeared while he was using them. Another photographer, T. W. Smillie, reproduced another series of prints during 1877 but did not complete the job.[22]

After Smillie left, the project to print the Brady negatives in their entirety seems to have been shelved. War Department employees carelessly handled and destroyed many of the negatives. In 1879, the War Department transferred the negatives to the War Records Office under the care of Colonel Robert N. Scott. Another infusion of printed images came to the collection after Secretary of War Robert Lincoln approved the loan of the negatives to the Military Order of the Loyal Legion, Massachusetts Commandery, in 1884.[23] Lincoln gave permission for the group to make prints under the supervision of General Albert Ordway (whose name will reappear in connection with other groups of Brady negatives). Under this agreement, Ordway made two sets of images, keeping one for himself and returning a second set to the government.[24] Although the number of negatives loaned to Ordway is uncertain, the government acquired at least 725 prints from this episode. Ordway must have printed other sets as well; in 1885, the Massachusetts Loyal Legion attempted to sell a set of Brady prints to the Loyal Legion of Illinois for $1,200.[25]

Finally, in 1885, the government resurrected the effort to secure a complete set of photographic prints from the Brady negatives. Robert Lincoln awarded the job to photographer J. H. Jarvis for an estimated cost of ten cents per print (with a total cost estimated at approximately $600).[26] Although Colonel Scott attempted to keep track of the negatives and the prints as they left the War Records Office, he was unsuccessful. The War Department delivered the negatives to Jarvis between January and April of 1885. But by April, as relayed in a letter from Scott to Lincoln, the War Records Office had received neither negatives nor prints.[27] Scott expressed his concern, and observed that when the negatives were returned, a more secure storage arrangement should be worked out. Shortly thereafter, Scott went to Jarvis's studio, where he found the negatives strewn about and piled on the floor, unprotected. In response to Scott's findings, Lincoln ordered that the negatives be retrieved immediately from Jarvis and moved to safety.[28] More than a year later, in July 1886, John S. Moody, the chief clerk of the War Records Office, filed a condition report on the negatives. Moody examined each package of negatives sent to Jarvis and produced a list, by negative number, describing which negatives were damaged or missing. Jarvis had rendered approximately 5 percent of the 6,000 negatives unusable. Though Jarvis apparently did print many of the negatives, the information available suggests that he did not actually complete the work.

It is unclear whether any photographic prints made by Brady's studio came with the two collections purchased by the government. Nick Natanson of the National Archives has reasoned that in all likelihood, few or none arrived with the materials at the War Department.[29] None of the records pertaining to Brady's transactions with the government specifically mention the presence of photographic prints.

During the late 1880s and 1890s, custody of the negatives continued to change in the War Department, moving from the Supply Division and then to the War Department Library. During this period, citizens would often inquire about the use of the collection. The standard response to such inquiries during the 1890s was that the collection had not been catalogued and that the photographs that had been printed were bound into a volume located in the War Department Library. In August 1892, Mathew Brady himself wrote to the secretary of war asking permission to print the very negatives he had sold to the government. Brady intended to reproduce some of these negatives for the impending anniversary encampment of the Grand Army of the Republic. The secretary of war denied his request with the standard curt reply.[30]

At some point between 1876 and 1890, 2,786 prints were bound in 28 oversize volumes.[31] Fourteen albums house prints from Brady negatives: volumes 1 through 6B contain field views; volumes 7 through 14 contain individual portraits. The remaining volumes contain prints not related to, but contemporary with, the Brady collection. Volumes 15 through 20 house the adjutant general's collection of Union officer portraits, while volumes 22 through 29 contain Civil War views assembled for the quartermaster general. (The volumes are misnumbered; there are no volumes 21 or 28.) The origins of these volumes remain a mystery. War Department records make few references to their creation, although the volumes containing the portraits by Brady are mentioned in their correspondence as early as 1890. Did Brady's studio create the bound portrait albums? The few existing clues to their origin make that possibility seem unlikely.

In 1897, the government published the first catalog of the War Department's Brady collection, "Subject Catalog No. 5, List of the Photographic Negatives Relating to the War for the Union," written by Brigadier General A. W. Greely, chief signal officer. Greely also wrote an official internal report on the collection for the secretary of war. The catalog lists only the negatives, describing the subject and the size. In addition to the subjects of the almost 6,000 Brady negatives, Greely's catalog includes a second series of

photographs taken during the war under the direction of the Army Corps of Engineers. A large number of portrait daguerreotypes taken by Brady also appear in the catalog. As Greely writes in his report, "Associated with the Brady War Collection, have been discovered . . . several hundred . . . daguerreotypes made in many cases between 1840 and 1850. Among them are portraits of some of the most distinguished Americans [Figure 9–3] . . . which barely escaped utter destruction or complete loss."[32]

From 1897 onward, photographs made by the Army Corps of Engineers have remained with the prints of the Brady photographs. In 1919, the entire collection was transferred to the United States Army Signal Corps. At about that time, the daguerreotypes were transferred to the Library of Congress because they lacked sufficient military value.[33]

Finally, in 1940, the War Department transferred the Brady collection to its current home, the National Archives. The Division of Still Pictures at the National Archives' facility in College Park, Maryland, now holds the glass-plate negatives that remain from the War Department's original purchase. The collection also includes 6,300 photographic prints generated from the Brady negatives as well as other sources.[34] Some of these photographs were collected by the quartermaster general, the Army Corps of Engineers, and from private donations. Included with these prints are approximately 2,000 portraits of military officials and prominent citizens, which were probably made in Brady's Washington studio between 1858, when it opened, and 1870. The remaining 4,000 prints depict field views—primarily the activity in the Eastern Theater of the Army of the Potomac.

Archivists have separated the prints and housed them by size, without regard to their age or origin. As a result, nearly every box contains evidence of the various negative-printing projects, shown through their different mounts, different identifying marks, different color tones, and even different printing methods. The simple act of comparing two prints from a single negative brought surprising results: in a brownish albumen print from the nineteenth century, a naval crew spread across the deck of their gunboat looked clear and crisp, while deep blacks in a twentieth-century gelatin silver print make the same scene appear as hazy and moody as a Pictorialist photograph.

Whether from sentimental attachment or financial need, Mathew Brady remained connected to the

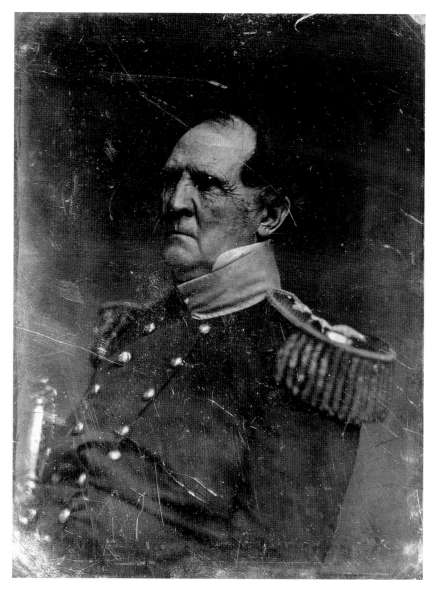

FIGURE 9–4

General Edwin V. Sumner

Albumen silver prints (stereo view), circa 1862.

Don P. Parisi

photographic materials that eventually went to the National Archives. This set of negatives, and the images they contained, more closely depict Brady's intended version of history, the version he wanted his nation to remember and embrace. However, this group by no means represents the sum of Brady's photographic collection.

We know that Brady used his negatives as an asset in his business arrangements with Anthony. Brady apparently used a large set of stereograph negatives as collateral with Anthony's to secure credit at some point during, or just after, the war. These bits of information are well established within Brady lore. The exact facts on which this information is based remain much less known.

In their biography of Edward Anthony, William and Estelle Marder write that E. & H. T. Anthony & Company "obtained a judgement against Brady [and] attached one set of war views that Brady had stored in New York. This set of Brady's war views, in stereo negative size, then became Anthony's property."[35] They do not, however, cite a source for this information. Paul Vanderbilt, a former photographic historian at the Library of Congress, notes the same—that the Anthonys "gained an attachment and later a judgement on the New York set of negatives."[36] While Anthony began publishing stereo views from Brady's negatives in 1862, and Brady's major bankruptcy foreclosures occurred in 1873, no exact date on the transfer of the negatives' ownership from Brady to Anthony is evident. The Anthonys printed and published many Brady stereographic negatives through the 1870s under several different titles, including *War Views* and *War for the Union* [Figure 9–4].[37]

In 1879 the Brady collection of stereo negatives changed hands when General Albert Ordway of Washington and Colonel Arnold A. Rand of Boston purchased the negatives from Anthony.[38] As private collectors, Rand and Ordway were not particularly interested in Mathew Brady, but rather in photographs of the Civil War. They purchased the negatives explicitly to make new prints of the historical images. To the set of Brady negatives, they added at least 2,000 negatives by Alexander Gardner.[39]

After making a selection of albumen prints from their negative collection, Rand and Ordway attempted to sell their negatives to the government. They felt that their collection differed enough from the government's Brady negatives to merit the addition of theirs to the government's collection. Records from

the forty-eighth session of Congress in December 1884 contain Rand and Ordway's presentation to the Senate regarding the sale of their collection:

> We are owners of about four thousand photographic negatives taken during the war of the rebellion. . . . The Government some years ago purchased what is generally known as the "Brady Collection" of photographic negatives. These two collections . . . embrace not only all that is now in existence, but all the negatives that were taken during the war. . . .
>
> The collection owned by the Government is made up principally of views that were taken during the first year of the war in the vicinity of Washington, and during the last year of the war in and about Petersburg and Richmond, together with a small series of views taken in and about Chattanooga and Atlanta, and a large number of portraits. The value of the collection is considerably diminished by the fact that, the original catalog being lost, a very large number of the views and portraits are unknown.
>
> Our collection is not only very much larger than that of the Government, but contains much more valuable material and is in perfect condition in every respect. Included in our collection are over two thousand negatives that were taken by the late Alexander Gardner . . . and cover the whole period lacking in the "Brady collection." The balance of the collection covers fields of operations of which no other illustrations are in existence, and includes about one thousand portraits of distinguished officers. . . .
>
> Believing that our collection, as a part of the records of the war of the rebellion, is of too great value to remain in private hands, with the liability of being scattered or lost in future years, we deem it proper to call your attention to its existence and to offer it to the Government on such terms as may be mutually agreed upon.[40]

The congressional record also includes a catalog of the collection. Though Rand and Ordway did not specifically indicate which views came from the Brady set of negatives and which views came from Gardner, their written description of each image's subject and negative size sheds some light on the probable authorship of the negatives. The negatives are primarily stereograph size—3½ × 7 inches—or 8 × 10 inches. Most likely, the smaller negatives are by Brady, since sources indicate that Anthony originally acquired the set of stereo negatives. A letter from Ordway to Colonel Robert N. Scott, chief of the War Department Library, reveals that the list was only a partial catalog and that the collection actually contained approximately 6,000 negatives.[41] The government ultimately chose not to purchase the Rand-Ordway collection, primarily because it was still having a great deal of trouble adequately reproducing, preserving, and protecting the nearly 6,000 negatives they had already purchased from Brady.[42]

In 1884, Rand and Ordway successfully sold their negatives to John C. Taylor of Hartford, Connecticut. Taylor, a Civil War veteran and photography entrepreneur, recognized the collection's commercial value. Under the names "Taylor & Huntington" and the "War Photograph & Exhibition Company," Taylor published large quantities of prints and stereographs during the late 1880s and 1890s.[43] In 1894, George F. Williams illustrated *The Memorial War Book . . . Reproduced Largely from Photographs Taken By the US Government Photographers* [sic] *M. B. Brady and Alexander Gardner* (New York: Lovell Bros., 1894) with images obtained from Taylor's War Photograph & Exhibition Company. In 1905 Taylor loaned the negatives to the United States Navy so that prints could be made to add to the government's collection. While the negatives were in Washington for printing, the Library of Congress ordered a set of the prints as well.[44]

Taylor sold the negatives in 1907 to Connecticut publisher Edward B. Eaton, who intended to market the negatives in book form. Later that year, Eaton published *Original Photographs Taken on the Battlefields*

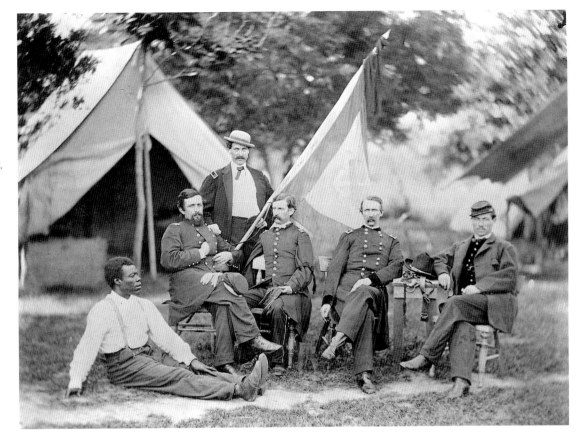

FIGURE 9-5

**Brigadier General
Napoleon B. McLaughlen
and staff**

Albumen silver print, circa
1861.

Library of Congress, Washington,
D.C.

by Mathew B. Brady and Alexander Gardner, the first of Eaton's several Civil War histories illustrated with the Brady negatives.[45] Along with Herbert Myrick, then president of Phelps Publishing Company, Eaton created the Patriot Publishing Company, using the negative collection as an asset. In 1910, the company enlisted historical writer Francis Trevelyan Miller to write its first publication, *The Portrait Life of Lincoln Told from Original Photographs in the Brady-Gardner Collection.* Several other books followed, including the ten-volume work published with the Review of Reviews Company and edited by Miller—*The Photographic History of the Civil War.*[46]

Following this publication, the collection languished in the dusty basement of Phelps Publishing Company. Finally, in 1942, Thomas Norrell, a railroad history buff, stumbled onto the boxes of negatives while searching through the Phelps's archives for a daguerreotype of a locomotive known only from a wood engraving.[47] By chance, Norrell recognized the subject in a fragment of a broken negative to be a view of the Tredegar Iron Works in Richmond, Virginia. The discovery led Norrell to uncover twenty-two wooden boxes of Civil War–era negatives. Norrell informed the National Archives, who in turn contacted the Library of Congress. Phelps Publishing Company subsequently sold the collection to the Library of Congress in 1943 for the cost of unpaid storage.[48]

As had happened earlier at the National Archives, no complete set of prints came with the collection, and none exists today.[49] The Library of Congress owns the prints previously mentioned, which were created in 1905 while Taylor still owned the negative collection [Figure 9–5].[50] An additional selection of

albumen prints from the negatives was made, mounted, and captioned by Albert Ordway, and the Library of Congress purchased it from Ordway's son, Colonel Godwin Ordway, in 1918.

Today, the Library of Congress owns the "Brady-Anthony-Rand-Ordway-Taylor-Eaton Negative Collection," as well as several other important deposits of photographic materials directly linked to Brady and his photographic historical projects. As noted earlier, the War Department transferred a set of 350 daguerreotypes of important historical figures to the Library of Congress in 1920.[51] In addition, the descendants of Levin Handy, Mathew Brady's nephew, bequeathed 11 daguerreotypes to the Library of Congress.[52] Together, these form the largest number of Brady daguerreotypes in any known collection [Figure 9–6].

During the 1950s, Paul Vanderbilt began cataloging the Brady daguerreotypes, but he could locate no direct source of information on them other than their history at the War Department. Correspondence concerning the Brady purchase does not specifically mention the daguerreotypes. However, subjects represented in daguerreotypes appear in A. W. Greely's 1897 "Subject Catalog No. 5," though they are not distinguished by format as daguerreotypes. Vanderbilt assumed that these daguerreotypes had hung on the walls of Brady's studio, and may have been intended as the basis for future volumes of the *Gallery of Illustrious Americans* [Figure 9–7].[53]

The 1954 gift from the Handy estate included more than 10,000 negatives, as well as the daguerreotypes. Of these, the Library of Congress has identified 4,000 as original wet-plate negatives and 1,300 as duplicate plates from Brady's New York and Washington galleries.[54] Descriptions of other library holdings related to Brady appear in Paul Vanderbilt's *Guide to the Special Collections of Prints and Photographs in the Library of Congress* and Kathleen Collins's *Washingtoniana Photographs: Collections in the Prints and Photographs Division of the Library of Congress.*

As noted earlier, Mathew Brady had a business arrangement with the Anthonys that involved Brady's surrender of carte-de-visite negatives to the company in exchange for royalties from the carte-de-visite sales. Evidence of this transaction first surfaces in a letter written on Brady's behalf by Alexander

Gardner, dated March 23, 1861, to Captain Montgomery Meigs, stating that "carte-de-visite negatives of nearly all my Gallery" were being sent to Anthony for publication.[55] In the *Catalog of Card Photographs*, published in November 1862, E. & H. T. Anthony noted that "this catalog contains, together with other subjects, the celebrated collection of portraits, well known in Europe and America as 'Brady's National Portrait Gallery.'" The catalog also advertises cartes de visite of Brady's *Photographic Views of the War*, though in the catalog Brady's images are not singled out from those derived from other sources.

Historian Josephine Cobb observed that Brady lacked adequate facilities to publish cartes de visite in the large quantities the public demanded. She cited a letter printed in *Humphrey's Journal* on July 1, 1862, describing the state of photographic publishing in New York City, which reported that the largest and most reputable firms, "such . . . as Brady's, Fredrick's, &c., are pleased beyond their ability, and that too almost exclusively with card pictures." Cobb believed that Brady also lacked the desire to produce cartes de visite: "This activity . . . was personally distasteful to Mr Brady because it represented a cheap form of portraiture which required little skill on the part of the camera operator with no opportunity for artistic embellishment."[56] While Brady may have aesthetically disapproved of the cartes-de-visite sales, he certainly needed the financial support they could provide. Cobb estimates that Brady earned at least $4,000 a year from his royalty arrangement with Anthony's.[57] As Brady sunk deeper and deeper into debt, he gave more and more cartes-de-visite negatives to the Anthonys, in an attempt to recoup some of his losses. In this way, the Anthonys ultimately acquired thousands of Brady's carte-de-visite negatives. They produced cartes de visite from them for many years, but eventually, like the stereoscopic negatives they had also obtained from Brady, these negatives ended up stored and forgotten. Time passed, and the E. & H. T. Anthony Company of New York City became the Anthony & Scoville Company of New Jersey. When the stereo negatives were sold to Rand and Ordway in 1879, the carte-de-visite negatives, apparently stored separately, remained behind. In 1902, the company still had the carte-de-visite negatives in its possession when Frederick Hill Meserve, a private collector, inquired about buying them. Meserve described his experience: "I entered the door of Anthony, Scoville and Co. . . and inquired of a man behind the counter if his firm still possessed the Brady negatives which I knew had not been used for some years." After learning that the company had the negatives stored in Jersey City, Meserve immediately went to the storage site to find them:

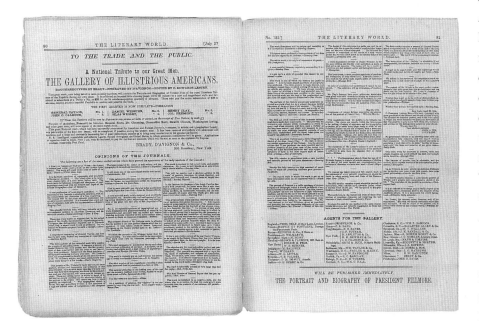

[I] was shown the piles of wooden boxes, opened a lid or two and had my first sight of the negatives. No one knew what or how many were there. I presented myself at the New York office. 'I'd like to buy them,' I said. A

price was arranged. Within a day a van backed up to my New York address and the Brady boxes were tenderly, due to my exhortations, carried in and stacked entirely to the ceiling. . . . I have never counted all the negatives I bought that day. . . . My impression is that all told, there may be eight or more thousand separate exposures.[58]

Meserve's keen interest in Brady's photography stemmed from his initial desire to illustrate his father's Civil War diary with original portraits and views from the period. This project led him to amass one of the most substantial private collections of nineteenth-century American photographs. The large group of Brady carte-de-visite negatives described above formed the core of Frederick Meserve's distinguished collection. A dedicated amateur historian, Meserve devoted himself to identifying, organizing, and even printing from the negatives to create illustrations for his privately printed volumes on nineteenth-century American portraiture. Meserve continued collecting nineteenth-century portrait photography throughout his life, later acquiring additional Brady materials, as well as a notable collection of ephemera related to Abraham Lincoln.

When Frederick Hill Meserve died in 1962, he left his collection in the care of his daughter, Dorothy Meserve Kunhardt. In 1981, with the assistance of the United States Congress, the Smithsonian Institution's National Portrait Gallery acquired a selection of Meserve's Brady carte-de-visite negatives from the Dorothy Meserve Kunhardt Trust. Today, the National Portrait Gallery owns more than 5,400 of Meserve's original collodion glass-plate negatives from Mathew Brady's New York and Washington studios. The photographs reproduced in this catalogue from the National Portrait Gallery's Meserve Collection are modern albumen prints, specially made by the Chicago Albumen Works from these original nineteenth-century negatives [Figure 9–8].

The infinitely reproducible nature of the photograph prevents scholars from reconstructing an accurate accounting of Mathew Brady's photographic career and collections. Certainly, there exist still-unfound deposits of his studio's works in both private and public collections. Researching this project has led to the attribution, and reattribution, of many photographs by Brady, as well as to the rediscovery of photographs that fit into the long, somewhat tragic tales of Brady's historical vision. Harvard University and the Chicago Historical Society house two such collections. Both of these collections were built by individuals with very distinct reasons for collecting.

Mathew Brady's photographs enabled the collectors to construct and illustrate their own personal interpretations of history. For Everet Jansen Wendell, Brady's photographs of prominent members of New York City's artistic community fed his

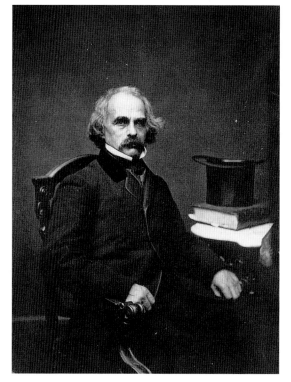

FIGURE 9–8

Nathaniel Hawthorne

Modern albumen silver print from collodion glass-plate negative, circa 1862.

National Portrait Gallery, Smithsonian Institution, Washington, D.C.

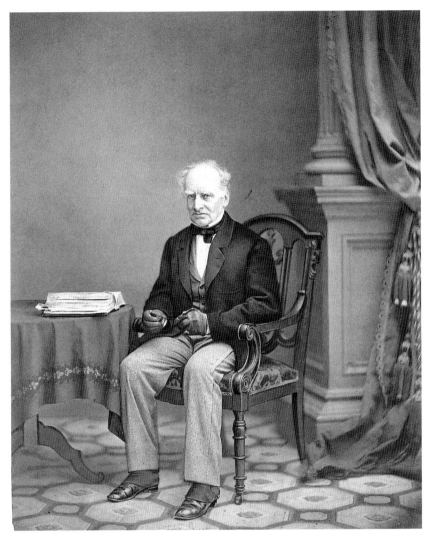

FIGURE 9–9

Dr. Emmett

Imperial salted-paper print,
circa 1859.

Fogg Art Museum, Harvard
University Art Museums,
Cambridge, Massachusetts, on
deposit from Harvard College
Library

zeal for American stage-related ephemera. Wendell, born in 1860 to a wealthy family, grew up in New York and graduated from Harvard in 1882. After college, Wendell became a full-time philanthropist and an ardent devotee of the theater. In the Harvard class report from 1907, Wendell described his collecting habits: "My principal hobby . . . had been the collection of memorabilia connected with the history of the American stage. . . . I think I can claim, with safety, that my collection of books, prints, photographs, playbills, autographs and daguerreotypes will compare favorably with any such collection in America." When Wendell died in 1917, he left part of his collection to Harvard [Figure 9–9]. This bequest consisted of more than 2 million items—among them 350,000 photographs.[59] The massive collection is today spread throughout several museums and libraries at Harvard. Wendell's assemblage of more than 400 Imperial-size photographic portraits (many embellished with ink or oil paint) of prominent New Yorkers is by far the largest extant body of Brady's work in this particular format.

Chicago's Charles F. Gunther shared Wendell's avocation for collecting. Gunther, born in 1837 in Germany, immigrated with his family to the United States at a very young age and grew up in Illinois. As a young man, Gunther made his career in the ice-packing business. In 1861, he moved south to accept a position with a prominent ice firm in Memphis, Tennessee, but his timing was unfortunate. The start of the Civil War cut off all trade, including ice shipping. Gunther eventually accepted a job as purser on a steamer in the service of the Confederate government. He spent the next year navigating the southern tributaries of the Mississippi, transporting Confederate troops and supplies.[60] The ship was captured and burned by the Union army in 1862, but as a civilian, Gunther was not imprisoned. He ultimately made his way to Chicago where, after some failed business attempts, he opened a very successful candy factory. It is unclear when Gunther began collecting, but by the early 1880s, patrons of his candy store could visit the second floor of his shop to view his curios from around the world and his Civil War memorabilia. In 1889, Gunther announced that he had purchased the old Libby Prison in Richmond, Virginia. The prison had formerly housed captured Union soldiers during the Civil War. Despite a nationwide flurry of negative publicity, Gunther had the prison dismantled stone by stone, shipped to Chicago, and rebuilt. Gunther grandly opened the prison in 1889 as a Civil War museum, housing his now-massive collection. In his 1972 article on Gunther, Clement Silvestro wrote that among the rooms "crowded with cases crammed full of

swords, bayonets, guns, uniforms, maps, newspapers, ammunition, camp equipment and shells" were por-
traits of Union and Confederate leaders.[61] The museum was successful and remained open until 1899,
when the structure was dismantled. Gunther continued to collect Civil War paraphernalia until his death
in February 1920. Because he had been a longtime associate and board member of the Chicago Historical
Society, Gunther's family arranged for the large collection to be partly donated and partly purchased by
the society. Today, it remains the backbone of the museum's collection. The Department of Photographs
at the Chicago Historical Society has dozens of Imperial and larger-size Brady-studio photographs of no-
table figures from the Civil War, primarily military and political, which had been collected by Gunther and
had probably decorated the walls of his Libby Prison [Figure 9–10].

FIGURE 9–10

Joseph Hooker

Imperial salted-paper print,
circa 1863.

Chicago Historical Society,
Illinois (ICHi-26738)

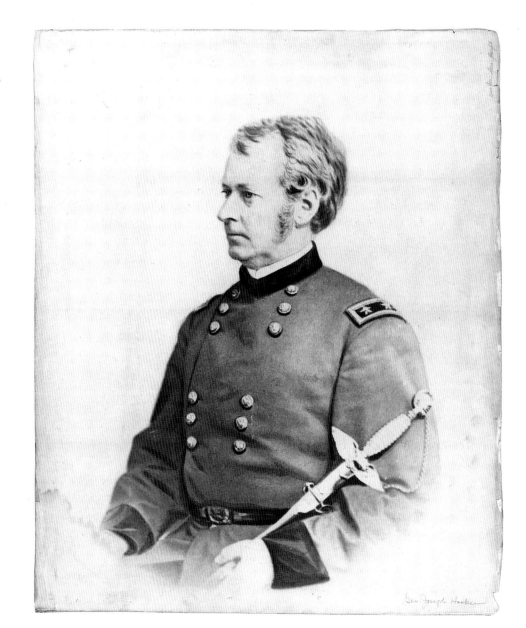

My greatest aim has been to advance the art [of photography] and to make it what I think I have, a great and truthful medium of history.[62]

<div align="right">MATHEW BRADY</div>

As objects, Mathew Brady's photographs had histories of their own. The photographs and negatives represented many different meanings for their subsequent owners. For Brady, every photograph his studio produced resulted from, and contributed to, his idea on how to successfully create art and history. Brady knew the didactic power of his photographs and always hoped that history would be remembered and written through the collection of photographs he created. Drawing the photographs together again, if only on the pages of a book or the walls of a museum, illuminates some small aspect of Mathew Brady's vision. Photography's fallible nature is proven here through the presence of photographs made mute by the absence of reliable history and the fading of memory. This project memorializes the remains of one man's desire to forge a photographic monument to a history that his nation, at times, felt was best forgotten. The effort is worthwhile as perhaps the only means of re-creating what has indeed become a fugitive testimony of history.

There is no collection like it in this country, nor in the world. . . . Once scattered, it could never be replaced.[63]

<div align="right">MATHEW BRADY</div>

NOTES

1. Horace Traubel, *With Walt Whitman in Camden*, 4 vols. (1907; reprint, New York, Rowman and Littlefield, 1961), vol. 3, p. 553.

2. Roland Barthes, *Camera Lucida: Reflections on Photography*, trans. Richard Howard (New York: Hill and Wang, 1981), p. 93.

3. Register, R. G. Dun & Co., New York Volume 368, p. 442, Baker Library, Graduate School of Business, Harvard University.

4. Kathleen Collins reports that Brady placed more than 6,000 negatives in storage in Washington. See Collins, *Washingtoniana Photographs: Collections in the Prints and Photographs Division of the Library of Congress* (Washington, D.C.: Library of Congress, 1989), p. 25.

5. Ibid., p. 178.

6. James D. Horan, *Mathew Brady, Historian with a Camera* (New York: Crown Publishers, 1955), p. 68; Josephine Cobb, "Mathew B. Brady's Photographic Gallery in Washington," *Records of the Columbia Historical Society* (1953–1956): 35.

7. A. W. Greely, "Subject Catalog No. 5, List of the Photographic Negatives Relating to the War for the Union" (1897), p. 2, National Archives, RG 94, Office of the Adjutant General Document File, Box 4944.

8. William and Estelle Marder, *Anthony: The Man, the Company, the Cameras: An American Photographic Pioneer* (Amesbury, Mass.: Pine Ridge Publishing Co., 1982), p. 178.

9. According to a letter from Secretary of War William Belknap to the Judge Advocate General dated April 9, 1875, "McEntee had purchased [the negatives] at a sale of the assignee in bankruptcy under a decree of bankruptcy court . . . and was very anxious to dispose of them" (National Archives, RG 94, Box 4944). See also Greely, "Subject Catalog," p. 2.

10. Barnard to Belknap, November 1874, National Archives, RG 94.

11. Barnard's account is in the National Archives, RG 94, Box 4944.

12. Record 1906158, National Archives, RG 94, Box 4944. The letter is written on stationery from 785 Broadway, New York City. Brady had lost his gallery at this address by this time due to bankruptcy.

13. Garfield to Belknap, February 18, 1875, National Archives, record 1906158, RG 94, Box 4944.

14. *Congressional Record*, March 3, 1875, p. 2250.

15. National Archives, RG 94, Box 4944.

16. Both letters can be found in the National Archives, RG 94, Box 4944.

17. Secretary of War William Belknap to Charles Gerding, August 25, 1875, National Archives, RG 94, Box 4944.

18. William Barnard to the second comptroller of the Treasury, October 15, 1875, National Archives, RG 107, Office of the Secretary of War, Registered Letters Received, Box 168.

19. Greely, "Subject Catalog," p. 4.

20. When the Brady negatives were part of the War Department Library, the United States Army Signal Corps would have been the logical choice for printing them. The Signal Corps was established in 1860 to provide signal communication services. As the corps evolved, the scope of its responsibilities was widened to include all aspects of observation, from photography to weather reporting. The field units of the corps are organized by function, so that some divisions expressly provide photographic services to the army. However, as Brigadier General Greely's internal report notes, the corps laboratory facilities were not adequately outfitted for that task.

21. Nick Natanson, curatorial report on Record Group 165-ALB, 1992, p. 11, Still Pictures Branch, National Archives.

22. Smillie eventually became the Smithsonian Institution's photographer.

23. Documents related to the loan are in Secretary of War, Register of Letters Received, National Archives, RG 107, Box 168.

24. The government would sometimes allow other organizations to make prints from its negatives—such as the Smithsonian Institution in 1888 (see letter, Smithsonian Secretary S. P. Langley to the secretary of war, February 15, 1888, National Archives, RG 107, Box 168). Private citizens were usually denied the privilege.

25. Secretary of War Robert Lincoln to Colonel A. F. Stevenson of Chicago, Illinois, January 28, 1885, National Archives RG 107, Box 168. Stevenson—of the Loyal Legion of Illinois—had written to Lin-

coln asking if it was possible to obtain prints from the government's Brady negatives for less than the $1,200 quoted by the Massachusetts Loyal Legion. Lincoln responded that Stevenson could obtain cheaper prints by purchasing them directly from the photographer currently contracted by the government to print the Brady negatives—at that time, J. F. Jarvis.

26. Jarvis to secretary of war, December 1884, National Archives RG 107, Box 168.

27. Scott to Lincoln, April 1885, National Archives, RG 107, Box 168.

28. Greely, "Subject Catalog," p. 7.

29. Natanson, curatorial report, National Archives.

30. National Archives, RG 107, Box 168.

31. Part of the bound volumes arrived at the National Archives from the War Department in 1950 and the rest in 1966.

32. Greely, "Subject Catalog," p. 10.

33. Paul Vanderbilt, *Guide to the Special Collections of Prints and Photographs in the Library of Congress* (Washington, D.C.: Library of Congress, 1955), p. 18.

34. The National Archives maintains a file of prints from the Brady negatives made in the 1920s. The prints are mounted on cards with the negative number and subject indicated. This file is available for public use in the Still Pictures Division Reference Room at College Park, Maryland.

35. Marder, *Anthony*, p. 178.

36. Vanderbilt, *Guide to the Special Collections*, p. 20.

37. Anthony published war views taken by Brady's staff, as well as by other photographers, such as Alexander Gardner, Timothy O'Sullivan, and James Gibson, in the same series. A credit line appeared on the stereo card listing Anthony as publisher and usually an attribution for the image (such as "Negative by Brady & Co, Washington"). If Anthony had purchased negatives from lesser-known field photographers, their names would often not be listed. At the same time, Brady commonly acquired negatives from itinerant photographers and appended his name to them.

38. Marder, *Anthony*, p. 179.

39. Vanderbilt, *Guide to the Special Collections*, p. 21.

40. From records located in the files of the secretary of war, National Archives, RG 107, Box 168.

41. Ordway to Scott, July 3, 1886, National Archives, RG 107, Box 168.

42. Secretary of War William Endicott to Hon. Joseph R. Hawley of the U.S. Senate Committee on Military Affairs, July 15, 1886, National Archives, RG 107, Box 168.

43. Vanderbilt, *Guide to the Special Collections*, p. 79.

44. Ibid., p. 79.

45. Ibid., p. 21.

46. Other publications by Patriot Publishing illustrated with the Brady negatives include: *Photographing the Civil War* by Henry Lanier (1911); *The Civil War through the Camera* by Francis T. Miller (1912); *Gettysburg: A Journey to America's Greatest Battleground* by Miller (1913); and a series of articles about the Civil War printed in the *Review of Reviews Magazine* throughout 1911.

47. Vanderbilt, *Guide to the Special Collections*, p. 22.

48. George Sullivan, *Mathew Brady: His Life and Photographs* (New York: Cobblehill Books, 1994), p. 23.

49. Vanderbilt, *Guide to the Special Collections*, p. 22.

50. Levin Handy, Mathew Brady's nephew, who often provided photographic services for the Library of Congress, printed these photographs (Collins, *Washingtoniana Photographs*, p. 37).

51. Records indicate that the daguerreotypes were transferred from the War Department to the Library of Congress because they had no military value. The acquisition is listed in the 1920 Library of Congress Annual Report, p. 17.

52. Levin Handy, nephew of Brady's wife Juliette, apprenticed in Brady's Washington gallery around 1870. By 1872, Handy had opened his own photography studio in Washington. Handy and his partner Samuel Chester became associates with Brady during the 1880s and shared gallery space. When Brady died in 1896, Handy was his only heir. Handy became a well-known photographer in Washington. He had a long relationship with the Library of Congress, photographically documenting the construction of the Library's Jefferson Building and serving as the library's only photoduplicator for many years (Collins, *Washingtoniana Photographs*, p. 27). Handy died in 1932.

53. Susan M. Barger, Condition Survey: Daguerreotype Collection, Library of Congress, conducted November–December 1985, p. 33, Library of Congress.

54. Hirst D. Milhollen, "The Mathew B. Brady Collection," *A Century of Photographs, 1846–1946* (Washington, D.C.: Library of Congress, 1980), p. 46.

55. See correspondence of Captain Montgomery C. Meigs among the records of the Office of the Architect of the Capitol. The letter is fully reproduced in Josephine Cobb's article on Alexander Gardner in *Image* 7 (June 1958): 124–36.

56. Cobb, "Brady's Photographic Gallery," *Records of the Columbia Historical Society* (1953–1956): 22.

57. Ibid.

58. Frederick H. Meserve, "My Experience in Collecting Historical Photographs and How That Lifetime Adventure Led to Great Friendship," *Lincoln Herald* 56, no. 1–2 (1954): 10.

59. From an article on Wendell in the *Boston Transcript*, October 14, 1919.

60. Clement Silvestro, "The Candy Man's Mixed Bag," *Chicago History* 11, no. 2 (fall 1972): 87.

61. Ibid., p. 89.

62. "Faces of Great Men: An Endeavor to Establish a Gallery of Portraits in This City," *Washington Post*, December 18, 1889. Thanks to Paula Fleming of the National Museum of Natural History for passing along this newspaper clipping.

63. Ibid.

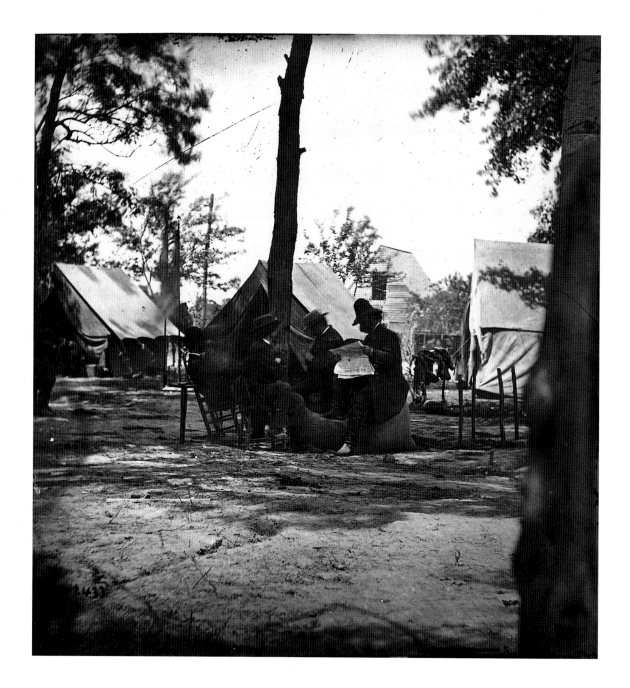

Appendix

M. B. BRADY AND THE PHOTOGRAPHIC ART
C. EDWARDS LESTER
The Photographic Art Journal 1 (1851): 36–40

The Daguerreotype has now assumed a permanent position among the arts of taste and utility. What was but twelve years ago, regarded as an accidental discovery, which excited the surprise and admiration of mankind, has since been brought, by various stages of progress, to a degree of perfection, which numbers it among the exquisite embellishments of life. It is well known to many of our readers, and they may all adopt it as an assertion which will no longer be disputed, that the Art has been elevated to a higher point in this country, than in the land of its discovery. And, although it is claimed by Daguerre himself, and his disciples on the Continent, that the superiority of our pictures is to be attributed more to the brilliancy of our atmosphere, than to our mechanical and artistic genius; yet, we are compelled to meet the assumption by an argument which cannot be answered, namely, that our own artists in Europe, carrying with them the recent inventions and improvements in the Daguerrean art, made on this side of the Atlantic, have been able to distance all competition, when they have had occasion to test their cleverness, with the artists of the Old World.

In the progress of this Journal, which has been established mainly for the purpose of tracing the development of the Daguerrean Art in this country, we shall have frequent occasions to make honorable mention of those men who have, from time to time, contributed to its progress. We shall begin at the fountain-head, and open our first records, with some account of the eminent artist who stands at the head of this column and whose portrait we have had engraved for our first embellishment.

Matthew B. Brady, who is now about thirty years of age, has devoted his life chiefly to the cultivation of the arts of taste and design. During his early life, he became extremely attached to Mr. William Page, the celebrated painter, who is now on a visit to Italy; and during his frequent visits to the studio of the painter, received many ideas of art, and tokens of esteem from him with a number of drawings, which he still preserves as mementos of his friend, and of his own youthful admiration for art.

When the announcement was made in this country, in 1839, that the wonderful discovery of Daguerre had been made; Mr. Brady felt a deep interest in it, and embraced the first opportunities which lay in his power, of acquiring a knowledge on the subject. Although there was, at the time, considerable incredulity in the Unites States, and it was generally doubted if the alleged discovery of Daguerre could be brought to perfection, and be numbered among the useful arts, yet the fact that the announcement had been made had excited an interest in the mind of the subject of this sketch, which has increased till the present time. His belief in the genuineness and utility of the discovery, was confirmed by the interest which was manifested in it by such men as Professors Draper, Morse, Chilton, Avery, and many others, who, being well known for their scientific attainments, were not likely to be betrayed by a pretended art, which was not based upon principles of science and of nature.

Availing himself of the first chance that came to hand, he got possession of a Daguerrean apparatus, and began experiments. Gifted with a warm, intuitive perception in such matters, and having already had a good deal of practical

Ambrose Burnside and
Mathew Brady

Albumen silver print, circa
1864.

Library of Congress,
Washington, D.C.

experience in mechanical and artistic experiments, he at once undertook a series of them for himself, which resulted so satisfactorily, that he resolved to adopt the art as his profession for life. He carried to the business a resolution which augured the success to which his subsequent and untiring exertions so fully entitled him. It has generally held true that those men who have risen to any considerable degree of eminence, in any calling or profession, have merited and acquired it, chiefly as the reward of long, resolute, and patient labors.

So far as the Daguerreotype art is concerned, we are not aware that any man has devoted himself to it with so much earnestness, or expended upon its development so much time and expense, as Mr. Brady. He has merited the eminence he has acquired; for, from the time he first began to devote himself to it, he has adhered to his early purpose with the firmest resolution, and the most unyielding tenacity. When Daguerreotypes were introduced into the United States, although many improvements were made within a short period, yet, by the public generally, they were regarded only as the results of a mechanical process, by which forms and impressions were left upon the plate, in which likenesses could be traced. They were satisfactory chiefly to persons of crude and uncultivated taste. In a word, they were destitute of every combination of what is usually understood by the word art, in connection with design. They were unsatisfactory in almost all respects, and artists of genius and reputation were, with few exceptions, unwilling to engage in the process. But Mr. Brady resolved to bring the Daguerreotype to perfection, and remove the prejudices which existed against it, by elevating it into the dignity and beauty of an art of taste.

Availing himself of everything that was published and known on the subject at the time, and seizing hold of every new discovery and improvement, he multiplied his facilities to such an extent, that he was soon able to produce pictures that were regarded as quite equal, if not superior, to all that had been made before. His first public exhibition was at the annual Fair of the American Institute, in 1844; and even at that early period, with many rivals in the field, he acquired the reputation of being one of the first artists in the country, and received a premium. Encouraged by his success, he made new efforts, which resulted in important improvements. While he offered inducements to the best operators and chemists to enter his studio, he superintended every process himself, and made himself master of every department of the art, sparing no pains or expense by which new effects could be introduced to increase the facilities or embellishments of the art. We do not know who was the first Daguerrean artist to introduce the sky-light, but Mr. Brady was among the first, and probably derived more immediate and decided advantages from it than any other man. There are several large sky-lights in his studio.

We might remark here, that the subject of light is the grand mystery into which the whole art of Daguerre resolves itself. Indeed it has now, by a long series of inventions and improvements, of which the original inventor never dreamed in the beginning, so changed its character, that it is fast assuming another name. Although it will forever shed lustre upon the name of Daguerre, it will soon be known in every part of the world, chiefly by the more euphonious title of Photography, which may be interpreted, *The Art of Light.* In the scale of advancement, many of the grades of progress have been regulated by chemical processes; but they all contemplated the action of light, and in the distribution of this subtle element, and the regulation of its force, the chiefest experiments have depended for their success. A vast amount of time and money has been expended in attempting to guide and control the action of light, but it has been to no purpose, and experiments have been rewarded by startling and beautiful discoveries, only when they have carried out the single idea, that, to bring the Daguerrean art to perfection, it was only necessary so to prepare the plate and screens, and regulate the lenses, in correspondence with the laws of light, that the invisible hand of Nature herself might, with her own cunning pencil, by her silent and mysterious operations, trace the forms of creation in all their delicacy, witchery, and power. More than any other of the arts of taste and design, here the work is done by Nature herself. With the painter, everything depends upon the genius that guides the hand. In Photography, everything depends upon the skill with which the elements are prepared to make way for the hand of Nature. And although in the ceaseless repetition of the Photographic process it might seem that the charm of the experiment would be lost in the monotony of its repetition, yet it has often occurred to us that none but a man of sensitiveness and of genius would ever have made the remark which Mr. Brady has so frequently expressed, that he has never, after upwards of twenty thousand experiments, grown so familiar with the process of Daguerreotyping, as not to feel a new and tremulous interest in every repeated result, when, after preparing his plate, he stepped aside to wait in silence for Nature to do her

work. There is nothing in the whole field of art or nature so impressive to a refined fancy or a sensitive spirit, as to watch and wait, with veneration and hope, to see how the eternal laws of nature shall recognize in our new experiments, some progress in that wisdom which will never grow into perfection, since nature, in her ingenuity, forever eludes and surpasses the genius of man.

We believe that, from the beginning, Mr. Brady's sky-lights have been so perfectly arranged, that his great success in the new experiments he has undertaken, can be attributed in no small degree to this circumstance. He has now reached such a stage in the art, that it seems to make little difference with him what the state of the atmosphere or light may be, since his lenses are so powerful, his camera obscuras are so numerous and varied, and the light shed upon the picture seems to be so entirely under his control, some of his finest pictures that we have seen, have been taken in the darkest and stormiest days.

In the early part of 1845, he formed the project of collecting all the portraits of distinguished individuals he could induce to sit for that purpose, with the intention, if his life was spared, of making in the end a more complete collection than had ever before been made, of the distinguished men of the nation. In 1845, he exhibited his pictures again before the American Institute, and received one of the first prizes for the best plain and colored Daguerreotypes. Artists of every description now generally awarded to him a high position and the most distinguished and discriminating of the journals of New York complimented him in the warmest terms on his superior skill and taste. In 1846, he again went to the annual exhibition of the Institute, with new specimens of his art, and contending with competitors from Boston, Philadelphia, Albany, New York, and other cities, he gained the highest prize.

Having now accomplished, in this respect, the highest of his ambition, he devoted himself with more earnestness to the carrying out of his favorite project, viz., to augment the number of his national collection, and embellish it with still rarer and choicer portraits. He visited the seat of Government, and opened a branch of his establishment there, where he was treated with courtesy and attention by the most distinguished men. We believe he is the only Daguerreotypist in America who has been honored by a visit at his studio from the President, and his Cabinet. Mr. Polk and all the heads of departments; General Taylor and His Cabinet, with the new President and most of his Cabinet, have given him sittings at his Gallery, and at the President's mansion. In 1849, he brought out his large picture of General Taylor and his Cabinet, which won for Mr. Brady no little honor; since it was the first work of the kind published in this country. With a branch of his studio in Washington, he has obtained the portrait of almost every man of distinction among our countrymen, and those of ambassadors and celebrated men from foreign nations. Senators, Members of the House of Representatives, Judges of the Supreme Court, distinguished diplomatists and visitors, with the most distinguished men of the army, of the navy, and the learned and liberal professions of every description, with those of the President's Lady, and other distinguished women, now adorn his collection.

In the year 1849, he made his last exhibition before the Institute, and his pictures were regarded as so far superior to all others, that there was awarded to him the first and only gold medal ever given to Daguerreotypes in this country.

The mere enumeration of the distinguished names which adorn his collection would occupy a larger space than we can devote even to the purpose of this sketch. Among them, however, we will enumerate General Jackson, John Quincy Adams, Mr. Tyler, Mr. Van Buren, Mr. Polk, Gen. Taylor, Mr. Fillmore, with every member, we believe, of their Cabinets, Webster, Clay, Calhoun, Benton, Cass, Foote, Fremont, Dickinson, and every member of the U. S. Senate, for a considerable number of years past; all the Judges of the Supreme Court, most of the members of the lower House of Congress, nearly all the foreign ambassadors, the generals of the army, the commodores of the navy, the governors of states, and nearly all those men who have acquired influence in the departments of literature, science, and public life. We should be glad to specify, if we could, some of these portraits, upon which we have looked with the deepest interest, and we should instance among them those of the venerable Mrs. Alexander Hamilton, Mrs. Madison, Mrs. Polk, &c.; but those we should speak of more particularly, are J. C. Calhoun and General Taylor. These, with others which have been engraved for the *Gallery of Illustrious Americans*, are not only superior to all that ever have been taken in this country by other artists, but they are probably the best which Mr. Brady has taken himself. The one of Mr. Calhoun was the last ever taken of that illustrious Senator. So perfect was it regarded by the family, that several copies of it have been made at their request, as also in the case of General Taylor, of whom the same remark may be made.

This gives us an occasion to speak of the most magnificent publication which has ever been brought out in this country, and which has seldom been equalled, and never surpassed, in the Old World; for Mr. Brady is one of the proprietors of the *Gallery of Illustrious Americans*. This great work was regarded in the beginning as an enterprize too formidable to excite the interest of any American publisher, and in the successful accomplishment of it more genius and exertion have been called into requisition than have ever been displayed in any other American work. It has given to Mr. Brady, as an artist in the Daguerreotype, a reputation which belongs to no other man. There had been National Galleries undertaken before this, but they had either failed for lack of encouragement, or been abandoned mid-way in their progress; or if completed, the portraits themselves had been copied from unsatisfactory paintings, in which few traces could be discovered of resemblance to their originals. Hence the mere announcement that another National Gallery was begun, failed to excite that interest which was soon after manifested in that enterprize. We would not wish to be understood as using unkind or ungenerous language towards those men who attempted to furnish the nation with works of this class; for, before the Daguerrean art was discovered, it is all useless to say that it was within the power of any publisher in the world, or any artist in the world, to execute such faithful, life-like, and strikingly beautiful portraits of our public men. At best, the engravings had to be made from drawings and portraits, executed for the most part by artists of no great talent, and where the original paintings were, as a rule, so unsatisfactory, it could not be supposed that engravers, who had generally never seen the subjects of the painting, could be expected to trace the likenesses with much facility, much less to infuse into their transfers the vital energy and living truth which are so conspicuous in works that are produced in our times. It will not be disputed that such a work as the *Gallery of Illustrious Americans* could not have been made before the art of Daguerre was discovered. Who, for instance, could measure the value of a collection of faithful Daguerreotypes, if they were only in existence, of the Fathers of the Republic. True, Stuart, Trumbull, and other celebrated portrait painters, did their best to transmit to us the forms of those venerable founders of our empire, and in some instances they were undoubtedly fortunate or skillful enough to seize with some degree of accuracy upon the features, and in a few cases probably, to transmit to us the prevailing expression of the countenance, but we have, after all, no idea, with all the services these artists rendered to the nation by their labors, that we are at this period familiar with the habitual characteristic expression worn in the cabinet, in the field, and around the fire-side, by the patriarchs of the Revolution.

We would not depreciate any of the arts, and least of all the art of painting to which the world was indebted almost exclusively, for a knowledge of the faces and the forms of great men until the time of Daguerre; but we do rejoice that in our age, facilities exist by this new art, which will make posterity as familiar with the faces and forms of distinguished men, as are their own contemporaries.

The first part of the Gallery of Illustrious Americans being now complete, and embracing as it does the portraits and biographical sketches of twelve of our most illustrious citizens, may well afford occasion for these brief remarks in reference to the artist to whom the world is indebted for these remarkable portraits from which they have been engraved. There is about them a naturalness of flesh tint, and the extreme fidelity with which the prevailing expression of the face and the distinguishing hue of the complexion are brought out. In Mr. Calhoun's portrait, for instance, we find a nearer counterpart to that great man's countenance than almost any thing we ever saw, either in oil, or in Daguerreotype. There is depth, and earnestness and intensity, and spiritualism, which eminently distinguish him from almost any other men, and which drew from the more critical of our journals the expression that "his face looked more like that of a saint than of an ordinary man." But these remarks are applicable to all the other portraits which have been engraved for the Gallery of Illustrious Americans. In only one instance out of the twelve portraits, can we conceive it possible that the likeness could be improved. They were all taken expressly for this Gallery, and in doing so Mr. Brady brought out the fullest capability of the Daguerrean art. So perfect have these likenesses been regarded, that there have been requests proffered from families, from societies, from publishers and engravers, and even from the committees of both Houses of Congress, as in the case of General Taylor, for permission to copy them in getting up memorials of those distinguished men after their death.

Before closing this brief sketch, however, we should remark that Mr. Brady's best improvement in the Photogenic art has been the production of miniatures on ivory which combine all the truthfulness and extreme fidelity of the fin-

ished Daguerreotype with the exquisite coloring of the final miniatures. It is a progressive art, as we believe that Mr. Brady himself still regards it, with all these improvements, only in its infancy. We may adopt this idea and say that we too believe it, because we are told so by the artist himself; but those of our readers who will visit Mr. Brady's Gallery, and look upon those oil colored Daguerrean miniatures, will probably find as much difficulty as we do ourselves in imagining a higher degree of perfection in which the art will ever be carried.

STANZAS

SUGGESTED BY A VISIT TO BRADY'S
PORTRAIT GALLERY
The Photographic Art Journal 1 (1851): 63

Soul-lit shadows now around me;
 They who armies nobly led;
They who make a nation's glory
 While they're living—when they're dead,
Land-marks for our country's future,
 Have their genius left behind;
Victors from the field of battle;
 Victors from the field of mind—

Doniphan, who trod the desert;
 Scott, who conquered on the plain;
Taylor, who would not surrender;
 Butler, sleeping with the slain;
Houston, San Jacinto's hero;
 Fremont, from the Golden shore;
Jackson, as a lion, fearless;
 Worth, whose gallant deeds are o'er—

Webster, with a brow Titanic;
 Calhoun's eagle look of old;
Benton, freedom's valiant Nestor;
 Kent, the jurist, calm and cold;
Clay, "ultimus Romanorum;"
 Cass, with deep and earnest gaze;
Wright, of yore the Senate's Cato;
 Adams, last of early days—

Pere de Schmidt, the Jesuit preacher,
 From the Rocky Mountains wild;
Tyng, Melancthon of the pulpit;
 Channing, guileless as a child;
Barnes, who pondrous themes has written;
 Bascom's eye, a gleaming bright;
Anthon, whose unceasing labor
 Fills the student's path with light—

Audubon, from out the forest;
 Prescott, from historic page;
Bryant, pilgrim of our poets;
 Forrest, vet'ran of the stage;
Inman, looking palely thoughtful;
 Huntington, with dreams of art;
Father Mathew, mild, benignant;
 Jenny Lind, who wins the heart.

Lawrence, type of merchant princes;
 Colt, of our mechanic peers;
Emerson, of Yankee notions;
 Miller, of our Scripture seers;
Mott, the hero of the scalpel;
 Cooper, wizzard of the pen;
Flagg, the glorious painter poet;
 Powers, of arts own nobleman—

From the hills and from the valleys,
 They are gathered far and near,—
From the Rio Grande's waters,
 To Arroostook's mountain drear,—
From the rough Atlantic's billows,
 To the calm Pacific's tide,
Soldier, statesman, poet, painter,
 Priest and Rabbi, side by side.

Like a spirit land of shadows
 They in silence on me gaze,
And I feel my heart is beating
 With the pulse of other days;
And I ask what great magician
 Conjured forms like these afar?
Echo answers, 'tis the sunshine,
 By its alchymist Daguerre—

Caleb Lyon, of Lyondale
Broadway, Dec. 12, 1850

M. B. BRADY

PHRENOLOGICAL CHARACTER AND BIOGRAPHY

American Phrenological Journal, Vol. XXVII, No. 5, May 1858

PHRENOLOGICAL CHARACTER

You have a temperament indicating a high degree of the mental or nervous, in conjunction with a wiry toughness of body, indicative of great propelling power and physical energy and activity. These conditions combined, produce intensity of emotion, depth and strength of feeling, and a disposition to be continually employed. You are living too much on your nerves, and need a great amount of sleep to recuperate your constitution, and to quiet your brain and nervous system; but you are tough, and will wear a long time, provided you take ordinary care of yourself.

Your brain is unusually large for such a body, and therefore you should guard against the use of everything calculated to chafe the nervous system and excite the brain, such as coffee, tobacco, alcoholic liquors, and also the common irritating condiments of the table. In addition to this, if you can secure eight hours of sleep in the twenty-four, you will find it greatly to your advantage.

The development of your brain indicates a great amount of force of character. You are a natural worker, and you would be truly miserable if placed where you had nothing to do. You like to meet and overcome difficulties, and ought to have been engaged in civil engineering, building railroads, navigating ships, or in some other way wrestling with the world's difficult enterprises. You have astonishing Firmness. It would seem that for all your life long you had been overcoming obstacles and bearing heavy responsibilities. Opposition is almost a luxury to you, and to meet and master obstacles and conquer impediments a mere pastime. It is utterly useless to try to force you to do anything against your will. You can not and will not be driven by your peers, though you can be persuaded by sympathy and friendship to go almost any length, and to sacrifice almost any amount of convenience or ease to confer a favor.

You have large Self-Esteem, which gives great self-reliance, disposition to trust to your own judgment, to rely upon your own resources, and take responsibilities. Firmness and Self-Esteem appear to have been greatly increased by use, for they stand out sharply beyond the other organs.

Your sense of duty appears to be strongly marked; and when your idea of honor, your will, your sense of reputation, and your integrity are at stake, you will do and suffer vastly to achieve what you know is right, and to crush out the wrong. If you think that a man is true to you and really honest, you can put up with ignorance, carelessness, want of capacity, and a variety of other unpleasant things, just because of his fidelity; but if a man is treacherous, and indicates a disposition to be an eye-servant, you bear but little, and rid yourself of him as soon as possible.

You have very strong friendships, and very great aversions. You like and dislike in the extreme and, for a friend you will go through fire and water; and if an enemy pursues you, you would run almost any personal or pecuniary hazard to punish him, or at least to repel his aggressions. You are a man of high temper, of real bravery, but not possessed of a malignant, revengeful spirit. Your anger is mostly made up of powder without the ball, and if you were to injure a man in anger, except it were in an extreme case of self-defense, no person would regret it more sincerely than yourself; but so long as the enemy's flag is flying, you have no idea of giving or taking quarter.

You love home devotedly. Nothing would give you more pleasure than to own a nice situation on the Hudson. Every vine, and every shrub and tree would seem to have a heart and soul beating in harmony with your own, and with these you would seem to take root in the soil.

You love children, and are a fervent friend, and capable of being an ardent, affectionate husband.

Your Constructiveness and Ideality, joined with Order and Calculation, appear to be enormously developed, as seen in that great ridge running upward and backward from the external angle of the brow. We rarely find Ideality so large; and Constructiveness seems wedded to it, as if your mind had been in an artistic and mechanical study and labor for years, and, moreover, as if it were natural for it to be so.

You are continually studying some new and beautiful design; and if you were a worker in marble or a painter, your reputation would be achieved through the talent to devise new patterns and work out original ideas. You are a natural

inventor, and had you been trained up as a mechanical engineer, you would doubtless have achieved high success as a inventor.

You have a full development of Imitation, and can copy well, but prefer to work right from the judgment or by the eye—to make new tracks rather than to follow old ones.

Another peculiarity of your organization is the immense development of the perceptive group of organs. Individuality or Observation just above the root of the nose, Form which gives width between the eyes, and Size and Weight which give a kind of frowning appearance, together with Locality, are all remarkably large. You see everything that comes in sight, and remember forms remarkably well, also distances, outlines, and dimensions. You study attitudes successfully, and as an artist would show skill in that particular. Order, as seen in the prominence of the external angle of the brow, is also large, making you fastidious in respect to arrangement, while your great Ideality gives you such a sense of the perfect of what is tasteful and stylish, that your feelings in this respect are almost painful to yourself; and even when you get things just as you want them, the exhilaration in your mind incident thereto is of such an extreme character, that it is hardly pleasurable. Few men are as highly pleased as you with that which is gratifying to your faculties, and few, indeed, are so deeply exasperated when things are wrong. This all grows out of—first, your large brain; second, your nervous excitability; and third, the sharpness and activity of those large organs which give perception and criticism.

Your memory of faces is first-rate, of places and outlines good, of dates, names, and of immaterial facts deficient. You love to read and study mind, and are rarely at fault in your first impressions of strangers. You like to read biographies and travels, in which action and character make up the chief attributes.

You have strong sympathy, and this joined with your friendship makes your character quite bland under certain circumstances; but you have had your mind screwed up to the laboring point so long, that it has become rather angular, and it is less easy to please you and keep you in good temper than it was formerly.

Your Veneration is subservient in its influences, and your respect for others depends upon ascertained merits, real achievement, and the power to do, rather than upon the common fame of the world in respect to them. Your religious feelings are shown more through benevolence than through devoutness. You have a kind of spirituality of mind which often leads you out of the region of the material, and gives, as it were, a foretaste of the inner and higher life, but you rarely attain to this state of mind through the action of your Veneration. Your imagination, faith, and sympathy constitute the only Jacob's ladder on which you climb.

Your forehead appears retreating, not because it is small in the upper part, or region of the reasoning organs, but because it is so very large in perceptive development just over the eyes.

Your sense of property is subservient. If you had a fixed income or annuity beyond the reach of mutation, you would like to work and make money to use in making experiments and in gaining knowledge. You value money solely for its uses—not to hoard it in a miserly manner. If you had been one of the British nobility, with a fortune and an education, you would have been likely to devote yourself to the culture of art and literature and science, as a source of mere gratification; and if you were removed from the idea or possibility of want, so that you could revel in the luxury of experiments and art, of science, literature, and travel, you would feel that heaven was almost begun.

You are working too hard, and wearing out your constitution. You should husband your powers, take life more easily, that you may retain your health and prolong your life to a good old age.

BIOGRAPHY

Matthew B. Brady, the world-renowned disciple of Daguerre, is a native of the northern part of the State of New York, and is now about forty years of age.

When a mere lad he was attacked with a violent inflammation of the eyes, and came near losing his sight. This misfortune, combined with an indomitable spirit of self-reliance and enterprise, induced his parents to send him from home for medical treatment.

He first came to Albany, where he made the acquaintance of Paige, the eminent artist, who soon became his warm friend, affording him aid and encouragement.

About this time the discovery of Daguerre having been introduced into this country, Mr. Brady decided to devote himself to the practice and development of the new art, and, if possible, to win a name and fortune as an operator and an artist—a resolve which he at once, with characteristic energy and intelligence, commenced to carry into effect. He learned the process, and familiarized himself with the chemical and artistic knowledge required to produce daguerreotype pictures, and soon was able to accomplish wonders in his new field of endeavor.

He shortly after came to this city and opened a gallery, which was soon extended and enlarged to meet the requirements of a large and rapidly increasing business. His popularity and success were established in a very short time, and Brady's Gallery became one of the permanent institutions of our city, and a center of attraction for the resident lovers of the beautiful in art, and for strangers visiting the city.

He early formed a plan for a National Gallery of Portraiture, which should be more complete than anything of the kind in the world.

In connection with this purpose Mr. Brady established a gallery at Washington, and visited Europe, where he received marked attention, and was recognized as the Daguerre of America.

In 1851, at the great World's Fair in London, Mr. Brady was an exhibitor, and carried off the highest award, thus establishing a supremacy which he has since maintained against the most determined spirit of competition.

With the introduction of the ambrotype and photograph he has won a distinctive reputation. Brady's imperial photographs have become a national feature in art, and are spoken of by the highest authorities with the respect due to the most celebrated fine-art creations.

He has recently reopened his gallery at Washington, which had been closed for some time.

He has also commenced, in this city, a splendid Gallery of Imperial Photograph Portraits of Distinguished Clergymen and Pulpit Orators, which excites universal admiration, and has added a most interesting and attractive feature to his unequaled establishment.

The last great success achieved by Mr. Brady in his art surpasses all previous conception of the possibilities of production. Single portraits and groups are taken life-size, with an accuracy, boldness, and perfection of naturalness never before attained.

Mr. Brady's name has become inseparably associated with the development and application of the Daguerrean process in this country, and its history could not be written disconnected from his name, labors, and numerous successful applications of the art to practical uses.

Few men have more vividly impressed individual traits upon a profession; few have ever illustrated any pursuit more brilliantly. His experience has been one of uninterrupted success, and in his hands a process, in itself mechanical, has become a plastic and graceful art, varied in its effects and almost infinite in its susceptibilities, exerting a revolutionary influence upon general art, culture, and taste.

The difficulties which surround the *introduction* and *application* of a new discovery are known only to those who have encountered them. Effects alone impress the popular mind, their complicate pluses being usually lost sight of. Thus while many have participated in the surprise and satisfaction occasioned by the remarkable development of this and kindred discoveries, few have recognized it as the result of combined energy, enterprise, and ingenuity.

The theory of Daguerre was of so startling a nature as to repel general faith in its practicability, and until its assumption by Mr. Brady, no effort commensurate with its importance was made to establish its utility.

Convinced from the first that it embodied the germ of a new and unique art; that it promised to fulfill an important social and esthetic use, he devoted himself to its development with a zeal to which his present exalted position and that of the discovery bear ample and honorable witness.

Improved instrumental appliances, free galleries, and various chemical and optical experiments were gradually productive of a result which soon attracted attention and affirmed decisively the soundness of Mr. Brady's judgment and the success and immense value of the discovery.

Brady's Gallery of National Portraiture, numbering more than six thousand specimens, surpasses in cotemporary [*sic*] interest and historic value any of a similar character in the world.

All of that Titanic race which has covered the present century with renown; all who have added to the art-wealth of the age, or augmented its lettered glory, or aided its material advancement, are embodied in this magnificent collection; and a new grace is lent to the art, a historic dignity imparted to the effort, that thus concentrates and embodies from life the greatness of an era.

Of the millions of engraved portraits issued during the last fifteen years by the publishers of this country, more, than from any other, have been executed from originals derived from Brady's Gallery, thus adding a universal recognition of the skill with which he has rendered the camera auxiliary to the art of the engraver.

Several works, among which the "Gallery of Illustrious Americans," a work unsurpassed in magnitude or symmetry of design, have been issued from his establishment.

In applying the camera to scientific illustrations of all kinds, Mr. Brady has rendered the most efficient aid to the cause of letters, and has given a greatly accelerated impulse to the introduction of illustrated periodical literature, which has become so marked a feature in the history of the times.

Few men among us who have attained great eminence and success in business pursuits are more deservedly popular than Mr. Brady, from claims purely personal; for none can be more distinguished for urbanity and geniality of manners, and an untiring attention to the feelings and happiness of those with whom he comes in contact. From this cause, as well as from the extraordinary character of his artistic creations, has Brady's Gallery ever been recognized by the most distinguished families in the country as a fashionable and popular resort; while thousands have come and gone bearing away a new sense of beauty, with treasured specimens of art reflecting the features of loved and cherished ones.

Mr. Brady, like all men who have impressed themselves with a powerful originality upon an age prolific in such characters, is a self-made man, and owes his present exalted position and remarkable artistic and business success mainly to his own unaided efforts and devotion to a high conviction and purpose.

BRADY'S GALLERY IN NEW YORK
The Photographic and Fine Art Journal (December 1858): 378–79. From the *New York Daily Times*

No feeling is more common everywhere than a desire to see great or famous people. In Europe, everybody turns out to see a victorious general; many will go far to catch a glimpse at a great statesman or a famous dancer, and there is a perfect mania for a glimpse of the cocked hat or bonnet of a reigning sovereign. In this country we carry the passion a great deal further, and with more reason. We rush in crowds to see a man who has distinguished himself on the field of battle or in the councils of the nation, and we are content to wait an hour for the satisfaction of taking such an individual by the hand. The reason is obvious: The popular mind loves the uncommon and when the uncommon is also admirable, the popular love is apt to merge into popular adoration—which is that unwise extreme of veneration known as hero-worship, for which Americans are said to be peculiarly distinguished. For ourselves, we do not care to be hero-worshipers. It is an unstable and very variable sort of passion, which we would be the last to encourage. But we confess that, in common with all the world and his estimable brother, we do like to scan the features of men whose talent has commanded for them a high position in the respect of their countrymen.

It is not, however, always possible to see many great men together; but as it is quite easy to see their portraits, which answer the purpose almost as well as the originals, we went to Brady's Gallery in Broadway a few days ago, expressly to pass an hour in an inspection of the features of the numerous people of note whom Brady keeps "hung up" in photograph. We found the amusement agreeable. It is pleasant, after reading what Senator Hale said to look at the features of the man who said it. When we hear that Senator Mason has been pitching into Senator Seward, it is agreeable to inspect the features, in a state of placidity, of the two belligerents. So, also, when we learn that the President

has been doing something tricky and evasive, it is not bad to have one's surprise immediately removed by a glance at the corresponding expression of features in the portrait of that venerable man. For the President is there—at Brady's—and almost opposite to the master stands the man, in the person of James Gordon Bennett, whose pleasant features excite, in the portrait, the same sensations of doubt suggested by the inspection of the original, as to the actual direction of his visual orbs. Our affectionate Brother Greeley is also there, the malicious photographer having placed him side by side with *his* affectionate Brother Bennett, just mentioned. Brother Raymond is also in the collection, and faithfully rendered, to the last hair of his moustache. We sought in vain for Brother Webb, who begins to appear in plaster with great frequency as a sign for image makers in the side street; he shines not at Brady's.

The most striking picture now in the Gallery is that of John C. Calhoun, a half-length portrait, photographed, life-size, from a daguerreotype minature [*sic*], and finished in oil. It is a beautiful piece of work, and wonderfully life-like. The ragged, wiry character of the face marking nervous energy,—the overhanging brow and broad intellectual development,—all mark Calhoun at a glance. We found, Mr. Speaker Orr—a right proper, staid sort of gentleman, with an expression of countenance speaking loudly of red tape. Then we have the high and mighty General Lewis Cass, Secretary of State, &, &, &, with the peculiar, "shut up" cast of countenance, which belongs to the high and mighty diplomatist. Mr. Breckenridge, the Vice-President, occupies a prominent place in the gallery—gentlemanly but rather disputable face, with a nose somewhat of the Edwin Forrest pattern. The Hon. Howell Cobb and the Hon. Humphrey Marshall may be said to be eminently the solid men of the establishment, the Secretary's face being indicative rather of good living than of specific duties, good humor than political intrigue—an expression which is heightened perhaps by total absence of whisker. In this particular, Mr. Cobb finds himself in the same category with Mr. Marshall, and with Senators Seward, of New York, Hammond of South Carolina, and Hunter of Virginia, the Hon. Mr. Stevens of Georgia and the Rev. Henry Ward Beecher. Senator Hunter, however, suffers from the want of whisker, in the absence of which he looks more like a great boy than a great man. Senator Wilson, has the genuine and original look of a lively Yankee, his expression impressing you with the idea that he is a clever (English clever) man, and that he is fully aware of the fact. Judger [*sic*] Parker appears on a lower row—with one of the most intelligent and even powerful set of features in the Gallery. Governor Wise is also present in photography, with the decidedly *premonce* face belonging to the Calhoun class—and near him is our beloved president, sunk in his chair—James Buchanan, with the "Buck" forehead thrust forward, and his eyes a long way behind, peering at you from ambush as though it is not a delight to the old gentleman to look anybody in the face—the features expressing a strange mixture of obtuse stolidity and sharp cunning. Judge Kane is also there, looking like "a fine old English gentleman, one of the olden time," with Chief Justice Taney near him, a plain scholarly-looking and lawyer-like, though somewhat hard-featured man. In the front row, stands the portrait of the Autocrat of the Breakfast Table, as quiet and sensible a looking man as you would wish to see—at breakfast or anywhere. The great financiers are represented by Erastus Corning, two of the Messrs. Brown, of Wall street, and Cornelius Vanderbilt—commonly called by persons who desire to impress you with their intimacy with the great "Kurnele Vanderbilt"—whose portrait, by the way, is one of the best-looking in the gallery: there is an air of aristocracy about the face which does not altogether accord with "Kurnele's["] beginnings, but there is also a shrewdness which is quite in keeping with the little trifle of $50,000 a month which the Commodore is said to receive as a bonus for not running his Nicaragua steamers. These gentlemen are just below Senator Hale, of New Hampshire, a sober, quiet face in contrast with Mr. Giddings next to him, who looks as if he could eat up every Southern man in Congress without so much as winking.

Senator Douglas is, of course, present in the canvass, or paper, or whatever it may be. Nobody fails to pay his frame a visit and note the somewhat fiery and slightly dogmatical, but highly intellectual character of what the Cockneys would call his "fizzog." Senator Crittenden is near "the gentleman from Illinois."

Senator Toombs, of Gorgia [*sic*], with what might, in Hibernian language, be called his bull-headed face, looking obstinacy and contradiction, stands near that most impressive of "mugs" belonging to Ex-President Pierce. The Hon. Edward Everitt [*sic*] is in company with Judge Daniels and John Cochrane, the last named of whom looks mild enough, in spite of his moustache and beard, and not at all like the "Fiend Incarnate."

The clergymen are in the background—or, in other words, in an apartment at the back of the principle [*sic*] gallery. They gather there, however, in great force; and it is pleasing to see Archbishop Hughes looking so amiable in the midst of the divines of the Blue Light sects, and apparently not at all disturbed by the proximity.

The best portion of the gallery, however, is that which contains the ladies; and it is in that part where the sight-seers most do congregate. At the head of a goodly array of beauty is the portrait of Mrs. Senator Douglas, a fine, tall, elegant woman, with a sweet, intellectual face, of somewhat dark complexion. The type of feature is rather French than American; and the expression, which is very *spirituelle*, is marked with a slight shade of seriousness which has the effect of enhancing its beauty. Mrs. Douglas is dressed most tastefully, and without that ostentatious display of jewelry so common at the present day, and which marks such miserable taste. A bracelet and a ring are the only articles of jewelry in the picture. The hair, too, is worn in simple flowing *bandes*, which are so much more becoming than the "combed back" style, in which we have seen the original to less advantage than she appears at Brady's Gallery.

Next in order comes Mrs. Crittenden—a matronly face, bespeaking firmness with good humor, and showing just so much of the mark of age as to enable you to admire the remarkable preservation of former beauty.

Miss Lane, the niece of the President, a fine, handsome girl, with an imperious rather than a winning, a handsome rather than a loveable style of countenance, is next to Mrs. Crittenden on the one side, and, on the other, to Madame Le Vert, the lady wit, authoress, and leading spirit of Southern society. Her face is more French than American, but the archness which pervades the features is decidedly American, and still more decidedly Southern. The features are, indeed, more full of pleasing expression than of striking beauty.

Miss Hale, the daughter of Senator Hale, is next to that of her mother. Both portraits are specimens of beauty, but the observer who permits himself to imagine from the portrait of Mrs. Senator Hale how handsome she must have been twenty years ago, would be apt to assign her even a higher place in the scale of beauty than that now occupied by her daughter. The portrait of Lady Gore Ousely [*sic*] exhibits the diplomacy which has been so effective on the weak-minded person at the head of this nation. Lady Ouseley's is not a handsome nor a very striking face, its chief peculiarity being a sort of *hauteur* which belongs rather to the other side of the water than to this. Mrs. Senator Pugh's portrait is a picture of a happy, mirthful little woman, with just a little dash of temper in to make the character spicy. The face is more of the Yankee cast than of that which one sees most frequently in the middle or Southern States. Mrs. Conrad's is one of the handsomest portraits in the collection. There is rare grace and elegance of manner in the figure, while the expression of the features does not belie the gift of charming conversation for which this lady is famous. Mrs. Postmaster-General Brown, if one of the stoutest, is by no means one of the least pleasing faces in the collection.

On the whole, it is a decidedly agreeable thing to look at these portraits when you cannot see the originals. There are historical associations awakened by the features of many of the celebrities whom we have named which are full of retrospective pleasure, not the less delightful because of the croaking cant of the day, which seeks to decry the present generation as unworthy to share the fame of previous ages. There are living statesmen and jurists now upon the scene of active life who will not be justly appreciated until they shall have been removed from among us, and whose virtues and ability will then be as highly lauded as are those of the preceding century. At any rate, that finer or better women never lived than those who live to-day, we are fully persuaded, and any gentleman who desires to question this assertion can find our card on application.

A BROADWAY VALHALLA

OPENING OF BRADY'S NEW GALLERY

American Journal of Photography and the Allied Arts & Sciences n.s., 3, no. 10 (October 15, 1860): 151–53

Broadway is not merely a great "institution" itself—an institution which all the world may be excused for determining once in its life to see. It is also a sort of Banyan tree, continually sending out tributary "institutions" which swell the "mighty parent" with a thousand new and various interests of their own. In Broadway, all merchants become princely, all trades palatial. The old contempt which wholesale commerce traditionally entertains for its more homely and familiar brother, commerce by retail, threatens to become ridiculous in the natural progress of Broadway. When ladies buy their laces and their ribbons under frescoed ceilings and within marble porches, and seamstresses may buy their wedding-rings in ornamental halls, it is absurd to pooh-pooh the mercer and the goldsmith in favor of the Indian magnate or the China shipper. The day is not far distant when every branch of human industry will have its representative palace along the line of our great thoroughfare; and scarce a month passes over one's head that we are not called upon to chronicle some new effervescence of the magnificent enterprise which is doing for New York what Caesar Augustus did for Rome.

The latest of these manifestations was made on Thursday evening thrown open to the inspection of the curious in such matters, and of the wise Gothamites of the Press, by Mr. Brady, the prince of photographers on our side of the water. For months past, this name, so long synonymous with "imperial full-lengths" and fresh celebrities, has entirely disappeared from Broadway. Brady has been in New York, of course, and no further from his old temple than at the corner of Bleecker street, but hidden there in a chaos of hair-dressers, glove-dealers, and miscellaneous men of bazaars; he has been Brady rather by faith than by sight to the sight-seers who associate his name with one of the established pleasures of the Metropolis. In that there has been an occultation of Brady, portentous to those who knew the permanent necessity of Brady to New York, of some new rising in a more splendid sphere.

The occultation is over now, and at the corner of Broadway and Tenth street, Brady has reappeared on a scale and after a fashion which strikingly illustrates the development of photography into a colossal industry worthy to take its place with the most significant manufactures of the country. The prosperity which Brady has now opened, throws a marvelous light upon the means which we shall bequeath to our posterity of knowing what manner of men and women we Americans of 1860 were. All our books, all our newspapers, all our private letters.—though they are all to be weighed yearly by the ton, rather than counted by the dozen,—will not so betray us to our coming critics as the millions of photographs we shall leave behind us. Fancy what the value to us would be of a set of imperial photographs of the imperial Romans? How many learned treatises we would gladly throw into the sea in exchange for a daguerreotype of Alexander the Great, as he sat at the feast with "lovely Thais," or an ambrotype of Cleopatra as she looked when she dropped that orient pearl into her cup with sumptuous grace!

Well, these we shall never have; but in default of them, our children's children may look into our very eyes, and judge us as we are. Perhaps this will be no great advantage to us, but, in our children's children's name, we ought to thank Mr. Brady and those who labor with him to this end.

The new Brady Gallery has been baptized the "National Portrait Gallery." It deserves the name, and more. It is cosmopolite as well at [sic] national. The ample stairway of rich carved wood, introduces you to a very Valhalla of celebrities, ranging over two continents, and through all ranks of human activity. Had we a Balzac among us, his creditors might be sure te [sic] catch him in Mr. Brady's gallery, for all types of New York and America have given each other a *rendezvous* in this *Ruhm-Halle*, or Hall of Renown. In this deep-tinted luxurious room, are gathered the senators and the sentimentalists, the bankers and the poets, the lawyers and the divines of the state and of the nation, kept all in order and refined by the smiling queenliness of all manner of lovely or celebrated women. Hostile editors here stand side by side, on their best behavior, stately diplomats make themselves pleasant in the very presence of undiplomatic Garibaldi; the Emperor of the French receives the editor of the London *Times* with unruffied [sic] brow. If the men themselves whose physiognomies are here displayed, would but meet together for half an hour in as

calm a frame of mind as their pictures wear, how vastly all the world's disputes would be simplified; how many tears and troubles might mankind still be spared!

And why should they not? For here at one end of the grand saloon behold a company of famous men who have in very truth so met. These are the dead of history. Story and Calhoun, McDuffie and Adams, Jackson and Benton, Webster and Marcy. Auduborn [*sic*] with his eagle beak and eagle eye, become the cousin of his own birds, and Irving placid as the New Amsterdam of his quaint dreams; here they are all in their lives so divided, often so much at variance—as one now in the interest they all inspire and in the respect which enshrines their memories. Let the living, famous or unknown, pictured or unpictured, pause here and take a not useless lesson.

This new and charming gallery will not be opened to the public until Monday next, but Mr. Brady plans, we understand, for to-morrow night, a general reception of ladies and amateurs, which bids fair to be one of the most unique and interesting entertainments of the current season. Then fuller justice can be done than is now in our power to the taste with which Mr. Brady has converted a four story house into a palace of light—absolutely catching the blue sky, and making it permanent in the glasses of his operating-room, by a curious process, which secures to him in all weathers the delicate blue lights essential to the perfection of his art.—*The N. Y. Times*, Oct. 6

BRADY'S COLLECTION OF WAR VIEWS
The Evening Post, New York, February 23, 1866, p. 2

At Brady's photographic gallery, on the corner of Tenth street and Broadway, a rare and extensive collection of photographic war views and portraits of representative men is now on exhibition. It illustrates the prominent incidents of the war with remarkable fidelity, and contains portraits of nearly every notable military and civil character on either side of the great contest.

The interest attaching to such a collection is very great now, but with every succeeding year it will become more and more intense, and its value will continually increase. The future historian will find in such a collection one of his most welcome helps toward the foundation of a true estimate of the leading men of our time whose characteristics are more truthfully embodied by the photographer's art than by the best and most faithfully written contemporary descriptions. It is highly fortunate that a photographer of such undaunted enterprise as Mr. Brady has exerted himself so untiringly and with such success in the work of permanently fixing for future generations the fleeting scenes of our great civil war. The military camps, fortifications, reviews, siege trains—the farmhouses, plantations and famous buildings of the South—the groups of prominent army and naval officers in the field and on the decks of our war vessels—the horrors of war, and its lighter aspects as seen around the bivouac fires, are all portrayed exactly as they were, and as no pen could describe them.

It is obvious that so complete a collection as this should not be dispersed or fall into private hands. It should belong to the public, and be placed where its preservation from fire or from loss by other means, should be rendered certain. In view of this fact Mr. Brady proposes to turn it over to the guardianship of the New York Historical Society, to be placed in one of its galleries. This plan has met with the hearty approval of all the officers of the Academy of Design.

STILL TAKING PICTURES

BRADY, THE GRAND OLD MAN OF AMERICAN PHOTOGRAPHY,

HARD AT WORK AT SIXTY-SEVEN

The World, April 12, 1891, p. 26

A Man Who Has Photographed More Prominent Men Than Any Other Artist in the Country—Interesting Experiences with Well Known Men of Other Days—Looking "Pleasant"

[Special Correspondence of the World]

WASHINGTON, APRIL 10—"Brady the photographer alive? The man who daguerreotyped Mrs. Alexander Hamilton and Mrs. Madison, Gen. Jackson, and Edgar A. Poe, Taylor's Cabinet, and old Booth? Thought he was dead many a year."

No, like a ray of light still travelling toward the vision from some past world or star, Matthew B. Brady is at the camera still and if he lives eight years longer will reach the twentieth century and the age of seventy-five. I felt as he turned my head a few weeks ago between his fingers and thumb, still intent upon that which gave him his greatest credit—finding the expression of the inner spirit of a man—that those same digits had lifted the chins and smoothed the hairs of virgin sitters, now grandmothers, the elite of the beauty of their time, and set the heads up or down like another Warwick of the rulers of parties, sects, agitations and the stage. As truly as Audubon, Wagner or Charles Wilson Peele [*sic*], Mr. Brady has been an idealist, a devotee of the talent and biography of his fifty years of career. He sincerely admired the successful, the interesting men and women coming and going, and because he had a higher passion than money, we possess many a face in the pencil of the sun and the tint of the soul thereof which otherwise would have been imbecile in description or fictitious by the perversion of some portrait painter. For the same reason, perhaps, Brady is not rich. He allowed the glory of the civil war to take away the savings and investments of the most successful career in American photography; his Central Park lots fed his operators in Virginia, Tennessee and Louisiana, who were getting the battle-scenes. It is for this reason, perhaps, that he is at work now over the Pennsylvania Railroad ticket office, near the Treasury Department, and only yesterday he took the whole Pauncefote family, to their emphatic satisfaction—minister, wife and daughters—as he took the Pan-American Commission officially. His gallery is set around with photographs he has made from his own daguerreotypes of public people from Polk's administration down, for he was very active in the Mexican War, taking Taylor, Scott, Santa Anna, Houston and Walker, Quitman and Lopez. I thought as I looked at the white cross of his moustache and goatee and blue spectacles and felt the spirit in him still of the former exquisite and good-liver which had brought so many fastidious people to his studio, that I was Leigh Hunt taking the hand of old Poet-Banker Rogers, who had once shaken hands with Sam Johnson, who had been touched for the king's evil by Queen Anne, and I had almost asked Mr. Brady about Nelly Custis and Lord Cornbury and Capt. John Smith.

"How old are you, Mr. Brady?"

"Never ask that of a lady or a photographer; they are sensitive. I will tell you, for fear you might find it out, that I go back to near 1823-'24; that my birthplace was Warren County, N.Y., in the woods about Lake George, and that my father was an Irishman."

"Not just the zenith-place to drop into art from?"

"Ah! but there was Saratoga, where I met William Page, the artist, who painted Page's Venus. He took an interest in me and gave me a bundle of his crayons to copy. This was at Albany. Now Page became a pupil of Prof. Morse in New York city, who was then painting portraits at starvation prices in the University rookery on Washington square. I was introduced to Morse; he had just come home from Paris and had invented upon the ship his telegraphic abphabet [*sic*], of which his mind was so full that he could give but little attention to a remarkable discovery one Daguerre, a friend of his, had made in France."

"Was Daguerre Morse's friend?"

"He was. Daguerre had traveled in this country exhibiting dissolving views and Morse had known him. While Morse was abroad Daguerre and Nipes [*sic*] had after many experiments fixed the picture in sensitive chemicals, but they applied it chiefly or only to copying scenes. Morse, as a portrait painter, thought of it as something to reduce the labor of his portraits. He had a loft in his brother's structure at Nassau and Beekman streets, with a telegraph stretched and an embryo camera also at work. He ordered one of Daguerre's cameras for a Mr. Wolf, and felt an interest in the new science. Prof. John W. Draper and Prof. Doremus counselled me, both eminent chemists. It was Draper who invented the enamelling of a daguerreotype and entered at last into the business, say about 1842-43. My studio was at the corner of Broadway and Fulton streets, where I remained fifteen years, or till the verge of the civil war. I then moved up Broadway to between White and Franklin, and latterly to Tenth street, maintaining also a gallery in Washington City. From the first I regarded myself as under obligation to my country to preserve the faces of the historic men and mothers. Better for me, perhaps, if I had left out the ornamental and been an ideal craftsman!"

"What was the price of daguerreotypes forty-five years ago?"

"Three to five dollars apiece. Improvements not very material were made from time to time, such as the Talbotype and the ambrotype. I think it was not till 1855 that the treatment of glass with collodion brought the photograph to supersede the daguerreotype. I went to the Hermitage and had Andrew Jackson taken barely in time to save his aged lineaments to posterity. At Fulton street, bearing the name of the great inventor before Morse, I took many a great man and fine lady—Father Matthew, Kossuth, Paez, Cass, Webster, Benton and Edgar A. Poe. I had great admiration for Poe, and had William Ross Wallace bring him to my studio. Poe rather shrank from coming, as if he thought it was going to cost him something. Many a poet has had that daguerreotype copied by me. I loved the men of achievement, and went to Boston with a party of my own once to take the Athenian dignitaries, such as Longfellow, whom I missed. In 1850 I had engraved on stone twelve great pictures of mine, all Presidential personages like Scott, Calhoun, Clay, Webster and Taylor; they cost me $100 apiece for the stones, and the book sold for $30. John Howard Payne, the author of "Home, Sweet Home," was to have written the letter-press, but Lester did it. In 1851 I exhibited at the great Exhibition of London, the first exhibition of its kind, and took the first prize away from all the world. I also issued the first sheet of photographic engravings of a President and his Cabinet, namely, Gen. Taylor in 1849. I sent this to old James Gordon Bennett and he said: 'Why, man, do Washington and his Cabinet look like that?' Alas! They were dead before my time. I went to Europe in 1851 upon the same ship with Mr. Bennett, wife and son. His wife I often took, but the old man was shy of the camera. He did, however, come in at last, and I took him with all his staff once—son, Dr. Wallace, Fred Hudson, Ned Hudson, Ned Williams, Capt. Lyons, as I took Horace Greeley and all his staff, Dana Kipley, Stone, H[i?]ldreth, Fry."

"Was the London Exhibition of benefit to you?"

"Indeed, it was. That year I went through the galleries of Europe and found my pictures everywhere as far as Rome and Naples. When in 1860 the Prince of Wales came to America I was surprised, amidst much competition, that they came to my gallery and repeatedly sat. So I said to the Duke of Newcastle: 'Your Grace, might I ask to what I owe your favor to my studio? I am at a loss to understand your kindness.' 'Are you not the Mr. Brady,' he said, 'who earned the prize nine years ago in London? You owe it to yourself. We had your place of business down in our note-books before we started.'"

"Did you take pictures in England in 1851?"

"Yes. I took Cardinal Wiseman, the Earl of Carlisle and others. I took in Paris Lamartine, Cavaignee and others, and Mr. Thompson with me took Louis Napoleon, then freshly Emperor."

I could still see the deferential, sincere way Brady had in procuring these men. His manner was much in his conscientious appreciation of their usefulness. Men who disdain authority and cultivate rebellion know not the victories achieved by the conquering sign of *Ich Dien*—"I serve."

Mr. Brady is a person of trim, wiry, square-shouldered figure, with the light of an Irish shower-sun in his smile. Said I:

"Did nobody ever rebuff you?"

"No, not that I can think of. Some did not keep their engagements. But great men are seldom severe. I recollect

being much perplexed to know how to get Fenimore Cooper. That, of course, was in the day of daguerreotyping. I never had an excess of confidence, and perhaps my diffidence helped me out with genuine men. Mr. Cooper had quarrelled with his publishers, and a celebrated daguerreotyper, Chilton, I think, one of my contemporaries, made the mistake of speaking about the subject of irritation. It was reported that Cooper had jumped from the chair and refused to sit. After that daguerreotypers were afraid of him. I ventured in at Biggsby's, his hotel, corner of Park place. He came out in his morning gown and asked me to excuse him till he had dismissed a caller. I told him what I had come for. Said he: 'How far from here is your gallery?' 'Only two blocks.' He went right along, stayed two hours, had half a dozen sittings, and Charles Elliott painted from it the portrait of Cooper for the publishers, Stringer & Townsend. I have had Willis, Bryant, Halleck, Guilan C. Verplank in my chair."

"And Albert Gallatin?"

"Yes, I took a picture of him who knew Washington Irving and fought him and ended by adopting most of his views. Washington Irving was a delicate person to handle for his picture, but I had him sit and years afterwards I went to Baltimore to try to get one of those pictures of Irving from John P. Kennedy, who had it."

"Jenny Lind?"

"Yes, Mr. Barnum had her in charge and was not exact with me about having her sit. I found, however, an old schoolmate of hers in Sweden who lived in Chicago, and he got me the sitting. In those days a photographer ran his career upon the celebrities who came to him, and many, I might say most of the pictures I see floating about this country are from my ill-protected portraits. My gallery has been the magazine to illustrate all the publications in the land. The illustrated papers got nearly all their portraits and war scenes from my camera. Sontag, Alboni, La Grange, the historian Prescott—what images of bygone times flit through my mind."

"Fanny Ellsler?"

"She was brought to me by Chevalier Wykoff for a daguerreotype."

"Not in her Herodias raiment?"

"No: it was a bust picture. The warm life I can see as she was, though dead many a year ago."

"Did you daguerreotype Cole, the landscape artist?"

"I did, with Henry Furman. I think Cole's picture is lost from my collection."

"Agassiz?"

"I never took him up, through the peculiarity of his tenure in New York; he would come over from Boston in the day, lecture the same night and return to Boston by night. One day I said sadly to him: 'I suppose you never mean to come?' 'Ah!' said he, 'I went to your gallery and spent two hours studying public men's physiognomies, but you were in Washington City.' So I never got him."

"I suppose you remember many ladies you grasped the shadows of?"

"Mrs. Lincoln often took her husband's picture when he came to New York after the Douglas debates and spoke at the Cooper Institute. When he became President Marshal Lamon said: 'I have not introduced Mr. Brady.' Mr. Lincoln answered in his ready, 'Brady and the Cooper Institute made me President.' I have taken Edwin Forrest's wife when she was a beautiful woman; Mrs. Sickles and her mother; Harriet Lane; Mrs. Polk. Yes, old Booth, the father of Edwin, I have posed, and his son, John Wilkes, who killed the President. I remember when I took Mr. Lincoln, in 1859, he had no beard. I had to pull up his shirt and coat collar; that was at the Tenth-street gallery. Mr. Seward got the gallery for the Treasury to do the bank-note plates by conference with me. I took Stanton during the Sickles trial and Philip Barton Key while alive. I had John Quincy Adams to sit for his daguerreotype and the full line of Presidents after that. I took Jefferson Davis when he was a Senator and Gen. Taylor's son-in-law. Mrs. Alexander Hamilton was ninety-three when she sat for me."

"All men were to you as pictures?"

"Pictures because events. It is my pleasant remembrance that Grant and Lee helped me out and honored me on remarkable occasions. I took Gen. Grant almost at once when he appeared in Washington city from the West, and Lee the day but one after he arrived in Richmond."

"Who helped you there?"

"Robert Ould and Mrs. Lee. It was supposed that after his defeat it would be preposterous to ask him to sit, but I thought that to be the time for the historical picture. He allowed me to come to his house and photograph him on his back porch in several situations. Of course I had known him since the Mexican war when he was upon Gen. Scott's staff, and my request was not as from an intruder."

"Did you have trouble getting to the war to take views?"

"A good deal. I had long known Gen. Scott, and in the days before the war it was the considerate thing to buy wild ducks at the steamboat crossing of the Susquehanna and take them to your choice friends, and I often took Scott, in New York, his favorite ducks. I made to him my suggestion in 1861. He told me, to my astonishment, that he was not to remain in command. Said he to me: 'Mr. Brady, no person but my aide, Schuyler Hamilton, knows what I am to say to you. Gen. McDowell will succeed me to-morrow. You will have difficulty, but he and Col. Whipple are the persons for you to see.' I did have trouble; many objections were raised. However, I went to the first battle of Bull Run with two wagons from Washington. My personal companions were Dick McCormick, then a newspaper writer, Ned House, and Al Waud, the sketch artist. We stayed all night at Centreville; we got as far as Blackburne's Ford; we made pictures and expected to be in Richmond next day, but it was not so, and our apparatus was a good deal damaged on the way back to Washington: yet we reached the city. My wife and my most conservative friends had looked unfavorably upon this departure from commercial business to pictorial war correspondence, and I can only describe the destiny that overruled me by saying that, like Euphorion, I felt that I had to go. A spirit in my feet said 'Go,' and I went. After that I had men in all parts of the army, like a rich newspaper. They are nearly all dead, I think. One only lives in Connecticut. I spent over $100,000 in my war enterprises. In 1873 my New York property was forced from me by the panic of that year. The Government later bought my plates and the first fruits of my labors, but the relief was not sufficient and I have had to return to business. Ah! I have a great deal of property here. Mark Twain was here the other day."

"What said he?"

"He looked over everything visible, but of course not at the unframed copies of my works, and he said: 'Brady, if I was not so tied up in my enterprises I would join you upon this material, in which there is a fortune. A glorious gallery to follow that engraved by Sartain and cover the expiring mighty period of American men can be had out of these large, expressive photographs; it would make the noblest subscription book of the age.'"

"I suppose you sold many photographs according to the notoriety of the time?"

"Of such men as Grant and Lee, at their greatest periods of rise or ruin, thousands of copies: yet all that sort of work takes rigid, yes, minute worldly method. My energies were expended in getting the subjects to come to me, in posing them well and in completing the likeness. Now that I think of it, the year must have been 1839, when Morse returned from Europe, and soon after that Wolf made my camera. I had a large German instrument here a few weeks ago, and some one unknown stole the tube out of it, which cost me $150."

I reflected that this man had been taking likenesses since before the birth of persons now half a century old.

Brady lived strongest in that day when it was a luxury to obtain one's own likeness, and he had some living people who began with the American institution. John Quincy Adams, for instance, was a schoolboy at the Declaration of Independence, or soon after, but, living to 1849, Brady seized his image in the focus of the sun. Had he been thirteen years earlier he could have got John Adams and Jefferson, too; and he missed the living Madison and Monroe and Aaron Burr by only four or five years. For want of such an art as his we worship the Jesus of the painters, knowing not the face of our Redeemer, and see a Shakespeare we know not to have been the true Will or a false testament. Our Washington city photographer probably beheld a greater race of heroes in the second half of the nineteenth century than the first, but in the growth of the mighty nation has come a refined passion to see them who were the Magi at the birth of this new star. Before Mr. Brady was Sully the painter, before Sully Charles Wilson [*sic*] Peale, working to let no great American visage escape, and in their disposition and devotion these three men were worthy of Vandyke's preserving pencil. The determined work of M. B. Brady resembles the literary antiquarianism of Peter Force, who lived in the city of Washington also, and the great body of collections of both have been acquired by the Government.

Geo. Alfred Townsend ("Gath")

TRIBUTE TO M. B. BRADY'S MEMORY

New York Daily Tribune, January 18, 1896, p. 4

To the Editor of The Tribune.

SIR: M. B. Brady, who died in the Presbyterian Hospital on Wednesday night, was long known as the leading photographer in the city, to whom many of the leading citizens of the country sat for their portraits. On the breaking out of the Rebellion he established himself in Washington, and soon put a corps of operators upon the various fields of action, continuing their services until the close of the war. During those years he gathered over 30,000 negatives, representing many fields of battle, showing the earthworks, the dead, the wounded, the captured prisoners, portraits of famous officers and thousands of scenes and incidents occurring during that eventful epoch. In making this collection, Mr. Brady expended the fortune he had accumulated in his former successful business, having faith that Congress would appreciate its historical value and eventually purchase it. His material was liberally used by artists, publishers and historians. Failing in his anticipations of its purchase, failing in health and business, growing old and nearly blind, totally incapacitated for months by being run over by a carriage, without means, without relatives, he returned to New-York several months agto [*sic*].

Since then he had been tenderly cared for by a few friends, and with aid from the Artists' Fund Society, the veterans of the 7th Regiment (he being one of them) and several gentlemen connected with, or interested in, our Museum of Art, who subscribed various sums for the purchase of a fine portrait of Mr. Brady, painted by Charles L. Elliott, which is now on exhibition at the Museum. His body was forwarded to Washington this morning, where funeral services will be held, followed by interment in the Congressional Cemetery, by the side of his wife. Mr. Brady is still warmly remembered by many of our old residents, as a most talented and enthusiastic artist, and as a modest, gentle, generous man.

New-York, Jan. 17, 1896.

SAMUEL P. AVERY.

Selected Bibliography

PRIMARY AND SECONDARY SOURCES ON MATHEW BRADY

Avery, Samuel Putnam. "Tribute to M. B. Brady's Memory." *New York Daily Tribune*, January 18, 1896, p. 4.

Cobb, Josephine. "Mathew B. Brady's Photographic Gallery in Washington." *Records of the Columbia Historical Society* 53–56 (1953–1956): 28–69.

George, Henry, Jr. "From Brady's Gallery." *Philadelphia Times*, February 12, 1893.

Horan, James D. *Mathew Brady, Historian with a Camera*. New York: Crown Publishers, 1955.

"In Memoriam—M. B. Brady." *Wilson's Photographic Magazine* 33 (1896): 121–23.

Lester, C. E. "M. B. Brady and the Photographic Art." *Photographic Art-Journal* (February 1851): 36–40.

Macloon, Charles R. "War Time Pictures: Brady, the Washington Photographer, and His Valuable Work." *Chicago Evening Post*, February 11, 1893, p. 5.

"Matthew [*sic*] B. Brady Dead." *The Photo-American* 7 (February 1896): 114–15 (from the *New York Sun*).

"An Old-Time Photographer and His Reminiscences." *Photographic Times* 25 (October 5, 1894): 226 (from the *Washington Evening Star*).

Sullivan, George. *Mathew Brady: His Life and Photographs*. New York: Cobblehill Books, 1994.

[Townsend, George Alfred] ("Gath"). "Still Taking Pictures." *New York World*, April 12, 1891, p. 26.

GENERAL SOURCES

Benjamin, Walter. "A Short History of Photography." Translated by Phil Patton. *Artforum* (February 1977): 46–51.

Boorstin, Daniel J. *The Image: A Guide to Pseudo-Events in America*. 1961. Reprint, New York: Atheneum, 1971.

Coke, Van Deren. *The Painter and the Photograph, from Delacroix to Warhol*. Albuquerque: University of New Mexico Press, 1972.

Frassanito, William A. *Gettysburg: A Journey in Time*. New York: Charles Scribner's Sons, 1975.

Fredrickson, George M. *The Inner Civil War: Northern Intellectuals and the Crisis of the Union*. New York: Harper and Row, 1965.

Freund, Gisele. *Photography and Society*. 1974. Boston: David R. Godine, 1980.

Gardner, Alexander. *Gardner's Photographic Sketchbook of the War*. 2 vols. 1866. Reprint, New York: Dover Publications, 1959.

Gernsheim, Helmut, and Alison Gernsheim. *The History of Photography*. 2 vols. 3d edition. London and New York: Thames and Hudson, 1982–1988.

Halttunen, Karen. *Confidence Men and Painted Women: A Study of Middle-class Culture in America, 1830–1870*. New Haven, Conn.: Yale University Press, 1982.

Ivins, William. *Prints and Visual Communication*. Cambridge: Harvard University Press, 1953.

James, Henry. *A Small Boy and Others*. New York: Charles Scribner's Sons, 1913.

Jenkins, Reese. *Images and Enterprise: Technology and the American Photographic Industry, 1839 to 1925*. Baltimore: Johns Hopkins University Press, 1975.

Jussim, Estelle. *Visual Communication and the Graphic Arts: Photographic Technologies in the Nineteenth Century*. New York: R. R. Bowker, 1983.

Klingender, Francis D. *Art and the Industrial Revolution*. Edited and revised by Arthur Elton. London: Paladin, 1968.

Levine, Lawrence W. *Highbrow/Lowbrow: The Emergence of Cultural Hierarchy in America*. Cambridge: Harvard University Press, 1988.

McCauley, Elizabeth Anne. *Industrial Madness: Commercial Photography in Paris, 1848–1871.* New Haven, Conn.: Yale University Press, 1994.

McPherson, James. *Battle Cry of Freedom: The Era of the Civil War.* New York: Oxford University Press, 1988.

Miller, Lillian. *Patrons and Patriotism: The Encouragement of the Fine Arts in the United States, 1790–1860.* Chicago: University of Chicago Press, 1966.

Newhall, Beaumont. *The History of Photography from 1839 to the Present Day.* 5th ed. New York: Museum of Modern Art, 1982.

Potter, David M. *The Impending Crisis, 1848–1861.* Completed and edited by Don E. Fehrenbacher. New York: Harper & Row, 1976.

Root, Marcus A. *The Camera and the Pencil, or the Heliographic Art.* 1864. Reprint, Pawlet, Vt.: Helios Press, 1971.

Rudisill, Richard. *Mirror Image: The Influence of the Daguerreotype on American Society.* Albuquerque: University of New Mexico Press, 1971.

Sandweiss, Martha A., ed. *Photography in Nineteenth-Century America.* New York and Fort Worth: Harry N. Abrams and the Amon Carter Museum of Art, 1991.

Scharff, Aaron. *Art and Photography.* New York: Pelican Books, 1968.

Sennett, Richard. *The Fall of Public Man: On the Social Psychology of Capitalism.* New York: Alfred A. Knopf, 1977.

Taft, Robert. *Photography and the American Scene: A Social History, 1839–1889.* 1938. Reprint, Dover Publications, 1969.

Trachtenberg, Alan. *Reading American Photographs: Images as History, Mathew Brady to Walker Evans.* New York: Hill and Wang, 1989.

Wilson, Edmund. *Patriotic Gore: Studies in the Literature of the American Civil War.* 1962. Reprint, with a foreword by C. Vann Woodward, Boston: Northeastern University Press, 1984.

Wilson, James Grant. *The Memorial History of the City of New-York, from Its Settlement to the Year 1892.* Vol. 3. New York: New-York History Company, 1893.

Photography Credits

Architect of the Capitol: pp. 58 (*Resignation of Washington*), 86 (*First Reading . . .*)

Wayne Geist: p. 156 (Beecher)

Marianne Gurley: pp. xiv, 102, 107 (*Soldiers on the Battlefield*), 108, 109, 121, 188, 192

Adam Reich: pp. 15, 18

Rolland White and Marianne Gurley: pp. 4, 6, 13 (Webster), 16, 17, 19, 20, 21 (Juliette Brady), 24, 25, 26 (map), 29, 31, 33, 36, 38, 42, 44, 45 (Anthony's studio), 46, 52, 53, 54, 57 (Moultrie), 60, 62, 63 (Calhoun lithograph), 64, 66, 67, 68, 69, 70, 72, 79, 80, 83, 86 (Abraham Lincoln), 88 (Robert Lincoln), 89, 90, 92, 100 (Ellsworth), 104 (Grant), 105, 107 (*A Contrast*), 112, 114, 115, 117, 137, 142, 143, 144 (Frémont), 156 (Willcox), 157 (Dahlgren), 161, 164, 165, 166, 167, 197, 201, 202

Index